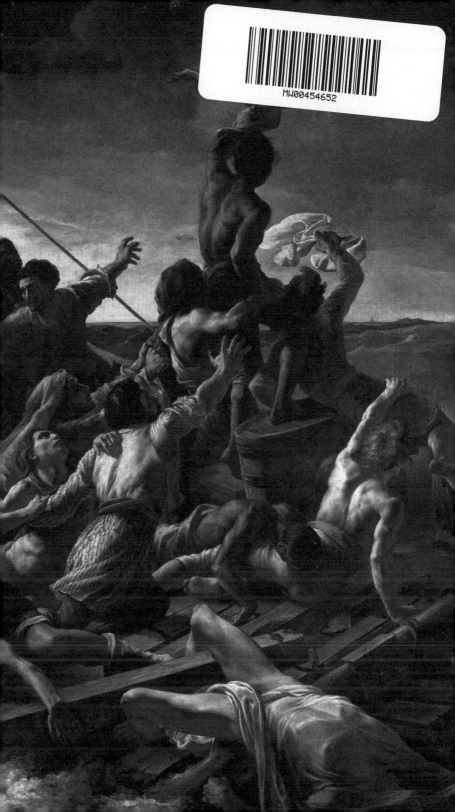

WRECK

WRECK

*Géricault's Raft and the
Art of Being Lost at Sea*

TOM DE FRESTON

GRANTA

Granta Publications, 12 Addison Avenue, London W11 4QR
First published in Great Britain by Granta Books, 2022

A CIP catalogue record for this book
is available from the British Library.

1 3 5 7 9 10 8 6 4 2

ISBN 978 1 78378 663 3
EISBN 978 1 78378 664 0

Typeset in Caslon by M Rules
Printed and bound by CPI Group (UK) Ltd, Croydon, CR0 4YY

www.granta.com

MIX
Paper from
responsible sources
FSC® C171272

For my mum and my sisters, for
all you are and help me be

51.7519°N
1.2578°W

Contents

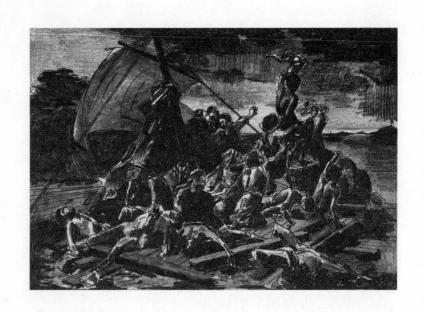

Prologue

Ghosts

Leave the door open for the unknown, the door into the dark. That's where the most important things come from, where you yourself came from, and where you will go.

REBECCA SOLNIT

I suppose this is a ghost story, of sorts. Many ghosts, not just one.

This will be the last time I'll see my dad before he dies. I know I won't stay, won't wait or return. He doesn't know this. He is barely alive. Cancer has ravaged his body. It has bloated his stomach, shifted the colour and texture of his skin and necessitated a colostomy bag, offering external markers of the internal destruction. But in these last few weeks the weight has fallen off and his skin is soft, smooth and milky-white, translucent. He is already part-corpse, a spectre. His mouth hangs open, a wide O. Each breath seems thinner, final; each exhalation

reveals the shedding of weight, the ribcage nosing up and out, skin stretched paper-thin. His lips and mouth are patterned with dried cracks, his speech reduced to a few barely audible airy words, a last grip on language. The machine of the body is winding down, achingly, painfully slowly. This is no longer really him; the self is already exiting the body, drifting like dust out of the room. He's half here, a husk really, stuck in the dusky limbo of being not quite dead.

I'm also only half here. Physically, dutifully present, but my head is back in Oxford in my studio. A sanctuary, my place of separation and isolation. All I can think of is the printout of a painting stapled to the wall. The print is worn, scarred by fold lines like an opened OS map, held together by bits of dirty masking tape, thumb prints of oily stains smeared around the border. The image is partially obscured by a splatter of blue cracked paint over one of the figures. Beneath the marks is an image of Théodore Géricault's *The Raft of the Medusa* (1819). A wooden raft, stacked with a diverse cast of bodies, the weight of which pushes its edges underwater. It is a dramatic reimagining of the horrors of a contemporaneous disaster, of a shipwrecked boat en route from France to Senegal, and the story of the 150 people who were left stranded on a hastily constructed vessel.

It is a painting that hits you all at once and then unfolds itself in parts. It is a painting which captures the horror and the hope, a tumult of light and dark in every sense. Theatrically lit, some figures sit in shadow against the diffused light of a sunset, others glow, bodies heavily contoured and sculpted by light. They are arranged into distinct groups which collectively mount up and fill the canvas, the stormy sea and brooding sky a backdrop to the central spectacle. Our eyes are directed dynamically through these expressive tableaux. Each is a scene of heightened emotion, in pose, action and facial expression. Frozen corpses,

figures held in the stillness of grief, a collective in animated discussion and thought, lonely souls lost to the shadows in the contortions of despair. Then the energetic shift, and we see the twists and turn of bodies lifting, lifted, reaching upwards and outwards, the muscular back of a black figure rising out of the crush of flesh, waving a red flag to the horizon in hope.

From the moment of my first encounter with the painting, the pain it depicts caught my attention. It was both an image of and an engagement with suffering which compulsively ghosted through almost every painting I made. It's a seminal work within History Painting, a genre which reached an apotheosis in early nineteenth-century France. History Painting is literally story painting, the theatrical arrangement of figures in space which depicts dramatic episodes normally drawn from history, litera-ture, mythology or religion. *The Raft* fits into a subsect of History Painting that attempts to translate stories of suffering into paint.

To me the world felt stuffed full of suffering, and Géricault's masterpiece had been a guiding light as I worked out what pur-pose painting might have in trying to capture and make sense of it, to enter it and to bear witness. It's an image I have been obsessed with for nearly fifteen years, but in recent months, the final stretch of my dad's life, that obsession has been bubbling up into something all-consuming. I know it is going to be the cen-tral reference point in the paintings I will make in the coming year. What I don't realise is that it will be a further seven years until this journey is complete.

The studio is littered with signs of life. Dirty teacups, mould puffing up green and frothing over the lip. Toast plates scattered with crumbs, stacks of glasses. Ripped scraps of paper, a floor covered in years of paint and the comforting smell of turps that never leaves the space. Here is a fertile compost heap of new

ideas forming, of multiple sources scattered into ideas across the walls and floors. *The Raft* is the centre point on the wall, but is surrounded by other images, sources and texts. Many of the prints stuck up around it are of paintings across a broad history, images of suffering and tragedy. Chopped up and dotted between them are pages roughly ripped from an unbound copy of Shakespeare's *King Lear*, the margins covered in scrawled annotations. Other pictures are from newspapers, or from the internet. Dominant are photographs of the Mediterranean Sea crisis and the unfolding conflict in Syria. Orange lifeboats weighed down by clusters of people, drone shots of Aleppo, aerial imagery of the scarring decimation of the city, stripped back to skeletal form. Newspaper cuttings of Damascus, ground-level shots of buildings shed of their walls, streets previously filled with colour and life turned to monochrome, dust-covered ghost streets. Pages from history books, piles of skeleton bodies dumped outside the Bergen-Belsen concentration camp like litter.

The sea of images is an ocean of echoes, and the raft bobs around in the centre, speaking to all of them. It is impossible to look at this painting, its heaps of figures crammed onto a raft lost at sea, and not see the cruel rhyme with the images of boats carrying refugees crossing the Mediterranean. It seems also to speak of the wider unfolding Syrian crisis, of a population fighting for survival and pushed to unimaginable extremes of suffering. Two hundred years after it was made, *The Raft* resonates with the cruelty and tragedy of the Syrian civil war and then further: the painting as metaphor, Syria as microcosm, a world in crisis revealed.

My studio wall of images is a map of multiple stricken worlds; literary, geopolitical, historical. The raft at the centre is my vehicle; the mode of transport I board to travel. On its back I am gathering material to remix into a new collection of paintings,

fractured reimaginations and reconstructions. I am at the start of a quest to look at the suffering of the world and, if I can get beyond mere spectacle, paint it. Géricault was on this same quest 200 years earlier. As he nervously laid those first marks on his gigantic canvas, he would have had no idea of how successful his quest would be, nor of the dark waters he would be entering.

My obsession with *The Raft* had led to a desire to re-enter these waters: of history, of the painting, of the stories connected to it, of Géricault's remarkable life. The studio is also full to bursting with hundreds of related books, shelves heaving under the weight, the floor carpeted in opened-up texts. They are covered in stains of paint; flicks, shoeprints, smeared marks from fingers and hands. The obsession isn't a search for cold, objective truth, but something closer to a desire to paint the gaps as much as the mapped terrain. Something similar to the writer Saidiya Hartman's idea to make art *at the limit of the unspeakable and unknown*. I am looking for a methodology to interrupt the certainty of the sources, to estrange and dramatise. I want to echo the Romantic vision of Géricault's painting, how it transforms and expressively reimagines what happened.

It was June 1816 when a small convoy of ships set sail south from Rochefort, on the west coast of France, to Saint-Louis, a port on the west coast of Senegal. Their mission: to return Senegal from British to French colonial control. Of the 365 people making the trip, 240 were on board the frigate *Medusa*, ready to start a new life in the colony. The *Medusa* and a vast swathe of its passengers would never arrive, as the ship would crash off the west coast of Africa. From the wreckage of the ship a raft was constructed for those who could not fit in the lifeboats. Unimaginable horrors awaited them, and the majority would not survive. The scandal and suffering are the contemporaneous subject matter of Géricault's painting.

It is a History Painting which stages the drama of a present-day catastrophe, as opposed to an episode from mythology or history. But it is elevated beyond genre painting, beyond the illustrative or journalistic. By centring the composition on the collective human struggle, it translates the story beyond reportage. It is a painting which immerses and consumes, fore-grounding feeling rather than merely illustrating action. The small paint-splattered printout in the studio helps conjure the real thing. If I shut my eyes, I can see in full the over-life-sized figures mounting up and across the picture plane. The frame fills the studio, the figures spill out across the studio floor. A room full of sea, the smell of salt and rot.

Nearly five metres high and over seven metres wide, *The Raft* is cinematic in scale. It is by no means unique in terms of its size. In the Louvre it shares a room with other History Paintings of similar proportions, yet they seem to shrink into the walls. *The Raft* feels impossibly bigger, its impact stretching way beyond the limits of its physical borders. Every time I visit it, it magnet-ically pulls me. I first view it from a distance, taking the whole picture in. Then I am gradually drawn closer and closer until I am at a tempting touching distance, barely a foot away, dying to press a hand or nose to the surface; I feel a gnawing need to be as close to contact as physically possible.

The murmur of people, the museum and the city melt away. The babble dims and vanishes, leaving stillness and silence. In that space the unheard symphony of the sea fills my head. Not just the roar of the waves in the painting, but as if I am completely submerged. Time stretches out of shape beyond all recognition, stills and stops; what the poet John Keats calls *Thou foster-child of silence and slow time.* Time and space operate at different speeds.

The Raft of the Medusa would be Géricault's defining statement.

It translated a contemporary catastrophe into a metaphysical masterpiece that captured forms of suffering that transcended its subject matter, and even its historical context. Much of the mythology around the work focused on the macabre and intense inner workings of Géricault's studio, in which he created *The Raft*, and on the unimaginable horror of the story it depicted. But really the painting starts with love.

A few months before Géricault's sixteenth birthday Alexandrine-Modeste de Saint-Martin entered his life. Aged twenty-two, she was to marry his uncle, twenty-eight years her senior, and so become Géricault's aunt. A friendship blossomed through a shared love of art. Alexandrine admired and supported her nephew's talent, which was otherwise largely ignored or discouraged. A year later Géricault's mother died, causing a catastrophic rupture to his previously privileged and upwardly mobile life. He was left with enough money to be financially independent, but it was the emotional vacuum and the accelerated entry into adulthood that defined his development.

Alexandrine offered the support of a consoling friend and a surrogate mother. With her husband largely absent on business, Géricault became her valued companion of shared sensibilities. When Géricault struggled to convince his father to let him study art and pursue his passion for horse-riding, Alexandrine convinced her husband to employ him in a spurious accountancy role in his tobacco company. His absences would be ignored, allowing him to pursue his dual passions, and to spend much of his time under the tutelage of the equestrian painter Carle Vernet.

In 1976, a secret that had been kept buried by family and early biographers for over 150 years emerged from the dark. The shifts and mutations of Géricault's relationship with Alexandrine happened over many years. Half a decade after their first meeting,

when Géricault was twenty-two and Alexandrine twenty-seven, their bond grew from one of emotional and financial support into an amorous affair. The deception that already marked their liaison developed into something dangerous and illicit. The shame and guilt of their betrayals, and the transgressions of their actions, began to eat away at them. Their relationship – adulterous and incestuous – breached any model of familial or societal ethical code. *What is stupider than a lover?* asks the twentieth-century philosopher Roland Barthes, and there is no doubt that for Géricault and Alexandrine desire became delirium.

We know little about Alexandrine, a figure largely hollowed out by history. We can only imagine into the gaps. She appears to be almost entirely absent from Géricault's work, although a sheet of drawings and an unfinished portrait are speculated by many biographers to be of her. In their quiet tenderness they hint at something more intimate than a study of a model. Yet it is the mystery surrounding these images that is most revealing, suggesting that even if she did appear in his work at this time, it was always private, always hidden.

My studio gave me something similar, a space to hide, to disappear. The constellation of printouts across the wall was a personal curated map through art history, to guide the way forwards. The studio was a place of isolation, separation, a space where I could block everything out. I longed to get back to it. I had spent a life using painting as a way to erase the self, to turn away from the inward gaze. But we cannot outrun ourselves.

With a soft squeeze of the hand, I am pulled back into the care home. Back to where I don't want to be. The room is strikingly bare and empty, sterile, functional and cold. I remember the calls and emails from the care-home staff encouraging me to bring photos, paintings, books, trinkets from my father's house to make the room homely. I brought nothing. In hindsight I

performed a theft of identity and comfort in not easing his last months.

I hover over my father, dripping water into his mouth and holding a wet sponge on his tongue to quench his thirst, to ease his cracked, sore lips. We communicate through grips and squeezes of the hand, a reduced vocabulary of touch. *Do you need anything? Is that enough? I love you.*

The closest I got to confronting him was several years before, when I told him I didn't remember much of my childhood, that I had huge, blank spaces. Instead of interrogating this he boasted about the depth of his own memories, prenatal in reach. He gave me a vivid, fantastical account of his birth, bizarre and upsetting in its gynaecological, embodied detail. He thought it wondrous, funny. The strangest aspect was the recollection of the near-fatal damage he caused his mother. The description was both violent and sensual, the most unsettling, worryingly literal Oedipal complex I've ever heard.

The not-knowing sits like a knot in my chest. I am unable to locate the extent or exact nature of the abuses and trauma at the heart of our relationship. I feel unhinged, only able to map the borders of a darkness, feeling its impact but unable to enter it. I exist uneasily in this state of uncertainty, of the unknown. Did he just make me uncomfortable, or was that discomfort a product of things he did? Was the way I protected my body and erased whole passages of the past a clear signifier of sexual abuse? Did my body remember things my mind had buried? I held his hand, knowing he would soon slip into non-existence and that any certainty of what had happened would die with him.

It is strange to look at someone this close to death and feel both a desire to hold them, hug them, and a wish for them to die. Pity and anger nudge up against each other in my throat,

merging into some kind of confused cancellation of feeling. I am as empty as the room.

My father's eyes are flicking in and out of sleep, of consciousness. In the moments of them opening, red and watery, we look into each other. We are both impenetrable. I am unsure what surface awareness he has, let alone what lies beneath. It is odd to be seeing into these half-open windows, into my father, into a body in the process of being unhomed, into this part-monster. As a child the monsters that most scared me were the ones you couldn't see, or those you only saw in the shadows. It is the spaces left to the darkest recesses of our imagination, beyond reach, that are the most horrifying. My father was a monster I couldn't fully grasp and could only ever know in fragments.

Looking at him in pain and discomfort, I also felt love and pity. He was so frail, aged beyond his years by illness, but all I could see was the small boy trapped inside, who had never been able to grow out of the perversions forced on him in childhood. An elder sister mysteriously abandoned, an upbringing in which he and his younger sister were blocked off almost entirely from the outside world. Home-schooled, living in isolation, brought up to believe that their distant aristocratic past made them superior to everyone else, breeding a deep narcissism and alienation from the world. When a German plane crashed in the woods near my father's childhood home, the wreckage of metal and flesh was the first time he was even aware the Second World War existed. When his relationship with his younger sister ventured into incestuous and violent mutations of love, it laid the foundations for a shattered psychology in which social norms and sexual identity were cruelly bastardised. Monsters are made.

I can feel all of this in the room, gathered up as fog. What lay inside my father? What memories, what feelings, what

mechanism to justify his actions? I wanted to climb inside him and discover the rot. A thought occurs and collects uncomfortably in my mouth. I want him dead.

I am ready to leave the stale, sterile emptiness of the care home, to leave my dad for a final time. I kiss him on the forehead. *I'm sorry, got to go. I love you. I do. You can let go now, don't be scared. I'm sorry, got to go.* As I pull away his hand grips slightly, resisting my movement. I gently remove his hand from mine, smile and shuffle to the door.

By the time I get back to Oxford from Devon it is late. I lie restless in my bed, find unnerving the weird mirroring of my sleepless body with his slow slip into the sleep of death. *For in that sleep of death what dreams may come?* That question haunts me. I had wanted so badly to get out of his room and now I can't scour the image from my head. I wondered if he was scared. I wondered what his last thought would be, what final image would pass through.

In this half-waking state the memory of a dream slides in, one I hadn't thought of for years. My earliest memory of a dream.

We moved from London to Devon when I was three and lived on top of a storm-tossed cliff. In my memory our home was on the edge, virtually peering over and down to the ocean from my bedroom. My mum assures me that we were a good few minutes' walk away, but for some reason I have moved the house closer.

In the dream I would fall asleep to the sound of the waves, my bedroom the inside of a seashell. Slowly the sounds would build, the sea rising up the sides of the cliff and crashing against the windows. The sea would eventually work its way into the room, which would fill with water, rising at pace. The waves' great shadowing hands across the walls. I was too scared to leave the bed, a boat rising up to the ceiling. I would either be crushed or drown. Then I was under. I would wake, bed wet, gasping for

air, stagger half asleep to my parents' bedroom. *The sea's come into my room again.*

At some point I realised my dad was the sea. In the months after his death the dream would return, a haunting from childhood. The sea would fill me up, drown me from the inside and seep and spill out across my canvases. It was far away, passed and past, but still it had found me.

I

Possession

To paint is a possessing rather than a picturing

PHILIP GUSTON

Standing in the Louvre, feeling small in front of the vast expanse of *The Raft of the Medusa*, you exist both in the three-dimensional space of the museum and look into another. The surface of the painting is resolutely flat and simultaneously conjures the illusion of another reality. Here lies the paradox of paintings, a two-foldness between the reality of flatness and the illusion of depth. *The Raft* plays with this paradox with particular force.

Empty the picture of its figures and what is left is a shallow stage. The wooden beams from which the raft is constructed build the illusion of depth in the painting and organise the composition across the flat picture plane. The raft, with its angled perspective, tilts the scene upwards and pushes the action to the foreground. The mast and the collection of figures create two striking pyramids so that action fills the frame. Space in the

picture has been squeezed to create a scene of claustrophobia. The tensions and contradictions of a painting's dual reality are amplified. Before we even make out the detail on the stage we are confronted with an architecture of intensity.

Géricault's vision of the raft was pulled from reality: a schematic design drawn by one of the survivors, Alexandre Corréard, and published in an account of the hellish days he co-authored with Henri Savigny, the surviving ship's surgeon. The bird's-eye view offered by this drawing gives a sense of its scale. Long wooden beams were arranged in vertical rows, huge rafters crossing horizontally, bound together by thick reels of rope. The raft was an improvised structure, engineered from the scavenged architecture of the ship, the wreck itself providing the repurposed means for potential survival.

Where does a work of art emerge from? How does an artist get formed? When does this process begin? And are these even the right questions? I had spent years reading and rereading every book and article on Géricault and *The Raft*, to collage together an understanding. The history of literature on both incorporates a wide range of contested and contrasting methodologies and approaches. My research feels like painting, in that I am trying to construct a full appreciation of the painting and find new ways into it. At the very least, to sketch the history which it comes from and speaks back to.

The backdrop to Géricault's formative years was a period of unimaginable, hugely troubled and accelerated evolution. He was born in 1791 in Rouen, when France was on the precipice of a bloody revolution. The pace of traumatic change never let up, with ramifications reaching across Europe, deep into Africa and across the world – from the *Ancien Régime* to the violent overthrowing of the monarchy, the formation of the Republic,

the rise of Napoleon Bonaparte and the bloody colonial pursuits of his empire, to the fall of Napoleon and the subsequent restoration of King Louis XVIII in 1814. Then came Napoleon's brief return, and the second restoration of King Louis XVIII in 1815. By the time the Bourbon Restoration had settled, France was a country where glory was replaced by the realisation of the horror of what had been. The war-wounded returned, spilling out of overcrowded hospitals. The price and sacrifice of war was laid bare in the streets, vivid sores across the city's body. Feverish patriotic pride was replaced by a sense of disillusionment in a country in decline. With war no longer the driver, the people felt passive, lost and detached. Géricault embodied this spirit: spectacle replaced action.

In 1811 he was conscripted to the army, but his father re-mortgaged their house, offering up 4,000 francs to pay for someone to take Géricault's place. This someone, Claude Petit, would only ever receive a quarter of this sum, as less than a year later he would die in an army hospital in Germany. Then, in 1814, with Napoleon exiled to the island of Elba in April, Géricault joined a regiment newly formed for the restored Louis XVIII. Its glamour appealed to him: the parades of the horses, the flamboyant outfits, a performance of war and a presentation of glory. When Napoleon and the Allied troops re-entered Paris, many of the men surrendered. Géricault followed Louis XVIII out of Paris, before the regiment was disbanded and forced to return, emasculated and embarrassed. Disillusioned, he left the army to go back to to painting, the only damage being to his ego.

Géricault's emergence into artistic maturity was framed by a confrontation with historical violence through observation, not participation. He was part of a generation born into the expectation of war and the heroism that followed, who ended up being a passive spectator. He was left with only the pomp and ceremony,

a performance of masculine virility neutered by circumstances. As a History Painter he was expected to make art from mythology, literature and the past, but it was impossible to ignore the violent drama of the events unfolding in the real world. History was happening in front of his eyes, and he needed to capture it.

A parallel and equally dramatic artistic evolution had taken place in France during this period under Jacques-Louis David, the figurehead of a new form of History Painting. Leading up to and during the revolution he painted scenes from Roman history as potent metaphors for the events of the day. Under the patronage of Napoleon and armed with a new political agenda, he was one of many painters happy to make works of powerful state propaganda. David codified a mode of History Painting characterised by its slick surfaces, veneration for the past, and geometrically structured scenes for an entire school of slavish followers.

David's History Paintings did not just chart the events of the day, but became their heartbeat. Completed in 1789, his painting *The Lictors Bring to Brutus the Bodies of his Sons* was a rallying cry at the start of the revolution. *The Death of Marat*, painted in 1793, is one of the great pieces of propaganda. Jean-Paul Marat, assassinated by Charlotte Corday, is martyred by the painting, giving heat and anger to the Republican cause as the revolution reached its bloody end. While he was completing this painting, David became a figure of significant political power and sat on the National Assembly, which voted for the execution of King Louis XVI.

On 21 January 1793 Louis XVI was escorted to a stage before a huge audience. He tried to hold back his tears, prayed for France, and wished that his blood would not spill out into more violence. The guillotine dropped its blade to a drumroll. Louis was buried with his head between his legs, stripped of identity

and status. Art was not just an illustration of the world at this time: its key players were complicit in its violent shifts.

But the History Painting of David and his followers, for all its creative inventiveness, had come to feel bankrupt. Géricault was in search of new models for this new world. A snapshot portrait of the artist suggests a psychology perfectly suited to tapping into this spirit. The literature on Géricault constructs and supports a mythology which was carefully sculpted from the start: the archetypal Romantic genius, *The Raft* his grand statement. Early biographies are full of neat stories of obsession and isolation, of an artist who rented a new studio for the sole purpose of constructing this huge canvas. Géricault is cast as the beautiful, vain, immaculately dressed dandy who locked himself away, shaving off his carefully curled hair in an act of monastic dedication and maddening intensity. The artist who went to great lengths to explore the truth, painting his masterpieces while surrounded by severed limbs, rotting heads and rats. The quintessential tortured soul, with elaborate anecdotes of a difficult temperament, suicidal depressions and eccentricities. But this is a caricature collaged together from truth, which simplifies a more nuanced and complex personality.

There is no doubt Géricault was an outsider from the start. His training was unconventional and informal, beginning in the studio of Carle Vernet, which perfectly suited Géricault's near-pathological love for horses. Then in 1810 he worked under the guidance of Pierre-Narcisse Guérin, a Davidian follower whose students underwent a scholarly and rigorous training, one which Géricault constantly pushed against. He was always looking for feeling over observed truth, always independent-minded and contrary. From the start he wanted to escape the rules of Classicism, to reach towards a looser, intense neo-Baroque style in subject matter, handling and staging.

He would find his most important training through self-directed study at the Louvre. Recently renamed Musée Napoléon, it had been filled to the brim with masterpieces looted during France's violent overseas expansion. In his copies of paintings and sculptures Géricault constructed an idiosyncratic toolkit of compositions, poses and methods. But it was in his study of the works of Titian, Caravaggio, Rembrandt, Rubens and Velázquez that he found his kindred spirits, taking lessons from their more painterly, expressive language. Yet even in his paintings after Poussin we see that they were never mere copies, that Géricault was translating them into his own language, adapting and reimagining them. In the masters exhibited at the Louvre, he found an artistic style distinct from the Classical models so carefully copied and venerated by his recent predecessors and contemporaries. These early studies never left his studio, and a number of them were carefully hung around him on his deathbed, lights from the past to guide him into the final dark.

In his earliest works we see the influence of these artists, but also a style very much his own. *The Charging Chasseur* (1812) and *The Wounded Cuirassier* (1814) are both large-scale paintings of soldiers and their horses. In part they can be understood by their difference to a painting by David of a few years earlier, the iconic propaganda of *Napoleon Crossing the Alps* (1801). The horse is more like a classical sculpture than a living, breathing animal. Idealised, it fills the canvas, statuesque and beautifully balanced on its back legs. Napoleon, his shawl swirling round in an impossibly formed wave, controls the horse with one hand while pointing onwards with the other. It's an image of, and a metaphor for, complete control.

Géricault's *Charging Chasseur* is an inversion of this vision of power. The soldier twists his body to look mournfully back, seeming to be about to slide or be thrown off his steed. The

horse is fearful, rearing up on its back legs, balancing on the tip of its hooves, unsteady legs certain to topple at any moment. It is wild-eyed and its nostrils are full of the red fire of the hellscape of war. In the distance, another horse returns our gaze, eyeball bulging out of its socket. The painting pushes beyond naturalism, capturing instead the animals' movements as external expressions of internal emotions, an outpouring of fear. Géricault was a keen and accomplished horse rider – he served as a horseman in the garrison of Versailles – and he intimately understood the wildness present in a scared horse. Two years later, in *The Wounded Cuirassier*, he painted another such inversion, capturing the deep melancholy of retreat and defeat. A soldier walks alongside his horse, firmly gripping his reigns as they both descend a hill. He looks up and back, his mask-like face shot through with worry and regret. He strains to control the bucking, startled horse. All is lost, left behind; survival is the only hope now.

Together the paintings are mirrors held up to the changing psychological landscape of a country and its engagement with war. The country was expanding its empire violently, war being the heroic statement of nationalism. The banks of the Seine were piled with soldiers' corpses, often rolling into and polluting the river, and the streets were teeming with the wounded and disillusioned. David's painting hides violence with insidious intent, while Géricault's two paintings offer alternative models of power and masculinity: portrayals of war's full physical and psychological ramifications. These scenes of modern warfare don't glamorise war but are crammed with its chaos and terror, reaching beyond the specific towards metaphor, with the horse as both political symbol – of the external state of France – and personal symbol – of the internal state of Géricault. They are anti-heroic images, representing the emergence of a Romantic

spirit in the animalistic energies and expressive handling of form and paint. They point forwards to *The Raft*.

What does *The Raft* signify? What is it about the painting that makes it seminal in the history of art? In so many ways it is a work which seems to bridge histories, simultaneously encapsulating a specific historical moment but also embodying and pointing towards so many histories which precede and follow it. It breaks with the models of Neoclassicism in its subject matter, its approach to composition, its application of paint and the particular theatrics of its narrative devices. But it is also underpinned by Neoclassicism and is far from a total rejection of it. It subverts, tweaks and is in part totally reliant on the older models. It is heralded as a Romantic masterpiece, opening up so many of the possibilities of Romanticism and paving the way for the poetic, painterly and dramatic radicalism of younger artists like Delacroix. It is a synthesis of what went before and what's still to come, at the localised level of French early nineteenth-century painting. It derives from these foundational contradictions.

Its references and borrowings function like an encyclopaedic palimpsest of Western painting, while also travelling at full throttle towards Modernism and the accelerated shifts and changes in art across the following century. *The Raft* is often heralded as the last great statement of a genre, the final hurrah ahead of the death throes to follow, with History Painting first losing its place at the top of a codified hierarchy and then largely vanishing from relevance. Everything *The Raft* stands for in its approach to history, storytelling, image-making and painting is given triumphant expression while also threatening the future relevance of such approaches. It owes a debt to painters for whom paint is a language, a poetry in which paint can signify many things at once. Paint as paint – a self-reflexive tool; paint as light, emotion, spirit, energy; paint as flesh. In its homage to

this tradition it also paves the way for the expansion of the language of the medium, most notably in the Expressionism and Abstraction to come. It also opens up the painter's relationship to their self and the world, internal and external factors feeding into a painting in mysterious and complex ways. It gathers up the pasts and futures of the medium while resolutely expressing its specific historical moment.

The books stack up in the studio, the margins smeared with fingerprints and stained with blotches of paint. My scrawled writing fills every empty space, often overlapping and barely legible, a stark contrast between the rigorously researched, beautifully articulated arguments, historical narratives and evidence of these texts and the idiosyncratic mess of my marginalia. Page after page of organised, logical thought fight with the maelstrom of my tangential ideas, illogical in their reach for associations. My notes leap to artists, writers and passages that chime with *The Raft*. This growing chorus piles onto *The Raft* like its shipwrecked bodies. Reams of paper overflow with thumbnail sketches of drawings and ideas, already turning the material inside the books into something else. The quests of the historian and the artist are different. The former is a search for historical truth grounded in detached, quantifiable methodology. There is nothing detached or logical about my engagement with this past; it is emotionally and psychologically unstable, driven by creative desire. I want to devour the history, to possess it, to have ownership of it.

The world today felt full of constant, violent change, as if it was breaking apart. The spectacle of suffering was coming to us at an ever-increasing speed and quantity, streamed through the flickering multiplicity of our televisions and hand-held devices. A 24/7 bombardment, buzzing in our pockets, glowing in our palms. Combined with this technology, my

obsessive-compulsive brain wires me into the flood of information and imagery. It is an age of dissonance and pure spectacle which can anaesthetise through over-exposure. I wanted to work out how we might un-numb ourselves to the magnitude of suffering in the world. The theatre of violence commits a secondary violence: the destruction of feeling. How do we see it and bear witness?

I wanted to capture the pain of the world in the flat space of a painting, to fold it into fractals which can then be unfolded. But I felt lost, drowning in imagery, spiralling into infinite possibilities. My childhood dream crept back into me, mutated by the developments in the studio. In the mornings I was not sure what parts were dream and what parts existed in the half-waking moments of circling thoughts and imaginings. The blurring came with the arrival of insomnia, where the safe detachment between waking thoughts and the subconscious space of dreams no longer existed but instead they fed each other.

The amorphous ideas in the studio started to find form in the space between waking and sleep. The character Poor Tom from *King Lear* had been entering my thoughts alongside dreams of *The Raft*. Tom is made of multiples. He is an actor on a stage, playing the part of Edgar, Gloucester's son, but then Edgar seeks refuge and goes into hiding, adopting the persona of a beggar, Poor Tom. I liked this idea of disguise and possession, the uncertainty of where you sit on the spectrum, of giving yourself over to travelling through a fictive world. Tom felt relevant because he is the character who sees and feels all the suffering, bearing witness to the horrors of the whole of history. He is a refugee, a figure without a body, let alone a home. It might be possible to enact this journey across the sources I had mapped out on the studio wall, travelling through history, literature and the play-world, across geographies.

The storm rises up the cliffs again, pours in through the windows, floods the bedroom. I can see the small-boy version of Tom. He is a stranger; he cannot hear me through the waves. I watch him sink under and gasp for air. The water keeps rising. The bed becomes a raft. The room vanishes and I am just in an endless, roaring ocean, alone on the raft, drifting through the expanse of a drowned world. The raft is now a stage. A huge, bobbing sea of figures in the dark can see me but I cannot see them. I enter over them, their eyes locked upwards and forwards towards the spotlights. It is a stage and a cliff top, that weird magic of the play-world, of dreamscape. Who is there? I'm playing Edgar, a young man, but Edgar is now also playing a part. He is in disguise as Poor Tom, or perhaps he now *is* Poor Tom, possessed by him. The other actor is my father, playing Gloucester, Edgar's father, who has been recently brutally blinded and told to smell his way to Dover. Gloucester has no idea that Poor Tom is his son. Such is the extent of his angst and grief that the blind man asks the madman to lead him to the cliff edge so that he can commit suicide.

Poor Tom doesn't take Gloucester to a cliff edge, but instead pretends he has. Blinded Gloucester relies on Tom's words to imagine the view that he believes is in front and below him. The audience is aware of the illusion, but empathises with Gloucester through the power of Tom's words, which sculpt the imaginary drop:

> *Horrible steep*
> *[…]*
> *How fearful*
> *And dizzy 'tis to cast one's eyes so low!*
> *[…]*
> *The fishermen that walk upon the beach*
> *Appear like mice*

We exist both in the flat space of the theatre and the space of the cliff edge. The words are vertiginous, and the cliff grows in front of us and drops off into depths beyond vision. Edgar talks of casting eyes, as if like fishing bait they could be tossed into the dizzying, fear-filled plummet. He paints a picture of the huge distance between Gloucester and the bottom of the cliff, turning a space of nothingness into one which reaches beyond any physical limits, unrestricted by the rules of reality. He conjures the *murmuring surge* of the sea below, the spread of birds at various levels, their voices unheard not because they do not exist but because the height of the cliff is so great. The words make us physically giddy. Tom says:

> *I'll look no more,*
> *Lest my brain turn, and the deficient sight*
> *Topple down headlong.*

It is a view we can't see and can't bear to look at any longer.

Gloucester asks to be taken to the edge, and for Edgar to leave. Edgar stands back to witness his father fall. Gloucester takes a step and drops, believing death awaits below. In that fraction of a moment, in the space between the step and him hitting the stage floor, there is a rupture. This vertiginous moment is of unimaginable psychological complexity. He is stepping to his death and has given himself over fully. Edgar knows there is no cliff, as do we; we witness Gloucester take an action which he believes will kill him. The space between Edgar the son and Gloucester the father is as huge as the imaginary space Gloucester believes he is tumbling through. They are standing feet apart, but Gloucester's blindness, Edgar's disguise as Tom and the impossibility of a reconciliation at that precise moment make the space a chasm. It is a scene of spatial and psychological nothingness becoming limitless.

In that space are multiplies. One raft, then another, then a hundred. Flashing TV screens and windows, openings on a world of fractals bobbing in the sea. Bodies everywhere. Collapsed buildings. Too many screens, too many images. Scraps of newspaper, and before you really see one another flares up. It becomes spectacle. It expands, spirals outwards, populated with pain. The array of repeating patterns is so vast it reads as white noise, dissolving back into the surf and vanishing. The infinite collapses into nothingness in my chest. The Germans call this *Weltschmerz*, literally world pain. The word points to a deep melancholy at the scale of global suffering. The sadness, grief and the sense of absence when you realise you are unable truly to connect to it.

Warsan Shire reaches for the feeling in her poem 'what they did yesterday afternoon'. Personal pain folds outwards into global pain as the poem develops and its ending, with its three-way repetition, is a beautiful articulation:

> *i held an atlas in my lap*
> *ran my fingers across the whole world*
> *and whispered*
> *where does it hurt?*
> *it answered*
> *everywhere*
> *everywhere*
> *everywhere.*

Hurt was everywhere. The cliff scene in *Lear* inevitably took me back to my dad. The personal flooded in and invaded this safe space of make-believe. A blind father at the cliff edge, an absent son watching on. There he was, creeping into the studio, sliding into the play-world, slipping on board the raft.

The days of waiting for his death had taken on a form of possession, and thoughts of him were occupying the world I was starting to construct in the studio. Looking around at this mass of images, piles of books and the exploded scattering of different histories, it struck me how different we were. Perhaps my creative approach was a rejection of the lessons he had tried to teach me. The only history my dad was interested in was his own and that of our family, so indoctrinated was he by his own father's beliefs. A life spent obsessing over the family tree and its roots to a faded past. My dad was an artist, a poet, a novelist, a photographer, a gardener, a naturopath, a maker of natural potions, a witch. A constructor of fantasies. He believed he was a creative genius and that artistic ability was an innate skill, that there was no need to engage with the art of others. The external world and the whole of history were largely irrelevant to his pursuits. It was as if we were islands with nothing existing outside of the self. Sitting in my studio, consumed by a hoovering hunger to take everything in, I was merely an inversion of him.

When I was still a small boy, in my head about eleven, he gave me a copy of his latest novel to read. It was a fantastical, fictionalised account of an upbringing very similar to the one he had shared with his younger sister. The dark heart of the book was an incestuous relationship between the siblings. It was formless, drifting from scene to scene of lurid, perverse eroticism, written in an idiosyncratic language both floral and pedantically graphic. What was based on memories and what was invented is impossible to know: both were equally disturbing in different ways. Was this perverted, inward-looking gaze what drove me to look obsessively outwards? As an adult I could find some detached order to help me reckon with the past, but as a small, confused boy I just felt a sense of wrongness.

Waiting for his death, I faced the question: where does a work

of art begin? What are the limits to the material that feeds into it? The romanticised image of the artist standing in front of a blank white canvas waiting for inspiration to pour in, or converting a perfectly formed design onto the canvas, is a nonsense. There is no one starting point, and all the beginnings originate long before the brush meets the canvas. Preceding that moment is an entire life and all the histories which have come before. The raft was built from the wreckage of the ship; one thing became another. In the studio before me was the wreckage of history, a compost heap of scavenged remains from which a new raft could be made; the materials from which I would build a vehicle to begin the journey in search of form and feeling.

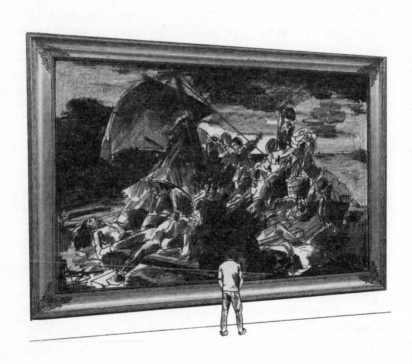

2

Terribilità

*It made so tremendous an impression on me that
when I came out of the studio I started running like a
madman and did not stop till I reached my own room.*

EUGÈNE DELACROIX upon seeing
The Raft of the Medusa

The Raft pulls you in. It hangs huge and heavy on the wall of the
Louvre. I stand in front of it, feet placed firmly on the ground,
a clear separation and distance between the imagined world
inside the painting and the reality I inhabit. The threshold of
the frame is first threatened by the tilted stage and the fear that
a pile of bodies might collapse into the gallery, water flooding
the museum. Then the movement reverses and the painting
opens up and wraps itself round me. To the right and the left,
two naked, moon-bright bodies are turned at sharp diagonals,
guardians tunnelling me into the centre and placing me on the
raft. It is an optical imaginative leap which nestles me into the

dark heart of the painting at *The Raft*'s centre. A cave-like space, hollowed out, as if it had been waiting to be entered, warm-walled by the cast of characters.

Once inside and on board, the movement continues, the viewer is taken balletically from space to space within the picture, from one clustered frieze of figures to another. Each group functions like a scene or a room. In the centre a group moves in a rotating motion, each individual pulling us into their action before flinging us out and into another part of the canvas. The painting is an accordion, opening and closing in the act of unfolding and refolding. I am dropped down to a pair at the front and centre of the raft who are moving at a slower pace to the twisting bodies above. One is hunched over and foreshortened, maybe dead, or at least collapsed in exhaustion, an arm resting limply across a sturdy beam of wood. Behind him sits an upright man, his face in profile, perhaps the most restful figure in the painting. He slows the viewer by a beat or two, before the tilt of his chest and his turned head move us on again.

The Raft is a wonder, a static, flat picture which not only creates the illusion of depth but seems to take you inside it, leading you into a dance. The experience is discombobulating, as if not just the painting itself is in motion but you are being spun in multiple directions. The viewer is both inside and outside it. It conjures movement, both within itself and within you. Gravity is cheated. You are no longer detached but are consumed, overwhelmed, made giddy by the forces taking hold of you. You are pulled not just inside the picture, but into feeling. It is form as feeling. It is a painting to fall into.

Géricault fell headlong into one such multidimensional vortex in Rome. In 1816 he took a trip to Italy. Travelling through Naples, Florence and Rome, he made an intense study of Michelangelo,

who became his greatest inspiration. Géricault wanted to see if biblical images of suffering in the work of other artists used artistic forms that represented the pain of the world. He was artistically and politically lost, but his journey was also an escape from personal turmoil and from feeling. It was an attempt for him and Alexandrine to put time and space between them, to cut their relationship off at the source. Géricault hoped to end the affair before it erupted into something they couldn't stop.

In his search to outrun the memories of Alexandrine he wanders the streets at night, strange alleys eventually becoming familiar. He has no purpose or destination. He meanders like a river. The lie of their detachment is futile. She is a ghost, suspended. He sees her everywhere, in the cracks in a wall, shimmering and slipping away in puddles. The streets are haunted by her. He writes to a friend: *my heart is never easy for it is too full of memories*. But language is a blunt tool and articulates nothing more than its own impotence. He watches the turn of the hand and the words take shape, but they seem empty and unable to hold the evasive essences of feeling. He longs for fingertips charged with expression, a first touch of Alexandrine that is bold in its articulation. He wishes he could reach into his chest, pull out his heart and squeeze it dry of memories; drain it of the litany of craved touches.

We know a great deal about Géricault's time in Rome, his immersion in Michelangelo's work and the city as a whole. It is a biography constructed from the works produced while he was there, letters sent home, and from the accounts gathered by early biographers. Charles Clément reports that Géricault ran to the Sistine Chapel as soon as he arrived in Rome, and mentions a number of drawings made there, now all lost. The loss of these primary-source materials leaves a huge gap in Géricault research. It is this mystery I want to enter in order to paint a

version of what might have happened, reverse-engineered from the influence that was clearly so foundational in *The Raft of the Medusa*: the Sistine Chapel, and in particular *The Last Judgement*. I intend to use the painting as my way into that lost past.

I think back to my own trips to the Vatican and the chapel. I try to empty it of the teeming masses of tourists, the bustle, the heat and the overly aggressive guards with loudspeakers, so as to leave just the art; I imagine myself into the space, looking up at the paintings that Géricault himself would have seen.

It was not Géricault's first encounter with Michelangelo's work. During seven years of study in Paris he observed and drew from etchings in the Louvre's collection. En route to Rome he travelled to Florence, where he filled sketchbooks with drawings of Michelangelo's sculptures. He marvelled at the way in which Michelangelo formed figures, and he translated these forms into his own paintings. Michelangelo was already a profound and central influence, but nothing can have prepared Géricault for the Sistine Chapel and the complex scheme of frescoes decorating the ceiling, pivoting around nine episodes from the Book of Genesis, with *The Last Judgement* filling the entire altar wall. This apocalyptic vision is an eye-opening revelation that captures the beauty and terror of the world.

Géricault is reported by Clément to have told a friend that he trembled before the masters of Italy. Biographers report other expressions of his state: awestruck, troubled, agitated and experiencing a collapse of self-confidence. It's easy to see how the Sistine Chapel, with its scale and dizzying complexity, would have had this effect. The space is a biblical encyclopaedia, an act of visual storytelling more epic than anything Géricault would have seen before.

The first thing that must have struck him was the size. His eyes straining upwards, he may have experienced an inverted

vertigo, as if the world was rotated on its hinges, the architecture of imagery shifting with each turn of his head. The mosaic-like geometry and circular patterning of the marble floor draw the eyes into formations and lines which repeat and then shift. It is an architectural and pictorial space of fractures, each opening out onto another monumental biblical scene. A space which rotates and refracts around you. The configurations of the room feel infinite, and the eye attempts in vain to take in the whole, instead homing in to focus on a single detail. It is as if Michelangelo held shards of mirror up to the Bible and to the history of painting and reflected them back in forms previously unseen.

The gaze is pulled skywards by the sharp rise of the side walls, where arched columns exaggerate the accelerated verticality. Spandrels act as curved bridges. The architecture seems to bend the space in unexpected ways, forcing the eye up and onto the ceiling. Each triangle is populated by a scene, figures filling the unusually shaped frame, little tented spaces of narrative and characterisation.

It takes a moment to see the trick, to realise that the spandrels are the point where architecture melds seamlessly in an act of remarkable illusionistic power. The ceiling initially appears to be a marble dome, the spandrels pointing inwards, with carved columns dividing the centre into a row of rectangles. Each column has a pair of wriggling, energetic putti playfully teetering at the edges. Between and above each column, figures sit as if projecting out of space, and their flesh appears carved. So solidly do they occupy their places that the viewer becomes destabilised, as if the laws of gravity have been morphed into their forms, taking the floor from under our feet.

Michelangelo shows how multitudes can be collapsed together into a single immersive experience. It is this complete

immersion that Géricault's *Raft* also enacts, in its own unique way, folding multiples into one singular frame opening up around you. *The Raft*'s Romantic model of vision rhymes with Michelangelo's Baroque inventions.

At the time Géricault was studying in Rome, the Scottish scientist David Brewster, famous for his pioneering work on the polarisation of light and experimental optics, was busy making a toy. His 'kaleidoscope' took its name from the Ancient Greek *kalos*, *eidos* and *skopeo*, meaning literally to look at beautiful shapes. Lord Byron was sent one as a gift, and saw in it the simple magic that would fascinate children and adults alike. It houses a series of mirrors inside a small tube, which also contains shards of coloured translucent materials. The repeating reflections of these inward-facing mirrors turn the jumble into a brightly coloured symmetrical pattern, which with each turn of the toy is in constant flux. Byron referred to it in his poem *Don Juan*, 'this rainbow look'd like hope – Quite a celestial kaleidoscope', as if nature itself were performing the trick of the toy, fracturing light into a beautiful curving pattern.

By the time Géricault returned home the kaleidoscope had become a mass-selling toy in Paris. Despite its novelty value it had found a unique way to polarise light, previously undiscovered by scientists, despite centuries of exploring similar optical experiments with arrangements of mirrors. It is no surprise it sparked something in Byron, nor that it captured the imagination of so many. The infinite possibilities of pattern, the ways in which the world can be endlessly remixed into startling configurations, chime with the Romantic spirit.

While children in Paris and London were first discovering the joyful wonder of the toy, a similar spark had ignited Géricault's imagination. Byron's 'celestial kaleidoscope', an apt description of a rainbow, perfectly fits the Sistine Chapel. While Brewster

and Byron were considering the mechanics and poetics of kalei-doscopes, Géricault was starting to see how he might refract the suffering of the world back onto the surfaces of paintings. *The Raft*, with its various groups of figures which spin the eye around the beauty and terror-filled spaces of the painting, creates its own kaleidoscopic reworking of reality.

Each frame within the Sistine Chapel suggested new ways to form stories in paint. In the centre of the ceiling are nine rectan-gles telling the story of Genesis. In the second panel Géricault would have seen God doubled, painted from the front and from behind, dramatically foreshortened, the soles of his feet and his buttocks facing out. Six panels up there's another doubling, whereby Michelangelo collapses *The Temptation of Adam and Eve* and their *Expulsion* into a single frame. A snake transforms into a human, wraps itself round the tree and provides both the moment of temptation and the compositional splitting of space and time. Eve's body faces Adam's crotch, while turning towards another temptation, the apple, the exaggerated dynamics of her body's muscular turn being an articulation of the dangers of desire. The eye travels onwards, without time to rest or digest, to *The Creation of Adam*. A white-bearded God flies on a womb-like shell and the pointed fingers of Adam and God are just about to touch, forever held in the moment of creation, forever about to be. The eye, drawn to that tiny gap, can see an electrical charge filling the small space.

The penultimate panel depicts *The Flood*. A child clings to its mother's leg while another is held in her arms, a woman rides on a man's back as crowds desperately seek refuge from the rising waters on high land. Noah's Ark floats off, a seabound house. In the middle a rowboat tilts upwards, towards the picture plane, pouring figures into the sea.

Just before leaving for Italy, Géricault had made a series of

images depicting floods. In *The Deluge* he paints a scene dominated by nature, thick, dark clouds hanging ominously over a radioactive-green sky, sheets of rain pouring into the inexorably rising sea. In the foreground a small cluster of figures cling in panic to rocks, then in the choppy water we see the head of a horse, struggling to stay afloat, burdened by the weight of a just-visible couple, the woman reclining motionless in the man's arms. In his focus on the landscape as the grand theatre and the figures as its cast of doomed actors, Géricault was riffing on a similar composition by his first tutor, Vernet. But in his handling of light, colour and paint he infuses the painting with a super-charged psychological energy.

Michelangelo's *The Flood* provides him with a different model. As with the entire Sistine Chapel, the focus of the drama in that painting is human, and we see a similar shift take place in much of the work Géricault did while in Rome. He makes drawings and paintings of homeless families and beggars on the street, scenes from the butchers' cattle market, and studies for a planned epic painting of the famous riderless Barberi Race. In all these the focus is on the human drama, pulling the viewer closer. It's a change of direction which reaches its inevitable conclusion in *The Raft*, a painting that, like the scenes in the Sistine Chapel, boldly and unexpectedly centres the drama on the human form.

In one of Michelangelo's lunettes is a painting of Jeremiah, his figure as solid as marble. He is bent over, his legs crossed and his mouth resting, covered, in his right hand. The weeping prophet, the body turning emotions inwards. The pose is remarkably similar to that of the subject in David's *The Lictors Bring to Brutus the Bodies of his Sons*, one of the most celebrated works in Paris at the turn of the nineteenth century, the ultimate Neoclassical model of what art could and should do. David's painting would have

been familiar to Géricault – it was the leitmotif held up not just to artists of the day but to an entire society. It seems likely that Géricault would have noted how David had borrowed Brutus's pose from Michelangelo's *Jeremiah*. *Brutus* is a domestic scene: Brutus, his wife and daughters are at home as the bodies of his dead sons are brought to him, the sons he sentenced to death for the greater good of the state. Perspective is used to create space, an illusion of a stage across which action can take place, in this case a stage ordered by the naturalism of a tiled floor. Architecture is a device with which to describe the type of space and also to order it. The roman columns in the background form a backdrop which arranges the action theatrically.

The bodies of the sons are carried in from off-stage, only the legs and feet being visible. The emotional drama of the painting is created by the arrangement of the figures. The female group is on the right-hand side, openly grieving. Foregrounded on the left but cast in shadow is Brutus, mirroring Jeremiah's pose. He is often described as stoic, for his supposed lack of emotion. But look at the toes, curled inwards, and the clenched hands, small details that give the lie to his body's taut, poised facade. In the figure of Brutus is a depiction of the horror of stoicism, a father suppressing grief for the greater good. His twisted form and bent toes speak of a raging turmoil buried within. In the Sistine Chapel Géricault would have seen similar emotional unrest, but rather than being contained it is let out in a series of figurative screams echoing around the entire room. In *The Raft* he would achieve a remarkable synthesis, staging a drama which explores this entire operatic spectrum of expressions of angst.

Michelangelo provided Géricault with a new rule book of possibilities. He grew disdainful of his contemporaries in Rome. Initially he had felt resentful of not being awarded the

prestigious Rome Prize, enabling artists to study in the Italian capital, heavily funded by the French state. On arrival he had seen the post as a rite of passage, an award given to a lineage of great painters, but now he felt it perpetuated a stale system which led to creative laziness and a gluttonous, safe lifestyle. In others' studies he saw a slavish aping of David's Neoclassical style and the suffocation of imagination. He wrote to a friend that *A solid middle-class diet fattens their bodies and ruins their spirits.*

For Géricault there was something immoral, distasteful and potentially dangerous in this mechanistic, academic approach to art, which mirrored a wider sickness in society. The trip to Rome was a well-worn path for artists, but he was determined to carve out his own; the blown-up Bible of the Sistine Chapel suggested many possible alternative ones. Its architecture suggested the collaging of multiples into a single space and unique ways to stage scenes. But it was *The Last Judgement* which pointed towards the drama of bodily action and a queered theatrics of the body.

Twenty-five years after he completed the ceiling Michelangelo, aged sixty-two, began work on *The Last Judgement*, painted behind and towering above the altar. It would take five years to complete. The scene was an exploded vision, figures scattered across the sky, pressed flat to the picture plane, brutally dismantling depth. A centrifugal force was at work, with all of humanity orbiting around Christ, mesmeric and wild in its energy. Christ floats outwards, as if pushing beyond the picture plane, entering the space of the chapel itself, super-sized and levitating. Rather than David's painting as theatre, *The Last Judgement* breaks the divide and falls out into the room itself. The maddening logic, the spiralling force of movement between groups of figures, and the way in which they are not contained by the frame but

seem to threaten the viewer's safe space would find their way into *The Raft*.

In the bottom right-hand corner of *The Last Judgement* there is a boat from which the damned are flung out, rejected. A horned Charon swings his oar, striking terror into his passengers which then fizzes through the viewer's skin. Our eyes keep circling back to this moment, the force of the painting spinning us down, away from the central image of Christ to the boat as the site of despair. It's a detail which must have planted itself in Géricault's subconscious, because later it would give him a solution to a problem he had yet to encounter.

We know Géricault produced sketches of details from *The Last Judgement*. They must have felt alien to the training he had received under Carle Vernet and Pierre-Narcisse Guérin, in which the body was a form to be rigorously observed and then modelled and reduced into an idealised version of itself. The process was constrained and mechanistic, suppressing the students' individual styles through a system of lessons which would see them all become stylistically homogenous. Géricault had already started to search for ways to move beyond this in his expressive abstractions, and then in his studies in the Louvre after Titian and Rubens. There were forces in their paintings, in the sensuous handling of form and flesh, which were lacking in the classroom. But in the Sistine Chapel there were forces beyond anything he had ever seen. Here the body was not idealised by reduction, but by exaggeration and addition; here Géricault sensed something animal, something of the wild potency he felt while riding, when his body was supercharged. This was art working at full gallop, in the grip of some unseen power.

A number of the poses in the Sistine Chapel were lifted from erotic bathhouse drawings in which men folded into and

out of each other, writhing in ecstasy. Michelangelo took the bent, contorted forms and uncoupled them, so the isolated figures become charged by pornographic energy, with a ghosted, pressing impression of sexual forces working from or into their bodies. The subversive eroticism confronted many of Géricault's contemporaries with danger and daring. The space, the figures, the movement between forms are enveloped in Baroque complexities by a queering aesthetic. Here was a new architecture, new theatrics and a new language, all ready for Géricault to ingest and make his own.

Throughout his year in Rome this language expresses itself, lessons are learned and applied to the body in erotic paintings and drawings of beggars. He feverishly explores ways in which painting can move beyond naturalism, can take the everyday and elevate it through the joint approaches of Classicism's idealism and Baroque's muscular deformations. It will be in *The Raft* that he finally manages to fuse these seemingly contradictory approaches, capturing the body in a quite remarkable array of poses which combine the sinewy eroticism and violence of *The Last Judgement* with the grace and idealism of Classicism.

Michelangelo's contemporaries coined the word *Terribilità* to describe the experience of seeing his work, a unique mixture of terror and awe felt on viewing the Sistine Chapel. In turn, *The Raft* is held up as a symbol of the Romantic moment, an embodiment of the sublime. A work of art full of threat, where beauty slides up against horror.

I had been trying to make sense of what united their work and how culture might express such awe and terror today when the secrets of a black hole were unlocked by a young student from MIT. Katie Bouman was working on an algorithm which sought to translate vast amounts of data gathered from the radiation emitted by a black hole into a visual representation. Her

algorithm was the final piece of the puzzle in a global effort to make the unseeable seen. In her image of a black hole, shaped like a doughnut, the laws of physics vanish into the space. The black hole erases all light and matter. Nothing can escape, so the result is an enormous vacuum of nothingness. Presence is formed through absence. The only way to map it is to capture the event horizon, to give visual shape to what surrounds its entrance. Radiation at the mouth of the black hole, at the edge between outside and inside, creates an orange glow on the image.

Much of the language in the media, including quotations from the team of scientific experts working on the project, describes the black hole in bodily terms, speaks of the surrounding gas and dust being consumed by the black hole, of the hole itself as a living thing, a mouth. A beast, a monster, a hungry god; an unseen life, a ghost devouring all life. The poet John Milton first described hell as something similar: *Hell at last/Yawning received them whole, and on them closed.* A space which didn't exist prior to their arrival, which came from nothingness. One in which the expelled dead fell for nine days to reach a moment stretched to the limits of imagination. Once there, what do they see, and what language does Milton, himself blind, use to describe this space? *No light, but rather darkness visible.* A perfect description of the image of the black hole. A hell-space for the twenty-first century.

The image of the black hole resembles an O, a form about which much has been written of its exterior line, of the infinite continuation of the circle. But what of the centre, of the noth-ingness which is both utterly empty and capable of holding everything? With the image of the black hole the universe feeds back to us a symbol loaded with ideas of nothingness and the infinite. The universe has a pure language, maths, and Bouman's algorithm translated this into something visible.

I wanted to understand the mechanics of the magic that happens in the Sistine Chapel and *The Raft of the Medusa*. I wanted to learn how to conjure similar energies. I wanted encounters which reached beyond the known and opened up the space into which fear could enter. Where threat spills itself out of one form and into the beholder, taking on a destructive force. A force or a scale whose immensity holds no logic but seems to touch the infinite.

What was happening for Géricault in the Sistine Chapel and for me in front of *The Raft of the Medusa* was not just occurring on the canvas, nor merely inside us. It was happening in the empty space between viewer and canvas, as if the two were mirrors facing each other, reaching into the infinite. These experiences shake us because they exist outside us and the work of art. We are flattened not just into something inconsequential, but temporarily into erasure. We are consumed by the experience, have entered a space beyond the limits of nature and into the work of art itself.

And in that space what do we see? In Gilles Deleuze's philosophical text *The Fold* there is something pertinent to *The Raft* and the Sistine Chapel. *The Baroque*, Deleuze states, *endlessly produces folds*. In this description the work of art is a pleated, folded fabric, a bending and mutating of possibilities. *The Baroque trait twists and turns its folds, pushing them to infinity, fold over fold, one upon the other. The Baroque fold unfurls all the way to infinity.*

In the studio, the printout of Géricault's *The Raft* as my companion, I was in turmoil at the internal process that was happening. Mirrors were turning inwards, as in a kaleidoscope, to face each other. In the studio I would start to see myself, and those incomprehensible, unknowable parts of my past. But now I could only feel numbness.

I was in the studio when I got the call. *He's dead.* It was a moment I had prepared for and I went on autopilot, opening an Excel spreadsheet I had spent the previous months preparing, with a list of tasks to work through as the executor of his will. Death is admin, a breaking-down of an existence in stages, a strange bureaucracy where a life becomes the self in paper form. Luckily everything at my dad's house was meticulously organised, filing cabinets filled with paperwork. For me the process was supposed to be one of neat closure, putting the past into a box and closing a difficult personal chapter. But my life became consumed by the death. The funeral was a few weeks later, and I was kept away from the studio, resentful of this deluge of duties. As I drove to All Saints Church in Mendham, Norfolk, hope descended. Might this be the final closure, after a series of false endings?

Only ten people attended. Most of us were there to consign him to the past. He arrived, his body transported from Devon to Norfolk, as he wanted to be buried at the same church as centuries of de Freston ancestors, despite having no living connection to Norfolk. Even in death he was more concerned with the value of a lost aristocratic past as a signifier of worth than with the people and events of his life. As his boxed body was lowered into the ground, I felt I was lifted. The root of the word 'grief' points to heaviness, to the weight of mourning. Yet I felt the opposite.

The absence of grief itself signified the magnitude of the moment. The numerical sign 0 is both a hole and an infinite circle. Memories suddenly imploded of the time spent at my dad's, cascading one after the other like the panelled ceiling of the Sistine Chapel. I was sleep-walking to the cliff edge, being dragged magnetically towards a black hole. But, unable to look inwards, I faced out, glued to the suffering in the world, in history, in literature. I papered my studio walls with it.

Trauma can erase the past, but it doesn't mean it is not still there. As with Bouman's algorithm, the paintings I made in the coming years would map the borders of a darkness I had been unable to see, let alone access. I was now travelling in two directions, outwards and inwards.

Géricault and I both wanted to make works which could point to metaphysical forms of pain. But we were in need of a specific anchor, a guide. There were holes in our personal lives, gaps waiting to be filled in our waiting studios. Into those spaces companions would arrive unexpectedly, to hold our hands in the dark. To show us a way in.

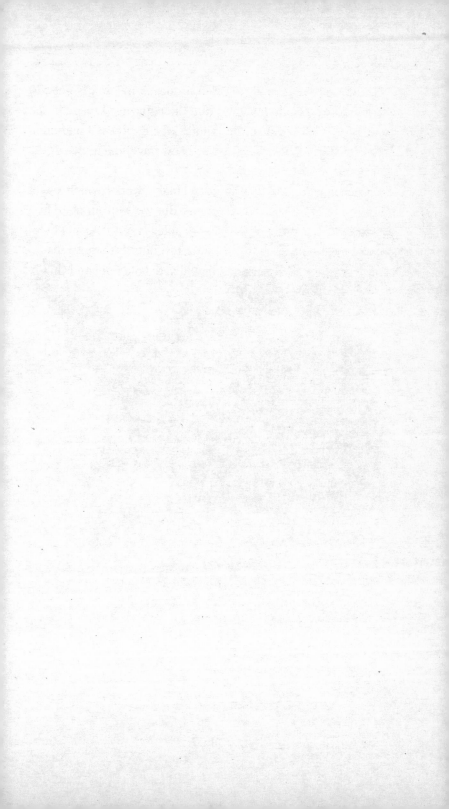

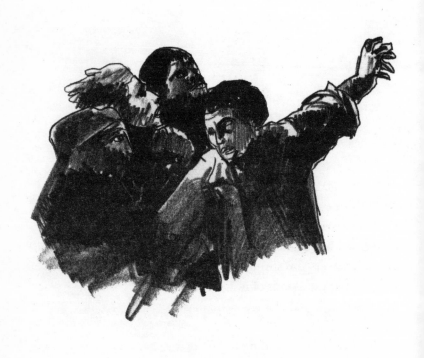

3

Rupture

Then dropped from sight

EMILY DICKINSON

Aged thirteen, I moved with my mum, stepdad and sisters from Devon to Warwickshire. A fresh start, away from Dad. In my rucksack I had a folder of drawings of Eric Cantona, and some pressed flowers and shrunken crisp packets ready to draw. I had no idea that thousands of miles away an event was taking place in a life that would change mine forever.

Ali Souleman was heading home. It was New Year's Eve 1996. This would be his last trip to see his family before moving to Paris to begin a PhD on Syrian theatre. He was handsome, charismatic and, at twenty-seven, something of a celebrity as a successful journalist and an aspiring academic. He was waiting at the station to catch the coach from Damascus to Aleppo when the bomb went off. Bright white, and then the world fell into darkness.

*

Just before Géricault left for Italy, a scandal was breaking as news of a shipwreck reached the public. On his return to Paris this story, and a stranger at the heart of it, would give him the inspiration he was searching for.

Alexandre Corréard was on board *The Medusa*; it was June 1816. He was an engineer and a geographer, looking forward to the opportunities that this new life would present. But when the ship crashed he found himself one of the unlucky ones, consigned to the raft, to the nightmarish ordeals which would follow.

As I stumbled into the space of denial in the months following my dad's death, Professor Ali Souleman, blinded by the bomb blast, was at home in Damascus with his family confronting the horrors of the Syrian war. Around the time Géricault decided to head home to Paris, Alexandre Corréard was making his way back from Senegal. Stories of bombs and shipwrecks would soon reveal pain that wasn't nebulous, or metaphorical, but all too real.

At the centre of *The Raft of the Medusa*, at the back of the beleaguered raft and half lost in shadow, is a cluster of men. Three of the four are arranged in a neat row of heads, creating a diagonal which moves up, across and through the picture plane. Furthest back of the three is a black man, only his head visible in the shadows, silhouetted into a beautiful dome, framed by the distant glow of a fiery patch of sky. Head tilted back, mouth a downturned arch, his one clearly visible eye is wide open, staring upwards. Next to him another man's face is shown in perfect profile, his eye fixed on the same point. His white face has an unreal quality, as if sculpted or a mask, qualities emphasised by the way in which his hair, dramatically blown back, completes a sharp-edged, shadowed contour to his entire face. The mouth

hangs open, but there is an ambivalence to the emotion; it could be despair, or hope; certainly a sense of suspended shock which hasn't yet resolved itself. The last of the three, furthest forwards, is the least visible of the figures, lost behind a mixture of shadows and the murk that has gathered and seeped into the painting over time. His head is wrapped in a cloth, his face further hidden by a dark beard. The shadows obscure his race, but he is of a different ethnicity to the other two. The most visible aspect of the final man is his hands: raised up and in front of his face, grasped tightly, knuckles protruding, in what we can presume is a hard-willed, open-eyed prayer.

The figures may be half hidden, but they are key to understanding the painting. The ethnic diversity is no coincidence and points to the cosmopolitan nature of the raft, and Géricault's desire to accurately portray the racial dynamic of the real-life events. This was not just for the sake of naturalism; it sits at the heart of the story and the painting's politics. To make a History Painting in France in 1819 that centred on such a diverse cast was in itself a radical act, but its true political weight was driven by, and spoke back to, dark discoveries Géricault would make along the way. These would lead to dramatic changes to the painting itself.

In front of these figures, the final member of the cluster is a man in a loose-fitting white shirt. His face is more visible than the others', cast into sharp relief by a light harsher than is possible. His forehead and eyebrows are taut, his mouth – framed by a thick moustache – slightly clenched in a stern concentration of concern. His arms are outstretched, one vanishing into darkness, the other reaching, almost pointing, upwards. This arm emerges out of the gloom and is completely surrounded by the warm, orange-flecked yellow of the sky, giving it both prominence and significance. The setting of the figure, the celestial suggestion of the sky's glow and the outstretched arms echo a crucifixion

scene. The figure and the entire scene are imbued with a sense of scale and importance, as if to signify a moment of huge import. He is not the only Christ-like figure in the painting, but his identity is worth noting.

The man who posed for this figure was Alexandre Corréard. A page of drawings in the Metropolitan Museum in New York provides the evidence. On the front are six pencil drawings of men, including three isolated heads. The third of these is a replica of the moustached face of the man on the raft. On the reverse of the page, alongside a few faded, half-erased, half-started sketches of horses, a gently scrawled name can be made out in pencil, upside down, fading but still clearly legible. *Corréard*. Géricault not only casts him in the painting but places him in the role of conductor.

With his arms outstretched the figure acts as the pivot of the painting's composition, the steadying bridge between its spinning parts. At first glance the pile of figures on the raft gives the impression of utter tumult, a fluid, teeming mass, but within that is a beautiful, organised configuration. The painting's structure makes sense of the rhythms of the bodies, uniting the separate parts in a coherent whole. Each figure is twisted, creating balletic movements both within the confines of their body and also in relation to the whole. The picture has the sense of a dance, of individual and collective movement, leading us around the scene. The figures have something of the muscular, erotic and unwieldy energy of those in Michelangelo's *The Last Judgement*. The operatic charge of the Sistine Chapel is laid into this painting.

The Raft is composed across two diagonals. In the bottom right-hand corner a reclining corpse points the eye across the picture plane to the group of men in their dark corner of fear, and finally to the billowing sail and hungry mouth of the sea. It is a diagonal of despair. In the bottom left-hand corner an old

man holds the body of a young boy, which again directs our gaze up and across, this time in the opposite direction. This diagonal moves the eye through a cluster of figures in motion, one rising from his knees, hand reaching up, to the final frieze of men stood precariously on top of barrels in a triangular formation, the central figure at its apex with his back to us, waving a flag to a ship on the horizon. We are moved from a space of death to one of life. The two diagonals are in unresolved conflict; hope versus despair. The dynamic energy of the painting rests on the precarious balance between the turmoil of the figures' movement and the artist's control of their arrangement, giving the impression it could spin out of control at any moment. It is an image of ceaseless rest; stilled motion. It is a carefully ordered chaos.

At the centre of it all, holding it together, arms outstretched, is the character portrayed by Alexandre Corréard. He played a similar role in Géricault's reality.

Géricault first hears of the wrecked *Medusa* just before he leaves for Rome. He is accompanying Alexandrine to the opera in the Salle Montansier, as his uncle is away on business and asked Géricault to take his place. He is in his room, carefully wrapping warmed folds of paper into his hair, twisting them round in sculpted curls. He washes his face, smooths his skin and lays out his outfit. Prettiness is public armour, and he is turning himself into a peacock.

There is a knock on the door, and before Géricault can respond his long-time friend Theodore Lebrun lets himself in. Géricault removes the curlers in a flurry. Lebrun pretends not to notice, looks to his feet. Géricault is mortified, his vanity revealed. Lebrun has brought a paper, asks if Géricault has heard of the latest revelations about the raft.

The *Medusa* crashed off the west coast of Africa, and the

consensus was that Captain Hugues Duroy de Chaumareys was to blame. Egotist. Royalist. A symbol of everything wrong with the recently restored Bourbon monarchy. An already divided country was further split as it took sides on the unfolding news of a naval tragedy. Then came shocking first-hand revelations. The *Journal des Débats* reported on those who survived. A surgeon and a geographical engineer were the most prominent. Henri Savigny and Alexandre Corréard both made it from the raft to Senegal, and eventually back to Paris. Their written accounts, shared with friends, were leaked to the *Journal* in September 1816. The scandal, now public, became a symbol of the rot within the restored monarchy.

Lebrun leaves the newspaper with Géricault and quietly departs. Géricault finds the report hidden among theatre reviews and the lottery results. It grips him and plants a seed in his head.

Over a year later he is home again. He falls almost immediately back into his affair with Alexandrine. They are clumsy with desire. Touch and language are deformed by it. He finds himself speaking uncontrollable monologues, a noise of nervous nonsense. Then words get blunted, unable to express what he is feeling. He has become stupid from love, crippled by it. Over subsequent meetings he notices a diminishing of speech and finds silence a more potent form of expression.

In the company of others he is almost mute. One evening he is with friends, playing cards in the corner of Carle's Vernet's son's studio. Horace Vernet's studio is a circus. A man with an extravagant moustache sits on the piano and makes up songs to order. Two young artists playfully box, another takes bets on the first to be floored. Vernet promises a fencing competition and participants offer their names. At the door strange handshakes take place, followed by warm embraces. It is a place of safety for an oddball mix of radical liberals.

Géricault's mind is with Alexandrine. He feels a hand rest on his and for a brief moment thinks it is her. He draws a card, tuning himself back in to the game and the conversation. His companions are gossiping about the *Medusa*. Henri Savigny and Alexandre Corréard have published a book detailing their recollections. The raft has become a symbol for liberals and republicans. Corréard senses an opportunity for personal and political gain, and uses the story as a signifier of everything that is wrong with the restoration and the ultra-royalists, whom he sees as endangering France with their blind faith and cronyism: Louis XVIII had appointed the incompetent Viscount Hugues Duroy de Chaumareys captain of the *Medusa* for political reasons. The callous actions that followed led to the death of nearly 150 people and the horrific suffering of Corréard and his fellow survivors. His trauma has become a narrative around which change might gather force.

The friends are talking excitedly, and Géricault slowly takes it in. One asks around and finds a copy of the book to lend to him. Tells him he must meet Monsieur Corréard.

That evening Géricault can't sleep, kept awake by jealousy and longing for Alexandrine. He lights some bedside candles, just enough to read by. The book distracts then grips him. For the first time in months his head is no longer colonised by desire. He falls into the story.

Four ships set sail from France, the *Echo*, the *Argus*, *La Loire* and the ill-fated *Medusa*. The majority of the crew were armed forces and officials, responsible for the return of Senegal from British to French hands. The gum, sugar, cotton, cocoa and slaves would soon be the property of France, to trade again. The lead ship was the *Medusa*, and its passengers represented a mini-society, including bakers, surgeons, teachers, a few families, a geographer, an engineer and naturalists.

Among them is a fifteen-year-old boy, his eyes locked on the horizon, daydreaming of his future. He struggles to sleep at first, but soon the rocking of the sea becomes a hypnotic heartbeat. One morning they pass Madeira, the wind filling the sails, skimming them across the sea's surface. An older man tells him you can detect the island's wine in the sea breeze, thick, caramelised fruit, roasted nuts and toffee. They stop at Saint Croix, which smells of lemons. A basket of oranges is brought on board. The boy peels his carefully and the skin falls off more easily than the ones at home. It oozes stickiness over his hands and with a bite it bursts with sweetness, filling his mouth. There is no better taste, he tells an officer, who in turn tells him of the food he has just sampled on land.

Within an hour of setting sail there is a commotion on the *Medusa*'s deck. The boy races up and pushes his way through the crowds to see a parade of porpoises riding alongside the boat. He shifts to get a better view through a porthole, leans out to feel the sea spray on his face and, with one fateful shift of the boat, slips through the porthole into the sea. He plunges beneath the surface, surrounded by a cacophony of squealing porpoises, far greater in number than anything he had seen on the surface. With a push of his legs he resurfaces, and before he can comprehend what has happened an arm grabs him and tries to pull him aboard. The force of the waves threatens to drag the man in too, and he lets go. In the confusion there is delay. Eventually a small boat is sent out and a buoy thrown out to sea. But it is too late.

A few prayers and words are offered up, but for most of the crew the boy is soon forgotten. What should be a tragic accident of note becomes a footnote preceding a catastrophe of far greater scale.

Concern precedes panic, as a few experienced sailors fret that they are sailing too close to the coast. Rumblings spread,

and some doubt the captain's judgement and ability. He has not sailed for twenty-five years. He only got the job because he's loyal to the king. Hugues Duroy de Chaumareys was losing his crew, and soon he would lose his ship.

Some have noted the shifting colour of the water, from the deep, dark recesses of the green of the ocean to something lighter, washed through with grains of sand. There is confusion about exactly where they are in relation to the coast, let alone their destination.

Measures are taken and depths recorded. Eighteen fathoms, a worry. Seventeen fathoms, sixteen fathoms. The worry grows as the depth decreases. Finally, the captain accepts they are on course for a collision with sandbanks, but it is too late. Ten fathoms, eight, five, two, then a shuddering: a deep, shaking scrape. The sound of wood yawning open and closed, the jolting of the vessel in three noisy episodes. Then total stillness.

Some stay frozen in shock, others hyperventilate in panic. Faces shift shape and colour. In the corner of the boat a mother holds her daughter's hand, assuring her in the calmest of voices that they will be fine. Reina Marais Schmaltz seems strangely disinterested in what has happened. She surveys the panic with disdain, giving her daughter, Eliza, a knowing look. Nearby, her husband, Governor Julien Schmaltz, realising that the captain has lost command of the ship, steps in. He sees the ship as a microcosm of France, divided and chaotic, and realises that in these moments a predator can prosper.

Schmaltz takes charge of a leadership group and they form a plan. The captain allows the coup to happen without friction and feels faintly relieved. A few men are sent to count the number of rescue boats on the ship. Six in total. They recount. Still six. Arguments are had over the maths, but everyone knows that 400 people will not fit in them.

Disorder grows. The optimists loot money and valuables to sell when they reach shore, the pessimists drink themselves into a stupor to dull the fear. Schmaltz suggests they construct a raft. He offers up a rudimentary design and cares more about the take-up of the idea than the solidity of the vessel. Carpenters gather to make a raft from the ship itself, joining lengths of timber, the boom and masts to form its body. One carpenter sees poetry in the process, turning the wreck into a rescue. After much work a twenty-by-seven-metre raft is complete. They put barrels of wine and flour in the corners to weight it, constructing a barrier round its perimeter to render the journey more bearable. A list is made of who will go on the raft and who gets the luxury of the boats. In that instant the *Medusa* is turned into a society of two halves. The privileged and powerful take to the boats.

The *Medusa* begins to take on more water, so the urgency to board their new vessels increases. The first to be lowered onto the raft are soldiers, selected from the lowest ranks, ex-prisoners deemed less worthy by those in charge. Some more barrels of flour, fresh water and wine are sent down to them. One barrel is chucked off before a wave flings it back on, knocking a soldier into the sea.

A ladder is lowered for people to descend, but it is too short, so they have to take a perilous leap for the last ten feet, crashing to the raft with a bruising bang. A broken ankle, a fractured wrist. As the raft fills it begins to sink, half submerging the crew. By the time it is full there is not enough room to move. Some people are piled on top of each other; the whole sorry contraption is overloaded. Without room to check supplies, a call is sent up regarding navigational equipment. A kindly man promises them they have everything they need, should an unlikely emergency occur, and that he will be joining them, bringing many

years of expertise. He vanishes onto a boat with a warm smile, never to be seen on the raft.

Reina Marais Schmaltz and her daughter Eliza chuckle as Governor Schmaltz sits in an armchair like a little king and is carefully lowered onto his boat by a pulley system. Ever the showman, he holds a tumbler of red wine in his right hand and waves to the crowds with his left. His wife and daughter love how even in times of trouble he retains good humour and dignity. They look at the raft, from which an unnecessary amount of fuss seems to be emanating. Some people don't flourish in adversity, they lose all decorum. Governor Schmaltz takes up his position and checks the provisions before being distracted by the splashing of a group of soldiers around his boat. They beg to be let on, for there is room for many more. Schmaltz pushes them away with an oar and stern words. *Know your place.*

The boats and raft line up in a neat convoy, rope joining them all. They have promised to drag the raft to safety. Despite the perilous state of affairs there is a wave of optimism and pride. *Long Live the King! Long Live France!* spreads like a wave across the vessels. Governor Schmaltz stands tall and proud at the head of the convoy, a leader, a hero.

The symmetry of the formation is soon broken, and progress is slow going. The weight of the raft and its inhabitants creates a strain. With the rope stretched to its full extent, the convoy lengthens. Schmaltz stands again, a silhouette now under the shifting sun. One man on the raft says he's sure their new leader has an axe in his hand, is sure he's bringing it down by the side of his boat. The others doubt his vision, refuse to accept the diagnosis or its ramifications. *I'm telling you: he's cutting the rope.* Hope blinds them and they restart the chant. This time nothing comes back from the other vessels. The people on board the vessel closest to them give an apologetic look. They can't tow

the raft without help. As the boats slowly drift into the distance, the realisation hits the raft's passengers. They are alone in an unforgiving ocean.

Schmaltz would find his way to Senegal, would turn his power into profit, would milk the colony for all he could. The coast is littered with ships he packed with slaves, chained into spaces smaller than a coffin, to be sent far from home.

Géricault reads on into the night, unable to believe this is only the beginning. He is transfixed by the depths of the darkness the raft's inhabitants will be forced to enter. He realises he must meet Corréard, must find out more direct from the source. He needs to give order and form to the chaos of this story, to turn words into paint. He has found his subject. He must paint this story.

I had no idea I needed to meet Ali, and our meeting came about through sheer chance. I'm at the house of my friend Simon, a professor of English at Brasenose College, Oxford. We have been collaborating on the *King Lear* project and are talking about Lear, *The Raft*, the echoes between them and the spiralling war in Syria. We are forming ideas for a possible project. Jo, a leading refugee lawyer and Simon's wife, was passing through to make a cup of tea. *I may be able to put you in touch with someone of interest.* A day or so later Professor Ali Souleman emailed Simon. He had recently moved to Oxford from Damascus. He was a theatre and literature academic, now based at Oxford University, but until recently had been lecturing at the Institute of Dramatic Arts in Damascus.

We meet Ali in his office at the Faculty of Oriental Studies, just next door to the Ashmolean Museum. The office is dark and almost entirely bare. Ali is tall, wearing opaque sunglasses, and

greets us with a warm handshake. We tell him about the project, our plan to map *King Lear* onto what's going on in Syria. I arrive nervous, tense and worried about our thesis being pretentious or offensive. Ali also seems nervous, and much later confirms he had been unsure what these two strangers were bringing. But any tension soon drains from the room and there is an ease between us all, an instant, fluid familiarity. We speak for hours, mainly about the Western media and people outside Syria, how we have little idea about what is going on. Ali tells us that Syria had been used as a petri dish for misinformation, for the media manipulation of narratives on a global scale. He tells us how estranging and enraging it is to sit at home and watch reports on the TV describing events happening outside your door, and to know those two realities don't match. The cynical conflation of complex situations into simplistic narratives, the desire of external players to create chaos. The conversation spirals into a broad discussion of the political climate. But towards the end of the meeting he shares an anecdote that changes everything, that shifts the axis dramatically from the general to the personal.

Ali's class were reading passages of *King Lear* aloud, transfixed. In the distance was the sound of bombs, the hard, thunderous thud of the landing, the swirling, submerged rumble that follows in waves – a sound as familiar as weather, a constant worry but not one that shocks. Then a shell hit. The whole building shook, as if startled awake, injured. The lights flickered, then cut out completely. The room filled with fear. Ali felt his throat tighten, as if being strangled from the inside, but knew he had to remain calm. He instructed everyone to find a table to get under, to breathe, to wait. *It will be OK.* He was not so sure. In the darkness the room was filled with the sound of shallow breaths. A hand reached, shaking slightly, towards Ali. He held it, told everyone to not worry.

His semblance of calm was a lie. The sound of the bombs threw him back to that day in Damascus, back to the bomb which nearly took his life, which stole his sight. Now blind, sound was one of the tools with which he painted a vision of the world. So this showering of bombs, this sound of concrete walls falling, of the whole building seeming to gasp under the weight of attack, sculpted a space threatening to collapse, threatening to send them all into total and permanent darkness and silence.

A week or two later the same thing happened, but there was a shift. They didn't shelter under the tables, they didn't feel the same level of fear. Even this had become normality so quickly. Instead, they continued to read *King Lear* out loud, passionately discussing how what was happening above reflected what they were reading down in their basement room. The exact types of echoes and rhymes Simon and I had seen in the text were suddenly present and alive in this entire class. I am reminded of Bertolt Brecht, of the importance of art, not in spite of darkness, but especially during it:

> *In the dark times*
> *Will there also be singing?*
> *Yes, there will also be singing.*
> *About the dark times.*

I feel a slightly unpleasant hunger when I hear the story. It sits grotesquely in my mouth, but I cannot deny it is there. There is something I have to pursue here. I am moved, but the emotions I should be experiencing are buried under this more voracious creative flickering of potential. I am a vulture. I can sense a wired energy building. A manic electrical current is running through me, fingers and toes silently tapping away.

The idea of working together takes shape. Ali as my witness,

my equivalent of Corréard, and I his Géricault. We will be explorers together, through memory, the play-world, history. Me in the guise of Poor Tom, Ali in that of Gloucester, a blind father figure. *'Tis the time's plague when madmen lead the blind.*

The coincidences seemed crass, but to Ali and me they were undeniable. We fell upon them desperately, grasping for each other, for things we did not know we needed. The parallels between the play-world and Ali's experiences are stark. A blind father living through a war-torn world. I can feel myself closing down a little, awkwardly dancing around the situation, trying to find the words to suggest what's forming in my head. I choose silence, and on the cycle home feel grateful. Shame gathers in my mouth and I try to swallow it. I feel it catch, gritty and bitter, at the back of my throat. But it is not long before I discover that Ali felt the same.

I didn't mention the raft in that first meeting, but later I notice in the spiralling scrawls of notes I had written and vigorously encircled 'we are on the RAFT'. And we were.

The journey had begun, we had set sail. In the coming months we met regularly to chat and circle around projects. For a while we explored the idea of a new version of *King Lear*, told across multiple media, which mapped itself onto the Syrian crisis. But the main development was one of friendship, trust and openness. Compassion no longer felt performative or self-aggrandising. In the slow unravelling of meandering chats and conversations, of sharing food and drink, new ideas revealed themselves.

I introduce Ali to *The Raft*, both the painting and the idea of us climbing on board, of going on an imaginative journey. He is transfixed by the description of the painting, his blindness meaning we are bound by the limits of language as I try to paint the raft in words. Later that night Ali emails me.

Tom,

I became aware after our meeting that I am struggling to visualise or imagine the painting of *The Raft of the Medusa*. I am now really obsessed by it. How to paint it in my imagination?! How to touch it, feel it, make my own image of it? I was overwhelmed by the reso-nance of this painting to the Syrian story of suffering and survival. I never felt during the last 10 years that a piece of art could represent the essence of the Syrian tragedy or the epic struggle for survival in our collective story as much as *The Raft*. The irony is that I cannot see this artwork. Yes, how can I make such a statement when I cannot see *The Raft of the Medusa*? What an irony! I know, it might sound somehow naive, even stupid, to elaborate, to read reality through a painting you never saw. Or, did I see it?

Even if I went to the Louvre and stood there before *The Raft*, I know that I won't be able to touch it, to feel the texture, to explore and discover that painting with my fingers. I will never bridge that void between reality and imagination, between language and the visual. Perhaps all I can do is to stand on the verge of that void, the cliff edge, and commit the impossible, to step into that sphere where reality and imagination are inseparable. Sometimes I imagine a strange sensation, like a craving in my fingers to touch this painting, to relieve myself from this obsession by creating a visual memory of *The Raft*.

This is already an enlightening journey for me. I wonder where we will go from here.

See you soon.

With my best wishes

Ali

The idea of travelling together struck me. But also, I wanted to see if there was a better way to make paintings visible to Ali, to give him the access he craved. The fact that Ali saw *The*

Raft as a symbol of the chaos and complexity of the Syria crisis suggested that the image was the way in, a mode of transport to enter the chaos.

I dived into research, working my way through reading lists, trying to get even a vague handle on the scope and scale of the Syrian crisis. But it kept unravelling and shifting more quickly than I could read. The chaos struck me most, of life not having the order of fiction, of events being truly random. In her essay 'The Site of Memory', Toni Morrison writes of the truism that truth is stranger than fiction, *it doesn't say that truth is truer than fiction; just that its stranger, meaning that it's odd. It may be excessive, not maybe more interesting, but the important thing is that it's random, and fiction is not random.* I wonder if one of the truths of art is that it provides order for the chaos of reality. But finding my way through this felt an act of hubris. The story of *The Raft* was beautifully self-contained, limited to the physical and temporal constraints of what happened on that vehicle over those days. There was a lunacy in trying to apply a similar lens to the Syrian war. It was too sprawling, too chaotic, it had no centre.

The absurdity of my approach hit me in the studio. The walls were now covered with hundreds of images from the war. One was a shot from ground level in Damascus. In the centre foreground a man is seen walking towards us. Behind him is a collapsed building, whole floors and ceiling folded down vertically, hovering above mounds of rubble. The odd black rectangle appears, revealing passages into the interior space. In another we see a still from drone footage across Aleppo. The sheer scale of destruction from aerial bombing is suddenly visible. Entire streets of houses are reduced to pixelated grey crumble. Smoke plumes from a corner. Any colour the world had is seemingly eradicated by the dust of destruction, a stripping-out of life, the skeleton of the city revealed. It is impossible to take in the scale

of these images, to comprehend that each rectangular opening was once a home full of life, laughter, stories.

It's something about the drone footage that makes me realise an obvious fact: that I am outside all of this. I am a voyeur, and any attempt to see or understand it is superficial, mere spectatorship. None of this is revelatory, but it hits on something about suffering and trauma. To merely pay attention to the visual effects of trauma is not to understand it, but just to see the result. To understand it and to empathise, we must at least try, however ludicrous and impossible it seems, to get inside it.

In our own lives we are all the only fixed point in a spinning world. If we are to understand the experiences of others, then we must access these fixed points, not stare into the chaos of the turning world. Ali's recollections were surely the fixed point, collected, as all memories are, in the present self. Ali was the anchor, in the same way that Corréard was both the anchor of Géricault's understanding of what happened on the raft and of the painting itself.

How do you go about making that journey? The notion of the artist as solitary explorer, heroic translator or witness figure made no sense. If Ali and I were to develop a project, then it would have to be truly together, creating together, exploring together. I needed to blow apart any hierarchies or idea of author and subject. We were on board this raft together. I needed to get inside Ali. I needed him to help me do so, to see it from his perspective. It was inevitably impossible, but the act of trying felt as important as whatever would come of it.

As our friendship grew, I noticed that there was a certain impenetrability to Ali. Perhaps it was a justified wariness. It could be the barrier of us communicating in his second language, a distance exacerbated by blindness. But while this was true, none of it felt quite right. There is something about trauma

that sends us inwards. It made me think of David's *Brutus* again, and the way his curled toes point to a more complex form of suffering and psychology buried within. The body tries, and fails, to hide the chaos that is held inside.

Most of the images on my studio walls are noisy and violent, but two stand out in opposition: Michael Andrews's *Thames Estuary* and Helen Frankenthaler's *Burnt Norton*. Each presents a lull, but as the splitting, staining paint of Michael Andrews's work suggests, suffering lies beneath. They both mirror the careful curation and control of chaos in Géricault's *The Raft*.

Frankenthaler's painting takes its name from T. S. Eliot's poem *Burnt Norton*, one of his *Four Quartets*. At first glance it's a remarkably simple and calm work. A green-brown mound, suggestive of a hill, and its reflection in a lake take up most of the canvas. Above and behind the solid curves is a pink and yellow pastel sky. Everything is soft and diffuse, the paint embedded into as opposed to sitting on the canvas. But the more you look, the more depth and movement there seems to be, as if unsettled and without defined limits. The safe sense of order gives way to a slowly emerging, rumbling chaos beneath the surface. It's a contradiction that mirrors similar paradoxes sewn through Eliot's poem, taking us into the subterranean roots of an Oxfordshire garden and the hidden passages and energies which lie beneath the tight form and order of his poem. The painting leads us to the same space as the poem, to that threshold between opposites, between form and formlessness. That's what drew me to Frankenthaler's painting, the still point with the turning world reflected in its water surface. An engagement with an image and a surface that appears to move in multiple directions simultaneously, both from and towards us, where arrested time and stillness sit alongside movement.

The painting, like the poem, arrests us and then takes us

down paths we did not, or would not, have taken. It leads us to those spaces Keats had spoken of, the dark passages and corridors of self, to open those doors, to confront *the burden of the Mystery*. If this project was to work, then we needed to travel beyond the calm exterior presented by Ali and enter the darkness and chaos of self, the things trauma had sent inwards.

The mirrors were also beginning to turn me inwards. The way trauma had impacted Ali mirrored my state following my dad's death. A desire to contain, to bury, to control things, to present a veneer of calm. But it, and I, would start to unravel.

I was stuck. My dad died in March 2013. I met Ali four years later. Everything kept moving around me, but I was still. I made *King Lear* paintings for the project with Simon, which was taken to many places: exhibitions, fellowships, publications and commissions. My partner Kiran and I got engaged and then married. We adopted our cat, Luna. Seven nieces and nephews were born. I left the commercial gallery which had represented me. So many stories, but in some ways stasis. I was no longer moving through time – what Denise Riley calls *an altered condition of life*, a *freezing of time*. In her account of her grief following the death of her son, *Time Lived, Without Its Flow*. I lived with numbness, refusing to confront the traumas of the past. I carried a false belief that the lack of feeling was healthy, a symptom of resolution.

I barely noticed the imperceptible creep of depression, the slow ebbing of energy from my limbs. My wife Kiran had described depression, for her, as being *crushed by an unmentionable weight*. But that sense of an external pressure had been absent in me. I had sent the forces inwards and repressed them, but they were crushing and colonising me from the inside, pulling me, as opposed to weighing me, down.

*

About a year after my father's death, I moved with Kiran into a new house in Oxford, at the centre of a floodplain. In the process of having a studio built at the bottom of the garden I dug up the lawn and borders, to remove the carpet of bindweed that was suffocating all other attempts at life in the garden's borders, winding its way round other plants in a spiralled strangulation. Covering them in its pointed-dagger leaves, greedily stealing all the light, its beautiful trumpet flowers announced its successful colonisation. Yet the surface was just the start. Beneath the ground, going down a few feet, was a remarkable network of roots, fed and strengthened by the mass of sprawling leaves above. They were thick and knotted, a system of survival and domination. After a week of digging, sawing, hacking with an axe, swearing and sweating, I removed it all. The garden could breathe again. Other plants would be able to grow, live, flourish. The disease had been cut out.

A year later, the bindweed returned. It had never gone, it had merely been temporarily cut back, hidden and buried. Yet it was thicker than the year before. The bent roots were like tangled, knotted humanoid forms, little earth-covered foetuses. It was impossible not to see these as my father returning, a network gripping deep. The bent roots were a haunting.

My father saw gardening as a form of control, as a way to exert his will and give order to a small domestic sphere of omnipotence. Gardening was to him magic, a space of spells and potions. He was a self-appointed witch, a claim that might have seemed ludicrous but was deadly serious to him. As a child I believed in his powers, but as an adult reason let me realise that they were just a confirmation of his narcissism and exceptionalism. Here, in the rooted hands spreading through the subterranean world of the garden, unseen till they burst up in spring, I saw a cruel, final curse.

Faced with the return of the bindweed and the surfacing of my father's legacy, I realised that I was ready to step out of this stasis. The dirt ingrained beneath my fingernails, I finally accepted that my dad's death had not been the end of my relationship with him, but just the start of the internal unearthing. The denial of the personal, which I'd fought so hard against portraying in my work, was a ludicrous impossibility. In the last few years I had been travelling back and forth through the past without realising it. A version of me had died with him, but another had been born.

Meeting Ali was some kind of tipping point, as if I was woken suddenly from a slumber, ready to move both backwards and forwards, both outwards and inwards. I was ready to see.

Life spreads out in a horizontal flow, a temporal, linear narrative, or at least when viewed from the outside. In reality, when we're inside our own life it is nothing like linear. We encounter moments of rupture to the flow, when the flat plane seems to open up to expose vertiginous depths, ones which house things beyond themselves. Moments which are filled with everything that has come before, which will then spread out and keep imprinting themselves on the rest of our lives. Moments which we fall into and can't escape, which sprout again year after year.

I didn't think my dad dying was one of these moments, but it was. I failed to see the cliff edge until I was hanging from it. The bomb going off was one of these moments for Ali. It was a sudden rupture in the world, in his life and self. Perhaps this was why Géricault, like so many artists of his time, was drawn to the image of a sinking ship. It is a symbol loaded with meanings, but what if we read it at its most basic level? A shipwreck is the ultimate symbol of an interrupted journey: we do not reach our destination but are left isolated and alone to confront the chaos of the sea, the unknown, spreading wide to the horizon.

As I thought about what Ali and I might create, or how we might go about discovering what to paint, I considered the type of vessel we would construct and the nature of the journey we would undertake. When the *Medusa* crashed they built a raft from the broken vessel. Perhaps that was what I needed to do. I thought back to Morrison's quote about life being chaotic and of Ali's experiences being a radical demonstration of this. What if the job of art was to approach the blown-apart chaos of reality, life, memories, history, and build something new from the wreckage; to construct a raft and travel through the shattered remains to the fixed point.

The journey could not be linear or horizontal. It had to go into the exploded spaces. Was that a descent downwards, or was it something even different to that? To enter the open doors rather than close them. A discombobulating elliptical experience of our relation to time and space, to our own pasts and future. I would have to accept in the coming months a dissemblance of self, moving in multiple directions.

Ali and I meet for another beer, and I realise these months have been a slow dance around what is to come. After a few hours of talk and alcohol, it's only when I leave Ali at his front door that he tentatively suggests the next step. *I would like to come to visit your studio, to see your paintings. Would that be OK?* Ali asks. *Of course*, I say, almost too quickly. But one question goes unasked. What can my work offer him? How will a blind man *see* my paintings? And what will he find if he does?

4

Lost at Sea

You may forget...

SAPPHO

The Raft is set in the midst of a stormy sea. The sail is a living, breathing character, stretched out into a gaping howl by the strength of the wind. The mast leans to the left, struggling to cope under the strain. The rigging ropes are taut. The wind takes form in the contortions of the raft's structure. It creates a powerful arrow of motion, the entire raft being pulled inexorably towards the ferocious waves.

The back left-hand corner of the raft is just about visible, where the grid of wooded slats of its base is being broken apart and flooded by the waves. The water is in danger of destroying the whole platform. The waves rear up hungrily, rising suddenly and sharply, rearing into an arching mountain which appears dark-green and solid. Water turns into rock. It is mounting the raft, about to wash over and devour it entirely.

Across the bottom edge of the painting the waves rise up through the slats over the raft's edge. The left arm of one corpse falls into the sea, the spume frothing around it as if gnawing and eroding the flesh. The small patch of sea in the bottom left-hand corner is a microcosm which could be sliced out to convey an epic sea storm in miniature, its scale only limited by the context of the raft. The eye darts and sinks into curve after curve of paint rendered as wave after wave. In the bottom right-hand corner, green passages of paint are covered in a tumult of white daubed harshly, almost crudely. The effect is startling and captures the energy and motion of water. The paint travels ahead of itself, signalling artistic advances that would develop into the Impressionistic watery surfaces of Monet. Géricault's style is the Gaelic cousin of Turner's stormed seascapes. Close up, these little details break into expressive abstraction; look like vast oceans full of shipwrecks hidden by the waves.

Géricault has moved into a huge new studio in the Faubourg-du-Roule. He is waiting for Corréard. He asks his assistant, Jamar, to prepare some food for the meeting. He runs his hand over his recently shaved head, feels naked but relieved, shed of the distraction of prettiness. The softness of the thin layer of hair that now adorns his skull surprises him. The shedding of the hair has calmed him, as if it had held the hysteria wiring through him. In place of the frantic instability of longing is a soft melancholy he feels more capable of working alongside. The studio provides him with the isolation he needs and gives him new separation, with a purpose. In this space he can work towards the annihilation of want, sweep out the flooding of desire which threatened to drown him from within. He will negate self in the studio and try to reach amnesia. Not just of Alexandrine, but of the teeming theatre of the world. The studio as a solitary stage.

Géricault feels small in this empty space. The huge, damp wooden floorboards soak up sound. They speak to him beneath his feet, creaking and wheezing, spilling out the soft-smelling must of damp. The space is like a belly, a room awaiting life. Jamar returns with Corréard. Géricault hasn't heard them enter, is startled; they seem alien. Corréard is all hard-edged, limbs jutting out of his clothes.

Géricault signals to Jamar to bring them two chairs. He apologises for the lack of formality and for the sparseness of it all. *I want you to fill this room with your story.* Corréard is willing, and asks Géricault where he wants him to start and what he already knows. Géricault recounts in minute detail the information he has gathered from Corréard's published account. Corréard is taken aback by Géricault's intensity and by the depth of his engagement. Géricault can remember the story better than he can. What Géricault doesn't know about is the feelings, the smell of the sea, the alienation Corréard felt out there in the grand expanse, the way that fear built. What it was like to be lost for days in the centre of those storms? Corréard begins the telling.

In the beginning, almost 150 people clung to the raft. They were more scared of what they might find when they reached the coast than what awaited them at sea. They were certain they would be washed ashore and that, barely armed, weak and short of numbers, they would be vulnerable to attack. They shared stories of the horrors they had heard, of a coastline filled with savages, more animal than man. Of cannibal tribes who would round them up, turn them into meals and use their bones for magic. Apparently white flesh is tastier, particularly babies and women. *They'll cook us alive.* Those they don't eat will be enslaved. Perhaps it would be better to wait out here

to be rescued. The more they spoke, the more elaborate their monstrous fantasies became.

They looked for the navigational instruments but found none. Eventually someone discovered a rudimentary compass, but it was soon dropped between the timbers. The sun was their only remaining guide. A carpenter erected a mast and sail, with the help of a few soldiers. For a while they were at peace, the sea was almost completely still, the sun setting and spreading itself like an orange paste across the horizon.

One of the barrels of flour is rescued from the sea, but the saltwater has turned much of it into a thick paste. They mix it with a little wine to make something barely edible. They tell themselves the wine makes it taste of home.

A large moon rises from the sea and illuminates the raft in an ethereal glow. As night falls, the moon drags the waves into solid mountains that batter the raft. They gather in the centre, huddled together. Some fasten themselves to the raft as it tilts close to vertical. They are chucked up and then thrown back down. Cries are barely heard above the roar of the sea, which hungrily opens its mouth to swallow them. They feel smaller than they have ever known, prepare themselves for death and offer up empty prayers. When survivors recall this first night, they say language can't reach it, that it goes deeper than a poet's capability.

In the morning, light redraws the ocean, which spreads into an infinite expanse. The raft is a tiny island in an empty world. Fear and alienation envelop the passengers. The carnage from the first night's storm is revealed. Bodies lie splayed across the timbers, limbs caught in the gaps. Bones are broken, wounds wide open. At least twenty lie dead. A father sobs, holding the body of his child close to his chest. *He's dead. He's dead. He's dead.* Some men take a closer look and sense a pulse. The doctor is

called and brings him back to life. In a few days, delirium sets in and the boy runs up and down the raft, tripping over legs and arms, calling for his mother, no idea where he is. His father is unable to console him.

Corréard's words fill the studio with waves. For a while there is silence. Then Géricault scurries off to a drawer and pulls out a folder of recent lithographs to show him. Napoleonic soldiers devastatingly injured by war, making their way back to France across the frozen ground of Russia, white snow stained with blooms of blood. He selects one to show Corréard. An exhausted horse, head slumped, legs buckling and weary, carrying a blinded soldier, his eyes heavily bandaged. His left arm, severely damaged, is in a sling and his right rests on the shoulder of his guide, whose feet, vanishing into snow, follow the direction of his exhausted eyes, forever onwards, towards the horizon and home, beyond the frame.

There was something resonant in the image. Corréard had made it back from his own hellscape to tell his story, to say what he had seen. Géricault wants to do for Corréard what he had been doing previously in these images of war. He tells Corréard he wants to turn the tragedy of what happened on the raft into a painting. Corréard becomes animated, says there is so much more to say, that the hellscape spirals ever deeper.

When Ali first visits the studio, a plan develops. I take his arm and guide him from the sitting room, through our kitchen and the conservatory and down the two steps into the garden. We walk slowly, more from my nervousness as a guide than anything. I count the steps for him to the studio entrance, the step up and down, and then we are in.

Ali lost his sight, and nearly his life, some twenty years ago. The terrorist attack responsible for the bomb is still shrouded in

mystery, but is believed to have been sanctioned by the Israeli state. As we sit in the cold studio sipping tea, I am not sure what his request to *see* some of my paintings will mean. I wait, and eventually Ali asks. *Tom, can I see some of the paintings? Would I be able to touch them?*

I guide Ali to a canvas and first show its scale, steering his arm to the bottom, which hovers just above the floor, and high above his head to the top. We take a few sideway steps for him to take in its full width. The painting is of a female figure pulling a male figure from two large, interlocking frames. Inside each frame is a view through to storms, to deep void spaces. Outside the frames is a solid dark blue. The female figure straddles the two spaces, body bent and straining to lift the heft of the limp and lifeless male body. I guide his hand across the painting, slowly describing the images beneath his hands and fingers. We measure out the pose of each figure, Ali bending his body to see if he has understood correctly, mimicking the dynamics of the motion depicted as he has understood it. I puppet him into the correct shape, shift his hips slightly, move an arm, twist his torso.

We spend at least an hour on one canvas. I have never had my work looked at with such intensity and tenderness. I have never looked at it with this focus and attention myself. Through Ali I have new eyes. Our hands are in a dance, hovering above and then caressing the surface. Fingers run gently across the stitched cotton, a thumb feels the rise of paint or the opening of a crack. To see through touch means Ali sees things that others don't. In the seemingly flat, blue surface he notices the undulations of breaking, layered paint beneath, touch revealing the hidden histories of the painting. The haptic experience of the hand feeling how the paint sits on the cotton is something normally inaccessible to the viewer, the exclusive privilege of the painter.

So in retracing the brush strokes with which I constructed this painting, Ali is bridging a divide, unpicking its mysteries.

He keeps coming back to the storm at the centre of the painting and where it meets the frame, viewing through to another space. It connects with Ali, excites and troubles him. There is a spark of recognition. We had intended to look at tens of paintings, but by the time we pause we are exhausted, drained by the energy we have put into this process of trying to see together anew.

I make another coffee, aware of the how odd it must be for Ali to be left in the studio alone. When I return he says he wants to tell me about the bomb. He has not spoken about it properly for years, but something in the painting has connected with what happened that day.

He remembers the day of the bomb in remarkable detail, up to the explosion. The plans for the food that would await him when he got back to his parents' house in Aleppo. The taste of coffee in his mouth. The smells of the city and the dust on his skin. The route to the bus station. Everything up to the explosion, and then nothing. A blankness, except for a few blurred things. A burst of heat, a burning across his face, a sudden and total whiteness, his body lifted, floating, then thrown. The bump and shake of a car, panicked shouts, the city louder but also distant. Car horns and more voices, lots of voices, and hands. Then nothing. A severance until he wakes.

While describing this memory, Ali seems not to be in the studio but back in the lead-up to the bomb. When we get to the explosion he returns to the studio, viewing the event from a distance with a wide-angle lens, only able to see it from the present day. *It was as if*, he tells me, *I had been chucked the other side of a mirror*. I remember how casually he dropped this line. There was an Ali before the bomb and a new Ali after the

bomb. The bomb had split the self. It had created a double, a new space, a new version of the world. I sat scribbling notes, my mind fizzing.

Was the other side of the mirror the space of blindness? What did it look like, what does it look like?

As if you were in the same world, but different, exploring it from a new space, from behind the glass, as if not fully there, but also there in ways you had not previously known possible. In ways you had not previously been able to access.

Are you still there?

Yes, still exploring this parallel world.

I took Ali back to the painting and held his hand to the surface again.

The space you talk about, the space of the other side of the mirror, is the space of this painting.

Ali ran his hand over the storm of blue paint.

It's a world like this, he said.

Do you mean a drowned world? A stormed world? Is the world after the bomb the world of blindness underwater? Our world, but submerged?

Something like that, but I don't have the word, just the feeling.

It didn't hang as a still image, more as an unfolding film reel playing in my head. A shadowy figure walked underwater, trying to map the dark, drowned interior. Could I touch on this in new work? In our process of pressing at the surface of the painting, flirting with the gap between one space and another, we had entered a place similar to the one he had been blown into with that bomb. This was what I needed to paint.

The next time Ali visited, my studio floor was covered with a series of white canvases, each the size of a large mattress. I walked Ali around them. They were surrounded by various pots

and buckets. I gave one bucket a stir with my hand and felt the chill of paint elbow-deep, the surface splitting into a snake-skin pattern as it separated. That morning I had mixed various paints with concrete powder, varnishes and soda water so that the result would be unstable, an array of things that resist each other, refusing to bind. I wanted the paint when applied to be temperamental, to not hold together.

Ali dipped his fingers in, running the slippery mixture between forefinger and thumb. He noticed the different viscosities and consistencies of each pot. I guided him to a seat by the edge of the canvases.

We will start with storms. The storms of the world Ali described, the submerged world of blindness, the other side of the mirror, the space he had been exploring ever since the bomb. I would paint the storm, and with it a new world.

The first marks are always hard, weighed down by the sense of possibility. A canvas is always approached with expectations and limitations. The moment I lay down a mark, the possibilities narrow further. I circle each canvas a few times, surveying it from every angle, stopping to crouch by various buckets. The paint starts to dry and cling to my palms. I try to wipe them clean on my jeans. Greying clumps clog under my fingernails. Taking a small screw from the floor, I scrape out most of the mixture, chew carefully to remove the rest, and spit. Ali sits in silence, listening and waiting.

These first marks need to both expand and limit options. As Harold Rosenberg writes in his seminal essay 'The American Action Painters', *the artist works in a condition of open possibility.* I want to be led by the process and guided by the paint so that the painting is a mode of exploration, not work towards a mapped-out destination. This approach to painting shares an ancestry with Géricault. It is similar too to how Ali had

described his blindness, as a mode of exploring the world from a new perspective.

I explain to Ali that these are our first steps but that I don't know where we will be going. I tell him I'm thankful that he is accompanying me on the exploration and that I want us to lead each other. *The journey will be as important as the destination*, I suggest, to cover up my fear of failure.

Ali takes my hands in his. *Tom, the worst that happens is we try and we fail.*

This is painting. It is the art of getting lost, of stepping purposefully into the unknown. It is a story, a form or an image that might not yet have been born, let alone found. As Rebecca Solnit urges, artists must *leave the door open for the unknown, the door into the dark.*

The raft was forced into a dark space after it was abandoned by the other boats, and it was this experience that Corréard told Géricault about in his sparse studio. That same year John Keats wrote to his brothers to describe a similar tendency, of which he thought Shakespeare was the greatest exponent: Negative Capability. Keats would write: *Negative Capability, this is, when a man is capable of being in uncertainties, mysteries, doubts, without an irritable reaching after fact and reason.* He expanded upon the idea in a later letter, describing life as a *Mansion of Many Apartments*, with many rooms locked shut from the self. The poet's job was to break down the architectural restrictions, open the doors, enter the dark passages and *shed a light in them.* When we are in that state, *We are in a Mist, We are now in that state – We feel the burden of the Mystery.* I wanted to enter the mist and leave the self, conscious thought and judgement behind.

I circle the canvas, reach into the bucket I am holding, cup my hand full of thinned-down paint and chuck it onto the surface. I move from bucket to bucket, as in a dance. There is a

theatricality to making these first marks that feels important. The canvas is a stage, also a raft, and is about to become the sea. It will represent Ali's life as a professor of theatre and literature, so the processes of painting need to be a form of theatre, of writing and rewriting. I am the actor and Ali the director. We are working in an improvised space on an empty stage.

Harold Rosenberg cited a critical point in American painting, specifically the mid-twentieth-century rise and dominance of Abstract Expressionism, where the canvas was no longer a space of reproduction but an event in itself. *At a certain moment the canvas began to appear to one American painter after another as an arena in which to act – rather than as a space in which to reproduce, redesign, analyse or 'express' an object, actual or imagined. The image, or the painting, would merely be a result of this encounter.*

The most celebrated artist of this phenomenon was Jackson Pollock. The theatricality of his process was captured on film by the German photographer and film-maker Hans Namuth. In photograph after photograph Pollock is seen stalking the canvas, pot of paint in one hand, brush or stick in the other. He leans over, kneels on or steps into the canvas, which is laid flat on the floor. He pours the paint or flicks the brush in a fluid motion, lines of paint mirroring the movement of his hand, arm and body. His artworks are created through a continual dance between painter, paint and painting. In one photograph, his arms, the brush and the paint become a blur of action, as if merged in motion, ghosting the space between figure and surface. The photographs are muscular, energetic images which mythologise Pollock's painting as virile. The brush as an extension of the body becomes a phallus, the paint marks sprayed ejaculations or territorial pissings. In the film footage we see Pollock's shoes covered in the markings, we watch as he drags on a cigarette and throws it away with seemingly casual abandon.

One photograph, taken from above, gives a sense of the scale and theatricality of the scene. The painting's lines have a rhythm which forms weaved webs that mirror the fractal patterns found in nature. In another photograph taken from below, we see Pollock's wife, the painter Lee Krasner, in the background. She is cross-legged on a stool, one hand on her hip, the other bent over her knee. Her softly blurred face is a picture of concentration. Pollock is the actor and Krasner the spectator, observing, like us, an art of action, one she helped form and would translate into her own unique vision. By placing her in the background of the photograph, Namuth foreshadows the sidelining that was enacted on Krasner, who, despite the originality of her own work, often found herself in Pollock's shadow. Pollock leans over the surface, gently. His hand is in perfect focus, the gesture one of delicacy and care. It shows the range of musicality in Pollock's actions and marks, a spectrum that should not be reduced to the single note of violent and erotic eruptions of paint. The theatre of his painting is both elevated and undermined by the limitations of the myth that surrounds it.

I remember these photographs as I make my first marks. I am aware of the link between my body's movement and the marks I make. This isn't the language of Ali's submerged terrain, it's my own, and I want the marks to take over and to make themselves. I begin with a matt mixture of black and watch it soak into the half-primed, semi-porous surface. Then I use two large decorator's brushes, one filled with a mixture close to ultramarine blue, the other mainly burnt umber. I narrate my actions to Ali, noticing decisions that I am not normally aware of. I squeeze the brushes inches above the surface, and let the two mixtures run into each other and consume each other as they absorb almost all light. I repeat the process, moving round the edge of the canvas, hovering the brush over the surface in gently waving diagonals.

Then I mix Prussian blue with Payne's grey, which splits into translucence, and light emerges from dark. It is the colour of the end of the day, the blue of the last evening light. Gradually I shift towards lighter and brighter blues, to lurid saturation, pouring half a bucket at a time across the surface. The paint makes its way through the canvas, drips beneath, blooms and stains. Gradually it clogs, and grips, and solidifies. The next layers slide across more smoothly, snagging at the toothed surface of the cotton, working themselves into rivers and tributaries. Slowly, different passages of paint find places to escape, spilling over the edge or gathering in points. A sky-blue melds into the Payne's grey and blends itself into a spectrum.

I vary the viscosity, the mixtures, and the way I apply the paint in response to the movement of each little passage of the medium. One bucket is a mixture of whites, both oil and water-based, with turps and resin varnishes, more cement powder, and acrylic from various pastes. I give it a stir, then put the lid back on to shake it into a foaming mass. I pour it into the bare space on the surface and watch it break its way into dark passages. It bubbles and resists the water-based paint. It sinks, then rises to the surface in iridescent globules. I move from canvas to canvas, letting the results of one inform another. Watching, waiting and applying paint again; it is a cycle of action and reaction.

I realise Ali is mirroring Krasner in the photograph and has become silenced by my actions. I need to involve him more for the process to be a conversation. Ali should be directing, informing and feeding into the decisions. I show him to one of the canvases, awkwardly kneel him down next to it and he presses his hand against the fabric, so that two rivers of paint run along the stretched canvas and pool round his hand, submerging it. I describe the range of blues in the river. Ali says that they remind him of the Euphrates, where the blue is shot through

85

with a light which makes it almost green. I scan through images on my phone and push the colour further in that direction.

The process of painting is opening up for me a closer engagement with the space of blindness Ali describes. Paint and words feed each other. As we move between action and discussion, at each stage me stopping to show or describe something to Ali, I become a magpie. When Ali points to how the surface might shift closer to what he was trying to put into words, I circle through a roller deck of mental references, of ways in which artists have used and applied paint through history, and draw on different artists to articulate what Ali is feeling. I quote artists, bastardise them, remix them, am guided by them. When Ali says the surfaces are too violent, I think of Helen Frankenthaler's lulling paintings. She worked directly onto unprimed canvas and let the thinned-down acrylic soak into the surface, so it spread and sat in ways previously unseen, a movement much like what Ali was describing. The submerged space on the other side of the mirror, the existence in an in-between state, between somewhere and nowhere.

When he says that the colour of his memory before the bombing is heightened, the blue almost unreal, I have Sam Gilliam in my head, and the saturated intensity of his work with its screen-like glow. We discuss how the surfaces need to crack more, to suggest the fragility and vulnerability of the terrain, the uncertain geographies of Ali's new relationship between self and the external world. I think of Frank Bowling, in whose art the paint gathers until it cannot hold itself and starts to crack. The cement and the other disruptive ingredients help it to break apart.

The canvases feel alive. The frame is a window, the lines not suggestions of rivers but optical, psychological and physical passageways and entrances into another world. The eye follows one vein of paint, then slips to another. The body dissolves into

the space within the frame. Tangible reality is replaced with a visceral other. Time slows and shifts into a different register. Perhaps it vanishes. The world falls away.

It's a feeling that Keats describes in 'Ode to a Nightingale', written in the same year Géricault completed *The Raft*:

> *My heart aches, and a drowsy numbness pains*
> *My sense, as though of hemlock I had drunk,*
> *Or emptied some dull opiate to the drains*
> *One minute past, and Lethe-wards had sunk*

The physical, numbing ache in which the physical self slips away has a drugged quality. Painting was entering Lethe, the river of forgetfulness and the passage between worlds. Everything dissolves, as Keats urges, *Fade far away, dissolve, and quite forget*. I always wish I could pause painting at this point and stay in that space forever. I'd like to show others this secret moment rather than exhibit the finished painting.

The canvases in my studio are now rivers of blues, run through with passages of light and shadow. The paint sits or floats in pools and lines of water, inches deep at points. The surfaces are maps of a new landscape and terrains in their own right, terra incognita forming in front of me, awaiting exploration. They have the depths of a submerged world. There is no certainty of what is up and what is down. A world viewed from the bottom of the ocean, lost spinning and floating inside it.

Here is painting as transcendence, inducing a temporary amnesia. Through the painting I have escaped the personal and the global. Like Keats, I forget *the weariness, the fever, and the fret*. Also the transience of life, *where youth grows pale, and spectre-thin, and dies*. In a letter to a friend, Keats longed for a *life of sensations rather than of thoughts*. He repeats the urge in the

poem, suggesting that *to think is to be full of sorrow*. To long to escape the pain of the world, and our inexorable pull to death.

Keats was attuned to the suffering surrounding him. His sensitivity underpins his poetic spirit and is fed by the losses he experienced. His life was shot through with death. His father fatally fractured his skull in a horse-riding accident when Keats was eight. His mother died from tuberculosis when he was fourteen, and two of his brothers perished young. As a medical student he regularly witnessed death and pain first-hand.

As we sat together in a pub near his house, Ali wondered aloud what it was I was trying to escape or forget, and why. My desire for amnesia reached into many aspects of my life, exhibited itself beyond the creative urge, most commonly in my complicated relationship with running and drinking. I had a nihilistic desire for erasure, to make the seen unseen. As Keats says, *That I might drink, and leave the world unseen,/And with thee fade away into the forest dim*. Gulping at a glass, I would feel a desire to drink more and drink faster. To fill my brain with claret. The world would shift into purple and red hues, wine bubbling in my stomach, racing through my veins. Similarly, running over long distances sends you into your body, pushing it so far that you can't exist just in your head. The repeating rhythm of one leg after another presses you into and through the landscape, as if you are becoming a part of it.

At the height of 'Ode to A Nightingale' Keats reaches a place of pure feeling and sensation, a landscape I was searching for in the moving wet pools of these paintings before they dried and settled. Keats writes of *embalmed darkness*, a paradise beyond sight: *I cannot see what flowers are at my feet,/Nor what soft incense hangs upon the boughs*. He wishes he could exist forever, but knows he can't. He is *half in love with easeful Death*, wishes the air would take his final *quiet breath*. Then he realises, as if it would

be the easiest thing in the world, that *Now more than ever seems it rich to die,/To cease upon the midnight with no pain*. He comes to the startling but logical realisation that the only way to remain in this state is to fall into death's arms. He imagines the emptying of the *soul abroad* as being a state of pure *ecstasy*.

It's a longing for a death of sorts, I tell Ali. I want to pull the words back in as soon as I speak, aware how offensive they might seem to someone who has confronted death directly, not just with the bomb, but as a daily possibility living through war. How every news report might bring news of the death of a loved one. He came to welcome the sound of a bomb, for its reassurance of life: as Mahmoud Darwish describes in *Memory for Forgetfulness*, *Keeping company with death has taught us that death has no sound. If you hear the hiss of the rocket, you're alive.*

I try to explain how I want to make the transient space of painting permanent. The running and the drinking I've become habitually entangled with are ineffective distractions. I wish to exist purely in the moving pools of paint, in the beauty of their potential, the landscapes they are forming, in the infinite possibilities they are birthing. I wish to obliterate self and the world and dive into the depths, to swim in the darkness.

At an assessment with a doctor, I was asked how often I thought about death. I realised I had become obsessed with the desire for complete and final numbness, total obliteration. I thought about death tens of times a day. Since my dad died I had been falling deeper and deeper into depression. Sometimes I experienced a violent desire to escape my own body. To *cease upon the midnight with no pain*. Suicidal ideations had started to shift into actions close to attempts.

On one such occasion, I stood at the top of a cliff, looking down. Jasper Johns's *Diver* came to mind: a monochrome diptych with footprints facing foward at the top, and handprints at

the bottom. A figure stood on the threshold, about to leap into the void. I was in Devon, a short run from where my dad had lived, staring down at a view I'd shared with him many times as a child, and run past many times as an adult. The cliff edge was the space of my dreams, the topography of my childhood memories. I thought back to the *Lear* collaboration with Simon, to his text about the cliff-edge scenes I had painted. *Tom is life at the cliff verge. A moment's decision, a moment's slip, and it is over. He looks down. Every detail gathers dimensions.*

I looked over the edge thinking about how easy it would be to tumble down, the powerful pull of the water and rocks below. I heard the siren call of gravity and release. I don't believe in ghosts, but another figure was present beside me. My father? My double? I closed my eyes and took a deep breath. I don't know how long I was there, or what stopped me. I can't tell Ali about this experience as I feel ashamed at what feels like indulgent narcissism. My thoughts are buzzing again and I cannot switch them off.

What is it you are trying to escape? wonders Ali, again in the studio, and I move uneasily in my chair, not happy to be the one under scrutiny. The words slip out and sit heavily between us.

My dad I suppose. Or what he might have done. I'm not sure I want to see it, say it, feel it.

You can't escape yourself, Tom, or your past.

He tells me a story. Blindness and war forced him to confront the world and himself in completely new ways. He tells me about one of his favourite trees in Damascus, an olive, and how he would ask a friend to take him to it. He would run his hands across its bark or a leaf through his fingers. At first the old visions would pour back in, the way the sun spread through that tree, raining dappled light onto the street. How glints of blue or gold would glimmer through the leaves as the breeze swayed the

branches and the leaves fluttered. But over time a new vision arose, almost microscopic in its nature. Touch opened a deeper connection with the tree. He could feel into it. Every tiny shift on its surface was alive on his fingers, as if the heartbeat from its roots ran up and into him. One day, after a serious shelling had occurred, he returned to the tree. A thick coating of dry powder lay across each leaf, the sprayed dust of blown-up buildings giving them a new skin. He could sense a suffocation of life, a dirtying veil over his home city. Through blindness and war he bore witness to horror and beauty. The world and the self opened up in new ways, with deeper complexities. He became intimately aware of the precious fragility of life. Why did I want to numb myself to this? Even if I did, escape was an illusion.

There is always something to snap us awake and to slip us into tangible reality. Keats likens it to a bell, *To toll me back from thee to my sole self!* The world floods back in. The other space drains away. It is frustratingly transitory.

In the coming weeks I become a master of watching paint dry. The pools of paint have made circular puddles, pushing down at the stretched cotton. The smallest shift has consequences. I slip folded bits of paper under a corner to move the puddles to new areas of the canvas, and the orbs float and create new veins of paint. The water evaporates slowly in the cool of the studio and the puddles shrink, leaving stained rings of remembrance and debris. Painting is an act of patience. What I don't do matters as much as what I do. Occasionally I text Ali, *still not quite ready, a few more days of drying. I'll keep you posted.*

Eventually the canvases are ready, fixed. I lift them up to hang them, and in the shift from horizontal to vertical mode a trick occurs. Gravity is cheated, as if these stilled storms of paint are held in the sky. On the floor the relationship between the marks and the history of making was clear. The concentric

circles record the way the pool of paint slowly shrank, and its rivulets look like landscapes seen from above, tracing the journey they travelled. Hung on the wall, these marks suddenly appear mysterious, their origins oblique.

Orbed forms floating in space. Soft-edged, layers built up, opaque and translucent areas. Each canvas has two central orbs, where the pool of paint moved across the surface and found new places to settle. The whole thing throbs. Forms merge from the depth and darkness and vanish back in. Energy pours inwards towards the two orbs, as if the painting is a pair of sinkholes. The paint looks as if it is coming from outside the frame, a slice of something bigger. I don't know how I painted it, or how it painted itself. I text Ali, *They are ready, want to come and see them together?*

These are not the paintings I imagined. They know more than the painter, they remember more, see more, find more.

Ali stands in front of one of the blue-stormed paintings waiting for me, waiting for us to enter this alien landscape. We are back with Géricault, who saw painting as a limitless terrain in which we can inscribe our thoughts and feelings. The figure in the bottom right-hand corner of *The Raft* hangs over the edge, crossing over the frame, breaking the gap between viewer and painting. We feel lost in front of it; lost in it. We are actually on the raft, adrift in the unreal space of the painting.

Other paintings contemporary with *The Raft* use the same approach. In Caspar David Friedrich's *The Wanderer above the Sea of Fog* (1818), a smartly dressed figure stands on top of a mountain peak, facing out towards a fog-covered landscape, broken by an array of other peaks. His pose in relation to the landscape mirrors ours in relation to the painting, setting up an equivalence of the experiences in nature and in front of a work of art. But it is not just a descriptive conceptual trick. The mirroring places

the viewer in the figure's shoes, in the painting itself and the imagined landscape. I am now looking at the mist. As Keats had said, *We are in a mist*, in those *dark passages* of the unknown and overwhelming.

A series of paintings follow which depict figures on thresholds. In Michael Andrews's *Thames Estuary* (1994–5), seen from above, they stand where land meets sea. In Mark Rothko's *Entrance to the Subway* (1938), the vertical pillars and stair railings drop down into the unseen subway, against the motion of two people emerging from it. The space below is not just that of trains, but an underworld of the subconscious. His latter works do something similar, pulling and pushing the viewer in and out of subterranean spaces, both architectural and mythical. To see Rothko's *Seagram Murals* (1958) at the Tate Modern, you enter a room where you are surrounded by huge canvases – an array of wine-reds, crimsons and plum-purples. Each canvas is made up of fuzzy-edged rectangles that mirror the frame. They read like windows or doors. There is an uncertainty about what sits behind or in front. Subtle shifts of tone and colour, alongside contrasting matt and gloss layers, create a shimmering illusion, a play of depths. At one moment a red rectangle projects forwards, hovering in front of the surface. Then it drops back into great depths. The paintings have a rhythmical pulse, opening and closing in front of us, entrances and exits into other spaces.

In Helen Frankenthaler's *Jacob's Ladder* (1957) the soaked passages of paint gather like a patchwork in the bottom half of the canvas, each irregular shape mounting up across the surface. Similar-toned greens, reds, pinks and yellows sit like a landscape of multicoloured fields seen from above. The eye is taken up and across the picture plane, following the ladder-like line of the central spread of shapes and colours to the top half, where weight, compression and concentration of form and colour give

way to something lighter and gentler. The solidity of the bottom half is replaced by a few curving lines and a pastel-pink series of bloomed forms. We have moved from the corporeal to the dissolving spirit world of light. It is a work which describes and enacts the process in which we are pulled away from the solidity of flesh and the concrete world. We are lifted somewhere else. In Pollock's *No. 1/Lavender Mist* (1950) we become the wanderer, the figure on the threshold, looking out at a view which invites us into a forest-like space of webs and interweaving lines.

But perhaps the painting most resonant with *The Raft* is Lee Krasner's *Another Storm* (1963). Thick white and crimson brush marks are laid over each other in an interlocking pattern, recording the movement of a hand or arm, the firm pushing of the brush across the surface in short, sharp marks. The marks cluster and knit. They pull the eye into the gaps in the layers, weaving a red-threaded net around us. The painting traps us in its labyrinthine, cave-like forms. A deep-red and white misting storm. It reminds me of the time I climbed Pen y Fan in Wales with Kiran. The fog thickened as we got higher. By the time we were close to the peak we could not see the edge, let alone any view beyond. A thick, white, expanding wall of fog engulfed us. We knew it gave way to a huge drop and an expansive view across the landscape. A sudden vertigo ran through my legs, and I had to climb bent over to keep my balance. The fog felt like death, a great, vast nothingness. In Krasner's painting the marks create a different kind of storm, but with similar depths beneath. It is a fractal scene that leads the viewer into repeated versions of the same vision, a spiral dive into an endless loop.

Where would these blue storms on the canvases in my studio take us? We begin. I start by running Ali's hands around the dried orbs of floating paint, tracing for him where the boundary is, how it has shifted and shrunk and left an echo of its journey

inwards. I move his fingers over the thicker arteries of paint and show him the array of smaller veins splitting off across the surface.

This mode of viewing mirrors the tactility of painting itself. Painting specialises in mapping the geography of the subconscious, and Ali translates the painting directly from his hand to his brain. We are ready to enter into the unknown, the unremembered.

In the Hans Namuth films of Pollock painting, some remarkable shots seem to be taken from inside the painting. Namuth got Pollock to paint directly onto glass, and placed the camera beneath the surface, facing out. The viewer looks up from the painting at Pollock, at the motion of hand and brush, at the gradual build-up of paint. We are on the other side of the mirror. Similarly, in Gerhard Richter's ink paintings the acetone has the effect of making them two-sided, slightly distorted mirrored views. Whichever side we view them from is both the front and the back, and we are standing beneath the surface, inside the mirror. Are paintings just psychic mirrors? Spaces which suggest the possibility of forgetting but are acts of deep remembering, spaces which let us travel to the depths we have attempted to bury or hide? Let us dream, imagine, discover. Was my own painting transporting me to the underworld of pasts and selves I had been trying to lock away?

Did the river, the painting, remember everything? Perhaps my memories were gathered beneath the surface, existing like trash on the riverbed, empty crisp packets rubbed free of their colour, used condoms, discarded rusty bikes, broken beer bottles, whispers of arguments. Memories as silt, each grain holding sequences, a sedimentary scattering and compression of past selves. All gathered there, homeless, or new-homed, memories without their person.

As Ali's hands skim across the surface we are in the shimmering space of paintings as a set of reflections, hiding or concealing what lies beneath, unseen. In Alice Oswald's narrative poem *Dart* the river collects narratives, time, lost things and all kinds of lost voices. She wonders who is moving in the dark, whether it might be the self in that watery mirror, all the submerged, slippery versions of self. The forms of the painting, full of ambiguities and uncertainties, trigger suggestions of imagery, like a giant Rorschach test. It feels alive. I swear I can see a jellyfish, then there is a dog, a bear, a mouth. All kinds of lives hiding in the surface come into view like a cloud drifting into shape. There is a suggestion of landscape, faces, whole scenes of action and perhaps, deep in there, *monstrous things*.

For Ali, his hand moving across these void spaces is a replication of the journey he has taken since the bomb threw him into blindness, into the drowned world the other side of the mirror. We stand together at a precipice, in front of and on a stage, in a space where vertigo works in more than one direction, spinning gravity. The storms under our hands are psychological, metaphorical, metaphysical. They take on a shape and power beyond meteorology. They are storms of madness, war, destruction. They are beyond dimension, they are the agents of chaos and destruction, attacking sanity, order and certainty.

When Lear stands naked in the storm, nature threatens the safety of home, theatre, the mind, family. The raft, cut off from the other boats, is left out at sea with a wide horizon and mountainous waves to face an unknown future. Here is trauma, suffering and chaos. I had lived here since my dad died, in the dark, submerged recess of a past. A storm hovers between canvas and viewer.

We start seeing more specific things. For Ali the painting is the Euphrates, the blue sky of Damascus, filled with migrating

birds; the whole flock a version of oneself, moving, migrating in search of a new home. We cling to the colour blue, inscribe upon it open space and limitless versions of the self. As associations keep pouring out of and onto the surface, I am reminded of Rebecca Solnit's excavations of the colour. For her, blue represents loss. Blue is the last colour to reach us, the furthest back in the spectrum. Blue is the colour left behind when the sun pours through the sky. It is the colour of depth and distance, and of loss. The hue of the sky reflected in the sea, in rivers, deception.

For me the painting is Devon. The surface of the painting is reminiscent of the views down across cliff edges into the sweep and swell of the sea in coves. Here in Oxford, as far from the sea as it is possible to be in this country, I carry it within me. It stains my lungs, I hear its hum, I taste it on my tongue. There are similarly unstable foundations within me, an ocean waiting to sweep out. My hands shake. Then there's my dream again, as if the paint has spilled straight out of my sleep and over the painting. My head feels sore and I'm unsure now whether I'm projecting associations onto the canvas, my brain misfiring.

I could go on forever, Ali says. *There is no end to this exploring and where it takes us.* But he is tired, and so am I, so we head inside for a coffee.

I have been trying to perfect making traditional Syrian coffee with the coffee granules Ali managed to get me from Damascus. A couple of scoops in a pan with water, bring to the boil, rest. The layers of spice slowly emerge as it heats up, the grains soften and gather. I pour us both a cup. As we finish the coffee, Ali tells me about an Aleppo tradition, performed with friends and family. You chuck out the last drop off coffee and then watch as the thick grains re-form at the base of the cup. You search for images, for meaning, in the river-like sludge. He asks me what I see in mine. *A hole*, I say, *it's contracting, shrinking, or perhaps*

expanding. I want to fall into it, into the limitless depth. *And what about mine?* He reaches his cup out to me, I peer inside. *A bird. It's a bird. Or more than one, and they are racing across the sky as if it's made of water and they are skimming stones.* We both pause for a bit, Ali gives the mug a gentle twist and the birds vanish into coffee. *Perhaps,* he offers, *those birds are us.*

Ali tells me his journey into blindness was not the cliché of descent but moved him in many directions. His description of blindness made me think of labyrinths, of mazes, of the kaleidoscope again.

We are retracing already what I have found myself doing, he tells me. The painting had revealed to us the shifting, rotating mirrors, the importance of getting lost, the fractured and shattered space. *We are doing it already Tom?*

He is right. We are on the other side of the mirror. We are in a maze, entering Ali's self and past, moving in multiple directions, across multiple levels. We will explore the complex, unseen world of his inner life and translate it into paint.

5

Wrestling

You make that person into yourself, you
inscribe their suffering on your own body

REBECCA SOLNIT

In the bottom right-hand corner of *The Raft of the Medusa* lies a corpse. This dramatically foreshortened form is covered in a white translucent sheet. The curve of material over the groin, and the delicate masking of the figure below, gives the cadaver an unsettling erotic energy, a sculptural sensuousness: flesh turned to marble. It is reminiscent of Bernini's *The Ecstasy of Saint Teresa*, which Géricault saw in Rome. Stone is carved into folds of fabric, concealing flesh but revealing a spiritual and bodily ecstasy bordering on agony in its abandon. In comparison, the sexual charge of Géricault's figure is latent, waiting to bloom.

Beneath the milky-white covering the corpse is degrading. It is hovering in that liminal space where death allows nature to

turn a human back into substance. The hip bone pushes out. The ribcage shows through the chest, threatening to break the thinning membrane of skin. The flesh is greens and greys, little flecks of red suggesting the last, draining colour of life. It's a body on the turn, worn and eroded, the stench of rotten meat undercut with sickening sweetness.

The stiffness of the body, held in a rigid contortion, suggests that rigor mortis has set in. For all its stillness, we can read on the corpse the memory of its violent death. It is bent, the pelvis pushes upwards, the thrust of the hips is morbidly eroticised. The torso hangs off the raft, on the edge, dropping into the sea. The chin juts up and the head is thrown back over the picture's frame, the clean, horizontal edge of the border decapitating it. This violent act brings us into intimate contact with the figure as it crosses the threshold that separates us from the painting.

Corréard had never noticed the kind, wide moons of cows' eyes before. He was sure this one was looking at him as the men dragged it, straining, into the courtyard for butchering, head lolling and scraping across the stone floor. Eyes rolling up, leaving empty pools shrunk to slits. Teeth bared with fear, a stench. For a moment he was transported back to the raft, felt the same anguished, quickening breath.

Corréard recounted the story to Géricault to explain his lateness and the lack of the promised steak. *It hits you in the strangest places*, he says. It is always unexpected. A smell. A sound. His home city invaded by lurking reminders of the sea. He could still see the knife slide into the side of the stunned man, his eyes wide in shock and the light seeping out.

Géricault is transfixed, desperate to know more. He wants to see what Corréard sees, what Corréard saw. He leans in, his face

a mask of concern, and rests a kind hand on Corréard's knee. Corréard takes a gulp of wine and returns them to the raft.

A solid black sky stretches wide, with a scattering of stars. Almost all warmth is emptied from their bodies. They knot together in huddles, trying to lock heat in. The moon is a sharp slice mirrored in the sea, rocking gently. A younger man, wet through from spray, is shaking, foetal. The group silently rub him dry. They wait for the release of a breaking day. For now, they are a single organism, united, breathing as one.

The first glimmer of sun redraws the horizon. Sharks have been spotted. At first everyone is terrified, but now the sharks seem like a way out. Two men leap in, hoping to exit through the lethal jaws. They've barely been in a minute and they are screaming, flapping about, desperately swimming back to the raft, being hauled on board by others. Corréard grabs a man's arms, looking nervously over the edge for the shark snapping at his ankles. Instead he sees a strange cluster of transparent bell-like forms and a mass of tiny tentacles. A beautiful accumulation. The men have been stung by a swarm of jellyfish; their bodies are covered in little red rash-like burns. Fear and despair pass into laughter, a respite from the sombre atmosphere.

The sun climbs high above them and they stretch themselves out to dry. Relief turns into discomfort and then panic. By midday they are looking for any kind of shelter. Corréard seeks refuge in the shadow of a wine barrel, covers his exposed skin with a few scraps of sea-soaked fabric. The heat is overwhelming. He watches the skin on his shoulder turn a deep red, then blister. A few men hang off the edges of the raft, cooling themselves in the sea. The saltwater stings their burnt, wounded skin.

A few soldiers bore an opening in the side of a wine barrel,

press their lips to the hole and gulp down vinegary mouthfuls. They lose the last threads of reason to that barrel. Anger and resentment spread like a disease baked by sun. The soldiers, drunk on wine and heat, start to cut the ropes that lash the vessel together, bent on self-destruction. Savigny, the doctor, tries to reason with them. Voices are raised. A clumsy struggle takes place. It escalates. The soldiers line up. They are armed with bayonets and sabres, wild-eyed and ready to attack. *It's a mutiny.* Except no one is sure what they are rebelling against. Corréard keeps silent, feels fear shifting within him.

Then it begins. One man charges, a lumbering blur of limbs and blades. The rest follow. A miniature war ensues. Two men wrestle one of the soldiers off the edge of the raft. Two soldiers push an unarmed woman and her husband overboard. Corréard watches nervously as Savigny drags them back onto the raft, the husband coughing up a lungful of sea. They place them on two stiffening corpses.

When someone grabs Corréard by the arm, a clumsy violence comes easily to him. With others, he fights a group of soldiers with rudimentary weapons foraged from chunks of the broken raft. Another two soldiers are pushed over the edge. A hand surfaces, reaches, and Corréard aims a firm kick, watching it vanish. But within minutes the soldiers have returned at the other end of the raft, arms grappling at the legs of others, trying to pull them in. A dagger is put through one man's foot. Corréard retches, a mouthful of bile. It's hard to know who is fighting whom, let alone why.

Géricault shapes it into a picture in his mind. He imagines himself a bird witnessing the spectacle. The mayhem pauses. In a wide, endless stretch of slate-blue the raft is an isolated island, overpopulated and frenzied with violence. Blood pours from its edges. The water is a shock of red fading into the blue,

a beautiful abstraction. Géricault sketches out images in his head as Corréard describes how the violence slowly comes to a halt, how a temporary peace was found.

The two groups gravitate to either side of the raft and there is an unspoken ceasefire. One of the mutineers lies badly wounded, a deep gash to his head. The soldiers begrudgingly let Savigny operate, with Corréard as his assistant. Savigny makes what effort he can to clean the wound with some rough fabric and seawater. He bandages it up tightly with a stretch of linen. Corréard does what he is told, cutting strips of fabric, placing a hand firmly on the wound. He marvels at the calm precision of Savigny's actions, the knowing dance of his hands.

Over the following hours the injured man is nursed back to something resembling health. Two of the soldiers explain to him what Savigny has done and the young man fixes his gaze on the doctor and reaches up two arms. Without warning his hands are at Savigny's neck, nails digging in. He looks feral with rage. He is restrained, a blade slipped into his side, and is rolled into the sea. Corréard watches the body float away, clothes soaking up the water, gathering enough weight to sink him. Savigny looks on in shock, one hand to his clawed neck.

Both sides overflow with paranoia; it is a tinderbox awaiting a spark. The mutineers become fixated on an officer called Danglas and demand he is given to them. They want to pluck out his eyes with a small knife. Corréard catches sight of a young boy trying to swallow his fear. He offers him a smile. The soldiers are told Danglas doesn't exist, has never been on the raft, and no one is quite sure what's true. Everyone is asked to give their name, one by one.

Whether through reason or exhaustion, the violence abates. In the aftermath Corréard and Savigny find a spot to rest together.

Not a word is exchanged. The husband and wife Savigny rescued come over to offer thanks. Savigny is embarrassed. They bless the Lord for their luck, for him, for each other. *Even in this seabound hell.* The woman insists Savigny take a small bottle of snuff, her only possession in the world. She tells them of her time as a military nurse and the suffering she has seen on the battlefield. Men reduced to mechanisms, reducing other men to meat. Bodies, still warm, half buried in snow, blood staining the soft whiteness. The strangeness of being sent to heal in a space where everyone else was sent to kill. She thought she had seen the worst, but this was even more hellish. *We are more than this. France is. I've not given up hope. When that's gone it's the end.* Her husband looks less convinced.

Darkness slowly envelops them and brings silence to the bloody machine.

Géricault is transfixed. He has taken pages of notes, scribbled little designs and sketches. He interrupts Corréard for the tiniest details, ekes out words that paint a picture of the scene. As the telling unfolds, Géricault watches Corréard's eyes reignite. The tale seems cathartic. But as the episode reaches its conclusion the adrenaline wears off, the pain of the memories rising. Géricault feels some pity, and much excitement.

Corréard looks drained. Géricault offers him some more bread and his voice seems to startle Corréard. The light has dropped and long shadows are opening up across the studio floor. Corréard stands abruptly, gulps down the last of his wine, and leaves in the gathering dark. Géricault watches his shadow from the window, a small form full of big stories. The painter pours another glass of wine and consults his notebook. He wants to paint it all, every last detail, every last breath.

In the coming months Géricault produces hundreds of

drawings, working his way through every episode on the raft. He invites friends to help him recreate scenes. The young Eugène Delacroix visits to pose. Géricault positions him on a wooden stage and lays him on his front, arms outstretched, head facing the floor. Seats himself just below, so he can map out a series of foreshortened sketches. He moves him a few times to vary the angle, to let the light from the window reshape the body. For Géricault, drawing is a process of transmutation, not just to capture the figures as they are but to translate them into something heroic. Light sculpts the body while Géricault's hand solidifies the form, making the figure more monumental, solid and static. He shifts muscles on the page to idealise the body, turning it into something mythical.

Théodore Lebrun, the friend who first brought word of the raft, is brought in to pose and Géricault is eager to capture his sickly, jaundiced skin, which speaks to him of the ravaged victims on the raft. Corréard is invited to pose too. He is dressed and directed, arms outstretched, the light falling across his face and body. He finds it hard to keep still, but Géricault works at a furious pace, capturing the shape and weight of his form with loose outlines that develop in detail.

Over time Corréard settles into posing. He learns to hold himself still, to focus on a point in the distance and let himself be elsewhere. Géricault invites him to sit in on a few sessions when he draws and paints Joseph, a young black model. Corréard finds the absolute concentration and stillness that Joseph is able to maintain magnetic. He watches the play and constraint between Géricault and Joseph. Géricault stalks the paper or canvas, rocking from side to side, skulking back and forth, eyes flickering, hands a-flurry as marks gather and collect on the surface. Joseph is sculptural in his stasis, not just staring into distance but conjuring and holding feeling. Corréard watches Géricault

work on a painted study, adding an oily dash of white to the eyes to give them the wetness of life. There is a dignity and beauty in Joseph's pose, a presence that reaches into a timeless space.

The studio is stacked full of drawings. Pen and ink on paper, pencil on paper. The entire story is laid out in front of Corréard, his trauma recreated on paper. Yet Géricault is full of frustration. Everything feels too illustrative. He needs to combine it together, to meld the moments into one grand statement.

Corréard introduces Géricault to the raft's carpenter, whom he also captures in an intensely conjured portrait. Géricault gets the carpenter to build him a model of the raft, watches the artistry of hands working with wood. Géricault meanwhile models a series of figures in wax, his fingers feeling their oiliness as he shapes them into contortions. He stages little compositions, lights them with candlelight. Mixes the set-ups in his drawings to find a unifying scheme that might capture it all.

A number of Géricault's studies focus on the mutiny. On one sheet of brown paper he layers up a deluge of black crayon, white chalk, brown and blue washes of watercolour. The drawings have a different energy to the final painting. The marks are frenetic, the layering more visceral. I recognise the ferocious intensity, the direct route from hand to mind in a drawing. Each mark is a diary entry, recording the twists and turns of the artist's hand, the pressures and tactility of one mark on top of another. Drawing is a form of thinking, of searching. It's an act of discovery.

Michelangelo's influence is clear in Géricault's drawings, and not just in the exaggerated muscularity of the figures. In a late Michelangelo study of the crucifixion, the figure appears to have been redrawn multiple times, each version laid on top of the other. The drawing remembers the journey of Michelangelo's hand, forming the contours of the body and then erasing and

repeating. There is a shifting exchange between conjuring a figure into life then watching it vanish into abstraction. The figures merge, shimmering forms pulsing into and out of each other like ghosts, melting into nothingness. It's hard to tell if the drawing is of one figure or many. Michelangelo's hand echoes the borders of the body, feels like a prayer made flesh in the face of the violent spasms of death.

Géricault's drawings have a similar quality, but they are like a hunt rather than a prayer, aggressively digging out meaning, trying to capture the traumatic violence of the raft. Géricault's drawings are battle scenes, biblical in their proportions. In study after study, figures sprawl across the surface, get swept into gushing waves. They are reminiscent in miniature of *The Fall of the Damned*, Peter Paul Rubens's monumental religious painting. Bodies tumble and twist, flung out by the mob. The raft becomes a microcosm of the French wars under Napoleon.

Another of Géricault's contemporaries, Francisco Goya, was struggling with the same questions. How do you paint violence? Goya had witnessed first-hand some of the horrors of war and illustrated the worst sufferings in his powerful *Disasters of War* etchings (1810–20), or as he would label them, *Fatal consequences of Spain's bloody war with Bonaparte, and other emphatic caprices*. Underneath one image he writes in Spanish, *I saw this* and under another, *And this as well*. A soldier stands, hands spread in fear, as a man swings an axe above his head. A blindfolded figure tied to a stake, firing squad in the distance. A landscape scattered with corpses. A mutilated body skewered on a tree stump. Another hung upside down on a branch, arms and head removed and hung separately, casual as a washing line. They are unblinking depictions of war.

In 1819, the same year that Géricault completed *The Raft of the Medusa*, Goya produced his most idiosyncratic work. *The Black*

Paintings were not made for public consumption. They covered the walls of Goya's home, where he had secluded himself following the horrors he'd witnessed. Dark, mystical images, they read like the products of undiagnosed PTSD. A giant Saturn, eyes lumps of coal, emerges from the pitch-black and devours the tiny, phallus-like corpse of his son. The head is already gone, the arms are vanishing into the wide black hole of his mouth. Two old men eat soup, their faces barely human, stripped of flesh. A circle of witches, their faces glowing masks, gather in ritual. A black dog's head, solemn and sinking, looks longingly up across a brown mound into the void. The nightmarish violence of the imagery, black spaces from which bright faces jump out, must have turned Goya's house into a claustrophobic cave. They are elliptical, maddening and noisy pictures, Goya's nervous system thrown across the walls, making seen the unseen, inexpressible nature of suffering.

Géricault's final painting of the raft has none of the explicit violence of Goya's prints, nor the chaos and mystery of *The Black Paintings*. Goya's works are the product of direct experience. Géricault was translating the ordeal of someone else, so his point of view was more detached. Death and suffering are present in Géricault's painting, but not the frenzy. It is calmer, more composed, more a symphony than a scream.

Goya was Corréard and Géricault in one, a man who witnessed the trauma and translated it into paint. Violence consumed and vomited out. Géricault, in contrast, was always the translator. He was possessed not by violence but by longing. For him the body was a house of flesh and bone where desire lurked like a ravenous animal.

At night he squirms in sleep, acrobatics of frustration, his limbs frantic. He's falling through the bed, through the air out of his body into an immeasurable depth, beyond vision, into

a venue without coordinates, scrambling and falling. Without Alexandrine he has become untethered, a crumpled puppet, alone on the stage, no longer brought to life by the invisible strings of her words and actions.

The affair is Géricault's disaster: a humiliating, shame-filled occurrence. A pathetic, egotistical, singular condition has overcome him, the 'catastrophe of the lover', which the philosopher Roland Barthes, in his book of fragments *A Lover's Discourse* (1977), compares to an inmate in Dachau. He ponders, rightly, the morality of such an excessive comparison. The lover's catastrophe is emphatically 'trivial' in comparison to the horror of Dachau. Yet it is precisely the gross and immoral lack of relativity that makes Barthes's statement so accurate. The all-consuming magnitude of personal feelings is excessive and inappropriate.

In the months during which Géricault is pursuing creation in the isolation of his studio, cells are dividing and growing inside Alexandrine's womb. Her belly is a room with life growing inside it, multiplying daily, beyond sight. Life sticking itself into being, floating in the swelling ocean of her body, a strange awakening. Feeling the reverberations of her heartbeat, the soft inside of her skin. Waiting to be flung out into the world, to spill out into full breath and scream at the flood of light.

What will the figures in the Ali paintings look like? Goya's *Disasters of War* images had captured the worst things the artist had seen. But those experiences had been ingested, had rotted and mutated inside him, before being translated into trauma on the walls of his house.

For Ali, his lived trauma worked in more complex directions. Blinded, he had experienced the horrors of war without sight. His challenge had been to navigate his way through an unseen

outside world. *Blindness has been, for me, like painting,* Ali tells me. *Because I had sight I can collage the world together from the memory of images, textures, feelings.* A world pieced together on an internal screen.

I wondered what impact war had on this process, how the experience of unseen suffering might alter the world he had collaged together. *It was like being blinded again Tom, bombed again.* The geography of Damascus had been blown apart, flattened out, buildings were stripped of their fronts. Movement through the city shifted, made complex and slow, war shattering its coordinates. *My map no longer fitted. Home became an alien world.* He was unable to piece it back together from memories.

Ali describes how he started to exist in metaphor. I am interested in what this means, in how his relationship to reality has been displaced in a multitude of ways, through blindness, war and enforced emigration. His is a poetic engagement with the external world whereby his physical and psychological encounters are reconstructed internally and translated into new forms and images. Given Ali's engagement with theatre, the language and methods of drama might help us find a way into the paintings. We have filled notebooks with scraps and fragments of stories and memories, each a small, isolated scene. *What if we were to use these as scripts as prompts for performances?*

A few days later we are back in the studio. I've arranged some wooden pallets in the middle of the room, the sandy-coloured slats grained with loose fibres; two large panel lights are directed down and across them. Two cameras are set up high on tripods, directed at the pallets, now dramatically lit in a frame of darkness. It is both a stage set and a miniature version of the raft. I guide Ali to a chair at the edge of the stage and describe the set-up. He will direct me, puppeting my body. I strip down to my boxers. Press record.

We start with the bomb. I want to subject my body to the types of forces Ali had described. Being thrown up and across space, lifted from the ground. That shift from weight to weightlessness, and then the thud and returned force of gravity. I think about the corpse on the raft and imagine Ali's body lying still, the violence he has been subjected to not immediately apparent. On the stage I mimic the pose, the positioning of the limbs and the raising of the hips. With the camera I record the same pose from different angles. I shift the direction of the lights to sculpt form in new ways, to let shadows carve under the edges and the light expose the chest, twisting to exaggerate planes. I begin to move out of my head and into my body, to be led by it.

I want to bring the corpse back to life, to inject it with the forces of the bomb. Ali sits, an audience of one to the absurd spectacle. My idea of his direction is abandoned. I fling myself from horizontal to vertical, legs thrown upwards, rolling onto my shoulders and head. Contort myself into corkscrews, try to work both with and against gravity, twisting my body. It's inelegant gymnastics without rules. I describe the poses to Ali as I do them, struggling to speak clearly as I'm balanced on top of my head, panting and out of breath.

It sounds hard work, be careful.

The posing becomes a violent dance. I start flinging and flipping myself across the pallets. I roll clumsily head-first off chairs, onto and off the little pallet arenas. One minute my feet are splayed vertically upwards, the next thrown backwards, down and across the spine, landing on my side, rolling over before flattening out. From the vertical downwards to the horizontal. I reverse the motion, trying to cheat gravity. I focus on the shadows cast on the stage, a darkness in which to disappear, an imagined abyss, into and back out of myself. Wrestling shadows.

The wood is rough against my skin. My knee smashes against

the edge and throbs. My elbow is scraped, my shoulder bashed. Upside-down, the blood fills my head. I can feel the weight of my body pushing downwards, hear the click of my spine. My pulse quickening in my ear. The empty room resonates with the bangs, flips and scrapes.

I am struggling to find the words to paint the picture, so I move Ali back onto the canvas and get him to stand next to me. I try to recreate some of the poses, keeping my upside-down body still at the top point. He reaches out, feels my feet struggling to stay still in the air, runs his hand down my side to touch the bend and twist of my body, then down to my head, turned on its neck, on the floor. I can't keep it still any more and I topple over onto Ali. *I'm so sorry.* We laugh.

Tom, these poses seem too violent. This is not my experience. It's all been softer, slower, less certainty that it is a fall. We pause. *I am sorry Tom, I think I lied to you, misled you. It's more like you are falling in water, drowning, sinking. You could be falling or floating, it's not so dramatic, not so definitely awful. There's beauty, uncertainty.*

I'd been wrong to start with the bomb, to focus on the dramatic violence of the body being chucked through the air. The bomb was relevant, but in large part was a blank for Ali. The type of falling he spoke of was more continuous, more encompassing, a state of slow falling or sinking that he had experienced post-bomb.

This was the state of blindness. The drowned world he had described. We had thought it through in terms of terrains and storms, but not physically in the body. I needed to express the movement through all dimensions. Ali had said blindness was in some ways a gift, a new way to see, and suddenly this image made sense to me, as if the drowned world wasn't just one of suffering but one in which you can explore in a great range of motions. It reminded me of the time I had been scuba-diving with Kiran,

how suddenly your coordinates are working in every direction as you freely discover the dimensions of what is around you.

It is not just one fall Tom, not even just falling, it's something more varied. This reminds me of other notes we had made about Ali's experiences. His slow, long fall drifted downwards as if in a sky made of sludge, but there were also moments of acceleration. The wider Syrian crisis teetered on a cliff edge. Each time you think you have hit the bottom, you find yourself on another cliff edge for another fall. As Gloucester asks, *but have I fall'n, or no?* The answer is multiple: it is a fall that's not a fall, or a fall that's many forms of falling.

I go again, this time in a slower dance, working to tighten from the core, creating poses where it is less certain if the body is falling or rising. Figures of directional ambivalence. Between poses I get Ali to show me how it might look or feel. He is far taller than me, so the movements of his body have a different grace. He bends over, his head as far down as possible, his arms limp against his side, as if folding in on himself. Then he stretches up and out as if in a slow motion burst upwards.

The thing that was missing was the architecture of the memories and metaphors Ali described. It wasn't the body alone, isolated and falling, but a figure falling through space, through collapsing buildings, frames, doors, windows. He had imagined the structure of a world falling apart.

My eye is drawn to the studio walls, to the large, blue-stormed canvases. It all felt stale and safe. The clean edge of the frame, the flatness to the wall, the known limits and dimensions, the lie of it. Could these paintings be the structure which the figure falls across, into and through? Could I literally get inside the frame and enter the painting? If the painting was the safe home, the architecture of the world we were constructing, then didn't that need to be broken apart?

I have an idea, I say. *I'm going to make the painting itself the stage.*

I am not quite sure what you mean?

I'll show you.

I lift one of the canvases off the wall, clumsily teetering about as the scale of it threatens to topple me over. I lay it upside down on the floor. I walk Ali round the edge and he bends down to feel the border.

Can I step on it? Won't I damage it?

You might, but that's partly the point. It's not a painting any more, it's a stage, a raft.

Ali steps on board. He is clearly unsure, uneasy, a bit lost.

I want to do the poses again, but working with and against this, I say, holding Ali's hand to the back side of the canvas running across the thick stretcher beams which keep the wide frames stable and square.

I crawl under the crossbars that brace the frame together, tangling myself in the wooden structure of the painting, becoming a part of the underside of this object. I get inside it. The canvas stretches to my movements, less separate now, a breathable, breakable skin. I start pulling at the edge, ripping the canvas from the frame, making small tears in the surface with a knife, pulling it open with my fingers, hearing the satisfying rip of the cotton threads. I'm attacking the canvas, breaking the skin, making a wound. I move it into various positions, putting my limbs, head, whole body through the rips and holes. I climb from one side to the other. I rip the canvas entirely from the frame, wear the slack fabric like a blanket. The frame, freed of the canvas, is suddenly a more flexible prop. It's a door, a gate, a window, an opening that I can cross or fall through.

I enter a trance in these moments, temporarily forgetting Ali is there, lost in the performance, searching for images and possibilities. I don't remember going to the garden shed but I have a

large axe in my hands. I start hacking at the frame, taking great fretting swings at the centre of each thick strut of wood. Finally I break through. With each strike I pause to pose in the new configuration, as the frame starts to become less and less of a solid form. Before I know it I am on the floor scrambling about, rolling within a pile of splintered lengths of wood and surrounded by various smaller shards. Each pose leads to more splinters, little chunks of wood poking, prodding and occasionally breaking my skin. I climb beneath the pile of timber, cover myself in it.

Are you OK? Ali eventually asks. *Where did you go?*

It's in this moment, as the performance reaches a conclusion, that I start to let thoughts in. They first creep, then seep, then flood in. I see the scene as if I am outside it, looking back at my double on the floor. I'm something else, someone else. Othered and mewling, a stranger.

We make a coffee and I flick through the footage, describing it to Ali. It looks like a theatrical performance. An embodying both of Ali and of Poor Tom from *King Lear*, but in a scene beyond the play, once the rest of the cast have left the stage, when the audience has gone. A figure subjected to unseen forces on the stage and a shadowed onlooker. I thought of the bombed-out, empty theatre in Damascus that Ali had spoken about, a space full of ghosts, of the sense of noise and lives, of plays and crowds now absent. We finish our coffee and I take Ali home.

When home, exhausted, I stand in the bathroom, looking at myself in the mirror. I'm wet with sweat and red-faced. My naked body is patterned with raw grazes and purpling bruises. The salty taste of blood is in my mouth, and I spit it into the sink. There is a small graze on the side of my head, which I wipe clean with a wet cotton pad. I throw cold water across my face. A slight sting. My knees and elbows are raw, skin pulled away. There are small bruises across my torso, a deep bluing bruise

on my hip, sore to the press. A rash across my chest. Splinters embedded in my palms and the soles of my feet. I remove them one by one. A good day's work.

That's when it hits me, as if the idea has literally taken on visible form in the reflections of the mirror. The steam from the shower has created a soft merge of the image. The figure in the mirror is now obscured, behind a thickening veil. I reach out a hand and smear a passage clear, and watch it drop back again behind the steam into a ghostly thing. That figure is not quite me. Here is the space Ali had spoken about so eloquently, of living on the other side of the mirror in a submerged, drowned space. Tingles of thoughts gather behind my eyes. I need to paint this.

There is a long and distinguished line of artists, musician and satirists who modelled poses based on *The Raft*'s cast including the artist Martin Kippenberger, whose poses were captured in 1996 by his wife, the photographer Elfie Semotan. Kippenberger, terminally ill with liver cancer, took the photos for a multimedia body of work inspired by *The Raft*, including numerous large paintings, drawings, lithographs and a wooden rug emblazoned with the original schematic design for the raft's construction. The range of work has no hierarchy. There is a chronology, with the photographs at the beginning, but to see them as source material, or the drawings and prints as studies for the paintings, is a false ordering. Kippenberger's entire career was an attempt playfully and aggressively to dismantle such distinctions and hierarchies. The force of his *Raft* works is the collective voice created by the conversation between the parts.

In each of the photographs, Semotan captures Kippenberger holding the pose of a figure in *The Raft*. In one he wears a loose-fitting white shirt, all but one button undone. His arms are outstretched, his left hand pushing towards us, breaking

the top of the photograph's frame, his right hand reaching into the distance in soft focus. It is a perfect mirror of the figure Corréard posed for. Yet Kippenberger is not looking up to that cluster of figures. He is alone in a seemingly empty room. His head tilts back, eyes fixed beyond the picture frame. In another he is shirtless, his body facing us. He has a mournful expression, his face is heavily shadowed and his eyes again look up and beyond into emptiness. Kippenberger's body does not have the sculpted muscularity of Géricault's idealised forms. Instead we see a very real form of naturalism. His body, blasted by liver disease, presents its mortality and human fallibility. The right arm is faded, perhaps slightly overexposed, seeming to vanish into the surface of the photograph and dissolve into light. It is a body both distorting and vanishing.

Who is Kippenberger posing for? In part, us. These images will have a function as art objects and an audience, so our future gaze is already in the room, in the body and its positions, in the camera. The photographs mindful of us standing in front of these images. But the artist is also posing for the black hole of the camera, that space of death. Each click is the pulling of a trigger, a slicing of a moment from the self. Each photograph is a murder, an act of slipping imagery onto the transparent, waiting surface of the film's negative. And, of course, he is looking at himself, aware that he will mediate these images, and that his future self will look back at him. Finally, he is aware of that unseen presence, the figure behind the lens, his wife. Her eye is there, guiding the performance. The photographs are a duet of connection between two creative voices, those of this couple, in love, recently married, aware of the imminence of death. We can see that this artwork was a great embrace.

It is easy to read these images as a continuation of Kippenberger's postmodern career, ironically dismissing the

earnest emotional drive of artists like Géricault. Yet the naked-ness and vulnerability in the presentation of the male body decry that supposition. It is weak and damaged, bloated by cancer. The images are full of tenderness, mourning and sincerity. The two artists committed here the ultimate subversion, replacing irony with sincerity. This is not an arm's-length dismissal of kitsch, but a radical call for authenticity. In place of a meta-narrative, this self-knowing cynicism is something simpler and more honest. It signals what the writer David Foster Wallace suggested, in the death throes of the last millennium, might be a rejection of cynicism. The real rebels would be those who reached for this type of truth, however saccharine, whatever the risks of being laughed at or dismissed as coy and soft.

In the process of reaching for empathy come connection and care. This is at the heart of what I am trying to do with Ali. We are jointly searching for something beyond illustration, beyond a visual reportage of his experiences.

In the liminal space of hospital, Ali says, he shifted into his body in different ways. In those weeks after the bomb he realised he had a new relationship with his flesh. He takes a sip of coffee, pauses, has a long drag on his e-cigarette.

Lying horizontal on the bed, face cocooned in bandages, closed off to the world, waking to complete darkness, Ali was unsure if he was dead or alive. Friends and family filled the corridors waiting for a turn to visit him after he had woken. The decision was taken to drip-feed him information about the extent of the damage. Over the weeks he became familiar with the new, dark space he existed in, before realising its permanence. Touch became his access point to the world. With his jaw wired shut, touch was sight and language and love. One day, when he began to suspect the severity of the damage hidden

under the covering, Ali ran his hand across his face, across the mask of bandages and wires. He felt locked in himself, unable to know what was happening inside.

He knew he was blind before they told him. When the final bandages, stitches and wires were removed the darkness remained, and so did the feeling of being inside a mask, inside himself. Blindness had sent him inwards. From the space of the hospital bed he would start slowly mapping and exploring the new parts of himself, parts previously unknown, perhaps previously non-existent. *It was an entry, not a descent.* An entrance into the body, into a new version and exploration of the world and self, composed in a new language, from a new perspective. *A start as much as an end.*

It was the story of these first steps back into the body that stayed with me. I wondered if there was a way to mimic a similar journey in my own body, or into the body of another, to mirror Ali's experience. Something similar to Edgar's transformation into Poor Tom, a disguise that moves beyond what Simon Palfrey calls a *Baroque performance of suffering* and becomes a new life. I looked back to those figures in *The Raft of the Medusa*, at their slick perfection. My knee was still scabbed from the previous poses, and I picked at it, carefully pulling off the dried skin. I prodded at the open wound; the thrill of pain was almost alien. Perhaps, as my friend Simon had said, I wanted to literally *enter the wound*. I wanted to open up these painted figures. To find the horror under the beautiful skin. What might it look like or feel like if I were to climb inside these figures? To climb inside myself, to experience something akin to what Ali had?

The studio is full of buckets, each claggy with a mixture of liquid clay, concrete and paint. The colours range from deep crimson through to putrid yellow, the palette of flesh. I pull tights over my head to smooth my features and create a porous

barrier, a structure for the mixture to cling to. I begin to coat myself in the liquid until it forms a second skin, stitching my body as it dries. I am afraid, I realise, when it comes to layering my head. To counter that feeling – perhaps to experience it more deeply – I plaster it on thicker there than anywhere else, layer after layer until my eyes, nose and ears are covered. I work in the dark, seeing with my hands as I let the new flesh thicken. The substance starts to dry and lock around me, closing me in. I have entered another body, exited my own. I am on the inside of a mask, sight and sound erased, myself fossilised. That covering was like a sarcophagus. It was how I imagine death to be. I can feel the self vanish.

In the same year Géricault finished *The Raft*, Keats published *The Spring Odes*. Keats had trained as an apothecary and was intimate with flesh, having dissected numerous corpses. In 'Ode on a Grecian Urn' he muses on art's ability to exist in the space between life and death:

> *Thou still unravish'd bride of quietness,*
> *Thou foster-child of silence and slow time*

Inside the drying clay I experienced part death, but also part rebirth. As I pulled it and the tights off I could feel the room return to me, I was reinhabiting my own skin. Like a caterpillar in a chrysalis, dissolved completely before reforming, transformed. It was unnerving, a practical process which accidentally turned into a ritual.

The films and photographs of the latest performance did not look like me. The clay caused a transformation. In some I appeared ghostly, the clay white and washed out, reducing me to a cipher of a figure, a molten marble sculpture, blurred and smudged. In others I looked monstrous, a Golemesque thing, a

homunculus with deformations of form and surface that turned the body into a zombie, an unborn humanoid, a bog person, dragged up from the depths, like a full-grown human but in a birthed state, slick with wet skin and blood and a viscous membrane. A face shattered, smeared, erased beyond individuality, a blank slate awaiting features and expression, hidden behind a wall or blown out, spread against a pane of glass. The whole body as wound, damaged, eradicated.

The ghostly, blurred imagery echoed Francesca Woodman's photographs, one of which has always particularly resonated. She is the model, the performer. The front of a fireplace has been pulled loose, leaving a small gap behind. Woodman's body crosses this divide, entering the hidden space, one leg reaching through into the dark depths of the fireplace, which has become a black square. There is a beauty and comfort to that alluring darkness. A place where all the light has gone and she can follow. Her head is obscured, partly through the blur of movement, partly hidden behind the loose facade. She is crossing a threshold, dissolving. Her identity is part human and part ghost, half self and half other. It is a haunting picture even without context, but within her entire body of work, where she is so often on camera but always in disguise, it takes on a greater impact. The blurs, recorded with slow shutter speeds, are traces of time, records of the mutation of self.

Woodman died aged twenty-two, two years before I was born. Grieving the end of a relationship and suffering professional disappointment and mental-health issues, she jumped from the loft window of a building on New York's Lower East Side. Depression becomes an exhausting white noise that engulfs you, simultaneously drowning and crushing you. Eventually something has to give. The silence and stillness of death offer release.

Later I realised that my performance was as much about

feeling my way into the body of another as feeling my way out of my own. Gilles Deleuze said: *The shadow escapes from the body like an animal we had been sheltering.* I wanted to erase my own shadow, to leave no trace.

I began to think about the importance of vulnerability as my friendship with Ali grew. The normal rules concerning art-making and viewing slid away as our exchange became more intimate and tender. The usual noise around looking at a painting became bankrupt, as I tried to translate into language what Ali was seeing through touch. My descriptions of the artworks required simple accuracy, not pretentious embellishment.

I had spent a long time researching the methods and language with which to show a painting to someone without sight. But, when put into practice, the official methodologies were too systematic and didn't fit the ways of seeing Ali and I were discovering together. Instead we formed our own idiosyncratic approach, often a language of metaphor and association. When seeking to describe a surface, a colour or a form it came down to a collective hunt for a memory from Ali's toolkit of visuals, so that he could combine the experience of touch and description with those memories to repaint the painting. We might end up describing an area of paint as having the quality of a jar of honey when held up to the light, of the glistening red of a ripe, sliced pomegranate. A surface might be like a piece of lightly toasted bread, or have the quality of flesh under a freshly picked scab. It was a language in search of specificity. It made me realise how alien it is to translate the experience of viewing a painting into words.

There was a careful, tender slowness to our looking. The experience had an intensity which made it charged, which seemed to accelerate the closeness of our relationship into being open and vulnerable. We found ourselves sharing things

that might normally be the preserve of the closest, long-term friendships.

We started sharing photographs. I had recently brought back a box from my father's house, and Ali had been sent an envelope of photos from friends and family still in Damascus. He asked me to describe them to him. We sat with a large pot of Syrian coffee. The smell of cardamom and warm spice filled the space between us.

The photographs from Syria were hard to describe, as I was not sure if they would upset Ali. One showed the beautiful, ornately patterned wooden front door of his house tilted and lifted off its hinges by a recent bomb blast. Some were views of a presumably local street, the wired infrastructure of a building visible. The one we spent the longest on was of his office. There was a pile of books on the table, an open pack of cigarettes next to them and what looked like a Zippo lighter. A wall of floor-to-ceiling bookshelves, full. Everything dark, save the bright white square of a window, the grating just visible. It was all covered in a layer of dust. Ali remembered the last time he had sat there, remembered the cigarettes. He seemed comforted rather than distressed by the translated vision, happy to know about it even though things had changed irreparably. He said a version of him was still sitting in that room, reaching for a cigarette, playing music to drown out the sound of bombs. In the silence we took a few large gulps of coffee. I reached a hand to his shoulder, squeezed, sighed, unsure how words could help.

I told Ali about the box of photographs from my dad's house squatting uncomfortably in the corner of the studio. He asked if I would be interested in looking at them with him. My dad was a photographer, and was particularly prolific at capturing our childhood in images. He was always behind the lens. So multiple versions of him were in the box. I couldn't remember much of

my childhood, particularly of being around my dad. There were gaping holes waiting to swallow me up. For lots of the failing memories these photographs were my only access.

I pull out one of the photographs and describe it to Ali. I am about seven years old, slight, and sit in the middle of an empty field in the branches of a large oak tree that has been struck by lightning. The tree takes up the entirety of the frame, its branches a knotted, chaotic mess. I seem impossibly small, surrounded by the burnt-out husk of clawing wood, and am looking back towards the camera, to where my father must have stood. I seem to be not quite there, slightly wary. I am like a tiny lost animal.

You describe small Tom as if he is someone else, Ali observes, and he is right. When I think of those memories I feel detached from them. I can't remember the feelings I had. That little boy is a complete stranger, glassed off behind a soundproofed wall. In image after image the same small boy has a detached expression, looking as if into a void. That gaze only appears in the images where it's just me and my dad; when my mum or sisters are there the boy is relaxed, is often smiling.

When I try to access my memories I feel empty. I am looking at stills from someone else's life. Then an odd thing happens. Ali's voice feels further away, as if underwater. I slowly separate from myself. My arms and legs are tingly, full of pins and needles which spread up my left-hand side and across my face. I am leaving my body, split from myself, looking down on the scene, at the two of us sitting in the room.

It's only temporary, and when I am back in my body Ali asks if I am OK. I try to explain the odd sensation. We sit with it for a bit, and then I feel a great wave of feeling for the first time, a yawning sense of melancholy spreading like gas through the room. There are a number of photographs that I skip past, and

I realise for the first time they are images I am ashamed of, that I now see are inappropriate, that I don't want to describe to Ali.

These are naked images of me as a small child. I look exactly as any child does. Happy in my skin, relaxed, smiling, unashamed of my body. But now I worry about the sheer number of photographs, and the way that many of them feel as if I have been posed, as if the nakedness isn't completely natural. John Berger said, *To be naked is to be oneself. To be nude is to be seen naked by others and yet not recognised for oneself.* In these pictures the naked child is objectified, turned into a nude figure, a looked-at thing. It is an act of perverting violence, a murder of childish innocence, a theft of bodily autonomy and identity.

I remembered the naturist magazines at my dad's house, where some of these photographs were published. One of me sitting on a plastic tractor, probably aged about four, with the words Big John covering the vehicle. Below the photo the caption, *Thomas and his Big John.* Why were these photographs taken, shared and published? Later I found evidence that they might have been distributed more widely, the suggestion that they may have been sent individually to strangers.

Was the child in the tree aware of the danger presented by the perversions of the figure behind the camera? Were these moments of dramatic disassociation from my body a remembering of things the mind had blocked out? Was I trying to get out of my own skin, out of a home under threat? Was I trying to get away from feelings of shame or fear? I had no idea and couldn't put my finger on the scale or scope of it. I was grasping in the dark for explanations.

A few days later, Ali was looking through more of my paintings using his hands to touch the surface when he said something that took me aback. He wanted to understand the hurt that is in my art, a feeling that is in the photographs. I tried

to deflect his concern, saying that the pain within my work is a reflection of the outside world. But this long-held certainty no longer sits so squarely.

Ali and I have been working through trauma in two directions. The bomb and blindness forced him into his body, separating him in part from the world. Trauma seemed to trigger in me this occasional separation from my body. For both of us, the body remembers and expresses more than we are able to.

Months before Géricault completed *The Raft of the Medusa*, Mary Shelley anonymously published *Frankenstein* (1818), the story of a corpse sparked into life. I had been trying to do the same to the cadaver in Géricault's painting. I hoped to bring it to life through improvisation. I wanted to create a figure that would wrestle itself. Barthes called wrestling a *spectacle of excess*, full of *grandiloquence*, a physical language of suffering reduced to pure spectacle for a voracious audience. But what if there is no audience or opponent? Then who is the absurd theatre for? I was looking to inscribe the corpse's remembered suffering onto and into my body, to use Géricault's language for the violence Ali had experienced. I was also now realising that this project related to myself, and to the violence my father had committed that I could not give voice to.

6

Flesh

A figure on the margins of *The Raft* is dropped into shadow, obscured and partial. It is hidden by the old man and the young corpse in the bottom left-hand corner, half blocked and sliced by the outstretched leg of the latter. A corpse? Perhaps not.

The figure, jutting up and out of the raft's beams, is in a diagonal counter-rhythm to the rest of this corner's motion, an abrupt point of dissonance. Only the top half is visible. The body arches, the chest pushed upwards, the head drops back in an elegant curve facing skywards. The skin is thin and stretched across the ribcage. The body seems stiff, possibly due to the onset of rigor mortis, yet the head suggests a flicker of life. The mouth hangs open: the last gasp of air? The lids initially appear shut, but they may be slightly open – either the musculature of death easing the eyelids or a final glint of life. There is a small,

carefully placed, vertical cut in the centre of the chest. A neat order of smeared blood. Is it a mortal blow, or the first surgical incision, to ready the body for butchering?

The bottom half of the figure is bisected by the curve of a deep shadow. The legs are presumably beneath the raft, between the gaps in the timber. Or perhaps that part of the body has already been butchered and devoured, and what we see are the remains. The right arm hangs off the raft, drops into the churning water, reaching to what lies beneath. It signals the horror of what is not seen. There is still a beauty and a carefully curated ambivalence about the figure.

Another detail in the shadows, further back on the other side of the raft in a nondescript middle space, signals an alarm of horror. I had been looking at the painting for nearly fifteen years before I first spotted this detail, behind an arm, almost lost. The axe would be menacing enough, but the shine of the blood across the blade ratchets up the horror. The droplets are painted with care and attention, and their bright colour and liquid texture look wet and fresh. Once seen, this suggestion of ultra-violence just committed cannot be unseen. The bloodied axe perhaps signals the brutality of the mutiny, or is possibly the tool of butchering. It looks like an executioner's blade. By dropping this detail into shadow, we are encouraged to look closer at the darkness and depravity.

Elsewhere in Géricault's study he was composing dramas of an altogether more gruesome and confrontational nature. The final images, along with the way in which he came to make them, are shocking and barely believable.

Géricault has taken to walking at night, waiting for the hours when the city is asleep. There is still some activity, but the people on the streets are on their own private journeys, their

eyes uncurious. The cloak of darkness gives him safer passage to sneak his prizes back to the studio.

Tonight the air is bitterly cold, the light rain almost ice-sharp as it hits accidentally exposed patches of skin. Géricault carries the gift, wrapped in thick canvas, under his arm. It is heavier and more substantial than he had imagined. The road is slicked by the rain, waste and sludge that has slid off the rooftops. He wants to rush, but with each step can feel the ground is slippery. He is glancing everywhere, checking behind him, vainly attempting to look inconspicuous, searching out eyes that are not there. A few people pass, barely notice him, and then he reaches the doorway to the building his studio is in.

A man startles him, and Géricault jumps backwards, nearly dropping the parcel. The men lock eyes, the stranger peering from the ground, looking up at Géricault, his eyes brightly glinting from the shadows. *A few coins for the wounded sir?* He's seeking refuge, drenched, wrapped in a sodden brown blanket, two wooden sticks leaning against the wall. Géricault spots his legs, protruding from the blanket. One is amputated at the knee, the round nub of it barely protected by the leaking bandages. The other bears a foot stripped of skin, crimson-red and gangrenous. Géricault stares and the man quickly retracts both legs. They both look for a distraction. Géricault rummages in his pocket, trying to balance the parcel under his other arm. Finds a cluster of coins, bends down to place them in the man's open palm. He feels a churn of guilt and wants to say something but is empty-mouthed. In the awkward silence he nods, lets himself into the building and returns to the dry safety inside.

Back in the studio Géricault hands the package to his assistant, Jamar, and asks him to unwrap it and lay it on the table. Jamar knows what's inside, is uncomfortable. He keeps it at arm's length, pinches the cloth between thumb and forefingers

and nervously slips off the covering. Géricault lights another candle, walks purposefully to the table, holds the candle close and inspects the still-fresh skin. He lifts the severed human head with both hands, places it back down, then secures the candle in a holder and plays with the positioning so that the flickering light casts the right kind of glow across the rounded form.

In the coming days the head would be joined by a growing collection of body parts, each brought back on late-night trips to Beaujon Hospital, across the road from his studio. How he was given access to these human parts remains a secret. We can imagine the networks and connections that led to this illegal trade. Did he convince a surgeon, or multiple staff members, of the importance of his work? Were parts stolen, bribes offered?

Géricault was given regular and open access to the morgues, dissection rooms and surgical amphitheatres of the hospital. The operating theatre was a place of spectacle, wonder and teaching, and the rapidly evolving practices of surgeons were theatrical. The medical theatre echoed its dramatic cousin; both were stages where the actors performed in the round, the audience looking on. The operating theatre had become a space in which to explore the mysteries of life, where the body was laid bare and its workings revealed. Yet to be granted illicit permission to take the remaining body parts to a private studio seems unprecedented. Géricault had become a scavenger of flesh.

Within the Beaujon Hospital were high-security prison cells where criminals awaited death by guillotine. Their bodies were subsequently returned to the hospital to be used in autopsies for research and training. With three to four executions a week the hospital was not short of bodies, made available for the study and fascination of others. The severed heads of criminals, and then their dissected bodies, were discarded as trash. Stripped not just of life but of identity, value and sanctity, the dismembered

parts were offered up to Géricault for his own experiments of an altogether different kind. A number of his pen-and-ink studies appear to have been made in the dissecting room. But moving from witness to choreographer of the corpses was an unexpected escalation.

Soon Géricault's studio began to resemble a charnel house. Limbs and severed heads were piled on tables for observation and portrayal. Géricault would instruct Jamar to arrange the body parts in new formations and compositions, to dress the sets with particular fabrics, to direct the candlelight to achieve differing effects. These were to be painted by night.

Corréard, like many of Géricault's friends, arrived at the studio with no knowledge of the shock that awaited. The sweet, acrid smell caught in his nostrils before he even entered the room, suddenly transporting him back to the raft, acid gathering in his stomach, sliding up his throat. On meeting guests, Géricault would shift between moods of intense concentration and the behaviour of a joker, ventriloquising a head.

As the days passed, the flesh sagged, greened and rotted. A new stench seeped into the wooden floorboards, into every nook and cranny of the studio walls. It grew into something putrid, it bloated the belly. Géricault had grown immune to it, barely noticing the way it embedded itself in his clothes. The painter smelled like a butcher's bin.

In the long hours of night, when Jamar had gone to sleep, Géricault would work with a new intensity on his studies of flesh. The flickering candlelight cast shadows of the heads and limbs across the walls and floorboards. Géricault was startled by the wind whistling through the crack of the windows. A scurrying rat, something living in its mouth. The creek and yawn of the wooden floorboards, footsteps on the stairs. The whisper of a few words, a soft groan from a head. The eyes

looking straight at him. Were they shifting and changing size? Was that an apparition on the wall, hovering just above the floor? The air suddenly colder, for a few moments Géricault would be filled with terror, sensing other lives, other voices in the room. Would feel the push and press of others around him. Then he saw Alexandrine's face, pressed up to his, a hand on the back of his neck, a few words uttered but indecipherable, her unreadable lips a vision vanishing into the void.

A year after Géricault was born, the magician Paul Philidor coined the term *Phantasmagorie* for his Paris show. In the coming decades the city would see a growing appetite for performances which incorporated magic lanterns and projections of images onto walls, screens and veils of smoke. Audiences came to be surprised, terrified, to have their fascination with the super-natural stimulated. *Phantasmagorie* evolved alongside horror theatre and the gothic novel, genres drawn to the exploration of the irrational spaces of dreams, death and the demonic. These forms of entertainment touched on a belief in many of necromancy, in the genuine possibility of communing with the dead. Crypts, caverns and underground spaces were taken over to create immersive experiences where ghostly spectral forms would emerge out of blackness, free-floating, palpably present. Audiences couldn't retreat to the safe place they had come to expect in the theatre, and for many the experiences offered up a portal to the living dead. The directors were cast in the role of magicians and witches, stimulators of marvels and terrors. In the long nights in his studio, Géricault was occasionally stepping into that waking dream space of the phantasmagoria, of spells and ghouls.

The function of the paintings which Géricault made from the body parts is still unknown. They reach far beyond preparatory studies. They are fully fleshed out works of art in their own

right, but they appear to have remained private and are hard to classify. There are five canvases, each medium-sized, the largest of the five sixty-three by fifty-two centimetres. This canvas is a deep, dark brown with no limits or clarity to its depth, a cluster of limbs half floating, half sitting in the middle, taking up the majority of the picture plane. The sole of a foot faces out at us, turned just enough to reveal the side and the ankle; the bottom of the leg is foreshortened, vanishing under a bent arm; the top of the knee and the bend of a leg are just visible in shadowy background. An arm is wrapped over the leg, the hand supple and soft, hanging across the bottom of another exposed sole. There is a gentleness to the arm, almost an embrace, the hand half grasping. It gives the picture both a dark humour and a surreal and surprising tenderness, a softness of touch, as if the entwined limbs are those of lovers.

In another study of limbs this combination is repeated. An arm is wrapped across a leg, almost holding the foot, and there is a genuine but distressing sweetness to the embrace of limbs cut from the body. The arm is severed at the shoulder, the wound half lost in the shadow but still facing frontally, exposed to us. A bloodstained rag is wrapped round the arm, almost comically redundant, the placement ironising the scene with deliberate black humour. Behind the leg is a smudge of crimson flesh, hard to identify, which blurs into the surface, smudged into half-existence.

Of all the paintings this one most notably reads as a still life, with the carefully heightened drama of the candlelight, the precision of the placement of the objects. Life and death are here explored from the surgical perspective; flesh shifts into matter. But the lighting that Géricault so carefully arranged indicates that beyond the reduction of life and flesh into meat and matter is the transience of flesh to spirit. That glow suggests the

presence of spirit in paint, of life beyond. It venerates the flesh. These discarded limbs are given new dignity. The corporeal and the profane are raised to the status of the sacred; on them is bestowed a heroism, grandeur and respect normally afforded to the noble or religious.

Géricault subverts the distinction between the sacred and profane, the same challenging transgression enacted by Mary Shelley's fictional Dr Frankenstein:

> ... a churchyard was to me merely the receptacle of bodies deprived of life, which, from being the seat of beauty and strength, had become food for the worm.

For Frankenstein the churchyard, a space of holy sanctity, becomes the refuse point from which he can collect samples for his study. The theft of bodies from their resting place is not an act of spiritual transgression, but rather removes them from the indignity of being worm-feed. Both Frankenstein and Géricault were radically destabilising normative behaviour.

A startling comparison can be seen between the types of still lives made by the Neoclassical followers of David and these seemingly gruesome ones by Géricault. The former made endless copies of classical busts, looking to them as models for the conception of the human form. Géricault applies the same focus and technical precision to the limbs of dissected bodies of criminals killed by the state. He gives the same dignity to the dregs of society as is given to gods and mythological heroes.

The other painting of limbs has a different energy. They are arranged so that the foreground action is centred on the cross-section of flesh where an arm or leg has been cut from the body. Here is something different from the cold, anatomical, illustrative quality of Géricault's studies made in the dissection room.

The dark, enveloping surrounding and candlelight, combined with the soft pulling of paint, make these wounds feel less like medical studies, less about biological accuracy, and more the presentation of human flesh as meat. If it wasn't for the half-obscured presence of a hand and a foot at the end of each limb, they would read as chunks of butchered cow. These three limb studies function together, creating a complex play of the sacred and profane realities of flesh. Any didactic moralising on the part of the viewer is instantly undercut by images exploring the inherent contradictions of the body when it becomes unhomed. Both worms' meat and wondrous spirit.

The severed heads further complicate the moral universe of these paintings. The guillotined head of a thief appears most regularly. In one sheet of drawings Géricault draws it in sharp profile, in three-quarters and then in two foreshortened forms, leaned back into the picture plane, leading the eye from the neck to the black hole of a mouth and up to the eyes. Each position of the head is carefully studied before it is rotated. Like a theatre director, Géricault is studying how he wants this scene played out, working through the angles of dramatics. He slowly progresses towards the resolved composition in the first of the severed-head paintings.

The single head takes up most of the canvas. It is angled at a sharp diagonal, the open wound of the neck at the bottom right, turned to present its full extent to us. The rest of the head is heavily foreshortened, so we look up through the chin and across the dramatically angled face, the cheek resting on the cloth-covered plinth. The weight of flesh is beautifully observed. Gravity pulls everything towards the plinth, softening it: the skin across the sharp angle of the jawbone, the slackness of the mouth, the musculature giving up. The slow hollowing-out and setting-back of the eyes, time sculpting the sockets skullwards.

The scratched, bruised, greening skin, blood and life poured out of it. Light and shadows work against the form, the surfaces which look wet drying, damaged, thinning, opening. Across the painting we are moving through the time-lapse of decay. Géricault was trying to get closer to feeling and communicating the intense, fleshy horror of the castaways' experiences. To truly empathise, he immersed himself within the sensations, rather than rely solely on first-hand accounts. This is the painter as a real-life Dr Frankenstein:

> I became acquainted with the science of anatomy: but this was not sufficient; I must also observe the natural decay and corruption of the human body.

Géricault shares with Shelley's fictional scientist an urge to reach beyond the textbooks of anatomy and to study directly the ways in which the human body degrades and behaves after death. Both were going to near-identical lengths in their quest to get to the heart of the mystery.

The final painting of the five features two heads, one male and one female, both laid across white sheets. Interestingly, while the male head was one he had collected, the female head was based on a young model Géricault paid to pose, thus performing an imaginary severing in the transition from looking to canvas. It's a subtle but central fact in the painting's dynamics.

The heads occupy the top half of the picture, the female head on the left, the male on the right. The empty space beneath them is a loaded absence, the space where their bodies would have been. The female head posed from life appears more as if she might be sleeping – or, if dead, then has had a calm passing. Her mouth is slightly ajar, eyes softly shut. There

is a soft and sensuous quality to her expression which sits in sharp juxtaposition to her grey-green skin.

There is nothing soft in either the violence or the surprising eroticism of the male head with its wide-open mouth, a black gaping hole interrupted by stubs of teeth and smears of blood, bright and moist enough to be fresh. It lets out a great gasp or an elongated scream of anguish. Either way the suggestion is of a slow, drawn-out pain. The eyes are open, dewy and alert, but slightly drugged and detached. They stare into the void mid-distance beyond the top edge of the picture frame, conscious but engaging with a different realm. The sheets are blood-soaked, a deliberate addition as the head in the studio would no longer have been bleeding. The blood has begun to coagulate, the shift in liquid form a metaphor for the movement from life to death, from one type of matter to another, the stilling and slowing. The skin is sallow, the colour of swamp water and dregs of clay, a dirge of grey-green in stark contrast to the splatters of fresh blood across the head. Colour is used to signify the violence of what had happened and the brutality of the damage displayed.

The painting reads like a couple in bed, two heads across pillows. One jolted violently awake, the other in soft, deep sleep. Neither, on close inspection, is explicitly dead. It is a surreal, fantastical scene, the suggestion of a bed perhaps hinting at a dream space. A dark, sadistic horror show of a nightmare. A strange erotism pervades the scene, but it is a playful, strange, unnerving necrophiliac comedy. The extreme focus on violence, run through with a psychosexual undercurrent, slides the painting into pornography. There is something consciously obscene in the provocations of the image, yet it is not singularly focused on the horror but serves a function, which makes it harder to condemn.

The image brings together an abundance of contradictory painterly methods, united to suggest that life is present in death. The heads are haunted, not with the ethereal life of a ghost but the fleshy life of a zombie. The intense focus on an unflinching and objective view of existence, stripped of idealising abstractions, pre-empts the Realism of painters such as Gustave Courbet some forty years later. But the unsettling estrangements and hauntings in these paintings point further forwards, to the twentieth-century psychosexual dreamscapes of Surrealism.

The fascination with death was also contemporary. These studies are not completely idiosyncratic, and to see them as the product of a maverick imagination is to ignore the preoccupations of Gothic and Romantic artists which had been taking shape in Europe across many different art forms: their interest in the nature of what activates life and their compulsion to get as close as possible to the material truth of existence.

Théophile Gautier neatly summarised the mood of the time in theatre, art, literature, across the arts, in both high and low culture. *The age was disposed to carrion, and the charnel house pleased it better than the boudoir; the reader could only be captured by a hook baited with a little corpse beginning to turn blue.* These paintings were the bait, the off-coloured corpse strung out to tempt or repulse, dangled in the murky waters, looking for a catch.

Géricault's paintings were not intended to appeal to extreme emotional and physical responses, to delight or repeal viewers. Mary Shelley's *Frankenstein* points the way: these dark arts were not just macabre displays of eccentric morbidity. Dr Frankenstein wasn't digging through graves to satisfy some perverse curiosity; he went to such extreme lengths to explore and understand the mysteries of life:

Now I was led to examine the cause and progress of this decay, and forced to spend days and nights in vaults and charnel houses ... I paused, examining and analysing all the minutiae of causation, as exemplified in the change from life to death, and death to life.

Géricault, like his fictional contemporary, was also trying to investigate the possibility of reanimating the corpse, of injecting life back into flesh, making a god of man. His paintings were lurid, bizarre depictions of this possibility. Yet even more, their pulsing, breathing flesh suggests that paintings might exist not as dead matter but as resurrecting zombified forms. Painting become the home of the living dead.

Géricault was part of a liberal circle, and many of his close friends were leading figures in various enlightened causes. A number of them were members of the Société de la morale chrétienne, a group that fought for the abolition of the slave trade and of the guillotine as means of capital punishment. There is no doubt that these works by Géricault are radical and provocative, would cause a stir in polite society, would arouse anger. Yet they do not offer a singular ideological agenda. They have an ambivalence, defying genre, and are maddeningly elliptical. The only certainty is their aggressive refusal to illustrate absolute values. Géricault's politics function at a human – as opposed to constitutional, ethical or legal – level. The messaging of his works lacks the focus of propaganda; they are private meditations, not public pronouncements: idiosyncratic enquires into the litany of absurd, beautiful, spiritual and horrific contradictions that lie beneath the flesh.

Géricault's paintings of severed body parts were significant stepping stones in his journey towards completing *The Raft*, but they also engage in an important, ongoing discussion with

painters interested in exploring paint as flesh. In his works, paint becomes a buttery substance. Flurries sit against delicate flickers. His paintings record the slow, incremental build-up of skin. Géricault brought to light the bodily imperfections that had been denied in the slick smoothness of Neoclassicism.

In his studies of severed limbs and heads Géricault was exploring the spark of life as much as the rot of death. Just as Frankenstein constructed new life from death, so Géricault painted these body parts into being. Mary Shelley was pregnant for a good period of the time she was writing Frankenstein, having already endured the pain of miscarriage. In 1815 she wrote in her diary: *Dream that my little baby came to life again; that it had only been cold, and that we rubbed it before the fire and it lives.* This desire at the heart of the novel to bring the dead back to life points to her longing for the child. In the hospitals and morgues where Géricault gathered his materials he would have seen a number of child corpses. And by the time he was pursuing the dark corridors of death, Alexandrine's pregnancy would have become public knowledge. The sudden and complete severance of Géricault from Alexandrine suggests that his identity as the father had also become public. While in Rome he had written to a friend, *Nothing seems solid, everything escapes me, deceives me.* And here again the architecture of his being, both the internal psychological workings and the instability of his personal life, seemed to be collapsing. It was a cruel contrast to the reality of *too too solid flesh*, the flesh of Alexandrine, flesh growing within flesh, beyond sight, beyond reach. Of the state of mind of Alexandrine, who was unable to pass the baby off as her husband's and whose life had therefore been thrown into turmoil and surrounded by shame, we know nothing.

*

Ali visits the studio and I talk him through the images I am planning to paint. I want to use the photographs from our performances as the basis for a set of figures, bodies playing out scenes and episodes which might be suggestive of Ali's internal theatre.

The storm-covered canvases are stacked in the corner, stages awaiting the arrival of characters. I turn off all the studio lights and hang a thick curtain across the glass doors, the only windows in the studio. The studio is pitch-black, so I guide myself with my phone's torch and finish setting up the projector. The first canvas is hung on the wall, waiting. I project the images that I have edited down for consideration, throw them up against the canvas to test possibilities, scale and compositions. The light of the projector casts a beautiful, unreal glow across the canvas.

I talk Ali through the images I have planned. A single figure, sitting in the middle of the canvas, its gravity just below the halfway point. The architectural details of the photograph will be removed so that the figure is suspended in a space of uncertainty, hovering between falling, floating and drowning. We discuss the pose, scale and the relationship of the figure to the space. We discuss whether it will speak of the particular feeling of drowning that his blindness has felt like.

I project another figure onto the edge of what could be a stage, or a raft, or a fragment of architecture. A figure at the threshold, looking down into what will be, in the space of the painting, a stormed nothingness. Ali recognises this description of standing at the brink of a spatially limitless descent as his experience of the Syrian crisis and the build-up to war. Of living, as an individual and a society, on the edge, the fear and anxiety growing and shifting almost daily. *You must paint this one*, he says.

In another projection, a figure lies, possibly dead. We toy with whether or not to have him on a stage or free-floating. In some I have clustered multiple figures, taken from the clay-covered

images of me, onto little floating, drifting rafts and stages. I play about with the arrangement, the number of figures and their organisation. I mention to Ali what he said of his life being a realisation of the multiplicity of self, as if through the many experiences of displacement he has become fragmented. I wanted to collate various versions of the same characters together in one place, to use the idea of multiple rafts across the storm-tossed surfaces as a metaphor for Ali's diverse iterations of self.

In other compositions we look at the figures grappling and writhing between frames, chucking themselves through. *I like the sound of these ones,* Ali says. I can feel the possibilities piling up in my head. Images are swirling, ideas spawning and pushing at the space behind my eyes.

Ali is more concerned about how I will translate the photographs to the canvas. *How do you get the figure on there?* His questions cut through the noise in my head. I flick back to one of the floating/falling figures and decide to draw that up to show Ali the first steps, the mapping-in of a skeleton image, pre-paint, pre-flesh.

I start by tracing the spine of the figure, the projection a template. I draw the stick of thick charcoal across this line, then at points decide to deform, to shift, to exaggerate. I press my thumb against the edge to soften it, then start pushing and pulling the flat length of the charcoal against broad sections of the figure's shadow, sculpting its form. I narrate the process to Ali. We hear the scratch and the swish of charcoal on canvas, the shuffling of my feet across the concrete. A few hours later I am done and ready to start painting. I hold Ali's hand and move his finger across the surface of the paper, tracing the outline of the figure and mapping its borders. The charcoal lifts in part onto his fingertip, coating it in black. When we are done I carefully clean Ali's hands with a scrap of fabric.

In the coming days I draw figures onto all the large canvases. Then gradually, over the coming weeks and months, I build them up, fleshing out their skeletal forms. A painting is a body. The canvas is a skin, the material pulled and stretched tightly over a wooden frame, which, with its multiple crossbars, is a skeleton holding the whole thing together, the unseen internal architecture. As De Kooning said, *flesh is the reason oil paint was invented*.

I break the oil paint down, mixing it with mediums and thinners, searching for a consistency between liquid and solid, ready to pull across the skin of canvas. I combine alizarin crimson with ultramarine and burnt umber, watching all life and colour vanish into a deep black. I pull white through the mixture and a rainbow of fleshy hues is revealed. Paint holds life and hides it. I push the syrupy, dark mixture into the mapped-out figure, laying it down with full opacity where the figure drops into shadow and leaving a thin membrane in the areas that would eventually be the highlights. Even at this early stage I am half blindly searching for a variety of ways to sculpt out the figure's structure from the hollow. Flesh is made of a dialogue between oppositions, offering up the possibility of harmony and dissonance in every single mark and mixture of paint.

I leave the figures a few weeks to dry, for the surfaces to tighten and solidify. The handling of flesh is fairly loose and expressive, but the figures are still broadly naturalistic. They feel of this world, static, known. When they're fixed, I invite Ali round to view them.

We spend a good deal of time on them, tracing their shapes and forms and describing how they sit within the whole picture. Then Ali takes control of the process, finding his way into each figure with little strokes, working his way around it and often circling back to the same point to check on it again, feeling every

small shift in the contours and abrasions. His focus on the variety of marks and their texture really amazes me, as if he is seeing through his fingers a version of each figure blown up, through the lens of a microscope, every tiny change magnified and heightened. He recognises hurt in one of the painted figures, where the paint has been more roughly applied and has clotted. Then somewhere else he senses softness, a different kind of beauty, a gentleness and care in the smooth spread of buttery paint. Elsewhere a glaze of paint has created a slick finish across a passage of skin, and he intuits the sense of being distanced and at a remove from the surface beneath.

He says it reminds him of his time in hospital when female friends touched his face, how he could feel their compassion and their manner and the nature of his wounds. He saw his face again for the first time through the fingers of others and was able to start to understand the damage that had been done to him. Touch became a new form of sight.

I needed to apply this sensitivity to the paintings, to open the flesh of these figures to the type of intimate complexity of Ali's intense looking. I needed to pull back the skin, to get somewhere deeper. Paint could capture this purpose, could get beneath the surface. Oil paint holds all the states of flesh within its colours and its texture: the skin, the blood, the organs, the liquids and solids that make up the mechanics of the human machine. It is a variety of pigments suspended in a range of mediums. Broken down with spirits, it splits and shifts like blood; built up with mediums, it is the sticky, in-between state of an open wound. Its thick, buttery substance is like an open body, then as it dries it stitches itself up.

Oil paint is sticky and messy. It dries slowly, so remains pliable and movable for hours, days and weeks. When we eat, have sex or are wounded we can become intimately aware of the

visceral nature of our internal matter. The mixing, application and viewing of oil painting is synonymous with this. It's alchemy. It is the transmutation of dead matter into life. Painting is also surgery, an exploration of that matter, a lifeless thing, flesh as meat.

In Titian's *Flaying of Marsyas* (*c*.1570–76) we see the satyr strung up by his legs, a surrounding cast witnessing the careful slicing of the top layer of skin with a shimmering, cruel delicacy of touch. His body drips with blood, which pools beneath his head. The cutest of small dogs innocently laps at the fresh, warm soup. The act of painting mirrors the act of flaying. Thin, delicate layers of paint are sensitively pulled across the canvas.

In paintings of cow carcasses made by Rembrandt van Rijn in the mid-seventeenth century, and Jenny Saville 350 years later, we see them hung at the abattoir, open and presenting the full architecture of their bodies to the world. In Saville's work, the flesh is imagined as great swathes and flanks of paint; spread, still liquid, across the surface. In Rembrandt's, flesh is created in clumps, paint half drying, gathering and clogging, appearing to cling and knot. Paint and flesh are gristle, and in the process of moving between liquid and solid states they are on the turn. Francis Bacon's cruel theatre of crucifixion triptychs pulls apart the *body without organs*, bringing him closer to Dr Frankenstein than any other painter. The body is presented as a container of all human suffering; a flayed thing in a godless world.

Jenny Saville's early figures are monumental things, based on photographs of people preparing for or having undergone plastic surgery. They are bodies and canvases that fill whole walls. We come face to face with the damage done to flesh, the skin scarred, scraped and stretched. Painting is itself invasive surgery. The canvas records the beautiful, troubling aberrations of hurt and damage. In the work of radical performance artists

such as ORLAN, the relationship is inverted, as the body itself becomes the canvas and the site of mark-making. Pain moves beyond image and metaphor and is tangibly realised. ORLAN undergoes a series of extreme acts of surgery on her face and body, reconfiguring it to challenge notions of beauty, to present the horror and aberrations that we, as a society, commit on the body. The operating theatre becomes a site of creation, a place where complex embodiments of feeling, image and identity are explored.

As Francis Bacon noted, *life is violent and most people turn away from that side of it in an attempt to live a life that is screened . . . the act of birth is a violent thing, and the act of death is a violent thing . . . the very act of living is violent.* As Gilles Deleuze says of Francis Bacon's crucifixion paintings, *for Bacon as for Kafka, the spinal column becomes nothing but the sword under the skin which a torturer has slid inside the body of an innocent sleeper.* In Bacon's flayed figures, the spine is a pole around which flesh dances, the figure flayed opened, organs exploded over the canvas. It is paint as a violation of the body. In the abstraction and destruction of the body's boundaries, we see pain poured into paint.

The same is true of De Kooning's female figures, splayed open-legged across the canvas. The artist's hand, his marks, his gaze – and ours – are a series of misogynistic, masochistic wounds. For all the bravura brilliance of De Kooning's paintings they are also worrying, both reflections and recurrences of the violence done to the female body, in action and gaze. As Rebecca Solnit points out, in the structural, systemic violence our society commits on women it is not hard to see that *violence . . . does have a gender.*

This concatenation of references is jumbling in my head. I want to change these figures, to paint them so that they start to visually communicate the things Ali is seeing in them through

his touch. I want to magnify the effects that are already there, but which have perhaps already been lost to me. I decide they must be attacked with more vigour, the language of paint must be expanded to start, in its every application, speaking of the damage to skin and flesh that Ali had experienced and was now communicating. I need the bodies within the paintings to be unmuted, for them to express lost stories. I am reminded of a passage from my friend Simon's text on Poor Tom, which had emerged out of our *King Lear* collaboration: *Tom is mime shattered into sound. With one ear we hear the lexicon of multitudes, with another white noise, with another the cry of a bird dying. Or hear no sound at all, but rather a wound.*

Over the coming months the modes of application keep diversifying, and I find new ways to distort, obscure and reconfigure flesh. I mix up large quantities of flesh-coloured paint, separating it into different ends of the spectrum, adding in gloopy mediums but barely mixing them together. I gather up handfuls off the pallet, chuck them across a face, watch the paint splatter across the surface, obscuring the more carefully constructed features below. The chest of another figure is still wet, and I drag a huge smear of paint across the surface, pulling layers from the surface with it. I take cloths, bits of old wood, palette knives and slices of metal and drag and smear paint. With the ends of knives and pens I draw lines back in, etch in boundaries and divisions. I'm using brushes less and less, and when I do it is to flick and chuck loaded lumps of paint. Soon I am using my hands. My palm is covered in cadmium red, pushed hard into the cotton; I feel the resistance of the sturdy wooden crossbeams below. A thumb, a knuckle, a fingertip, all used as tools.

Occasionally I paint blind, for hours at a time. I want to close the gap between my method of making the work and Ali's mode of looking. My hands and fingers are covered, chucking

and smearing paint onto the surface. I look to take control further away, fill my mouth with paint, spit and spray it across the surface. Lay it on the floor, distort a section with the base of my foot. It feels frenetic, but it is still slow and considered. There are long pauses before I commit to an action. I survey the damage, decide if I should push the figure further into obliteration or pull it back, excavating the form and certainty out of the mass of gathering paint.

There's beauty in the damage. The marks were layered up, one hiding another, a web of interlacing sounds. The painting of flesh is visual music, a limited set of repeating signs and combinations which can fold out and back into each other over the course of a single piece to set up a world of varying rhythms and rhymes. One image would be barely recognisable as a face if it wasn't for the context within the rest of the body. The mouth is the only familiar thing, the rest of the head looks like a bomb site, the eyes reduced to dark pits behind layers of paint. Forms are only just holding on, nearly slipping into abstraction.

I again invite Ali to view the paintings of bodies, these sites of trauma, these bomb sites of paint. The paint is still wet, so we only touch and work our way across a few figures. In one of the less complete ones I let Ali feel the paint, now thicker, the differences more defined. He notices the change in texture of my hands, nails clogged with paint, palms raw from the excess of turpentine and scrubbing to clean them, knuckles cracking from the drying of skin. *You're becoming the painting*, he says. *Be careful*. We laugh, but he is only half joking. *Don't go too far.*

We spend a long time discussing the figures. Ali notices the obvious difference between them and the storms, as if they now belong to two languages of paint, as if they are physically and geographically, perhaps even phenomenologically, different from each other. They don't feel or actually look like figures

falling, drowning, drifting, viewing across thresholds into voids. They look like figures and space which are dissonant, disconnected, binary.

I wanted the paintings to communicate the way blindness had seemed to Ali to form a new relationship to his body, to flesh in general, to the world through touch. This closeness, this intense and beautiful engagement, was in stark contrast to my slow detachment from my own body.

The dissociative feeling I had when viewing the photographs with Ali had started to become more regular. It began as a numbness to my hands, arms and legs, but it spread up across my head and the left-hand side of my face. After months of denial, I went to the doctor. That was how I ended up in an MRI machine, with a diagnosis of possible brain cancer.

Being inside the long tube feels like you are descending into the bowels of the earth: loud drilling and beating sounds of a low bass, then wide-open ones which suggest great expanses. I was in there for an hour and a half, and different ghosts appeared. I thought a lot about Ali and our project, how this machine was now translating the interior of my body and its unseen landscapes into images. I thought back to my father. As cancer consumed his body, I had become fascinated by the idea of what lay beneath as the disease colonised him. I would spend hours researching biomedical imaging techniques, spent days in a hospital watching open and laparoscopic surgeries and C-sections, each revealing the interior of the body in different ways, vivid in its range of colours, seemingly expanding into a fantastical Romantic landscape, inviting exploration. Locked in the claustrophobic space of the MRI tube, with the clay covering still fresh in my mind, it felt like many elements of my life were rhyming.

Seeing the MRI scans of my brain and spine was remarkable.

My friend Sam is a consultant oncologist and a poet. I sent him the images as I wanted to understand what they showed. *The images rely on the magnetic properties of your dust.* I sent back an exploding-head emoji. He explained further. *Protons, which are the positive charge of an atom, tethered to neutrons in their nuclei: the sun on them, I think.* Another exploding-head emoji and a few exclamation marks. These odd versions of self were not just the unseen, but the making-solid of what was not really there. The gaps in me were turned into something visible. Not so much images of my self as my echo, seen in strange abstraction. This shadow self looked alien, eyes free-floating moons. Flesh was depicted as light and dark, but its combined solidity and fragility was apparent.

I became familiar with the limbo state of the hospital corridors in the coming weeks, and thought a lot about Ali's past as I passed through them, of how unsettling it must have been to face up to his new world from the confines of a bed, from the cloak of darkness. My doctors ran a litany of tests, but each one only ruled things out, as opposed to clarifying. The neurological clinician noticed that depression was mentioned in my records and dug a bit deeper.

In recent months the depression had grown. It felt like a cancer, splitting under the surface, spreading and colonising. It mutates, emerges from the depths, takes over, pulls you into a new, deformed version of self. He mentioned a condition called bodily migraines, which are psychosomatic and often caused by traumatic triggers. The traumatised mind causes your brain to unhook your body as if you are not in full connection with it. He is describing the phenomenon to me that I remember from looking at the photographs with Ali. The only other diagnosis relates to a herniated disc they found towards the top of my spine, which was likely to have been caused by my reckless,

clumsy posing, chucking myself continuously, hour after hour, onto my head, neck and shoulders.

They had been searching for something solid, for a deformation of flesh, but had found nothing concrete. If bodily migraines were responsible for the numbness, then the flesh had detached from the self, not damaged it. If it was related to the herniated disc, then it was the result of self-imposed physical recklessness, driven by a cocktail of creative compulsion and depressive-destructive tendencies. The unseen was clearly becoming more important than the seen. My body was articulating things buried inside, beyond the limits of flesh.

7

Flaying

DEATH's cold SPELL

MARY DARBY ROBINSON

An image of mourning inhabits the bottom-left of *The Raft of the Medusa*. An old man holds the corpse of a younger man, his hand resting gently and paternally on the youth's bare chest. The body is naked except for his feet, which are wrapped, presumably wounded. Its curves and juts are accentuated by hunger. The old man is clothed, his elbow bandaged with a bloodstained cloth. A red shawl is wrapped over his head and round his shoulders. It frames the figure, draws our eye to the intensity of his pose and expression. Red is the colour that reaches our retinas first, so it always jumps out, grabs and holds attention more than any other. His head rests on his hand, his expression set in deep shadow, his eyes dark sockets of sadness. He stares beyond the picture frame into the blank void of grief. He could be contemplating the horror of what he has seen, or is now confronted with.

The direction of his gaze off stage merely heightens the strength of feeling, giving it a meaning beyond our reach.

His expression recalls for me the shell-shocked soldier photographed in Vietnam by Don McCullin in 1968. In the midst of battle, the American Marine grasps his rifle as he faces the viewer. But his gaze does not meet ours. He is looking beyond us, through us. McCullin captured some of the most obscene horrors of war, and the twentieth century is littered with such images. Susan Sontag quotes from Virginia Woolf to illustrate this proliferation of disturbing war imagery in modern media: *the photograph of what might be a man's body, or a woman's; it is so mutilated that it might, on the other hand, be the body of a pig.* But McCullin's photograph, in its absence of anything as explicit, reaches to a deeper horror. We are forced to imagine what he sees.

The old man's stare carries a similar weight, but our psychological attention is more acutely focused on the body he cradles. The pose echoes Michelangelo's *Pietà* (1498–9), inverting the maternal religious icon into a paternal secular image of grief. With the older man playing the role of a father figure it becomes a scene of quiet mourning, full of the worst horror imaginable, a parent losing a child. It sits in stark contrast to some of Géricault's studies, which point more unflinchingly to the type of horror Woolf describes, to the most gruesome episodes from the raft.

What's the worst you saw?

Corréard looks at Géricault as the memory forms. He can taste the shame, dry and bitter in his gums. He goes to dip his bread, thinks again, pushes the bowl of chicken broth gently away.

We did what we had to, he says, as if trying to convince himself. He had left part of himself out there, at sea.

Flaying

Géricault's head is over-full, a pandemonium of parrots in a cage. Still reeling from the nightmare that had woken him that morning, suffocated, surrounded by multiples of his uncle's face. Heads floating, sinking back into and pushing out of the walls. Mouths and eyes spawning, a swirling murmuration smothering his breath.

He needs a distraction. He is a scavenger, hungry for Corréard's story, for another form of suffering to feed on.

Corréard is visibly vulnerable and uncertain. They sit for a long moment, heads down. *This was the worst.*

Four days in and the raft is covered in death. The fresh water is gone and the supply of wine has run low. Most of the mutineers have been killed, and everyone left is too tired to fight. They are husks. The days and nights slip into each other in a half-awake nightmare. People try to drown themselves but are too exhausted. A smiling man has entered a trance. He is lost in a dream space, the sea a glimmering stretch of silver, the clouds morphing worlds.

Corréard's stomach is a cavernous pit. His mouth is paper-dry and his lips are covered in deep cracks. They search for anything to dull the ache. One man gnaws on a corner of the raft. He digs his teeth into the soft, wet wood and is temporarily relieved by the feeling of substance in his mouth, barely noticing the splinters entering his gums. Another man tries to chew on an old bit of leather and finds brief satisfaction in his bitter saliva. Everyone drinks their own urine, convinced there will be some traces of nutrition. One man's piss is stolen for its slightly sweeter taste. Corréard sticks to his own, swallows it down, nose squeezed tight. In the corner a man shits into a piece of linen. He crouches over it, stares for minutes on end. Everyone is watching. Carefully he scoops a small amount into

the palm of his hand, holds his nose and takes a small bite. He cannot swallow, runs to the raft's edge and drinks mouthful after mouthful of seawater, violently scrubbing his teeth and tongue with sharp fingernails. A mouthful of blood. Corréard feels gut-hollow. Everyone pretends not to have seen.

No one knows who suggested it first, but the decision is surprisingly frictionless. Desperation and hunger have pushed them beyond arguing and moralising. Corréard is amazed by how quickly a body that housed a friend can be transformed into a potential meal.

We should at least try, surely?

The butchery is carefully discussed. They decide that Savigny, as a surgeon, should perform the operation. A group huddle around. Corréard shuffles next to Savigny in an unspoken agreement that he will be the assistant. Savigny settles in with a strange ease, as if he is back in surgery. He knows how to repair wounds, stitch up skin, remove a diseased lump, diagnose. Yet here is a human as something to harvest.

Corréard senses the tension building over the first cut, but suddenly the entire thing seems far too normal. A shallow line is drawn down the thigh, a thumb slides under the skin and with a slow, firm tug a patch is removed. Man turns to meat. It is dark pink, with only a tiny scrap of white marbling and a few remnants of skin. Savigny looks around. There are no immediate volunteers so he takes responsibility. A few bites, closed eyes. *Tastes OK. A bit like pork.*

The rest of the leg is butchered, everyone eats. Some find it harder to swallow than others. The decision is taken to not dissect him any more, as there are plenty of others. They give him a thankful burial in the ocean. The body is carefully wrapped, the face covered. Some prayers are offered up, heads bowed to the sea or raised to the sky. There is solace in the ritual.

Corréard has no sense of how much time has passed. It stretches out wider than normal. Soon the hunger returns. It is agreed they should butcher an entire person and make a meal of it. The first is picked, Snowy – something to do with his time fighting in Russia. Tall, broad-shouldered and less withered than the others. Adam, another soldier, says he was trained to butcher pigs and goats while serving, so offers to take charge. There are no complaints.

Two of the strongest men are picked to help. Joseph, the carpenter, is one of them. He constructs a crude system from which to suspend the body. They tie it by its feet in a clumsy struggle. It hangs with a slow swing.

They begin by removing the head. Corréard has to turn away. He cannot believe how long it takes, and cannot bear the sound of sawing back and forth. It is a solemn moment and the gravity of it presses on everyone. They carefully wrap the head in cloth, blood seeping through. Adam lays it in the sea, stands watching briefly as it drifts off.

The back-and-forth rhythms of the sea mirror the gently swinging corpse. It's a magnetic spectacle. Adam returns to the task. The two men flank the body and hold it still. Corréard watches Adam take the knife and run it from the neck to the groin, hovering above the surface, practising the route he will take. Pauses, is ready, repeats but this time pushes the knife into the skin, drags it upwards till he reaches the groin. With a tug he pulls the long slit open, tension suddenly giving. He takes a quick step back to avoid the gush of blood. They watch the body bleed out across the raft, staining the timber. He slides the knife beneath the chest, runs it along the ribs. Corréard is surprised by the smoothness of the incision. Adam pulls off a great flank of meat, letting it fold back on itself, cutting at the joins. It is released, heavy, and he bends to lay it across the timber.

As he continues with the rest of the body it becomes a dance between him and those holding it. They spin it round, tilt and shift it so he can reach various sections. They are working in unison, in an unspoken language of where he needs to get to and how. It becomes a job. The meat is cut into stretches, hung out to dry.

The clouds contract the sky, bring it in close to them. A cloaking of rain etches across the slate-blue. It runs heavy, washing the raft clean. Then a miracle occurs. There is a frenzy of action in the water, and suddenly the appearance of a huge school of flying fish, passing like a wave over the boat. A shock of glitter. A staccato patterning of thuds. Hands grasp, but mostly the fish slip out. A huge number are caught between the raft's beams, flapping about in confusion. Each fish is barely the size of a hand. They marvel at their wing-like fins. An empty barrel is found and everyone seizes fish by the handful.

Someone remembers the last of the gunpowder, still dry, stored at the top of the mast. A small fire is made inside a barrel, using linen and bits of dried wood broken from the raft as fuel. Someone else fashions a little grill. Scraps of fat are cut off the flanks of meat and thrown in first, followed by the fish, butter-flied open with a finger. The mixture is divided up into rations. They all eat. Bellies ache with the glut of it.

Géricault sits back in his chair. Picks up a large chunk of bread, holds it for a long while in his bowl, letting it become heavy with broth. He lifts it to his mouth, dripping. The fish seem a marvel, and the telling has lifted Corréard from the despair of recounting the cannibalism. Yet all Géricault can think about is the dissecting of the corpse. He wants to ask for more details. He imagines the pulling-off of the skin as one giant coat. Imagines the tug, the return of the blade, the removing of the last tags of flesh.

The astonishing revelation of a person opened. The muscle, the range of reds, deep crimson, patches of purpling muscle marbled with blue-grey and then the surprising richness of the flesh. He imagines it must be similar to an animal, with a thin, milky membrane, translucent across the chest. He's overwhelmed by the idea, the sheer array of colours, the intensity of life. A thing of wonder, surely. He wants to see it, to be taken there in his mind. He wants Corréard to paint with his words, to miss out nothing. Corréard says that his memory is less of the sight and more about the stench, the most visceral thing. *A cacophony of sensations*, thinks Géricault. He wonders about the textures, but Corréard is clearly nauseous. Géricault resists pushing further, but makes a mental note to investigate. He must find a way to pull back the curtain, to discover the mysteries of flesh. He offers Corréard more broth. Corréard declines, suggests it's time he headed home.

It's easy to see why Géricault was drawn to this scene and would make many drawings of the cannibalism. His work is full of his compulsion towards the macabre. During his time in Rome, he had witnessed and drawn a public beheading. The set of small paintings that emerged from that killing give glimpses into the theatrical public spectacle, and Géricault's fascination with it.

Throngs gathered in the Piazza del Popolo, hungry to witness the execution. In the first drawing we see the condemned man fully clothed, wearing a smart, wide-brimmed hat which frames his frowned concern. He is encircled by three monks, in full robes, their heads covered, small slits for their eyes. The figures are drawn without shading in bold, hastily applied ink outlines, which heighten the terrifyingly austere nature of their appearance. With their bodies and faces hidden and the hoods all sharp, aggressive angles, their identities becomes entirely subsumed within the role, chaperones towards death.

Then there is a gap. Between this drawing and the next we must imagine the action and piece it together from other sources. The monks were members of a confraternity whose job it was to prepare, lead and comfort the victim on his way to the scaffold. He would have been taken into a chapel, stripped down, blindfolded and offered a last chance to give a formal confession or prayer in the quiet, before being led back out to the masses and the long, slow walk to the scaffold. The procession, witnessed by everyone but the doomed man, was a theft of agency, to send him inwards, to force a contemplation of what had been done and of what was to come. The disorientating sound of footsteps in front of him, the clattering hooves of the horse and carriage from behind. The sea of people encircling him and spreading into the distance, the voices gathering as one wave of noise, opening up a sound-shaped path to the scaffold.

The guillotine was invented to make executions more humane and the moment of death fast and efficient. Dr Joseph-Ignace Guillotin had proposed it to replace the prolonged agony of previous methods with something kinder. He had intended it as an act of radical reform, to make the torment instantaneous. Yet the result left him morally conflicted. As the Reign of Terror hit revolutionary France in the years following Géricault's birth, the guillotine would provide the public prosecution services with a weapon that allowed executions to be performed on a scale never seen before. He had mechanised death.

As a small child Géricault attended beheadings in Paris, the throng awash with music and laughter. The *tricoteuses* would have sat front and centre, a small group of avid fans quietly knitting as the guillotine fell. Géricault, like most Parisian children, would probably have owned a miniature toy guillotine, fully operational, ready for beheading vegetables, dolls or small rodents.

Back in Rome, the mode of execution was the axe, but the same false logic – that the efficiency of the device made the ordeal more manageable – applied. An axe, of course, didn't have the same mechanical certainty as the guillotine, and was reliant on the skill and strength of the executioner. Yet even in instances of a clean and complete cut, there was a fallacy that speed reduced the suffering of the victim. All the other aspects of the ordeal denied them relief. There was a tortuously slow build-up. In that long, processional, ritualised walk to the stage the victim was not being presented with a hastened death. The preparation was drawn out. The waiting was the worst agony, in imagining what was to come. And the sadistic cruelty was heightened by its state-sanctioned performance in front of the public. To the blindfolded man, the crowd would have felt like a vicious, baying mass of voices, of unseen eyes. Among them would have been expressions of pity, but looks of compassion were stolen from him.

The monks' role was to offer hope, comfort and the possibility of redemption, and this is suggested in Géricault's next drawing. One monk stands directly behind the condemned man, his left hand placed carefully, almost gently, on his waist, guiding him up to the first step. Behind them another has his hands clasped in prayer, in the hope of a life beyond. The final monk points upwards, signalling that the victim should offer prayers to heaven. Yet the man is blindfolded, and the figure faces outwards, to both the crowd and to us, the forever audience. Is the monk making a final, hopeful plea for salvation? Whatever the case, the image is ambivalent, focused on moments of human complexity rather than the brutal violence to come. That violence is only signified by the executioner in the top left of the image, almost offstage, pushed to the margins. He has his back to us so is faceless, the axe in his right hand leaning on

the ground, ready and waiting. He is drawn in bold, muscular form; his legs, buttocks and arms stretch and sculpt his clothes, suggesting the physicality required for the executioner's task.

The main group of people are drawn with a remarkable efficiency of line, as is the victim, bent over, his left foot finding the first step, his mouth slightly open. Beneath the drawing is an erased first attempt, just about visible, a palimpsest. It suggests both the speed at which Géricault was working and the care and attention he gave to getting it right. He wished to bear witness, to focus on what he saw with a clear-eyed directness, to make a fact of looking.

Then comes another gap in the sequence. The brutality and horror are left to our imagination. Was the man forced to his knees, or did he give himself over to the process? Was the tying of his hands behind his back a clumsy and awkward struggle, or was there a neat efficiency to it all? Then the presentation of the rope hoop for the head to enter through, that final readying for the chopping block. Was it passed into willingly, silently or with an impassioned desire for life? In each execution the victim's response would have varied, of course. Some would have shouted out prayers, confessions or protestations to the crowd, desperate for a last chance to be heard among the noise and chaos, to be given some kind of final agency. When the victim knelt, the same thing tended to happen – the noise dropped away and silence fell. What sudden shift of register, of hopelessness or acceptance, of fear or calmness, would have entered the man's head? More prayers? To himself, to the crowd, to the skies? Surely now there was an internalising and the victim would have felt alone and isolated, aware of being on the brink, the wait over. Down the axe came.

After this Géricault picks up his pen again, records what follows. The final drawing is a preparatory study for a painting

which has since vanished. It marks a shift from straight observation to something he would look to paint. The corpse lies lifeless over the cutting block, his arms still tied behind his back, his knee bent on the edge of the stage. We only see up to his neck; the figure of the executioner, standing in front of him, obscures the site of trauma. For all the horror of their subject matter, this set of drawings do not focus on the gruesome; their concern is human drama. The executioner holds in his outstretched hands the now-decapitated head. He lurches forwards, taking a large stride from the stage into the empty space just in front. Looking left, to the place the crowd would have occupied, he presents the head to them. The forward motion of his body severs the fourth wall of the painting, and we become the crowd. Unlike in the previous drawings, the image seems more purposefully composed, to have moved beyond mere naturalistic observation of facts. As the art historian Wheelock Whitney points out, it nods to Caravaggio's *David with the Head of Goliath* (1607) and to the figure of Charon in Michelangelo's *Last Judgement*, both of which are set in Rome and would have been on Géricault's mind when composing the image. Accordingly, he raises the everyday to something heroic: the executioner is cast in the role of Charon, the ferryman of the damned across the River Styx.

The executioner's eyes are solid blocks of dark-brown ink, making him expressionless, impenetrable, masked. There is no such lifelessness in the severed head. His eyes are circles, covered by a few vertical strokes, a veiled shadow in contrast to those of the executioner. Blindfold now removed, is he possibly looking out at the crowd, at us? Does he have sight after death? In the right-hand margin of the paper is another head, another attempt to get the victim's face right. It's softer, perhaps rubbed out. But there is no mistaking that the eyes are open, the pupils are visible, and that life is there.

This is no trick of the eye. In a contemporary publication, as cited by Wheelock Whitney, an English visitor to Rome describes witnessing the same sort of moment Géricault depicted:

> ... from the expression of the countenance when the executioner holds up the head, I am inclined to believe that sense and consciousness may remain for a few seconds after the head is off. The eyes seem to retain speculation for a moment or two, and there was a look in the ghastly stare with which they glared upon the crowd, which implied the head was aware of its ignominious situation.

In his drawing, Géricault is observing the flickering suggestion of life, as the head *glared upon the crowd*. The head is given its vision back, cannot just see but can also judge. The victim reclaims his gaze from the voyeurism of the crowd. The drawing performs a dramatic about-turn: the crowd is not just seeing but is seen.

Witnesses of executions believed that there was a moment after decapitation when the head still had life and consciousness, when the figure was neither dead nor alive, but in a space between. In the drawing, the victim is held in limbo forever. The purpose of executions was to warn the public of the consequences of breaking the law. Yet Géricault's image gives the victim agency to judge – the process, the state, the executioner, our voyeurism.

At first glance, Géricault's drawing can look gruesome. In his deliberate decision not to focus on the horrific moment of the execution, Géricault points us to something beyond the act, to a consideration of the consequences of violence rather than the brutal act itself. It's an image of mourning, a meditation on those

final, transient moments of life which he captures and holds still on paper. It is this slippery point between life and death that fascinated him in the *Raft* studies. Image after image shows that the overriding noise of Géricault's work is not that of violent screams, but something quieter; not pornography, but poetry.

Much of the commentary at the time, and the literature that has followed, implies that Géricault was seeking subjects to satisfy his obsession with the goriest depravities of human behaviour. Yet the works suggest something else. He was drawn to the horrific, to the capability of humans to commit acts of extreme cruelty. He wanted to shock conservative polite society and hold a mirror to the mannered morality and idealising didactic pomposity of his Neoclassical contemporaries. Yet he was always searching for beauty in horror, looking not only for the worst of humanity but also the best. His paintings and drawings are never voyeuristic. Géricault was a hyena, a scavenger searching out the bloody carcasses of human depravity to feed his imagination. Yet these scraps were always in turn fed back into an imaginative process which fuelled an aesthetic and political sensibility

If these works hint at Géricault's purpose in *The Raft*, another set of studies show Géricault on the hunt for a contemporary scandal to paint. The Fualdès affair gripped the Parisian public in the early months of 1818, appealing to a growing thirst for the gruesome and bloody. Antoine Fualdès, a magistrate, was murdered in the obscenest fashion by a group of far-right terrorists. These extremists were typical of the gangs who roamed the streets of France committing acts of ultra-violence to give oxygen to their political cause. The murder instantly appealed to Géricault, drawn as he was to the repugnant and savage and seeking a subject befitting the type of visual political statement he wanted to make.

Géricault, like everyone else, heard about the story from the front pages of the newspapers, in pamphlets, on the stage in melodramas and from a wide range of illustrative prints made by artists and circulated cheaply. A number of arrests were made. Those who were present at the events and the public hearings that followed revealed the story to a fascinated public. Madame Clarisse Manson, who witnessed the events first-hand, became a temporary celebrity, her accounts filling the front pages; but she was also pathologically driven to embellishment, and day by day her story found new, illogical additions, fed by, and feeding into, the public hunger for ever-increasing sensation. Journalism and the arts sought not truth but melodrama.

Géricault, like the popular-print makers, approaches the story episodically. He uses his drawings to move himself and the viewer through the events. He depicts the assassins gathering round a table to plot, Fualdès being forced into the brothel, the dead body on the table and the murderers fleeing. The most telling are the middle two scenes. Fualdès is surrounded by a series of nude men, each pushing, grappling or dragging him towards the open door. Fualdès plants his feet and arches his back in a desperate, futile attempt to resist the inevitable. It is a scene of struggle and violence that portrays a figure being hauled from life to death. His hand reaches up to the assassin who is dragging him towards the door. The ink has gathered across his face and hand and merges into a dark pool, a puddle of uncertainty and ambiguity. Considering the control Géricault exhibited in his application of ink and line, the mark is unlikely to be accidental.

These images never resulted in a painting, and we cannot be certain why. But it seems Géricault was searching for a political event of violence and horror that approached the metaphysical, an image which would allow him to express his political and artistic philosophy. He couldn't get close enough in the Fualdès

sketches, being held back by the smoke and mirrors of the media.

For Géricault, painting's role was to reveal dark truths. Was no one paying attention to the world they were living in, to the rotten underbelly of France? The depth of violence and immortality and death that spilled out onto the streets, the tragic consequences of war visible in the abandoned soldiers, flooding limbless from hospitals? Were they not tired of war, not ashamed of the stories that made it back from the colonies, of humans as chattel? The Salon, with its slick, shimmering paintings of myth and literature, was full of high-minded distraction.

For all Géricault's anger and dark imagination, his *Raft* painting lacks any of the visceral horror of the worst episodes that took place. There is none of the bloody gore of cannibalism, not even the skeletal visions of hunger. The dramatic lighting turns the scene into theatre, Caravaggio's proto-cinematic Rome altarpieces clearly being a model. Where Caravaggio took grand biblical subjects and set them in the streets of Rome, Géricault takes a real-life event and raises it to biblical proportions in a nod to Baroque and Classical precedents.

Géricault had spent months in the Louvre making copies of Titian's work, expressive surfaces of paint turned into flesh. Surely Géricault would take this as a model and push it further? But instead, the skin of his figures is closer in texture and style to paintings by David and Caravaggio. They are beautiful things, solid, slick and glowing.

Géricault was able to see beyond Corréard's account to find beauty in the horror. He realised that moral judgements were not simple, that the raft's passengers were victims first and foremost. To focus on cannibalism would be to induce disgust, not pity, in the viewer. And it is empathy that Géricault provides in the

figures of the old and the young man – indeed, in all the people on the raft.

The raft is notably stripped of female presence, despite the prominent role given to at least one woman in Corréard's account. In an early study, as the art historian Linda Nochlin points out, a family group occupies the centre of the composition, but the mother has been erased from the final painting.

It's impossible to know for sure the reason for this omission of women and mothers, but it's hard not to consider the role of Alexandrine in Géricault's imaginings. Alexandrine had given birth by the time Géricault conceived of and painted *The Raft*. The pairing of the man in the red shawl and the boy – subverting the *Pietà* model – feels especially significant. In his remixing of the *Pietà*, Géricault replaces a mother with a father. Even if there is no correlation between its inspiration and the picture's gendered singularity, they are both still instances of deep loss and pain. But perhaps I am searching for ghosts, for messages from a subconscious where there are none.

We know little of the circumstances around Alexandrine's pregnancy, except that they were tragic. She had carried her child for nine months. She had felt the effects of her bones softening, separating, her body opening itself up to make room for the growing guest. Felt the first kick, imagined herself into her womb to the beating heart of a life bound to hers. Felt the full miracle of it, mixed with fear and shame, as her belly expanded. Then the birth: the pain, the violence done as a life entered the world. Love took over her body, pushed into places of extreme pain, eased by the release of chemicals to make her forget she had ever felt it. The baby was a small, impossible gift of flesh in her arms, breathing, heart-beating, screaming. Yet an act of unimaginable cruelty would end this brief moment of happiness.

*

The violence in my paintings feels too prominent. After more impatient waiting, the figures have finally dried out and the top layer of flesh has sealed itself off, protecting the still-drying, sticky mass below. I mix up more paint, add in some clay and concrete powder, combine oil-based and water-based paints and mediums. More storms emerge in my buckets. I add Payne's grey, which splits so beautifully; ultramarine blue mixed with burnt umber, each melting into an alchemical blackness; cerulean, a dash of raw sienna to pull through some warmth, viridian to plunge us under. I pour in some rivulets of water and turps, then flick, tip, pour and run channels of paint into them.

The rivers enact destruction, erasure, evolution. I cast a thick passage of nearly white paint over the chest of a figure, shrouding him in mist. A sky-blue tributary of paint cuts across a leg, a wash of water, clearing a passage to reveal the skin beneath, trapping the limbs between layers in a space of uncertainty. Puddles of paint sit on the explosion of flesh, swimming in and out, gathering up and breaking down the still-tacky surface beneath, merging them slowly, the figure dissolving into the riverbed, into abstraction.

As I watch the separate layers start to reunite as one, I think again to some of the fragments Simon had written about Poor Tom. *The rise translates as horrifying muteness, the paroxysmal mouth behind glass, at once the museum exhibit and the creature pushing vainly for the sun.* This was the figure in the paintings, now behind these storms, pushed into the surface, just out of reach.

An electric current runs from my head to my mouth, down through my body. I manically photograph details, text myself fragments of barely readable notes and text Ali to ask if he can come and see the paintings when these surfaces are dry. I stumble out of the studio, where there is barely room to walk around the canvases laid flat on the floor, filling the entire space.

Ali visits the studio again to spend another few hours looking through the paintings. We are standing unusually close, the familiar smell of turps and oil paint filling my nostrils, drifting into the back of my throat. Ali pays intense attention to each shift and change, letting the imagery emerge from the mist of the surfaces. As my eyes scan the movements of his hands, exploring the surfaces below, I feel flushed with a sense of success and already can see the exhibition of work coming together. A collection of large paintings hung on clean white walls.

Then the mood shifts like weather, clouds massing. There is doubt in Ali's hands, a tightening and nervousness developing. We drop into a silence that stretches out and yawns into a chasm. Fear gathers in me, nestled with confusion and dissonance.

Tom, these paintings are mirrors, Ali says, but there is hesitation, a disappointment in his tone that he is trying to mask. *I think they might be mirrors reflecting you as much, or possibly more than, as they do me.* There is detachment in his voice. The muscles beneath my eyes tighten, my teeth clench painfully. I am devastated. Doors flung open in my head slam shut, possibilities vanish. I am at a dead end.

This short, sharp pain happens quickly, but in moments slides away as I assimilate the failure. I am ready to move on, to work out where I have gone wrong, to ask Ali what it is he sees in these works that makes them me, not him. I sweep away the pain and disappointment and am instantly ready to try to repair the wound, to move forwards.

I can feel the pain in the figure, but I don't recognise it. I can't see or feel the hurt. He says he recognises himself in parts, but only in the details. His pain is hidden, obscured, detached. What is presented in front of him feels as if it is an accidental self-portrait. I have painted myself.

The moment he says it I can see it too. I am traced here,

invisible parts of myself are present in the work. But it's worse. These paintings are not just metaphorically connected to me, they look like me. It's absurd not to have seen it before. I've fooled myself that the figure, which bears a physical resemblance to me, is an expression of Ali's experience. The hair is a flurry of fiery yellows. I had convinced myself these colours were a nod to the bomb. But it is a lurid, saturated version of my own hair. I have been blinded by my own pretence. It is laughable how closely the figure resembles me. I have performed an act of accidental but cruel violence, ripping Ali's experience from him and placing it into my likeness and body. Erasing, decontextualising, colonising. Perhaps this unforgivable accident was a result of my own trauma, the nature of my obsessive repetitions, my compulsive desire to circle around the same methods, imagery and ways of seeing. I persuaded myself that the tiniest changes meant profound shifts in meaning, but instead merely set up a narcissistic circle of mirrors facing myself.

I am so sorry, I say.

Ali doesn't seem concerned, more interested. Later, when I drop him off, he says, *Perhaps all your work has been about yourself.* He wants to understand where my compulsion to depict trauma and its effects comes from.

The thought sits with me in the coming days. There is something in my tendency to portray the suffering of others that speaks of my own. Perhaps if I can get to the bottom of this I can find a way forwards. I write to Ali to ask if he wants to look through some older paintings.

We are told that the author is dead. I like the idea that when a painter leaves the last mark, he or she vacates the work. But the artist is always there, ghosting in the surface. I saw this clearly when looking at one of Kippenberger's *Raft of the Medusa*-inspired paintings. It is a large canvas covered in a primary-red

underlay. The red contradicts itself, it is a literal and figurative backdrop that pours forwards, flooding out of the image through the collection of figures.

The composition of figures broadly mimics that of *The Raft*, but with bodies, limbs and heads often outsized. In the central bottom half of the picture two similar heads seem to float forwards, larger than most of the painting's whole bodies, like caricatures of the iconic head from Munch's *The Scream*. The outlines of arms and legs are drawn in thick, hastily applied lines, hollow and transparent, nothing more than outlines, revealing the surface beneath. The paint is smeared on and the flesh is often green, in stark contrast to the red backdrop: two ends of the colour spectrum in glaring, jarring opposition. The raft's mast is depicted by its absence, the negative space around it painted in blue, leaving the red background to become the shape of the mast. The painting has a cartoonish, punkish energy.

It is typical Kippenberger, attacking the notions of good taste in painting, approached with a childish, wilfully abrasive energy. It undercuts our expectations of sophistication; it is a cynical, ironic, humorous take on history. Kippenberger tangles himself in the raft, not with pious homage or reverence but with carefree abandon. It's a deliberately farcical and exaggerated depiction of terror. The noise and register are not the austere Baroque scream of the original, but something more dissonant. In place of Géricault's operatics is a theatre of the absurd, a jarring horror house in which a clown screams.

The sea is depicted with a few lines of splashing white paint. A speech bubble comes bursting out from behind one of the waves. 'Je suis Méduse' is written inside in a thick scrawl. The letter *e* breaks the bubble and is painted in a slightly brighter shade of blue to the rest. It looks like a throwaway comment,

but meaning pivots around it, no longer anchored. It is a direct pun on the original painting and its title – *Le Radeau de la Méduse* – but it takes on a double meaning once we consider where this voice comes from. Who is speaking, unseen, from beneath the surface of the waves? *Méduse* also means jellyfish. Is this a humorous reference to the jellyfish that had surrounded the raft and stung its suicidal captives? Is this the hidden sea creature announcing its existence? It's just the kind of absurd-ist joke Kippenberger spent his career making. Meaning in his work is never stable. And in the context of his wider riffing on self-portraiture, the message – painted in this final year of life – seems to be one of questions about mortality.

Kippenberger played with symbols, breaking them and open-ing them up so they signify multitudes beyond the limits of intention. He leaves room for the viewer to enter and to project fluid meaning into his work. In that depth beneath the wave and in the gaps of the wordplay I spy an immortal jellyfish. I can hear it, disclaiming its presence. 'I am the jellyfish' – and I am, of course, immortal, forever heard and unseen in this painting.

The *Turritopsis dohrnii* is a genetic miracle, the only organism known to scientists capable of biological immortality. It lives in the dark spaces of the ocean, searching out warmer waters. It floats about, glowing in the dark, its translucent, bell-like skin softly opening and closing to move it around pulse by pulse. Through the bell a red, heart-like core shines, and beneath the main form a knot of spiralled tentacles reaches out, each an elec-tric shock of white-blue light. A strange, alien beauty, beyond imagination, and also seemingly beyond possibility.

The jellyfish begin life as collective forms, each genetically identical clones of the other. The collection breaks away from the sea floor, maturing into free-swimming individual crea-tures. Yet if subjected to stress, extreme environmental change

or physical attack, they can revert to their previous state and become multiple again. Trauma turns them into a pre-sexual form, back into the colony of polyps attached in safety to the seabed. Then, ready for resurrection, the cellular structure of the jellyfish transforms. And as a colony, the life cycle starts again, a biological Ship of Theseus. The jellyfish travel beyond death.

Je suis Méduse

Is this not Kippenberger, calling from beyond death? Is he not here, still alive, a ghost behind the surface of the painting, immortalised, constantly reborn in his work, taking on new meaning through its magic? Brought back into the world with each viewing of the canvas. The ultimate last laugh from beyond the grave, half alive in paint. Was the free-flowing jellyfish not exactly how he saw himself, always shifting, always travelling, in his migratory imagination, his roaming work and in his nomadic life? A vagabond and vagrant, calling out to us in the form of a hidden jellyfish.

The next time Ali visits, we look through a stack of old paintings that I have arranged for the viewing. The first one we pull out depicts a two-horse-headed figure, splayed on a white butcher's block in a sparse, dark room. Standing behind and over them is someone wearing a luminous orange prisoner's outfit, staring at us with an enlarged, gold-haloed, cartoonish version of the *Mona Lisa* for a face. The figure is passive but appears to be both the spectator and somehow the perpetrator of the brutality that has been enacted on the screaming beings below. Their bodies have merged into curves and cancellations of flesh-coloured paint. Ali runs his hand across this site of violence and abstraction, notices the sheer weight and mass of flesh, the array of different marks and textures. The smooth, clean finish of the onlooker's face

feels impenetrable to him and beyond touch, which slightly unsettles him. He can't get at it.

The next painting is older. The first thing Ali notices is the roughness to the surface, caused by the thick, mustard-yellow pigment, suspended in a medium that has been sprinkled and rained across, settling in lumps and clumps like a disease-ridden skin of pockmarks pulled across the painting. I describe it. Hundreds of falling figures, arranged in a four-way symmetry, a *Fall of the Rebel Angels* as if patterned into a lurid William Morris wallpaper. Figures arriving into and forming a hellscape. We carefully trace a few of them with the tip of Ali's finger, because there is no way to distinguish them from the rough, thick surface that sits over everything. Translucent to sight, opaque to the sight of touch.

Next, a figure with a huge, triangular head and giant golden horns, mouth wide open to expose piano-key teeth and a bright-pink tongue mid-scream. The head is turned upside down on a cross and hangs to the floor, lifted out of a dark, stark room which looks like it could belong to a computer game. A green and purple fantasy space awaits the other side of an open door. The painting has a slick, crystal-clear glossy varnish, and the surface feels like glass, completely smooth. To Ali, it's like being hidden behind a window he can't open. We are reduced to words.

In the next painting, a man is on his knees in what could be a shipping container or a stage set. A single bare light bulb shines. He is blindfolded, facing out to us, wearing only socks and boxers. We can see him but he cannot see us. He is surrounded by four orange-clad men and a hand hovers just above his head, a knife held in waiting. It is a conflation of various images from the war on terror. Rendition sites, internet beheadings, scenes of torture from Guantanamo Bay, a remixing of the spectacle of violence, recast as the blinding of Gloucester scene from *King*

Lear. Ali doesn't want to touch or look at this so we move on. I wish I hadn't described it to him, suddenly it feels like a crass image. I don't describe the next one, shifting it aside. It is a green sea, as if the whole painting is drowning, and it depicts a waterboarding.

The next, *At Home with the Macbeths*, is a bloodied dreamscape of a painting. Seen from above at the doorway to a bathroom, Macbeth sits on the toilet, red boxers around his ankles, penis pointing into a black hole. Lady Macbeth lies naked, dead or asleep, on the tiled floor. The painting is red-raw in colour, as if soaked in the blood of pasts, futures and worries. Ali finds the surface, with its shifting topography, strangely appealing, sensuous and beautiful, in stark contrast to the horror of the imagery I am describing.

I move on to another painting, huge and made up of two canvases. In the centre is a figure with his arms outstretched, another double horse head, his body split by the join of the canvas. In the distance is a landscape populated with a community of horse heads, each referencing episodes of suffering from across art history. Ali wants to go through each single figure, a painstaking, slow revelation of different modules of narrative. He is confused and interested in this compulsion towards such imagery, this desire to replicate or reimagine historical, literary and global pain, this cyclical tendency towards the apocalyptic. None of my normal answers feel appropriate, so I don't say anything. Words dry up in my mouth. We are nearly ready to finish for the day when I come across a small work, possibly the oldest I have stored in the studio, from about twelve years ago.

The picture is divided into three vertical stripes of equal width. The side stripes are dark-umber columns, and they read like the facades of two solid towers. In the centre is a graduation from a dark, cloud-like space at the top, which bursts into rain

and then pure light. In the middle, a shadowed figure falls. The painting is called *Icarus*, and to the right the shadow of a crow-like form passes horizontally through the architecture, a nod to Ted Hughes's *Crow*, an agent of destruction. As Ali observes, it clearly references the destruction of the Twin Towers and the notorious photograph of the falling man. Ali asks if I had consciously depicted this scene, and I think carefully before realising that the seeds had indeed been sown on that day.

We were glued to the unreality on the TV screen. I am ashamed to say I saw a beauty in the terror, rubbing uncomfortably against shock, confusion, fear and disgust. Yet cognitive dissonance, beauty colliding with horror, was the intention of the event. The violence was symbolic as well as real, a violence in which there was a paradox between the signifer and the signified, between the thing we were seeing and the reality of what it meant. It was a carefully constructed and composed spectacle, gripping us with the tricks of a Hollywood thriller. The plane's horizontal arrival, its penetration into the building. The doubling of both the building and the attack, the shock of its mirroring. The giant burst of orange amassing in the bright-blue sky. The long pause before the seemingly impossible collapse, the descent through verticality of one after the other. The buildings' height was a bar graph on the skyline, the symbol of a system falling in front of our eyes, unfolding in real time across screens globally. The play between these oppositions in a sequence of images cinematic, operatic and designed to be catastrophic cannot be unseen. The loss of life makes such an analysis distasteful, but it was not just life under attack but the symbol of a system. The attackers turned the West's visual iconography back on itself.

The attack coincided with the first day of my art foundation course, and one image affected me so profoundly I turn away

from painting for four years. It was the image of the falling man. As many as 200 people decided to jump from the towers, to take their own life rather than have it taken from them by the fire and smoke. Eyewitness accounts, hundreds of photographs and video footage were recorded of these figures, but one photograph stuck out, taken by Richard Drew.

A man falls headlong through the sky. The backdrop is filled with the straight, repeating lines of the tower from which he has jumped. Unlike so many of the other photographs, here the building's lines are nearly perfectly vertical, reflecting the rectangular shape of the photographic frame. The building becomes a succession of grey strips, from deep-dark to light, running across the picture like an optical abstraction. The corner of the building coincides with the centre of the image, but rather than suggest depth the framing causes the split to flatten, to read as a shift from dark to light from left to right. The man, plummeting down, intersects this shift. His body appears relaxed, the vertical lines of the building and the point of the head accentuating the speed and force of the downward motion, the tragic pull of gravity. The figure's pose has a stillness, an elegance and calmness. There was a lot of moralising about those who jumped, but the leap was surely a chance to have some kind of agency, some last, futile moment of agency and choice. Not a nihilism, but a taking back of control.

The journalist who took the photograph was consumed by a vulture-like desire to find out who the man was. For years he was identified as a Latino pastry chef from Queens. His family were chased and harassed in the quest to identify the man, with no remorse or concern for the distress it was causing them. Eventually this attribution and a number of others were proven to be false, and the man remains unidentified. The cruelly compulsive desire to name him, when grieving families were asking

them not to, shows the journalists' refusal to allow the photo to slip into the space of metaphor, as if that were abhorrent.

In an investigative piece in *Esquire*, Tom Junod concludes: *One of the most famous photographs in human history became an unmarked grave, and the man buried inside its frame – the Falling Man – became the Unknown Soldier in a war whose end we have not yet seen.* Even if the figure's identity were known, the image refuses to be locked down by specificity. It forces a metaphorical reading, a shift into the mythic, which can be read as robbing the man of agency – as a form of violence, a sign being broken, a signifier ripped from its signification.

Perhaps that is what I had been doing all these years. Performing acts of appropriation, lifting the violence out of the external world. Piously claiming engagement with iconography, its politics, its ethics, its reading, but just colonising images of pain for my own purposes, my own unacknowledged narcissism.

I seemed to have been mediating the world through imagery. Suffering was reduced to spectacle, a kind of pornographic excess, stripped and ripped from its human context, devoured emptily. World pain was viewed by opening windows on the Web, images were mediated, divorced, not really known. I had started to fervently consume such images and had become anaesthetised to the human consequences and pain.

Was I similarly bastardising Ali's experience for my own ends, making it into myth; reducing it to a metaphor for the universal, erasing his identity and experience? Was I re-enacting another kind of trauma, selfishly making his experience mere matter for image-making, another resource to churn through with a scavenger's eye?

In painting after painting I had been making images which refracted back mutated versions of the suffering in the world, in history, in literature. In these recent paintings that we had

worked on together I had accidentally and explicitly painted myself for the first time, had recorded the grief and trauma I had buried. I felt embarrassed that in my efforts to capture Ali's unseen experience my ego had emerged.

But Ali saw it differently. He said he felt honoured that he had helped me unlock these things for the first time. He placed his hand on my shoulder, gave it a small squeeze. And in that act of tender kindness I felt myself relax, felt relief, as if a process was starting to take place. *Show me something else.*

I did. Another photograph from my childhood. It is shot across a dinner table, presumably by my father. I am at the other end of the table in front of a large bowl full of red spaghetti hoops, the type of food I would soon stop eating completely.

My life has been run through with a discomfort in my own skin, characterised most obviously by an eating disorder. Aged about three, I became terrified of food. I still am, but I am braver now. From my earliest years, I could only let a few things enter my mouth. Nuts, bread and crackers, all dry and constant. No fruit, no vegetables, no pasta, no rice and no meat. No sauces, nothing mixed or touching on the plate. Chips and cereal were allowed, but under very strict conditions. I remember needing to ensure I knew exactly what the food would feel like in my mouth. I couldn't let anything unknown in.

This photograph was taken just before that dramatic change. There is no sign in it of what is to come. I am shovelling the food in, my arm held high, the spoon tilting the spaghetti into my wide-open mouth, my eyes closed in what reads to me like pure delight. What triggered me suddenly to refuse everything that was good for me, and to remain in that infantile state long into adulthood? I only started eating more in the final years of my dad's life, after I had established a distance and detachment between us. I now think my disorder was a drastic form of

protection. I needed to retreat into my body, to block out the world and its alien textures.

I loved my dad. He was my hero growing up. But even as a child, I understood I had to keep him at arm's length, and food was the way I could do this. Feeding is an intimate experience, a meaningful way in which a parent gives a child love. I didn't want it. I needed to protect the boundaries of my body. I was closing my mouth as a point of sensuous entry. He was unsafe, and to refuse food was to defend myself from something more troubling, a buried horror.

I think this might be the root of the numbness, I tell Ali. *The eating and the numbness might be two manifestations of the same thing.*

The not eating to put a boundary around my body. The numbness to separate my psyche from my body, to escape the home it didn't feel comfortable in. I show Ali this photograph because there is a relationship between our experiences, and the way trauma works its way into or out of the body. For him the bomb and blindness forced him into an internalised world in which the space of the body became a different kind of home. For me the murky trauma around my dad and my body led me to block out the external world, reduce unknown sensations to a minimum. Over the course of thirty years I caused a disassociation from my body, a discomfort in my skin that meant I was literally separating myself from it.

What happened? asks Ali. *With your dad.*

I don't quite know. Whatever it was, it has stayed with me, planted itself in my early rejection of food and now, even after his death, is making me try and climb out of my own skin.

One day Ali tells me that the thing he is most scared of is also the thing he most longs for, to go back home. Because he knows that the Syria he wants to return to has been destroyed, changed, that it can never be the home that it was, that such hopes are

an illusion. It is this detachment, this sense of alienation which drags him back into depression. *How can I survive the fate of doubt after witnessing the destruction of my world?*

Stephen King describes three types of terror. The first two are the more expected blood and gore, the monsters under the bed, the visibly present forms. What of the monsters we never see? Of those, like the old man's gaze from the raft, outside the frame? This is what King describes as the worst form, terror: *when you come home and notice everything you own has been taken away and replaced by an exact substitute . . . you feel something behind you . . . you feel its breath against your ear, but when you turn around, there's nothing there.*

The uncanny mirror space he describes felt true to what had happened in my clay performance. I was the shadow haunting myself, creating my own double. As King also said, *alone, yes, that's the key word, the most awful word in the English tongue. Murder doesn't hold a candle to it and hell is only a poor synonym.*

Perhaps painting was where these invisible versions of self emerged and found form. Perhaps we are always in the work, however much I had always denied it. Perhaps the unseen inner life finds its way into seen form. The very thing I had been trying to do with Ali I had done with myself.

What's the worst you saw? This is what I imagined Géricault asking Corréard. It's what I had been asking Ali. What if I was to ask it of myself? I had ignored a therapist who said they thought I had PTSD, that a response to trauma had switched me off from my past selves.

I wasn't even able to notice the worst things when I saw them. I had shown Ali a photograph I had taken of a cow, cropped in on its eyes, these beautiful, kind moons. I can remember taking the photograph, my lens close to its face, my dad beside me. Ali was distressed at the idea of my dad recklessly letting me be so

near the animal. Then I remembered a story my dad told the small-child version of me, of when he and his sister had tied two cows' tails together, then watched them buck and struggle in agony. As I retold it, I could hear the sadism of a father choosing to tell his son a psychotic tale just as he was marvelling at the kindness in the cow's eyes.

Looking at the stack of canvases and the new paintings alongside them, I realise it is time to let go. I need to confront these selves I had denied were present. I need to rid myself of them. A final severance. I need to commit an act of violence to the work itself.

8

Emergence

I am terrified by this dark thing
That sleeps in me

SYLVIA PLATH

At the centre of *The Raft* lies a darkness. Hidden in the gloomy shadows of the billowing, swirling sail at the base of the mast are two figures, almost lost from sight. They are not afforded the same light or space as the others, being cut off from the bright theatricality and quasi-religious glow of the main cast. These figures live, or cling to life, in the gloaming, a cave-like pocket of space. It is as if they belong to altogether different surroundings, separated from the others in a realm beyond hope, one of pure, anguished despair.

One of the figures is in profile, leaned up against the unseen side of the mast, at the deepest point of the group. It is hard to decipher his appearance or race. A shadow has climbed up across his back, veiling his head, consuming it. Is

this the shadow self? Not just of that now-lost individual, but of the whole raft, the whole of France or Europe, the whole of humanity? A figure left to live in the margins, to carry the burden and weight of the repressed troubles of the raft and humankind.

The second figure sits on the other side of the mast, emerging into view out of the shadow, on close inspection decipherable, a spectre of utter dejection and angst. Both hands grasp the sides of his head, while his eyes and mouth, barely visible, are contorted into a picture of existential worry. He is reminiscent of one of the souls thrown from the boat to damnation in Michelangelo's *Last Judgement*. He stares into nothingness, as if he is contemplating the hellscape the raft has become.

These two figures lie almost alone in this dark heart of the painting, foetal in their loss and despair. There is something else hidden in the windswept shadows and folds, and another face emerges. Two pitch-black horizontal marks counter the diagonal and vertical folds. They read like the large eye and nostril of a face, perhaps more a skull. Once seen it cannot be unseen. The head of the figure in deepest shadow now morphs into this new face, becomes an open, gaping mouth, a wide scream. A head the size of a cluster of bodies, formed by the billowing wind, weather finding human form, cruelly screaming as it pushes the raft towards the waves.

The face is reminiscent of another from Michelangelo's *Last Judgement*. Just below Christ, St Bartholomew holds a life in one hand and his flayed skin in another. It flops down, neither dead or alive, half human, half ghost. At the centre of the drooping flesh coat is a skull-less face, a self-portrait of Michelangelo, unlike any portrait seen before or since. It is a face shattered into near-abstraction, into pure expression. The mouth is a few long, loose, downward drags of paint, the physicality of

Michelangelo's turning wrist remembered in them. The eyes are gouges. It is remarkable that it was made, let alone that it exists in such a rarefied setting. It points forwards, beyond Géricault, to painters like Cecily Brown and De Kooning, its broad marks reaching for feeling ahead of representation. In paint full of pain, Michelangelo situates himself at the heart of his spinning, centrifugal painting, at the symbolic heart of Christianity. His skull eyes belong to depths beyond those seen in the figures of the damned below. He stares out at us, screaming.

Géricault painted the darkest shadows of *The Raft* in bitumen, a seductive, glossy black. But as Julian Barnes points out in *A History of the World in 10½ Chapters*, his inspired novel that centres on *The Raft*, bitumen is *chemically unstable*. It rises up, blooms and spreads across the surface. As it tightens it shrinks and pulls the rest of the paint with it, blossoming and bubbling into pattern, enveloping whole areas of paint, obscuring and erasing passages of the surface, which is lost to a wrinkling, staining disease. One of the most prized paintings, hanging huge in the world's most famous museum, is committing an act of auto-cannibalism. As Barnes says, *The masterpiece, once completed, does not stop: it continues in motion, downhill. Our leading expert on Géricault confirms the painting is 'now in part a ruin'*.

But perhaps it is not a simple descent to deformity, destruction and death. Perhaps the painting is alive. It is a living history, certainly not static, slowly dying. It finds a new voice, reaching beyond intension in these fresh, self-made marks. It is slowly rotting, enveloping itself from within, but should we not listen carefully to the voices and forms it shows us in its slow, drawn-out dying breaths?

I look again and I'm less certain the head I saw is even there. From another angle it seems to disappear. Were these lives

coming from or being placed onto the painting? There are ghosts in the shadows, living in the gaps. We just have to look for them.

Géricault pushes his palm down on the handle of the knife, pivoting the blade through the centre of the red cabbage, slicing it clean into two near-identical halves, a beautiful purple and white maze, layering and flowering outwards from the centre. Split, separated, the fractal patterns of nature are laid open in the little arteries and corridors of the cabbage. He feels longing layered up inside him, pushing at his stomach. A rising, acidic sickness. Thinks of the array of separations. The birth of his son, Georges-Hippolyte, the split from his mother. A family that never could be.

Later, when the cabbage has become part of a warm soup, Géricault, still thinking only of Alexandrine and his child, watches Corréard spoon the purple liquid into his mouth. Watches Corréard's lips part gently. He feels a transposition of desire, the discomfort in his thoughts finding form in a new body.

The studio is a place where sitters come and pose, to be turned into clusters of lines, patches of shadow on paper. The penetrating gaze of the painter, the turning hand, caresses them into shapes and forms, into poses suitable for the final drama. *The Raft*, as Linda Nochlin points out, is underpinned by Géricault's contortions of the male body, his recalibration of the role of gender. *Homosociality – or even homoeroticism – is the conscious as well as the unconscious underpinning of the almost unbearable build-up of visual and psychic tension*. The entire painting is built upon a *carefully orchestrated symphony of masculine desire embodied in the crescendo of muscular urgency*. How does Géricault compose this symphony? How is it played out musically by its orchestra of bodies?

Look first at the bodies. To the debt to Michelangelo in their muscularity and the blending of the erotic and the violent. Look to Caravaggio for the lighting, for the fusion of the sexual with the spiritual in a heady cocktail of the sacred and profane. Everything is in excess: a head lolls back in the limpness of death, mimicking the pose of orgasm; the body succumbs to itself, frenzied. Hands reach out into space. The hips twist, around, upwards, in a series of balletic, thrusting penetrations, the twisted, translucent fabric pulling our eye to the groin, not just covering it but cutting it away, castrating it, shaping it into labia-like folds. The corpse figures are sexualised, slip into nec-rophilia. The fabric thins over the torso, the ribs are pushed up, nipples erect, everything both dead and aroused. Covered and decapitated, the body is a vessel, an object to be fetishised, no longer an individual but a site for the lusty hunger of the gaze. Castration fallacies are everywhere. The shrivelled penis of the young boy's dead body has almost completely vanished. Sex and death intermingle.

Then look at the poses. A man, perhaps dead, or certainly wounded, flops over the body of another, as if risen from fellatio, his head now turning to face into the lifted, curved, pert but-tocks of his pairing. The scene is queered – the body, the poses, the movements of the figures. Even more startling for the time is the racial difference between these two male figures, one black and one white, locked in an embrace that combines violence, suffering, intimacy and eroticism. It is an inter-racial, homoe-rotically charged image. Both consciously and subconsciously, Géricault is subverting the norms. The Davidian codification of gender had underpinned History Painting in France, feeding back into the socio-political structures of the day. Gender was binary and had a clear psychosexual role in the theatrics of paint-ing. There are examples of David subverting his own codings,

notably in his painted study *The Death of Young Bara* (1794). Bara, a child solider, lies naked on the floor, his wounded or dead body unnervingly eroticised, his penis seemingly tucked away and hidden, taking the image into a space of gender fluidity. But this was an exception.

The male was active, heroic, erect, stoic. The female was curved, a passive victim, the object of action. Dramatic roles, psychological and emotional expression, composition and even form were assigned gender. Within the drama of an all-male cast Géricault dissolves the binary and contains the range of gender presumptions within the male body, filling it with contradictions, complexities and ambiguities. It becomes a site of supposedly female energies. In the starved form the hips are shaped not just into muscular solidity but into sensuous lines. The corpses take up dramatic, horizontal positions, they are reclining nudes, dead and unable to be active, unable to return the gaze, objects awaiting the penetrative looking of the viewer.

The greatest focus is on the collective. The movement of these diagonal corpses rises upwards in the twists and pulses of the bodies, accelerating to the climax, erupting in the phallic raised figure at the top of the pyramid, flags waved aloft as ejaculatory flourishes. The painting has a mounting orgiastic energy.

As Nochlin concludes, the absence of women from the raft is, paradoxically, *a relatively positive gesture: an absence that is, in fact, a moving and provocative presence.* While this would be broadly true of the majority of his public output, it is interesting to note the presence of the female body in some of his private works. In Rome, much of Géricault's time and energy had been focused on plans for a large-scale work, *The Race of the Riderless Horses*. Alongside these studies he filled an array of more private sketchbooks, which far more obviously carry the influence of the Sistine Chapel. He produced a huge amount of highly

erotic drawings and prints, using various media, of a wide range of subject matter.

Prior to Rome, the female nude rarely appeared in his work. One page from an early sketchbook shows three views of a nude woman, two from behind and the other just of her bottom half in profile. They are probably studies made from a life model, but there is a tenderness to the observation and to the line of the pen and ink on paper. The central figure, with the weight on her right foot, shifts her hips inwards, forming a set of sensual curves. These female sketches are markedly different to almost everything he would produce in Rome.

In one sketch he made in Rome, a couple are wrapped in a sexual embrace on a bed. The man is kneeling back on his calves, the woman is kneeling upright on him, turned away. In the background, washed into shadow, his left hand pulls at her left ankle, opening her legs. He is hunched up to her, his face turned and buried in her curls of hair. Her right thigh rises vertically and her torso is twisted into a dramatic curve, jutting towards him from her hips through to her breasts, while her arms, neck and head arch back in startling contrast, her head facing directly upwards, neck exposed, eyes closed and mouth open. The man's curved spine leans in, mirroring and following her pose, or perhaps pushing her into it, his arm reaching round to her breasts, as if his whole body will consume her. Their bodies are muscular, sketched in bold, dark lines etched into the page.

The scene is filled with exaggerated lust. The image shows sexual conquest of the female figure, who willingly gives herself over to the male. It communicates unbridled pleasure and release, not pain or resistance. Despite its fierce and brutal energy, it seems fantastical, expressing a longing for such an encounter. Such ambivalence is not present in many of the other studies.

In a chalk and gouache image of a satyr and a nymph, the scene is one of resistance. The goat-legged satyr, drunk on lust, reaches clumsily and aggressively for the nymph, who arches her body away from him, her hand attempting to resist his forceful embrace. It is a scene of sexual abduction, played out in a series of studies. The satyr's horse-body adds a wild energy, matched by the brute force in his action and facial expressions. In each image the naked female figure can be seen squirming, pushing at his hands and face, desperately trying to resist his violent sexual assault.

Scenes of rape are common in art history, and many, like Géricault's, use mythology as a screen behind which to hide and disguise the horror. The private nature of these images and their particular form of violent expression make them more troubling, as if they are the manifestation of fantasies, or at the very least an external outpouring of violent and burning repressed sexual energies.

In Géricault's series of *Leda and the Swan* studies he explores all manner of configurations, as if his hand and the two figures are engaged in a dance across each page. In a more heavily worked and resolved image he settles on something. He uses washes of watercolour over black chalk, the layers building up to create a night-time scene, the blue and brown shadows coating Leda and the swan, only a lunar light picking out the tops of their forms. Night is about to envelop the spectacle in darkness, and the scene is a waking dream. It sits in that time between night and day, between the real and the imagined space of the subconscious dreamworld.

The pose of Leda is lifted almost directly from the Adam of the Sistine Chapel ceiling. But whereas Adam's body is a laid-back compliance, happily awaiting the life force of God's touch, Leda resists. One hand grips the sheets, the other

reaches to throttle the swan's sinuous, phallic neck. The muscular contours of Leda's body mimic Adam's, but in place of idealised athleticism is the muscular expression of desperate struggle. The swan, a transformed Zeus, replaces the finger-point of creation with an open-beaked penetrative sword of destruction. Géricault was following and borrowing from a long line of artists who had depicted this scene, but even with a subject of such violence his depiction has an especially unsettling quality. Its wildness, its bestial nature, suggest reason overtaken by animalistic energies in which uncontrolled lust and violence become one and the same thing. It's a deeply disturbing image.

Géricault's early biographer, Charles Clément, quotes Géricault as saying, *I begin sketching a woman and she becomes a lion*, so perhaps his sketches of Hercules fighting a lion are most revealing. In the Hercules and the Lion drawings we read through a narrative of struggle in an unordered, scattered, comic-book strip. Hercules pushes the lion onto its back, firm against the floor. The lion resists his mounting with his paws. He rips open its jaws and peers inside, as if he wants to enter it. He mounts it again, this time from behind, one thumb in its eye, a phallic bludgeon ready to swing. In image after image he sits atop, overcoming the lion, riding and writhing upon it. The final painting depicts a bestial, lustful force. Here Géricault openly explores the dark, fantastical eroticism that his trip to Rome was supposed to suppress. A controlling, brutal form of sexual longing was bubbling up in him. It had become a festering and toxic mix of emotions.

Géricault's relationship with Alexandrine and his response to her absence wormed its way into the darkest corners of his psyche and exploded in myriad forms into his work. It's impossible not to see their relationship reflected in his Rome drawings;

to read a desire cut through with guilt and shame, to see the poisonous failure of his repressed sexuality.

Yet the repressions seem to run deeper, back to the homo-erotic energies and gendered subversions of *The Raft*. In his lithograph of an execution, the male-on-male violence is suffused with erotic energy. A muscular, naked victim has his hands tied behind his back and a thick rope around his neck. The executioner, legs bent and arms strained, pulls the ropes into a tight knot. The victim's back and neck arch, his mouth hangs open, expressions which could be read as pain or ecstasy. In the letters from Géricault to his close friend Dedreuz-Dorcy there is a hidden queer history, expressions of longing and lust which reach beyond the platonic towards the sexual. At the very least, he was an artist whose work and life both embraced and rejected heteronormative models of masculinity, suggesting a sexuality full of complexities and contradictions.

It is time to confront my own repressions, to be rid of them. It's been possibly a month or two since Ali visited. I have been searching for a way forwards. Ali is due to visit and I am not ready.

The studio has spilled out into the house. The floors and walls of both are covered with layers of drawings, prints and research material. The recent failures have had me attack my work with a manic compulsion. I have been desperately searching for solutions. There are thousands of drawings and prints, exploring new configurations of figures, looking to distort, obscure and abstract the subject further, to get it away from the self and closer to Ali.

The work includes a mutating cast of characters, but they are cartoonish monsters. I am circling in on repeats, on tried and known methods. It's a form of obsessive idiocy and I am hoping

for change through repetition. Each iteration offers a glimmer of evolution, but it's false. I realise that I haven't been making anything new, I've just been creating more of the same. Each rectangular sheet of paper piled on top of another, an uneven grid spreading across the floor and walls, a shouty reminder of failure, the same figures that Ali had seen in the paintings but in new guises. I'm moving backwards, not forwards, spinning myself into a labyrinth. I am searching for a monster to slay. I need to confront it in my work, and let go.

I wake at 5 a.m. on the morning of Ali's next visit, the sky opening up into blue. I start dragging paintings from the studio to the garden, accompanied by a flurry of birdsong. I stack them up, all the recent large paintings and about twenty of the older canvases Ali and I had looked through together. I had expected it to be a furious process, but it is slow and drawn out.

One by one I start stripping the paintings. I push my fingers under the canvas stapled to the frame, find a way in, then pull it bit by bit. I carefully remove the more awkward staples with the point of a knife. The canvas comes off the frame like one huge skin. The surface of the paint cracks, separates at points from the fabric and reveals the layers. The glass-like varnish peels in places. The backs of the canvas have their own beauty and history. Stains are soaked though them, memories of processes buried in the surface. Once all the canvases are stripped off I get to work on the frames, breaking them apart into long, individual strips of timber. I stack them neatly up. A few of them are harder to separate, so I take an axe to them and attack the joins.

I gather most of the drawings into boxes. Scrunch one sheet at a time into a tight ball. Others I fold and tie into a compressed knot. Chuck them in a stacked cluster into a rusted metal cylinder. Everything is now arranged. The canvases, the piles of timber and the paper. I head off to pick up Ali.

Ali now knows the route from the front of the house well. I don't need to say how many steps there are till we reach a door. He has mapped the house. I talk him through the piles of paintings, explain to him what I am planning to do. At first he seems shocked, then concerned. He must notice the calm in my voice, though, my clarity about the decision, however extreme it might see. Something needs unblocking. The occasion is solemn, a ritual rather than a feverish thing. There is a funereal feel. This will be the closure I had thought would come so easily at my dad's funeral. Here we are, years later, laying some ghosts to rest.

I pile armfuls of the timber into the metal cylinder. I fold a couple of the large sheets of canvas and stuff them in around the wood. Pour on some turps and then light it from the holes I have drilled into the bottom. The fire gathers and then catches the turps and spreads up in a wave. Soon the canvas and paint are alight, billowing out darker swirls of smoke. The timber follows, and the fire now has its own internal momentum.

Ali takes a few steps back as the wind is occasionally wiping the flames sideways and the heat can be felt a few metres away. I position him downwind so that he is not caught in the clouds of smoke. I use one length of wood from a frame to prod the fire and make room for more material. I'm dripping with sweat from the heat and the smoke catches in my throat, making my eyes water. I should be wearing a mask, I think. It's only mid-afternoon but I pour us both a large whisky, feel a need to mark the occasion, to make a ceremony of it. While we wait for the fire to die down so that I can add more paintings we stand back, silently taking it all in. The dance of the flames, the spit and crack of paint, the smell spreading across the garden, filling our nostrils and throats, sitting on our tongues.

The silence is broken by Ali. *What you are doing is very brave.*

I wish I could do what you are doing, let go of parts of myself from the past. He explains that he feels there are versions of himself left in Syria, still haunting the world. I wonder if the painting we are working towards needs not just to capture his unseen interior life and pasts, but also give him a way of processing and letting go of the trauma, of the lives and selves he has lived with for decades, the ghosts he hasn't been able to banish.

I don't remember the words I said, or how much sense they made, but I know what I tried to convey to Ali that day, however clumsily. I wanted him to know how grateful I was that, although our quest to this point had taken a wrong turn, he had helped me find a way through the trauma of my own past and shown me things I hadn't seen. I was sorry we had failed in our first attempts; I was taking a necessary step in burning the paintings. As I tried to express my thoughts I felt an absolute clarity, as if I could see clearly. A light was shining on the dark. I hoped I was now ready to do for Ali what he had done for me.

I put my hand on his shoulder, and it feels like we are ready to step out into the darkness again. The birds call out in distress, alarmed by the smoke, encroaching on their homes. A neighbour comes over to check everything is OK. I apologise for the smoke, offer an explanation and a bottle of wine. Everything is OK for the first time in years.

We sit around the fire through the gloaming and into darkness. As the chill sets in we are grateful for its warmth. We work our way through the whisky. Every half-hour or so the fire clears some space, and I add in more broken paintings. The piles decrease, now only visible by the flickering glow of the fire, an illuminated carpet across the garden. The destruction is much slower than I imagined. Each time I submit a new piece to the fire I describe it to Ali, offer up some anecdotes about its history and making. As the evening slides in we settle into a sharing of

stories, sparking an accidental game of association. Storytime around the fire.

Loosened by the whisky, I ask Ali what it was he was referring to when he said he wished he could let go of things from his past. He says there are versions of himself in Syria. A version before the bomb. Other versions in Oxford from when he was first studying. He meets them occasionally, in the smells of a favourite pub or the taste of a favourite whisky. He is fragmented, scattered, broken. We talk about childhood, ghosts and monsters. Ali tells me about growing up in Syria, a few hours north of Damascus, near the dam that his father worked on. It's mainly a childhood full of play with brothers and sisters, along the banks of the Euphrates. The blue of the river has imprinted itself on Ali, and his memory is coloured by its water. But there is one flash, a scar of red, that disturbs his youth.

Ali was about twelve, possibly thirteen. Until then his childhood had been peaceful. One day he saw photographs in the newspaper of the Sabra and Shatila massacre, when Palestinian and Lebanese Shiite Muslims were massacred by right-wing Christian militia. The violence in the outside world burned itself into his consciousness and suddenly filled his childhood with fear. He could still conjure the pictures easily. Numbers of the dead varied wildly, from 500 to 4,000, but regardless of the final tally it was genocide over days of carnage. The perpetrators had been allies of the Israeli Defence Forces, who had control of the area and who at best turned a blind eye to the slaughter and at worst, as many suspected, supported it.

As Ali describes the images, I google them on my iPhone and bring up a series of disturbing jpegs, illuminated windows onto an atrocity from the palm-sized screen, my thumb scrolling through in repeat cycles. I've looked at a lot of disturbing images

of war as research for my work, but seeing these with Ali's child eyes sent a cold bolt through the back of my neck.

Most of the images are in black and white and are of low quality, either grainy, slightly blurred snapshots from the time or poorly digitised versions. Bodies and buildings are broken down, pixilated, the horror is semi-obscured. But a few are in colour, sharper, pressing the detail and reality of suffering up against and beyond the screen. In one the side of a building can be seen, its cream facade scarred, scrawled with graffiti, paint flaking off the surface. Damaged, scratched and bruised. To the right is an opening onto a floor of rubble; to the left the wall stretches into the distance and a doorway can be seen, a black, rectangular entrance. At the base of the wall, on the street, is a pile of at least ten bodies.

Photo after photo shows similar scenes. Perhaps the most unnerving eerily recalls footage from the days after concentration camps were liberated. Bodies are piled up to the point where one figure conjoins with another, limbs merging into a cumulative mass of death. There is something in the general chaos and the pyramidal structure of the bodies that mirrors Géricault's raft. I snap out of the image, back to Ali's voice and his words, unnerved by the echo.

Ali asks if I knew of the massacre. I had heard of it but had never seen these photographs before. Ali says they didn't so much disturb him as make him aware of the violence in the world, of the unstable foundations of the region he called home, and of the danger that lurked in a space he had previously known as safe and calm. I can't help feeling that he is holding something back, or that he is in denial about how distressing these images must have been for him at a very young age. But he resists any such suggestion. He becomes colder and more detached, and a distance suddenly appears between us.

He asks what I had heard about the massacre, and I tell him that I only knew of it through a huge painting by Dia al-Azzawi in the Tate Modern, *Sabra and Shatila Massacre*, which was finished in 1983, the year I was born. Al-Azzawi is an Iraqi artist and made the work from his home in London, having read Jean Genet's first-hand account of the massacre. *A photograph doesn't show the flies nor the thick white smell of death. Neither does it show how you must jump over the bodies as you walk along from one corpse to the next ... A barbaric party had taken place there.* Al-Azzawi's picture captures something beyond photography. It is an act of radical empathy and imagination which depicts the horror Genet's words so eloquently describe. The work is made of six panels, drawn in ballpoint and pencil directly onto paper, which was later mounted and fixed to canvas to secure it. It's a remarkable image which mixes the calligraphic language that Al-Azzawi had developed to form a uniquely Arab visual identity with newspaper reportage, prints and cartoons. The picture has a childlike energy and form; being drawn in pen, it tries to translate the world in a way a child would. This style, juxtaposed with the bodies and bombs piled up over the picture plane, makes the picture all the more arresting. Thinking of it now with Ali, it seems pertinent. Horror in the eyes of a child.

It's a suffocating work. There is no room or space. Everything is pushed up against us, confronting us. Our eyes have no chance to rest in a centre of gravity. Cascade after cascade of bodies are bombed out and bent out of shape. The monochrome image is only occasionally interrupted by violent splashes of red, a caricature of blood. The picture is an explosion, a violation of sight. People often compare it to Picasso's *Guernica*, but it is Picasso's later *The Charnel House* that resonates with me. Painted towards the end of the Second World War, it depicts a domestic interior, a family of bodies huddled under a table, full of fear. Al-Azzawi's

picture feels similarly claustrophobic, but in contrast is spread out across a city of figures, capturing a scene after the violence has occurred. A wounded populace is crammed into the picture.

As I describe the picture to Ali I think back to Géricault and his desire to condense the experience of being trapped on the raft into a single image, and how he succeeds in his aim. Could I stop making illustrations of specific, sequential episodes and instead try to capture everything in one work, in the way that Ali has to carry his trauma with him at once and always? A single space that could house all Ali's feelings, give them form and a way for him to move beyond them?

I pour the last of the whisky and Ali takes a long drag from his e-cigarette. I stoke the fire with more paintings, can remember applying the oppressive red background to this one in Cambridge. Towards the end of the pile, I reach the box of drawings I did as a child with my father, and ring binders full of small drawings and paintings he made in the last years of his life. I tell Ali how, after he died, I covered a number of his paintings in storms of paint and then half buried them, or perhaps planted was a better word, in the borders of the Botanical Gardens in Oxford as part of an exhibition. Now I was going to burn all of them. Ali asks if I might go through them with him first.

As a child, I would spend long days drawing and painting with my dad. We would conjure up wild and mythical beasts, islands populated by our creations. A whale-like creature with teeth the size of houses. A bug-eye-striped one covered in horns and wonky features. Wild things, monsters, a bizarre bestiary of beings. My favourite book growing up, perhaps still my favourite, is Maurice Sendak's *Where the Wild Things Are*. I cannot read it now without being reduced almost instantly to tears. In my drawings I was looking to travel to similar islands. *I think I've been escaping the same thing my whole life.*

I talk Ali through a few schoolbooks of drawings and stories from when I was about seven. Most of them are joyful little annotated images of domestic bliss. Three simple figures jumping in a field, with the description scrawled below, 'I played with my sisters and it was nice.' A single figure seen from above, surrounded by a scattering of small coloured circles. 'I played marbles and it was nice.' A Christmas tree surrounded by boxes and a dog. 'We decorated the Christmas tree, it was nice.' Then a few are stranger, missing the repetitive addition of 'it was nice'. A drawing of a large, towering, bespectacled figure waving a hand to the air, 'My daddy is a witch.' Another tall figure and a strange half-animal, half-human next to him. 'My daddy and the monster.' A tree split in two and a zigzag of yellow through it. 'My daddy made the lightening break the tree.' A small boy in a bed, loops of blue all around. 'The sea in my bedroom.'

Why did you draw your dad as a witch, Ali asks, holding the small drawing in his hand, trying to discern any textural clue in the smooth paper, the drawing and writing beyond touch.

Because he was one. I catch myself, chuckle. *Or at least he believed he was, and when I was little, I believed anything he told me.*

My dad genuinely appeared magical to me. I believed his stories of being able to bring things back to life, to control nature, conjure storms and oceans and move lightning at will. He practised necromancy, would talk to ghosts, point them out in rooms and woods. He hexed other drivers, the wave of his hand causing a future fatal crash. I was in awe and terror of his secret magic, caught under the spell of his fantastical, sociopathic, crippling form of love.

I don't think you should get rid of these, Ali says, *it feels reckless.*

Perhaps the same is true of my dad's work, and my reckless desire to exorcise him. I talk Ali through the folders of drawings. My dad had made art throughout his life, but the small drawings

and paintings he did in the final years of his life were different. They feel like private spells, fantastical dreamscapes. I am also struck by how similar they are to the drawings we did together. Fluid, fine pen drawings with bright, solid gouache and acrylic colouring. Small, idyllic islands covered in exotic, brightly coloured and otherworldly flowers and plants, surrounded by bright-blue seas. A small boy playing football, then flying a kite on a solid-yellow background.

Others are more esoteric, combining occult and religious symbols with sexualised and violent imagery. Two figures conjoined, spun into a pattern where only their heads, hands and oversized acid-pink genitals survive. A female figure, legs splayed, penetrated by a crucifix. The entire body wrapped and trapped by the same Star of David my dad always wore. He gave me a silver one when I was nine and I wore it all the time, convinced it was a form of protection. He insisted on being buried with his gold one placed on his chest. The imagery of these drawings is a confused blend, the idiosyncratic and nightmarish sitting alongside the cute and playful. It is the work of an outsider. They were drawn carefully, with attention. Multiple photocopies had been made of each drawing, letting him experiment with different colourings and combinations. In their maddening eroticism and occult symbology, the teeming worlds of Henry Darger come to mind. A perverse Boschian nightmare, they are symptomatic of a disturbed mind. These drawings are his spells, windows into perversions and mutated views of the world.

I always thought my dad's belief in himself as a witch was a perfect symbol of his narcissism, of his delusional detachment from reality. But I have started to believe in magic again. The fire is reflected in the windowpanes of the double doors to the studio. It has turned them into a flickering, temporary painting. I wish I could lift them off their hinges and hang them as a

diptych, the fire held in the panes of framed glass. They remind me of works Jean-Michel Basquiat made of a pair of wooden doors. Two doors as entrances into rooms beyond. Lifted and hung; no longer functional. Access denied, unreachable, perhaps not in existence any more.

Painted on the left door, a black figure looks out, flat, fragmented, circumscribed by a sharp line, scratched back into the surface, his bottom half missing bar the bones of his right leg. Broken, absent, flattened, a shadow self. On the right door there is some text, hidden among and partially obscured by a cluster of marks and symbols. It reads *To Repel Ghosts*, a recurring phrase throughout Basquiat's career. Like so many of his signs and symbols, the phrase is repeated, remixed. He creates a new lexicon from recycling and sampling, his creative process being related to the musical innovations populating New York bloc parties in the 1980s.

Basquiat's paintings have a feeling of alchemy, of bringing things magically into being, of conjuring up life as a mode to stave off death. The eyes in his skull paintings are alive and stare out, fizzing with movement. He pauses time, explores and finds safe passage through the underworld of the subconscious. Painting as shamanism, to repel ghosts. But what are these phantoms? The trauma of childhood, of alienation from the world? They are elusive, both internal ghosts of self and the external ghosts of the world. Painting keeps at bay the chaos of existence, the loneliness, the racism, the violence of life, the oddness of living in a body. He paints a world in crisis, and his paintings are both songs of despair and forms of protection.

Perhaps this fire is my spell.

I have always thought of myself as enjoying solitude, and the isolation of the studio as a refuge. Before I met Kiran I would spend days in the studio, sleeping there, barely eating. But I no

longer feel alone. The intense, hermit-like obsessions were a form of self-harm, a cutting-off into an enforced loneliness. To Ali, my dad and I were three forms of horror seen through the eyes of a child. The images Ali saw at a young age. My father as a figure of fear and horror, his drawings revealing him as a small, confused, perverted child trapped in an adult's body.

In burning my work, I was getting rid of so much more. After dropping off Ali I came home and sat by the pile of smouldering paintings, dousing it with more water. It hissed, birthed a blooming cloud of thick, white smoke which rose slowly and swirled around me. A casting-out of ghosts.

I'm forced to confront my past in this smouldering pile. There is a creep of feeling in my throat first, then my chest. A pulsing, a pulling downwards and inwards. It is a feeling I regularly have, but normally one that gets ignored. Before I can locate it, my brain starts spinning, one thought after another, each breeding more, reaching, grabbing, spiralling outwards. A knotted cloud, as if wrapped in barbed wire, builds till it surrounds me and suffocates the feeling, now lost inside a swarm of anxiety.

Today, with the paintings gone, I stay with the feeling. It pulses and drags. A knot in my stomach pulls me down. I feel a tightening into my body, like a long chord trying to drag me under. The feeling scares me, this pile of embers now scares me. Here is the darkness, here is pure feeling.

I collapse onto all fours like a hurt animal. Silence, then I crumple into tears. I want to reach inside myself and pull out whatever is inside. To cut it out and chuck it into the fire. Then it is as if he is there, standing over me. I expect to experience a deep, violent anger, as if the feeling buried in the darkness would be a scream of fury. But in this black hole it drops away, scattering into ash. I exhale. A flood of melancholy washes over me. My face is swollen with tears. *I loved you.* And that's where

the pain is, not in hatred or anger, but in the scale of love and trust betrayed, which makes the damage so much worse.

Then a magic trick occurs. Something unstitches within me. I feel a letting-go, an exorcism. The deep well of sadness gushes out and becomes the rising steam of the fire's last gasps. I feel lighter, a great weight lifted. Unburdened of the past held in my paintings, I am ready to move forwards.

9

Hope

No light, but rather darkness visible

JOHN MILTON

Hope is a smudged ship on the horizon.

The Raft is dominated by the raft and its cast, which stretch to the full width and height of the painting. The action is squeezed so far into the foreground as to be almost pushed against the frame. The angle of viewing means the raft is tilted up, creating a vertiginous sense that the whole scene might collapse. Both the sharp triangulation of the raft and the diagonally placed corpse dramatically cross the threshold of the bottom of the frame. The safety of the divide between viewer and painting is threatened. The contents of the painting spill over, in the same way that we fall into the painting, lost in the chasm of the non-space between painting and viewer. The drama is a claustrophobia gathering in

the foreground of the painting, in the frenetic heap on that submerged stage.

For all the foreground action, there is also deep space. To the left of the raft the waves pile up in a wall, blocking sight in, compressing space, forcing us to remain in the threat of the foreground. But to the right, beyond the raised figures, there is an opening. Everything drags the eye to this vanishing point. A small gap separates the top of the raft and the horizon, registering miles. At the horizon the dark green-grey of the sea meets the gloaming light of the sky. Or is it a sunrise? Is hope slipping into the darkness of light, or is the day unfolding, bringing with it life and hope? The golden glow of this last or first light sings all the more brightly against the mounting darkness of clouds gathered above, which weigh down and threaten to consume all our attention. What do we find where the sea meets the sky, where the horizon and the painting's vanishing point pull us to a place of disappearance? A smudge ship, a ghostly thing, shrunk by distance, half erased in paint, vanishing into the buttery light. Around it pivots the human tragedy of the painting. For here lies hope. The dream of survival, of life, of a future, lying in a small smear.

Glide your eye into the painting, onto the raft, up to the back and its outward-looking figures. Then skim across the surface of the sea like a flat stone, or dive in through the rough waves to the deep distance, to that ship. Climb on board. Now turn round. What do you see? The wide expanse of the sea again. The other side of the sky, already dropped into the blackness of night, or yet to wake from the darkness of dawn. The sun is the other side of you now, and everything in that distance is in darkness, is almost beyond sight. Look carefully. Is there any life in that blackness, or is it all lost? Is that the raft, is that a cluster of figures waving scraps of fabric in our direction? Are those

faces you can see, full of hope and fear? They are calling to us. And beyond that tiny little raft in the deepest distance you see a figure, a reflection looking in. Is that you? Or me?

Corréard's stories have got shorter, reduced to something closer to reportage, as if he is exhausted by the effort of sharing details. Two episodes sit side by side today, one of further horror and one of unexpected hope.

Géricault wants to carry some of Corréard's burden, wants the painting to relieve the pressure on Corréard's desire to make the scandal public. He shows Corréard the huge canvas he has had assembled in the studio by Jamar; measuring almost seven by five metres, it takes up an entire wall. Hopes he will recognise an ambition in the frame, to give the story scale and purpose.

Corréard describes how, after the first cannibalism, more bodies are butchered. More grim decisions are taken. Two soldiers are caught drinking from the last supplies of wine. Justice has to be served. They are chucked overboard. A count is taken and there are just twenty-seven passengers left of the original 150. The wine is running out fast. Someone points out that at least ten of the survivors are close to death, have lost their minds, are severely wounded and barely hanging on. The decision is taken to end their suffering, but also to ensure that the remaining supplies can be stretched further. They convince themselves it is for the greater good, that there is a kindness and pragmatism in the cruelty. The husband and wife are among the condemned. They plead to be spared, say they are barely scratched. A woman who has given twenty years of her life to healing the war-wounded faces death at the hands of her fellow countrymen. They are rolled into the sea.

Suddenly there is some hope in the dark. The horizon had felt like a distant lie; land a thing from the past, not a possible

future. A white butterfly lands on the raft. All the survivors turn their attention to it. One man moves slowly, hands open, to catch it and hold the hope. The raft inhales as he cradles it between his palms. Then off it flutters as if it had been a dream. The butterfly and the sky-bound appearance of a seagull make them sure they must be near the coast. As night settles in they pray for a storm in the hope that it might drag the carcass of the raft towards the shore.

Corréard tells Géricault that hope was the hardest thing. It hid in the smallest spaces, haunting and torturing them. There was a freedom in despair, in accepting the inevitability of death. Despair had a certainty. Death was a route out of the horror, a choice when all others had been stolen from them. Hope promised things which seemed impossible, and each time it appeared it would slip away. It was a trickster, tying them into knots. Hope lifted them up from the depths of the sea then plunged them back down. Then they spotted the ship.

There were only fifteen of them left. They had gradually started to deconstruct the raft, to shrink their home. Had begun to build it up higher, to keep themselves above the water. They saw death in each other's eyes, in their deepening sockets, shrunken flesh and skull-like heads. They were covered in salt-filled ulcers, infected green wounds. Their skin was deep red and dry, pustuled from burning. They were more corpses than anything else. They slid into another night's sleep, hoping they might slip into death.

They woke to a bright dawn. The sky swung up into a flat blue and spread its reflection across the sea. At first they were not sure whether the ship was a mirage, but it seemed to grow, to be getting closer. The raft burst into life. Barrels were piled up onto boxes, leaned up against the mast. In panic they built upwards as quick as they could. Strips of fabric were tied

together and a pyramid of men hoisted to the highest point. They shouted, screamed and waved, sending all their energy across the sea towards the boat. It was coming for them. It was getting closer. They had been spotted. They would be saved. Then the boat vanished. Hope plummeted off the edge of the horizon, fell off the edge of the world. The line between sea and sky was empty again. They were alone in a water-filled world. A flesh-and-blood-covered dot in a never-ending blue.

Corréard was ready to give himself over to death. The raft was mute. Each of them was alone, in silent solitude. Bodies were giving up, death would arrive soon. Soon there would be silence, stillness and order.

Géricault is troubled by that word, hope. He recognises what Corréard described, the pain of hope and possibility. Even though he knows it is an impossibility, he sees a future that he longs for. Him, Alexandrine and Georges-Hippolyte, together. Riding through the forest. Walking by the sea. Holding them in his arms. A future where the deep ache is gone and the hole inside him is filled.

In reality his dreams are moving further away and close to vanishing. After extensive research Jonathan Miles, in his *The Wreck of the Medusa: The Most Famous Sea Disaster of the Nineteenth Century* (2008), seems to have got closest to the mystery that the family tried to erase. Georges-Hippolyte was deemed to be the legal possession of Alexandrine's husband, despite his clear knowledge that Géricault was the father, a cruel aspect of the French legal system at the time. The child was declared anonymous, orphaned with both parents alive, and moved into care.

It is clearly Géricault who named him, with Georges a nod to his father and Hippolyte Greek for 'I release the horses'. A son

flung out into the world, untethered. Alexandrine's feelings, presumably a crippling mix of grief and guilt, are undocumented. As Géricault prepared to fill a canvas with intense emotions which would endure over time, those of Alexandrine were quietly but forcibly silenced and lost. Histories are written as much by erasure as by anything else.

Hope is held in paint. Hope is clinging to flesh. The figures are sculpted in light. They are filled with the drama and theatrics of Caravaggio, whose altarpieces in Rome made a powerful impression on Géricault. He uses the lighting of those religious scenes in the godless world of the raft. There is no naturalism here, and the bodies are closer to classical sculptures than to the husks of degraded flesh holding on to life that Corréard described. Their athleticism is exaggerated by the lighting, elevating them to something biblical in form, if not subject matter. They are unreal, otherworldly.

The figures are painted from the inside out. First drawn up at pace, then filled in, shadows of paint poured into their outlines. Flesh is built up, a play of oppositions pulled into each other on the palette and then directly on the canvas, where a greener passage of paint sings in harmony or dissonance with one of redder skin. Flesh is an optical dance of colours in vibration, built up musically. The precision of the figures slowly emerges, layer by layer.

Light comes from within each figure. Flat passages of shadow sit next to subtly undulating areas of white paint. Thin, translucent glazes and tints are slowly built on top, like sheets of liquid glass. When dry, light doesn't just hit the painted surface, it pierces these layers. It finds its way to the bottom, sinks into the black and is consumed by its hungry depths. Then the undulating, thin layers of white reflect and refract the light, and

on its way back those glazes create further refractions, before the light escapes back from the surface to us. Light is literally emanating from within the surface, projected by the paint. The dead matter is alive.

The impact is profound. The figures are no longer restricted by the material bounds of their being. The corporeal essence of flesh is imbued with an ethereal spirit. Géricault enables a quasi-religious mutation in a secular setting. This is painting as alchemy, mud turned to light. Are these figures the damned or the saved? Reaching upwards to the heavens, or about to fall into oblivion? They are both.

The light in the sky has a different quality. The figures on the raft were modelled in the studio, carefully illuminated. The sky is a mediation of Géricault's engagements with sunsets and sunrises out at sea, on trips Géricault had taken to Le Havre to observe the behaviour of light. The sky is consciously different from the figures in tone, direction and colour, as if belonging to another time and space. It is pure exterior. The contrast between sky and raft gives a heightened sense of the isolation of the figures. They occupy one state, and the horizon another. The raft is hell, the horizon a version of heaven.

As Géricault worked on the final painting, the ship on the horizon gradually shrank in size and was moved further into the distance, pushed to its visible limit, almost to non-existence, the very state of doubt that Corréard had described. The sky slowly closed in around it. Géricault also effected another reduction. He had originally surrounded the figures on the raft with props and additions, items of clothing, objects, identifiers of their history and being. As he neared completion, he obscured these carefully painted symbols and signifiers of narrative. He worked thick, glossy bitumen and glazes of shadow over whole areas, dropping the details into darkness. The raft is elevated beyond

the specificity of the moment. It drifts into new waters, from the specific to the metaphysical.

I barely sleep again. I am worrying about the fire pit and whether it might catch light and spread. Each time I get up to check, our cat Luna joins me, confused by my nocturnal activity in the drizzle. The grass is wet beneath my bare feet, and, too anxious to waste time getting dressed, I feel the oddness of being naked outside. There is still heat, but no sign of danger. Perhaps I am not checking that the fire has reanimated, but that it was not a dream. I figure it's best to be safe, so I drag out the hose and spend a few minutes unknotting it before soaking the smouldering pile. Water puddles around me and the grass turns to mud, covering my feet and ankles in an ashy mess.

Sleep finally hits in the early hours as the sun works its way upwards. I don't wake till late morning, my body clock jumbled. I struggle to drag myself out of bed, feeling bone-tired, and go down to the garden to inspect the remnants. Everything is soaked, and I pour the contents of the cylinder onto the lawn to drain some of the water. The grass below is burnt by the heat. The pile of ash-filled material is cold, wet and claggy. I sift through it, pulling scraps out, finding some chunks of timber, pitch-black and covered with thick, cracked lines like a dried-out riverbed. Bits of frame have melded together to form lumpy, irregular crosses. There are grey, rock-like forms, condensed amalgamations of paint, canvas and wood, reduced to ashen geology. They are fragile to touch, breaking between my fingers into sprinklings of ash.

Elsewhere are pieces of fabric. Some are solid black, smoke and ash covering what were once paintings with a solid, impenetrable dirt. Others are lace-thin, the fire having stripped them bare of paint and thinned out the canvas to a translucent sheet

of material, punctuated with tiny, delicate holes. I hold a piece up to the light, and it seems to dissolve from sight into a net curtain of a thing. Some have retained paint and details of the image that had been there: little, isolated, misshapen pieces from a mosaic which I can still rebuild in my mind. I hold one in my hand, the remnant of what was once a face, only yesterday a single character in a painting containing many. A small, surviving piece, a last breath. Most of the face has gone, but the mouth and the suggestion of a nose are still there.

I run my finger over the paint, which is still smooth but only just clinging to the canvas. It is dirty with smoke, which seems to have got inside the paint and melted it into a polished, jewel-like surface. I lick my thumb and rub, pull some of the dark coating off, and discover the brightness and colour that had been there.

I decide I will keep all of these pieces, and I sift my way through the pile to sort it into types, even boxing up the flakes of ash and charcoal. Ideas which have yet to find expression start to bubble. There is the seed of something here in the fragments.

At the very least, the destruction has clarified for me the truth that trauma is a form of damage. The etymology of the word trauma is fairly simple; it has no extravagant roots or evolutions. It comes from the Greek, literally meaning wound. In medical usage it still means this, and in psychological terms it is useful to think of trauma as infliction of damage, of the mind, the memory and the self. It can shatter us into many parts. It is the experience that Ali spoke of when confronted with the bomb, blindness and the violent displacements of war and migration. Each of these episodes of trauma broke him into new selves, each a site of damage and loss. In a different, smaller way, trauma is the outcome of my relationship with my dad. I had been reaching for memories I could no longer access, for parts of myself that were no longer there, focusing on the dark gaps and

spaces I couldn't inhabit rather than those I could. I had been trying to rebuild a jigsaw from shards.

I hold the fragment of a face in my hand again. It shifts and changes, lacking the certainty and limits of its previous form. It opens itself to interpretation, its frayed edges offering a world of possibilities. It is a cousin of the howling face I thought I'd seen in the folds of the raft's billowing mast. The mouth is a snarl and the contortions belong to some kind of monstrous creature. I'd been painting monsters for years. Yet the scariest monsters lay in the shadows. In the imagination the monstrous goes beyond the limits of the known. That is why the dark corners of my past had felt so overwhelming, why Ali's suffering felt beyond measure. If I was to create something true of his experience, or of trauma more generally, it had to capture the gaps of the unknown rather than put the fragments back into a whole. It needed to be a mosaic of split selves, the cracks laid bare.

The next day I feel flushed full of hope, cleansed by the fire and ready to go again. Ali and I are in the studio and I am showing him the little stage I have constructed, surrounded by a set of props to play and improvise with. I want us to spend today turning me into characters and scenes from his inner world, to make flesh the multiple Alis scattered inside him. *We need to be more like children*, I suggest. Recently, my sister had brought some of my nieces and nephews round for a day of painting. There was a joyous abandon in the way they used paint. Like them, we needed to strip away austere premeditations. I show Ali a mixture of stuff saved from the fire and other detritus from the studio. Piles of ash, scraps of charred wooden frames, burnt, paint-covered fabric, chicken wire, paint, clay, concrete powder, powder paints, powdered plaster, old tights, broken boxes. *This is our playground*. I wanted us to travel together into his interior world and discover who lives there. Ali had spoken about the

dark interiors of blindness being flooded with passages of light and life, and I wanted us to find those now, to give them voice.

The fragment of the face rescued from the fire triggers the idea of filming and photographing a series of faces or masks. I set up a couple of cameras and some lights a few metres from the two chairs we will be sitting on, so that the frame of the image will be filled by my head. I position Ali's chair near enough for him to be able to touch my face. All the materials are around our chairs so we can reach for them.

Together we mix up some of the buckets of paint and clay. It is thick and cold to the touch. I load a large chunk onto Ali's hands, and ask him to smear it across my face to give us a base to work on, a mask which can be sculpted. I pull a pair of tights over my head, feel the slippery clay squeeze into my nose and across my lips and into my ears. Everything sounds a bit further away, slightly underwater or the other side of a divide. I load more of the clay into Ali's hands, pour some water over my head, get him to start spreading it across my head and eyes. He pats it carefully around my eyes, and I feel it start to cling, creating a wall between me and the room, dropping me into a temporary blindness.

Can you still see? Ali asks.

No.

Together we grapple with chicken wire, with scraps of fabric, and build detritus over my face. Ali sprinkles plaster over my head, chucks some at my face, can feel it stick and gather and clump in the wet clay. My face is an architectural site, a fire lost in a broken room, the chicken wire the exposed interior of a wall, a bent and broken grid.

I can feel the sharp ends of the wire poking into my face through the layers, clinging and scratching and spiking my lips, gripping the soft skin under my eyebrow, pulling a bit at the

223

eyelids. I get Ali to sculpt some more material on top of my mouth, but soon my airwaves are blocked so I push my fingers in to create a hole. I manage to free up my mouth enough to ask Ali to try to pull bits of the wire and clay off, so that I can get some photographs and footage of my mouth emerging. His hands feel for my lips and he gently pulls the wires aside. There is something important about the lips. We pause the sculpting so that I can make sure I have as much footage of the mouth peering through as possible. I press the remote shutter in my hand, turn my head at various angles to where I think the cameras and lights are positioned.

We work our way through various configurations. Building the face up so that it is wounded, layering pink- and red-paint-filled clays on top, spilling inks over my head. Slowly configuring the face to form into new faces and characters, clownish attempts and figures. We water the mixtures down further, turn them into liquid states, pour them over, let them set and solidify. I am barely able to decipher what Ali is saying.

After an hour or two I remove a load of the material and carefully uncover my face and eyes. I can still feel the clogging matter in my ears, drying on my lips. I rinse out my eyes to remove any debris. I clean my hands so that we can go through the footage and the stills on the cameras. They are not at all what I had envisaged. Lots of them barely look human, especially when my head has got too close to the camera and the image has been obscured. They seem like bits of buildings, different non-human life forms, perhaps close-ups of animals or organic growths. But the defying focus of the mouth, and its centrality to the human presence, is often visible.

What interests me is how the slightest alteration in the expression of the mouth changes the feeling of the stills. Many of the expressions are pained. Grimaces, screams, seemingly

wounded and anguished. But with a subtle shift an image suddenly acquires something slightly erotic, sensual, almost alluring. Sites of atrocity and arousal sit close together. There is an ambivalence to the strongest images, as if they could easily slip between these extremes. These images feel closer than the previous work to the psychological ambiguities and layers Ali has described, the nearest we have got to a truth.

I ask Ali if we can pose for some photographs, if he will take off his glasses, but he is uncomfortable with exposing himself like this and revealing the damage to his face. So we focus on his mouth, which he moves from closed through to stretched open, tight-strained grimaces to full-throated screams, trying to find the point where the emotion is uncertain, where it can be read in multiple ways. I pause Ali with each tiny movement of the mouth as if working on a stop-motion animation, then take a series of photographs of each iteration from multiple angles, playing with the direction and intensity of the light source.

In the photographs we have taken of my face there is a queering of the aesthetic. The identity, gender and emotional state of each figure, even its very state of existence, is fluid. I try to enact similar subversions in the photographs of Ali, cropping in, changing the angle, using lighting to re-sculpt his face.

As I take the photographs, I tell him how this reminds me of the games I used to play with my sisters when we were small. They were three and five years older than me and would dress me up in their old frocks, tie my long blond hair in ponytails. I was their living doll. I carried that through into the games I played alone as a child, and then into the photographs I would take. In my art today I was still dressing myself up, shifting my identity, seeking out disguised characters.

The next day I print a selection of 500 images and work paint

into the faces, to reproduce on the flat surface the types of trans-
formations we did live. By obscuring the faces with passages of
paint, I want to replicate the fragment of a face I found in the
fire, and the expressive possibilities of the mouth Ali and I had
found the day before. I mix oil-based paints with varnishes,
turps and other flammable liquids. When it has pooled I take a
blowtorch to the image and set it alight. The pool catches fire,
jumps up. I blow it out.

I repeat the process on image after image. I burn them so
the edges catch, start breaking the rectangular page into little
island-shaped masks and scraps of faces. Letting the flame
work across the pools of paint, eating into the face below, I wait
till only small sections of face are left, then either blow out the
flames, trying to avoid ingesting the thick black smoke, or pour
water over it. The water marbles with the oil-based paint. I leave
it to dry with its new patterns. I let just enough of the image
below remain for recognition. When the flames get too big I
stamp them out, my foot imprinting the paint with new marks
and surprises. Soon the entire lawn is covered with little burnt
faces, acid colour next to dark, burnt edges. Each is held down
by small stones to stop the wind taking it.

Over the coming days I work my way through all 500 images
and each becomes a unique character. Some are full of scratches,
with holes where the eyes once were. The impression of where a
foot had put the fire out. Thick, cement-filled paint cracks, with
the opening of a mouth just visible. No one is the same in look
or feel. Scattered across the lawn, they look like an archipelago.
The marks, colours, surfaces and play with imagery are more
exciting than anything I have made before. The destructive
power of fire has become a creative tool. These mouths, these
shards are singing to me. Each is a voice expressing something,
telling me what needs to be done. I can't yet decipher what is

being said, and I needed to unpick the dissonant melodies and find a harmony in the melee.

I start thinking through other acts of destruction that reinvigorated a work or changed it. The rising bitumen in *The Raft* comes to mind, but perhaps the most startling and resonant example involves some violent, beautiful slices across the body of a painting.

Mary Richardson was a prominent member of the suffragette movement in the United Kingdom. In 1912, an arson campaign to underline their demand for votes for women was begun, its aim to burn down the houses of MPs opposed to female enfranchisement. Diplomacy hadn't worked and the system needed razing to the ground.

Mary was surprised at how easily the frame of an old window at the mansion broke away. She pushed out the entire frame then clambered into a solid black interior, the moist rot of the place catching at the back of her throat. She felt her way to the cupboard under the stairs and quickly and skilfully constructed a little stack of kindling materials, then soaked it with petrol. She returned step by step back to the window, unravelling a reel of twisted cotton wool as she went. Then she set it alight, watching as the flame worked its way along the fuse. She retreated to the safe vantage point of a bush and then she saw the fire erupt.

This act of arson would not be the last time she was arrested. Mary had been wandering and sketching in the National Gallery for a few hours, trying to shed her nerves. She kept circling back into the room, viewing Velázquez' *Rokeby Venus* (*c.*1647–51) from various angles. It was one of the most beautiful paintings in the world, but was symbolic of so much that was wrong. It was prized for worth. The female body it depicted was reduced to meat in the objectifying male gaze. It was sanctified and eroticised, while a few miles away in Holloway Prison women made of flesh

and bones, not paint and canvas, were treated as the property of the state.

The government had sanctioned prisoner officers to force-feed prisoners on hunger strike. They forced a pipe down Emmeline Pankhurst's oesophagus, poured in liquid food and ripped all autonomy from her, making even her body a prison, a site for them to control. The state was more concerned with a work of art than with human suffering. And while the state-sanctioned violation of the body was disturbing, the public apathy was worse. Mary needed to wake people up to these human violations. She knew there would be more of an outcry at the damage to a painted woman than there was to a living one. The hypocrisy needed exposing.

She had arranged a series of safety pins to hold the meat chopper in place inside her sleeve. When one of the guards left for lunch and the other vanished behind his newspaper she was ready to strike. She released the pins and pulled out the axe. With all the force she could muster she brought it down on the glass covering the painting. It broke with one blow and a shattering sound resonated through the gallery. She would now only have a small window of time in which to commit the damage. She swung a succession of blows across the canvas, felt the fabric rip and give way to the force. Then within seconds she was at the centre of a melee, and a blow was delivered to her head, then another. She was at the heart of a swarming cluster of people, hitting her with arms and books as she was wrestled to the ground.

There was the inevitable venomous outcry. Perhaps as a political act it failed, but as an accidental artistic act it is remarkable. The painting was soon repaired, the cuts to the canvas neatly, surgically returned to something close to the original smooth veneer. But a black and white close-up photograph of

the damaged canvas survives and it is surprisingly beautiful and moving.

The picture shows a cropped figure, its famous bottom and back filling the frame, a mirror out of view. Richardson's first blow was to the top right of the painting. Not quite having penetrated the surface, it leaves a mark which breaks outwards from the point of impact, like a little section of a cobweb. Then across the centre of the image are six diagonal cuts, lines of varying length and depth. The angle of the cuts get steeper, the length longer as they move like sliced beats across the surface. These marks remind us of the lie of the painting, exposing its flatness and revealing its skin as thin and vulnerable. The flesh and body of the image contrast with that of the painting, the former violating and showing up the latter.

The elegant cuts present not just as marks of destruction, an attack on a bankrupt society, but as a forward-looking premeditation of what might be possible in painting. This approach appealed to painters such as Lucio Fontana, who between 1958 and 1968 made a series of *Tagli* (cuts) paintings, where the canvas is slashed, opening up the surface to reveal the empty space behind.

The *Venus* had to be repaired, of course, but to hide the marks seems to be a lie to its history; part of its biography that should be at least acknowledged. The stultifying reductiveness of a painting made by and for the male gaze is challenged and given female voice and agency. By 1932 Richardson had somehow come to believe that fascism was the answer to the rot in Britain, and she joined Oswald Mosley's British Union of Fascists. This is a greater crime than her attack on a painting, yet it is the latter which most offended the British public.

I needed to harness some of Richardson's destructive energy, to bring it to bear in the final work, to open up the gaps in

the flatness of painting which would leave room for people to enter through the limits of the painting's gaze. I'm preparing some materials to show Ali when he next comes. I want us to go through all the experiments and works made to date to plot our path forwards. Coming across a little video I did early on, I decide to show it to Ali. There is something in the imagery which feels resonant. It's unusual and hard to describe to him, as the screen lacks any of the access through touch that a painting allows.

The video is two different films overlaid on top of each other. The top one is at 50 per cent opacity, so that it can be viewed through to the video below, as if it were a translucent screen. Images from both films dissolve into each other, layers which sometimes flatten and sometimes deepen what is viewed. The first film is footage taken of a murmuration of starlings in winter through the silhouetted early morning, the wind blowing them into forms of reeds. The sky is pink. The birds are swarming, performing their magical dance in the sky, and it is still mesmerising even via the detachment of film. They pattern outwards, spreading as if never to return, before spinning back into a hurricane of curving spirals to become one. *It sounds beautiful*, Ali says.

The second video was filmed by a free-diving friend. It captures me diving underwater, trying to push my lungs to the limits in the sea. We had made about fifty of these videos that day, and this one I laid over the murmuration. I am seen from below, turned into a soft shadow by the light from the sky scanning down into the ocean, just breaking the surface of the green water, paddling myself under before my body starts to appear bigger. Then I dive towards the camera, as if heading towards the surface of the image, looming larger and crisper as a shadow, slowly filling the height of the frame. My figure bends, curves to begin an assent upwards, a desperate rush towards a

gasp of air, and we see it break and reveal the ocean's surface. Ali remembers me having told him about the video at one of our first meetings three years before, when I was considering what the drowned world he described might feel like. *We have come a long way*, he says.

I play the combined films and talk Ali through what is happening on the screen. Unexpected abstractions happen when the two sets of images are laid over each other. The green and the pink combine into dissolved light and colour, which reminds me of the water and light that Whistler or Turner might paint, the type of coloration I have never been able to reproduce despite countless efforts.

The most interesting thing is the play between the single figure in the water and the mass of winged lives in the sky. The birds, filmed from the distance, appear to remain at a similar point on the surface. The figure, in contrast, moves dynamically through this axis. The two modes of movement are in opposition, and there is a fascinating interaction between these two sets of shadows, between the singular and the multiple. By the time the figure has reached the deepest point in the water filling the frame, it appears as a hollowed-out shadow which the birds first pass through, filled by multitudes.

That's what I want to paint, I tell Ali. *Not what it looks like or is, but that feeling, that space.* There is a short silence while Ali thinks carefully. *I like this idea*, he says. *Can I say something?* he asks. I am always amazed at his politeness, his grace.

Ali says it was the sound of the video that really struck him, asks if he can hear it again without me talking over it. I hadn't noticed that, like the footage, the two tracks are overlaid with equal balance. The crackle and warp of the sea grows louder as the figure gets closer and breaks through the water, seeming to speak in gulps, hisses and rushes. Around this is a constant white

noise and a voice in the far distance, trying to communicate from the sea's depths. Perhaps it is the friend filming, blowing out air. In contrast, the murmuration can barely be heard, but occasionally penetrates the ocean. The odd wave of rushing, beating wings can be heard. Ali is constructing the spaces in his head through sound, giving the image shape and form. He feels himself drop underwater, drowning, and then rising with the rush of the birds in their ascent.

I ask Ali what he means about sight through sound, and he tells me two stories knitted together across time and space. The first is how he noticed the war's encroachment mainly through what he could hear from his office. He would sit there working and listening to music. Daily he would hear the bombs. At first they were a faint rumble in the distance, a reminder of the presence of war. Then slowly the front line became his neighbour, and the noise got closer, more varied, not a hum you could block out. Hours would pass with just a distant rumble, then suddenly there would be a louder flurry as if from nowhere, and each bomb, as it hit the ground, would destroy the space for Ali, as if threatening to break in. Occasionally a bomb would be so close as to erase all the sound of his music and would vibrate through his body. It was then he determined that he, his wife and his two daughters had to find a way out.

A couple of months ago, Ali phoned a former girlfriend who was still in Damascus, close to where he used to live. He begged her to try to leave, accept help to find a way out. But she was determined to stay and thought that leaving would be a death of sorts. When they spoke on the phone the line would often cut out, but he could also hear the familiar sound of the bombs. The first time they spoke, the bombs were a terrifying trigger, dragging him straight back to his office, the war zone and the threat of death. It filled him with fear for his friend.

But a strange thing happened which unsettled him. During one conversation he asked her to stop talking briefly so he could listen. He suddenly realised he missed the noise of the bombs because, however awful, they defined the space of home. This sound was the closest he had come to being back in Damascus. In that brief moment he could almost see the home and the selves he had left behind. He felt a deep longing and sadness. *To miss bombs is a confusing thing,* he told me.

Whatever we made next had to give Ali a chance to step back into those scattered selves and spaces through paint and touch. I wanted to create doorways into the corridors of self and memory. Paintings as houses, or at least theatrical versions of home, in which we would gather up the many selves and make them whole.

10

A Painting Is a Poem

Touch has a memory

JOHN KEATS

At the centre of *The Raft of the Medusa*, a group of figures is caught in frozen flux. The corkscrewing forms give a heightened sense of their suspended animation. One exhausted figure is held aloft, working in opposition to the weight of his flesh and the pull of gravity. His hands cling to the shoulder and arm of his companion, desperately trying to hoist himself up, to stop himself from sliding back down. His companion, holding him in one arm, pushes up from his knees, his torso curving upwards. He reaches out his spare arm, his hand about to grasp at empty space. Our eye looks to give definition to that search, resulting in a sense of pulsing, repeating motion. We are locked in the just-about-ness of the action, the fluid uncertainty of a moment in flux. A painting's unique narrative ability is to capture a shifting moment for eternity.

The painting pivots around this tableau. It is the vehicle that moves us through the diagonal, through the space, from the front-left depiction of death and mourning to the sense of hope that awaits us in the vignette of figures at the back of the raft. This grouping is a dynamic swirl of energy, a point of transition. In the men's movements we see a shift from seeming certainty of death to the possibility of rescue. They are the dramatic crux of the painting's narrative expression. From their central point, our eyes move through the picture in an exponential curve, a series of moments knitted not just by chronology but by their movement through different psychological and physical states of being. We travel from mourning to a frenzied ecstasy. The central figures are dancers, leading us through the painting from stasis to eruption. What awaits us, in the space beyond their desperate grasps, is the painting's grand gesture, its cumulative, erupting moment.

It is a brilliantly inventive solution to storytelling in painting, combining multiple compositional devices. In it we can see the lessons Géricault has learned from art history, from his time studying in the Louvre in particular. A huge majority of Western paintings have hidden within them the architecture of the key Christian narratives: the Deposition, the Resurrection and the Annunciation. *The Raft* combines all three, and the central grouping of figures holds all three within it.

The man propped up by the timbers, his body bent and only the top half in view, echoes the Deposition; the descent from the cross, when Christ's body moved from life to death. This figure is represented in the bottom-left of the painting, his head tilted back, eyes looking longingly upwards, the weight of flesh holding him down. His companion to the right reflects the movements of the Resurrection: the rising of Christ's body, transitioning him from the painting's lower half to the top half.

That upward trajectory from the space of death to life is reminiscent of Christ's ascent. Between them, the pair illustrate the compositional mechanics of Christ's physical and spiritual elevation, the descent follow by the ascent. In *The Raft* it becomes a narrative, psychological progression.

Each figure inclining to a vertical axis, together they move across the horizontal. It's a motion, from left to right, across the central divide, borrowed from the compositional structure of Annunciation paintings. The arrival of an angel, entering stage left, from the heavenly realm beyond to the interior space of Mary's earthly domesticity. The placement of the figures in the composition signals that a message is being delivered.

The Raft is a tapestry of these various strategies, of compositions as narrative, psychological and spiritual signifiers. Each section of *The Raft* is a stanza, which, explored line by line, combines to form a poetic reading.

Across his many studies, Géricault had been trying to isolate moments in Corréard's life. In the same way, my approach to Ali's story had been episodic. In his synthesis of compositional models and multiple narratives, Géricault provides a solution which creates a unified composition, compressing many moments in a singular picture.

No one had been sent to find the raft. The *Argus* came searching for gold from the wreckage of the *Medusa*, but found human flesh instead.

Corréard tells Géricault about the rescue. It has blurred in his memory. He remembers waking to clamour and shouting. A boat is approaching, suddenly up close. It is not a dot on the horizon, its crew are calling to them. The look in the eyes of those on board is full of shock and fear. Corréard sees the rescue through the eyes of the saviours; he perceives himself and the

other survivors clearly for the first time. He barely recognises the thing he has become.

They have hollowed-out, skeletal faces. Their skin is stretched tight. What clothes they are wearing hang loose and ripped. They are covered in sores and are surrounded by the stench of death. Flanks of meat are hung up to dry, the residue of butchery scattered across the raft.

Corréard remembers the journey back to land as a surround of voices. He slips in and out of something like sleep. A few of the survivors don't make the short journey and die of fever and exhaustion en route to Senegal. In the coming days, Corréard feels not relief but shame and guilt. Both feelings stalk him, closing the walls of the berth tight around him. Shame and guilt have haunted him ever since. The experience on the raft lives with him and mutates into something else. He wishes he could have left it at sea. But the sea comes home with him, swirling and storming from the inside, swelling till he is drowned from within.

Corréard doesn't think he can bear to be alive any more, but when he hears about the horrors committed by Governor Schmaltz he is fuelled by anger. He has a purpose again. Géricault is desperate to know more, but Corréard is exhausted and needs to go home.

Géricault finishes the painting, adding a final touch of varnish to the spectral ship. He is exhausted and exultant. *The Raft of the Medusa* is transported to the Louvre for the annual Salon. This public unveiling is the moment Géricault has been working towards all these months, mainly alone in his studio.

But the painting is hung too high. Louis XVIII, gout-ridden and barely able to walk, is pushed around in his wheelchair. He is introduced to each artist as he inspects the paintings alongside

the head of the Louvre. The walls are packed, with small works dotted along the lower parts and the huge History Paintings at the top. It is the busiest Salon in a few years, a defiant effort to celebrate the Bourbon regime and the king. He cranes his neck to take in Géricault's painting, but the angle is too sharp. He signals with a hand to be pushed back a few feet and looks again. Géricault feels his stomach heave upwards as the pause of contemplation is prolonged. The king jokes that Géricault has painted a shipwreck, but the painting and the artist are not a wreckage. Everyone laughs, the tension is cut. Géricault has royal approval. He now waits for the head of the Louvre to find him, for any signal that the work might get purchased for the collection, but he isn't approached.

After much persuasion, Géricault secures a re-hang, lowering the picture so that its drama returns and the viewer feels as if they are about to step on board. Géricault's painting is unusual among the other History Paintings, which mostly follow the Davidian school. David is now living in exile and his greatest disciplines are in decline, but Bourbon society is wrapped up in nostalgia for the codes it understands as elevated and noble. The pastiche conservatism of much of the work filling the Louvre chimes perfectly with a society desperate for certainty. Géricault's work shouts against certainty in style, subject matter and taste. It offends the sensibilities. It is a shocking new vision that disturbs and fascinates the public. They are baffled, confused and magnetically drawn to the canvas. His painting of a scandal becomes a scandal itself.

Having worked in private and near-solitude as a relatively unknown painter, Géricault is suddenly the focus of public and press attention. Not all of it is favourable, and responses are split along the same political lines drawn up in the aftermath of the *Medusa*'s wrecking. The ultra-royalist press is appalled at

the way in which the shipwreck has been used as a weapon to attack the monarchy, viewing Géricault's painting as a monstrous disgrace in bad taste, a putrefied depiction of death, hunger, despair and anger in a turgid mass of corpses. An image of pure horror, empty of hope.

After the shipwreck, the moderates highlighted the need for reform in the Bourbon regime; they wished to clear out the impotent and corrupt mechanisms of state. They, like many critics, saw the painting as problematic: too dark, confused and lacking any focal point. A hideous spectacle but a beautiful picture. The liberal papers leaped on the scandal as a symbol of larger corruption, of a regime that needed to be brought down. They saw the painting as having drama, originality and a powerful emotional impact. Some visitors to the gallery were moved to tears by the scene.

Géricault was confused and exhausted by the reaction to his work. He felt as if people were filtering their responses through the lens of their political agendas. The public attention made him want to shrink back into himself. He felt unhinged, lost and directionless. The safe bubble of his studio had been blown apart and thoughts of Alexandrine and Georges-Hippolyte flooded back in. He was drowning. He escaped to the country and sank into a deep depression. He resolved to never paint again.

After five weeks in Australia working on another project, I return to my studio in deep winter. For the next few months I plan to lock myself away in order to move towards the imagery that is bubbling in my head.

I ask Ali to give me a list of the books in his library in Damascus that he can remember, and order copies of as many of them as I can. Mahmoud Darwish's *Memory for Forgetfulness* is

the first I read, and afterwards I pour ink onto each page, letting it stain and seep through, obfuscating and refocusing. I leave it to dry and then open it up to reveal a spread of butterflied dark clouds, soaked into the book's gutter. The majority of the text is unreadable and only little snatches of evocative passages remain. I rip off the spine, carefully slicing down the edge to free the pages. I set fire to them and let the corners burn, blowing and patting out the flames before the text is turned to flakes of ash. Each scrap becomes a ripped, burnt, cut, stained individual. A scattered archipelago of voices and incomplete snatches of stories from the same central home.

I see a choir of selves floating in the dark, as if I can hear their silent testimonies. Allegri's 'Miserere' comes to mind, the choral Renaissance piece traditionally performed once a year in the Sistine Chapel. Groups of voices are arranged around the chapel, the sound forming in shifts from the singular to the collective. I keep thinking of it, and of a line from Beckett's *Not I. Just the mouth*.

I close my eyes and imagine a murmuration of mouths floating around the studio, silently singing. A mass of *Not I*-like mouths speaking poetic fragments of Darwish, each giving testimony in a dissonant choir. I want to extract the voices from inside Ali and spread them across the walls of the studio. I want to turn the studio into a kaleidoscope for Ali to enter. To make a version of selves which he can step into. I start to assemble a choir of mouths and masks.

Collaging some of the burnt and painted mouths onto canvas and sheets of wood, I bury them in storms of thick paint. Bright reds, deep crimsons, aqua green on another. Thick with cement and mediums, cracked and breaking. Stacks of canvas and wood, each with a mouth. Each has a different mood, a different expression in the shift of the lips, the colour and thickness of the

paint. Some are nearly lost to the soaked puddles, others push forwards. Some scream with abjection, others in ecstatic orgiastic moans. Each one informs the next. I cover some in puddles of turps and flammable paint, drag them out to the garden and set them alight. I pile up one on top of the other and set fire to them. I lift a board and a wave of flames leaps out. I pour turps onto the burning wooden support and watch a flame race up towards my hand. Flick, chuck and spray oil paint. Soak sheets of fabric to fling over the burning surfaces, pour buckets of watered-down paint to put out the fires, watch the paint mix and resist.

Hacking at some of the boards with an axe, I let the sides split and break before burning them again. Others I cut carefully with a jigsaw, and work at their edges with a blowtorch. I stack a load of the burning sheets of wood on top of each other. The heat gathers and the edges become red-hot. Across an afternoon the heat starts cracking and splintering the surface of the wood. The edges are brittle, steaming, and break with a kick of the boot. I wait till they seem ready, whatever that means, and put out the burning pile with the hose. A huge cloud of steam spreads across the fence. I take a bottle to the neighbours again to apologise, but they haven't noticed.

After a few weeks the studio is full of hundreds of mouths painted on canvas and wood. Some are small, about the size of a head, the mouths fairly true to life. Others are two metres in width and height, the size of whole bodies. Ali and I spend a few days exploring the surfaces. The roughness and damage of some unsettles him. The smoothness of others surprises and entices him. I tell him that each one is a portrait of him. He says it is odd to see himself like this, as if meeting a stranger. I explain how the mouths are obviously soundless, as if waiting to be given voice, and for Ali to animate them. I realise that Ali, as the viewer of the finished works, will be as much the author of

these paintings as me. Only when he tells me what he sees and hears will they come alive. My job is to create the stage, each mouth a scene for Ali to enter, inhabit and reanimate.

I start playing with scale. I print off photographs of Ali's mouth onto acetate, cut them into little transparent squares and layer them into slide frames, two to three per frame. I burn the plastic with a lighter, holding the flame so small pockets of it bend, bubble and then open. I scan all the little slides and view them on my laptop screen. The layer of mouths has caused a distortion. They are more like openings to caves, mouths only readable in some of the images but completely abstracted in others. Here is the interior world of blindness that Ali described. Ali is intrigued by the slides, and the sheer number of works on paper piled up. He is interested in the scale, in how small those slides are in the hand, tiny versions of self versus the large-scale, whole-body-sized mouths.

I try to capture this emotional and figurative ambivalence on paper. Pouring inks on stacks of paper, I mix permanence with impermanent sunflower oil, acetone and hairspray. I play with thresholds, with spaces that open and close, a movement into and out of darkness and light. Pulsing shapes, suggestive of the interiors of bodies. The pages are small, they gather together as a little book in which each folio, held in the hand, is a prayer. I produce stack after stack, thousands of paintings, or books, or mantras.

I try to replicate some of these forms on a large scale. I take an unstretched, unprimed canvas. Free from the frame, it opens up in new ways, an absorbent, double-sided surface which can be attacked with different physicalities. I remove paint with a power washer, so that it is as much about what is erased and lost as what is left. I use paints which will soak into, soak through, and penetrate the now-porous surface; a material you can fold,

can step over, squeeze till the paint gathers into the joins, the folds holding the action till the canvas is a small packet, hiding the secrets of what is bubbling away beneath. I leave it for days, weeks, weigh it down with whatever comes to hand. I plead with it to offer up secrets, whisper to it in the hope there is something worth unpacking. It will be stretched, or hung, or laid. Those decisions are for another day.

In the coming days the studio resembles a construction, or destruction, site. Sitting in the middle of the room, I am surrounded by huge, sprawling piles of materials, half-completed paintings and stacks of finished mouths. There are dozens of dirty tea mugs, in some of which a thick green and brown mould grows on the inside. It's an organised chaos. A noisy space. I need a central structure to pivot the work around, and I settle upon a triptych. My friend Matt, a carpenter, makes me up three wooden boxes, each roughly the size of a coffin. These will be the containers in which to order the sculptural paintings.

Ali and I apply the first surfaces. I know these will be covered and lost to the viewer, but it feels important to do them together. We both lie in the empty boxes and get to know them. Then I lay down rivers of paint to replicate the views of Euphrates that Ali remembers from his childhood, into which Ali plants his foot. I can access the river from Google images, aerial views of the artery of a country. We cover the soles of his feet with black paint, then pour more around his toes. We sit for an hour or two waiting for the streams of paint to slow, for it to start drying, then lift up his feet to leave footprints in the surfaces. I bring over a basin of warm, soapy water, dip my finger in to check the temperature. I roll up Ali's trousers, lower his feet into the water and then softly scrub off the paint. There is a tender intimacy to these moments, of skin on skin, the cleaning a small ritual of thanks and connection.

Matt makes me eighty-one miniature wooden boxes, each the size of a head, a little fractal of the larger ones. The plan had been for the small boxes to contain piles of works on paper, like unbound books, each relating to different moments, but it feels too episodic. Ideas are formed and discarded quickly now. I pile up the boxes into a stack in the garden and create a small bonfire. I remove them at different stages; some are just slightly charred, others broken apart into flat sheets by the fire, the edges and borders coming away. These planes will be little stages, the size of a face, to go into the larger boxes. Twenty-seven per box, each a character and a voice. Each large box will be a choir singing a different song, charting a different arc from Ali's life.

I work up each box with a view to it focusing on a different emotional thread of Ali's life, mapping out a different psychological terrain. Organised by feeling, the boxes will relate to a mass of selves and moments across his life, not singular instances. The left-hand box will focus on Ali's movement into blindness. I build up the panels over the coming weeks, placing everything so there is a downward energy, an inward swirl. Each panel focuses on a mouth as an opening, a cave-like entrance into darkness. I layer up sheets of Perspex to create little angled windows, breaking up the space, pour on expanding wood glue and set it on fire.

I spray expanding foam around the images and start using it to make sculpted versions of the types of marks I would make with paint. The foam crackles and shrinks when the blowtorch is applied to it, the white surface breaking into a hive-like structure of golden yellows and browns. I glaze crimsons over the surface, weighting the light at the top of the box, and then gradually let the panels cascade down into darkness towards the bottom. I break in scatterings of ash and charcoal from the burnt paintings, raining them across the surface. I want the triptych to

replicate Ali's description of descending for twenty years into a new world. The mouths, all lifted from the burnt and scanned slides, only just represent something we can recognise. This painting is the Deposition, the descent from flesh.

The right-hand panel is the Resurrection. Ali was worried about the violence and damage in my surfaces and the horror in the imagery. He felt it wasn't true to his experience of the bomb, blindness, war and the final displacement of having to leave home for another country. There were aspects of his entire journey he saw as a gift, opening new ways of thinking and seeing the beauty and richness of the world, and his gratitude for it. Many of his stories were about the women in his life who had saved him from depression. Women who had shown him new forms of touch and sight and opened up a new version of the world and self. This hope, this erotically charged beauty had to be in the work, particularly in this panel. I wanted it to replicate the patterns of the murmuration of starlings, to play with the rhythm of that ecstatic, gravity-defying dance.

Many of the processes were similar to the final box, but I used richer glazes, soaking the whole thing in layers of thick, clear liquid resin, suspending broken scatterings of rose petals into the surface. Ali had spoken a lot about roses in Damascus and the roses in our garden were a similar colour, so I had been gathering and drying hundreds of them over the last three years, sensing they would find a place in the work. They were a beautiful array of purples, reds and crimsons, and the flicks of the petals in the resin glimmered against the sienna tints below. The surfaces looked like damaged skin and wounds close up, but excessive and luscious desire was present in these surfaces too.

The central panel is the bomb blast. The Annunciation, the moment of rupture. The mouths emerge from piles of grey paint, concrete and rubble. They are hidden and entrapped

behind chicken wire and dust. Sculpted, rock-like forms, which could be skulls or chunks of broken building, are made with tights stretched over chicken-wire frames, covered and filled with clay, cement, paint. Holes are burned to reveal the interiors. Fragments of wood, nests of collected hair, broken shards of glass and pieces of shattered mirror are laid at various angles. The mirror reflects spaces, mouths and surfaces at new angles. There is no centre, as everything explodes outwards. The image holds a concatenation of references, aerial views of Aleppo bombed out, street views of Damascus with buildings flattened or opened up by explosions, the sudden white heat and light of the bomb blast, the feeling of being chucked up into the air then thrown down and buried in rubble. The studio is full of noxious fumes and dust. It gets into my eyes, my throat, my lungs.

In all three boxes the mouths and faces are only occasionally recognisable as Ali, and only just. They are abstracted to allow the viewer to see themselves into the face and wear it like a mask.

This triptych is the only artwork I have not shown Ali. I want to hold it back as a surprise. He also doesn't know that the studio is full of all the material we have been working on, gathered together as a single piece. He is coming tomorrow.

I have spent a couple of days tidying, sorting the groups of paintings into sets along the wall and stacking them from floor to ceiling, with the triptych leaning on the end wall. I empty my studio of books better to display the works, gathered like steps leading to that final piece. I clean out the detritus and paint the floors and walls with three coats of paint. Matt comes over to install the triptych, screws it into the wall with brackets. *These won't budge*, he says.

The studio is ready. Standing in the middle of the pristine, empty floor, I am surrounded by the memories of everything

we have done. Behind all the Ali paintings are neat stacks of previous work I have made over the past ten years, around thirty large canvases, including the ones Ali and I spent so many days looking through when he got to know my work. The history of the project and our friendship surrounds me. Whole worlds and lives, each painting and object a little entrance. A space of fractals and layers.

I have been thinking carefully about Ali's visit, and the cave-like space he will enter. It attempts to evoke the cave paintings in Santa Cruz, Argentina, the Cueva de las Manos, between 9,000 and 13,000 years old. The walls are covered in a series of stencilled hands. The artists are thought largely to have been female. They held their hands to the wall and then sprayed red paint around them through pipes made of bone, leaving negative prints against the walls. Perhaps the paintings were at the centre of wider rituals, when tribesfolk came together in ceremonies of fire, music, dance and food. They might have been painted for hunting ceremonies, or were very early forms of religious paint-ings, conjuring up places and spirits beyond. It is easy to imagine how mesmerising the spectacle would have been, the pattern of hands against the curving, uneven surface illuminated by the flickering flames and the shadows of dancing people. The cave became a cathedral, a womb-like space in which the group were held and transported elsewhere. Entering it, they stepped both through and down into the earth. Perhaps painting has always been capable of giving us entrances into new worlds. The studio has surrounds of mouths, rather than hands. There are similar ghosts here, waiting for us to meet them.

I've spent a career being told my approach is too much. Too many images, too much movement between form, media, process, collaboration, stories and meaning. I've been told to reduce, simplify, explain and box up my work for commerce. But

I wanted to embrace the polyphonic and to trust in my instinct, and here I have held nothing back. Everything is here. I feel like I have been working in a huge cauldron, mixing potions. Bleach, inks, expanding flammable foam, wood glue, varnishes, paint stripper, clays, concrete, acetone, oils. Conjuring ghosts, like my dad used to do.

The final addition to the exhibition is a little figure, about the size of a two-pence piece. It is sculpted around a tiny plastic figurine, shaped by clay and paint, then reshaped with a needle after being made malleable with a blowtorch. It is a minuscule version of Ali. I place it in the centre of the middle box in the triptych. It is smoke-covered and black and almost vanishes into the darkness. It nods towards Friedrichs's *Wanderer*, but also to the flag-waving figure on the raft. This figure is Ali looking out to his world. I want it to simulate the place he will be standing when he comes to the studio. It won't be seen straight away, but once noticed it will shift the room on its axis. The gravity and spatial order will be upended. Everything will spin out from that figure. He is my pivot, my lost hope. The explorer between worlds.

I'm finished, but I have a nervous desire to fiddle. My various trips to the hospital have resulted in a diagnosis of OCD, and it manifests itself in offering me endless possibilities I cannot ignore. I am destructively compelled to experiment, and I can't switch off. A swarm of wasps gathers in my head. A patch of the work catches my eye. Could it be dropped back, a bit more darkened and burnt? I will rough it up and singe it a little more. The boxes are bolted to the wall. I probably shouldn't burn the surface inside. But what's the harm? I feel an itch behind my eyelid, an obsessive, twitching fidget. I am caught in a manic pattern. Eyes blinking, heat gathering in my head. Rational thought is now buried. I should wait till I can move the boxes. I can't wait. It will only take a moment. A moment is all it takes.

I switch on the blowtorch and pass it over the surface. I see the satisfying bubbling of the foam and feel the calmness of making. The swarm of wasps drift out of my head. I let the foam bubble more, from white to toffee. I watch the edges crisp and shift to black. I up the contrast to heighten the drama. Just a second more. Then it catches and a small flame flickers into life. I'm calm. I blow, pat, blow again harder. The flame spreads further, the shift is sudden. It gathers to the size of a clenched fist. Suddenly it hungrily gulps at air through the holes to the space behind. Panic sets in. I reach for a tin of water, chuck it on. The flames dampen and shrink, but only briefly. They regather, climb upwards, let out a heavy breath and then crackle. They spread fast, spitting. In pure relief, I remember the fire extinguisher. I clumsily pull the tag out and point, squeeze. Nothing comes out. I shake it and squeeze again. Still nothing. Flames are sprawling now. I race up the garden, grab the hose and turn it on. I sprint back down, knowing it won't reach. I feel utter desperation, hoping for a miracle. I'm spiralling. I pull at the hose, desperate, and feel it break off. I dive back into the studio.

The central panel is now in on fire. I try to get it off the wall and feel the flames against me. It doesn't move an inch. The fire is now spreading outwards across the back wall, an expanse of flames gathering around the triptych. Smoke fills my lungs and I am engulfed by panic, my eyes full of fire. As I turn, the studio is opaque with thick, black smoke. I can only just make it out of the door.

I run to the other end of the garden, back into the house and call the fire brigade. Kiran is abroad, and I try but fail to stay calm. In pure panic I race upstairs to search for Luna, our cat. She's safely in the bedroom and I slam the door shut. I can hear the fire from here, crackling. I run downstairs. The double doors to the studio are a bright-orange rectangle, the studio is a ball of

fire. Waves of billowing smoke roll out and upwards. The roar of the fire is punctuated by the occasional explosion of canisters of paint and medium.

I start screaming to the neighbours. One smashes down the side gate and others are gathering. I am breathless, crying. The evening sky is filled with the black smoke, shifting in the wind, spiralling upwards. I am consumed by pure and utter terror, and the heat can be felt ten metres away. My entire body is dripping with sweat, shaking. My eyes are full of the fire.

I hear the sound of sirens. There is a noisy rush of feet and a cluster of firefighters burst through the garden fence, dragging four hoses behind them. The inside of the studio is an incubator, flames pouring out of the doorway. It is a tinderbox of flammable materials.

Everything inside has gone.

II

Wreckage

The Ruin was
havoc
damage
within.

EMILY DICKINSON

Everything leads us to him. The grieving figures at the edges, the collective group in the middle of the painting, the final heap at the back of the raft, erupting upwards. All point to him, at the top of the pyramid. A figure held and raised, waving his red and white flag to the horizon.

His right foot is planted flat on the tilted barrel, knee bent as he pushes up, raising his left foot onto the tips of its toes. He performs a careful balancing act, seeking elevation. He leans precariously to the left, firmly held by the clutch of another figure whose right arm reaches round to his right leg. He supports himself by grasping and holding the other man's wrist.

There is just enough stability to free up his left hand to stretch up and out, fabric wrapped tight around his wrist, and wave boldly into a curve which flows from the bend of his arm and torso. A contrasting curve is rendered by the musculature of his back, drawing a line up his spine. It is an athletic and dynamic pose, full of opposing forces of grace and effort, balance and instability. The body represents the drama of the raft's uncertain destiny.

He functions like Friedrich's *Wanderer*, painted the same year. Friedrich's single figure stands centrally on top of a mountain, looking out across a sea of fog, contemplating the wonder and awe of nature. It is the archetypal Romantic image of the sublime. The figure's central placement, facing outwards, mirrors our position in front of the painting, so an act of frictionless empathy takes place. We can imagine ourselves in him. The experience of viewing nature becomes synonymous with that of viewing painting. The mechanics are similar in *The Raft*, but the relation between the figure and the scene is different. The wanderer takes in the whole scene, exerts some kind of control over it. The figure in *The Raft* is anything but. It shows a man in a state of desperate hope that seems capable of toppling over or disappearing at any moment. The individual is replaced by the collective, carrying the expectations, hopes and fears of the entire population of his small, seabound world. He too faces outwards, away from us. We look into the painting as he looks out into the sea, and then we join him there.

The spiralling terror Géricault had experienced in front of Michelangelo's *Last Judgement* in the Sistine Chapel found new expression in his own painting. Critics, who read the painting as a shipwreck, thought its themes should be limited to the category of genre painting. They failed to see that Géricault had elevated the ordeal to the highest level, lifting specific, real

events to the realm of the metaphysical. Its play of diagonals, of hope versus despair, mirrors the ways in which any Last Judgement painting becomes a battle between the spiritual and visual forces of hope and despair, heaven versus hell. Everything has combined to transmute the painting into a secular Last Judgement.

The *Apollo Belvedere* is often considered the reference point for the figure, but it more closely resembles the image of Christ in the Sistine Chapel, with the same bent knee, open foot planted and the other on tiptoe, the same counter-motions in the bends and twists of the whole body, the muscular contrap-posto. In the Sistine Chapel Christ is high above us, looking down, reasserting our smallness in his resurrected presence. In *The Raft* the action hangs low and the viewer is conjoined with the saviour, looking out not just across the horizon of the ocean but of history. It is the ultimate sublime, Romanticism at its most radical.

This figure is the painting's heroic centre. Rising from death, from the bloodstained stage, from the horrors of what lies below. Phallic, erect, erupting from collective despair and death to signal hope. The figure transcends the collective, breaks the space, suggests the possibilities of time and space beyond. Yet at the painting's unveiling, in the press that followed and in the literature over the next few decades, there was almost no men-tion of this figure, as if he didn't even exist.

The painting was described as lacking a centre, as hideous, ungodly, coarse, dark, repulsive, without hope. This criticism goes beyond aesthetic and political leanings; it is a collective blindness. Viewers were literally incapable of seeing a black figure as the central protagonist in a painting, a symbol of hope, the secular equivalent of Christ. When writers did start to reference him they became blind to his colour, writing it out

of the literature, somehow seeing his actions as hopeless and despairing.

For a long time, the figure wasn't part of Géricault's *The Raft*: in the majority of the studies for the painting there was no human element in this final space of hope. Instead there was a gap on top of the barrel. In one small pen-and-ink work the groups below reach up their arms, but into an empty space, hovering over a cirular stain of ink. Then slowly the idea of the figure emerges. At first it is white, and then come a series of drawings where it is harder to be certain.

Then, in one beautifully observed study, there is no doubting the figure's ethnicity. It is a fragment, the head and arms are reduced to outlines, the back the only part to be fully fleshed out. The twisting musculature, the warm umber hues will later, in the final painting, pick up the warmth of the sunlight.

The raft's crew, both in life and in the painting, were racially diverse, but the late decision to cast this central black protagonist as a cypher for Christ was remarkable and consciously political. It went beyond naturalism. Were the critics who deemed the painting too dark and turgid expressing a racist response to a work that didn't centre on whiteness? In their inability to see this figure were they expressing the thinly veiled, deep-rooted racism of society?

It is widely presumed that the acrobat and model known as Joseph posed for the figure of hope. Charles Clément made the claim, but more recently some doubt has been cast on the reliability of his account. Two portraits by Géricault are contemporary to the study and are often cited as evidence. The first is presumed to be Joseph and the second the raft's carpenter. However, both portraits appear to be more than studies for *The Raft* in their direct and tender observation and the way they capture the individual's appearance. Joseph's features are carefully

observed, especially the wetness and slight redness to his eyes as he stares beyond us into mid-distance. The study suggests an intimacy between painter and sitter not found in the black figure in *The Raft*.

At the very least the portraits suggest that Géricault saw both men as more than mere actors in his drama, whereas the final figure of hope is consciously turned into an archetype and is depicted facing away from us, becoming something the viewer can inhabit, a body we can step into. The racial politics of this is complex, and Géricault's intent cannot be fully understood. We can't simply identify the figure as an abolitionist statement, or an expression of ethical or racial politics; it poses as many questions as it answers. As the art historian Albert Alhadeff explores in depth, the racial politics of Géricault's entire ouevre, while remarkable for the time, are still shrouded in contradictions, tangled in conflict and fraught with ambivalence. Yet, in a society which viewed black people as inferior on social and political grounds, it was undoubtedly radical and progressive to cast a black man as the symbol of salvation, the saviour, the dynamic leader of the collective who will lift them out of darkness.

The picturesque power of the painting hides its anarchic reach. It is a Trojan Horse within the establishment, emitting waves of revolutionary energy. It was painted during France's most bloody period of history, between two murderous revolutions, and hides in plain sight of the onlooker its despair at the state of the regime and that of the world. That same year, Percy Bysshe Shelley wrote his political poem *The Masque of Anarchy*, a peaceful call for freedom and resistance in the aftermath of the Peterloo Massacre. The iconic final line speaks aptly to the image of the raised figure, calling out to those abandoned and left to die, *Ye are many – they are few!*

*

Géricault returns to Paris from his self-imposed exile. He hasn't seen Corréard this animated or driven by conviction before. For Corréard, *The Raft* is spiralling into something beyond an expression of the suffering he had experienced. It has become a symbol for all that is wrong with the Bourbon regime. He sees it in the figure waving the flag, in the sprawling grandeur of the painting. He is determined to right wrongs, to uncover the corruption at the centre of France.

When he was rescued, he heard rumours of Governor Schmaltz committing horrors in Senegal. He could still see Schmaltz's face, its calm contempt as he was lowered onto his lifeboat, superior in his armchair. Corréard is working with a group on a petition against the Senegal administrators and Schmaltz, to investigate the illegal slave trade practised in Senegal after Schmaltz arrived. His group wants to shine a light on the rotten underbelly of the establishment. The horrors on the raft had just been the beginning of the human suffering caused by Schmaltz. Corréard tells Géricault what he has been able to find out and embellishes the scene with details.

Three hundred and ninety-six people had been on the *Medusa*. Two hundred and forty-six made it to Senegal on the lifeboats, led by Schmaltz. The formalities of the handover of Senegal from Britain to France had been hampered by the chaos caused by the shipwreck. Schmaltz seemed more concerned by the paperwork left on the ship than the raft full of people he had left stranded. It would take a further six months till he was put in charge of the colony.

Senegal had been colonised primarily to export slaves to the French West Indies. On leaving Paris, Schmaltz had been given strict instructions to end the exportation of slaves and to lay the foundations for a slaveless economy. The gum trade would replace the wealth earned from slaving, and there were natural

resources to exploit. The message came from King Louis XVIII and the Bourbon regime; the reasons for ending slavery were less about humanitarian concerns than the decline in its economic value, and the realisation that there was political capital in the abolitionist movement. The handover of Senegal from Britain to France was the moment to close down the slave trade. Not long after Schmaltz became governor, at the beginning of 1817, Louis XVIII officially banned the importation of slaves to the French colonies. The following year he would formally abolish the slave trade.

Schmaltz saw an opportunity to exploit. Humans were a more efficient and lucrative commodity than crops and he would profit from one last push before the slave trade was shut down. Corréard has recently read about French vessels loading slaves under cover onto ships at the port of Saint-Louis. He tells Géricault about what he has heard. Some ships were tiny, only able to fit about ten people, others were larger vessels into which 300 would be crammed and chained into spaces no bigger than coffins. Between 1805 and 1813, twenty people were exported as slaves by France and Britain from Senegal. In the year Schmaltz became governor that figure grew to 757. In the six-year period that followed, the numbers grew exponentially: 13,617 people were stolen from Senegal.

One story Corréard tells is of another shipwreck. Captain Le Rodeur, his boat full of chained-up humans suffering from oph-thalmia – a disease which would make them blind – sank it as though they were nothing more than rats. He saw the problem as an economic one: his stock was tarnished and without value. If he could make the episode look like a naval disaster, then he could claim on the insurance.

Corréard wants Géricault to support his campaign. *The Raft* is an icon around which to build it, but they need Géricault's

involvement. Géricault tells Corréard that he has been thinking of stopping painting altogether and is keen to help in any way he can. In truth, the troubles of the outside world feel too big to take on. He is emotionally, professionally and creatively lost. He was left with significant financial support after his mother's and grandmother's deaths, allowing him the freedom to work without worries and to take on a project as ambitious as *The Raft*. But with the painting left unsold at the Salon he is now close to bankruptcy. It has been a huge financial gamble and appears not to have paid off.

Then an offer comes out of the blue which suggests a route out of the financial hole. An eccentric entrepreneur, James Bullock, invites Géricault to exhibit *The Raft* in London. He has a private gallery in Piccadilly, the Egyptian Hall, which pulls in paying crowds to view its displays of curiosities and exotic mysteries. Géricault arrives ahead of the painting, and the two men work together on an exhibition pamphlet, which includes a hastily drawn print of the work and a shortened version of Corréard and Savigny's story. Adverts are placed in popular publications and newspapers. The painting is displayed as if part of a theatrical set. The crowds pour in, and over the following six months it is claimed that 50,000 visitors pay to see it.

The exhibition is a grand spectacle and an even bigger financial success. The painting travels to Dublin, the first of a number of trips lined up. But a panorama painting inspired by *The Raft* eclipses it. The twentieth-century biographer Lorenz Eitner describes the scene, in which a vast roll of canvas is slowly unravelled in front of an audience, accompanied by an elaborate orchestral score and a light show projected onto it, slowly revealing huge, crude, figurative depictions of successive episodes from the catastrophe. A poetic masterpiece is upstaged by pantomime gimmickry. The second show is a

failure and closes early, eating into the substantial profits the pair have made.

Géricault splits his trip in two. He briefly travels to Brussels to pay his respects to the self-exiled David, before returning to London. As a leading figure in the revolution, a prominent supporter of Napoleon, and having voted for the execution of King Louis XVI, David is threatened by the Bourbons' return to power. He has rejected the offer of a pardon by Louis XVIII. For both artists, politics and painting are violently, viscerally connected.

Géricault's fifteen months in England are busy. Buoyed by success, he forgets his resolve never to paint again. He arrives with rolls of lithograph paper, convinced that the new, transportable lithograph technique will be a route to profitable work. With no studio, he dedicates his time to printmaking and developing studies for paintings on his return to Paris. Corréard's stories of the slave trade have given him the idea for a new, large-scale project.

Géricault diagnoses himself with Anglomania and immerses himself in the culture of this new country. He is fascinated by England's love of brutal sports like boxing and finds himself drawn to the spectacle. He sees craft and artistry in the dance between the two fighters, the variety of movements made in and out of the contact zone. The twists of the torso and the power from the legs contorts the bodies into beautiful and surprising shapes. He wishes he could pause the fight and capture that conjoining of limbs, that smack of fist on flesh. He writes energetic letters to his friend Dedreux-Dorcy in Paris, essentially love letters to London. She is *not in the flush of youth but still beautiful and, surrounded with the prestige of a great fortune, got it into her head to fall madly in love with me, she is literally crazy about me ... she calls me the god of painting and addresses me as such.*

His love of horse-riding is hampered by bouts of debilitating

sciatica. Trips to the Epsom Derby and to the stables of various horse owners sate his appetite. He gambles large sums on racing and makes studies and a painting of the Derby, the horses gliding through the air, all their legs impossibly off the ground. The painting captures a depiction of speed.

London is a city split in two, containing both those who live under the gloom of industry and those fattened by it. Géricault is a hyena, searching through the foggy streets for subjects on which to feast his eyes. He hears from a friend about the upcoming execution of the Cato Street conspirators. Public executions are a popular spectacle in London, and he feels the need to witness this one and capture its brutality.

It is May Day, 1820. He makes his way down to Newgate Prison. The streets are thronged: thousands have come to attend the hanging. People are leaning out of the surrounding windows, looking down upon the scaffold. It is on a raised stage, over ten feet high, giving even those towards the back of the crowd a clear view. The spectators are infiltrated and encircled by armed officials, ready to clamp down on any unrest.

The Cato Street conspirators were to be hanged for their plot to execute the prime minister and his entire cabinet. The revolutionary group had significant public support, fuelled by the social unrest caused by economic hardship. Rumours circulated that one of the conspirators was a butcher who had promised to decapitate the cabinet and display their dripping heads on Westminster Bridge.

The five condemned are lined up neatly along the scaffold. The hangman has a practised grace and goes about his task in an orderly way. He carefully pulls the hoods over each victim's head then places it in a noose. The crowd falls temporarily silent as the bodies fall. Géricault records it all in his head, making a mental sketch of the scene.

A few months later he sketches a hanging in crayon and brown ink on paper. It is a frontal view, two of the condemned facing us directly. On the right a smartly dressed man has his back to us as he carefully lowers the hood over the first victim, whose eyes are closed, not wishing to take in a final view of the cruel world. Behind him is a figure barely drawn, a wash of shadow and some hastily drawn repeats of lines sketching out a body readying a noose. Then in the centre, standing alone, is the second victim, the cloth slightly transparent, his features imprinted on it. The imprint reads like a death mask, a premonition of what's to come. To the left is the final victim, yet to be hooded. A man, potentially a priest, looks at her while seemingly in prayer. His gaze is ignored. She stares straight out at us, face sternly set and eyes wide open. She returns our gaze as she confronts death. She challenges us to bear witness to the cruelty, not just of the act, but of our looking. Witnesses become perpetrators.

Géricault arranges the picture not to illustrate a specific hanging, but to challenge us. The first two figures induce pity, the final one shame and guilt. He turns a piece of theatre into an internal drama.

His trip to London is punctuated by illness. He spends weeks in bed with a wheezing cough, pain running through his chest. He is exhausted and has occasional outbreaks of a shaking, feverish sweat. Medics diagnose pneumonia. The coughing exacerbates his sciatica and bolts of burning pain sear up his back. Friends worry he is sinking back into melancholia. He is found walking like a ghost along the bank of the Thames, eyeing up the depths.

In the isolation of his room, he lights the coal-burning stove, blocks up the doors and the windows, giving the smoke no exit, lies down on his bed and waits for the pain to go. *Now more than ever seems it rich to die,/To cease upon the midnight with no pain . . .*

To take into the air my quiet breath. As the room fills with smoke and his eyelids grow heavy, the door bursts open, the windows are flung wide and the stove is put out. He promises his friend this will be his last attempt on his life

Géricault's mental ill health crippled his creative output, robbing him of the time and space he needed to make his work and the intensity and clarity of thought it required. Between bouts of depression and sickness Géricault began a four-year cycle of studies for a new, large-scale work. Triggered by his conversations with Corréard, he had become heavily involved in the campaign for the abolition of the slave trade. Progressive circles on both sides of the Channel were joining forces, and Géricault knew that his most worthwhile contribution would be a work of art. For the first time since he had produced *The Raft* he felt his energy and drive returning. This work would be its companion piece, the macro to its micro. The public and critics had not grasped the significance of the painting's message, so this time he would be more explicit in the politics.

His crayon-on-paper sketches, for *The Abolition of the Slave Trade*, depict multi-figure compositions. They mostly resemble the scenes of the mutiny on the *Medusa* that he had made in preparation for *The Raft*. Two groups surround two central figures; one is white and one is black. The white figure leans back, his arm holding a baton above his head, his body arched and ready to apply the full force of a blow. His left hand holds in place the black man, hands tied behind his back, restrained by another man. The victim's face is the most worked-up element of the drawing. It is a picture of calm concentration, another Christ-like figure facing up to cruel violence and staring straight into the perpetrator's eyes. The oppressor's face is barely drawn, more a skull-like mask of harsh, mean features, verging on caricature. His victim is the only figure fully humanised.

Two women, perhaps a mother and a child, perhaps the family of the victim, cannot bear to witness the violence. One covers her eyes in despair, the other looks out of the picture frame skywards, longing to be somewhere else. A naked female figure to the left tries desperately to reach up and grab the perpetrator's arm. Her efforts are in vain as she is seized at the elbow and wrestled into submission. The symmetrical set-up of the picture, split in half and with its shallow staging, sees a return to a more simplistic theatrical arrangement of the type seen in the works of David. Perhaps Géricault had been thrown by the criticism levelled at his complex asymmetric composition in *The Raft*. Here the message could not be clearer.

This painting mirrors the set-up of a sophisticated lithograph he made of two boxers fighting. They are seen from below, both leaning back, arms braced and ready to unleash their power. They are encircled by spectators sitting on the floor, occupying the same point of view as us. As with *The Raft*, we are brought into the action and made part of the crowd. This binary is set up as a fight between equals, a black boxer versus a white boxer. Much of the literature presumes the black boxer is based on Tom Molineaux, a bare-knuckle boxer and former slave. It is everything the similarly composed *Slave Trade* study isn't – which had explored the power of a white force on a black victim with a clear, didactic, political, humanitarian and ethical message to shine a light on Governor Schmaltz, on the Bourbon regime, on the cruel racial and economic injustices inflicted by colonial forces. In contrast, here is an image of near-perfect symmetry, suggesting a fight on a level playing field between two men as equals, a clear challenge to the racial hegemony presumed and enforced by society. The four-year duration of Géricault's studies for this painting testifies to the limits ill health put on his output, but also to the ambition of his plans.

Géricault never began, let alone completed, his *Abolition of the Slave Trade* painting. *The Raft* speaks of the same histories as those he hoped to explore in it. In taking an everyday scandal as his subject matter, Géricault had pushed History Painting into new territory.

Returning home in the final weeks of 1821, he was again close to bankruptcy, due to a combination of bad business choices and his excessive lifestyle. He was persuaded by one friend to invest heavily in the stock exchange, and by another to put money into an artificial stone factory. Both proved disastrous investments, and he sank again into financial insecurity and depression.

The horror perpetrated by people like Schmaltz began to be smoothed out, forgotten. In the nineteenth century, men like Schmaltz were given statues and turned into heroes. In Bristol in 1895, over 250 years after he was born, a statue was erected of Edward Colston. Cast in bronze, he stood tall and proud, a mediocre Victorian pastiche of heroism. The plaque read, 'Erected by citizens of Bristol as a memorial of one of the most virtuous and wise sons of the city'. In his role at the Royal African Company he oversaw the transportation of nearly 85,000 men, women and children across the Atlantic who were traded as stock, each branded with the company's logo. The 19,000 who died en route were tossed into the sea like litter.

Schmaltz and Colston are just two figures in this history of slavery. But what of the names and lives of those they treated like cargo? So many of their stories are violently severed from history. How do we retrieve these losses, and face up to our complicity in these horrors, the ways in which the foundations of our lives and privileges are still built on that silenced pain? It's the question Saidiya Hartman takes up in her essay 'Venus

in Two Acts', her attempt to reclaim the lives not recorded in the archives, to give voice to the *unspeakable* and the *silences*. As she says: *The intent of this practice is not to give voice to the slave, but rather to imagine what cannot be verified, a realm of experience which is situated between two zones of death – social and corporeal death – and to reckon with the precarious lives which are visible only in the moment of their disappearance*. But she finds it beyond reach, and acknowledges that the tragedy reoccurs when the failure to discover the voices repeats a loss. As she says, *Given the condition in which we find them, the only certainty is that we will lose them again, that they will expire or elude our grasp or collapse under the pressure of inquiry*.

How else might these histories be reclaimed?

In June 2020 Colston's statue was toppled by the citizens of Bristol, rolled to the quayside, the port where his ships would dock, and dropped unceremoniously into the harbour waters. On Instagram, the Bristol-based writer Nikesh Shukla posted a picture looking up at the empty plinth. *I can see more of the sky*, he wrote beneath it. The Bristol-based poet Vanessa Kisuule wrote of the statue spinning from the vertical to the horizontal, crashing down to reveal a surprise:

> *But as you landed, a piece of you fell off, broke away,*
> *And inside, nothing but air.*
> *This whole time, you were hollow.*

Hollow statue, hollow figure, hollow history. A few days after the toppling, Boris Johnson admonished the nation in a long Twitter thread. *We cannot now try to edit or censor our past. We cannot pretend we have a different history*. Yet it is the act of making sure we don't censor, pretend or erase that marks the pulling-down of the statue. It is something between community

activism and performance art, a history in motion as opposed to destruction. It is the fight against a narrative of erasure.

When I saw the footage of Colston coming down, I thought of the figure of hope from *The Raft*. A figure raised up; a figure pulled down. One figure looking to the future; one entangled in the histories in which we are complicit. History is not a passive act of reverence for propaganda. It is an active, creative and hard-won archaeology. Pulling down people like Colston is an act of deep remembering.

For years my dreams have been flooded. Rooms and bodies full of oceans, my bed a boat. Reaching for the surface, for gasps of air. But now I am facing fire. The night after the fire I barely sleep for waking dreams, visions burning across my retina, flaring across the bedroom walls. In the deep silence of night I can still hear the flames crackling, roaring with the odd jolting pop of something exploding, the crash and collapse of paintings. I'm in a cold sweat of anxiety but the heat of the fire suffocates me in waves across my body.

On my tongue I can taste the acrid smoke and fumes which are laid down my throat and up my nose like a new skin, as if I am full of them. Little flashing video reels play on a looped repeat, projecting themselves across the back of my eyelids. I am scared to close my eyes because of what I see: a bright, bright light. The silhouette of the studio against a still, flat, grey-blue evening sky. The solid black smoke pouring out from the gap in the closed door, rising and swirling into grey plumes. The square opening of the double doors, the solid, pulsing orange below the black, with bursts of flaring yellow heat. A hellscape.

I watch myself run panicked around the garden, as if I am a character in a first-person-perspective video game. My high-pitched repetition of FUCK, FUCK, FUCK, FUCK, only

occasionally broken by breathless crying. I hear the sound of heavy breathing in my ear, as if that version of myself is curled up next to me in bed, looking for comfort. Our cat Luna is snuggled into my side, confused, knowing I need her. There is an empty space in the bed where Kiran would be. I am longing for her to be home.

The following weeks are consumed by the clear-up. My mother and stepfather come down to look after me and help me work though the initial logistics, hiring a water pump, buying wellies and a torch, tackling the arduous bureaucracy and battle over insurance. I wait till Kiran's return a few days later to tell her what's happened. I break down fully and completely for the first time. I am inundated with offers of help from family, friends, neighbours and strangers, both in real life and on social media. But I need to clear up alone.

I am performing an act of mourning, a slow unfolding of grief as I confront the scale of the loss piece by piece. I need to make the hazy nightmare real. The clear-up will ground me. It is too personal a process to share. The long hours feel like a kind of ritual, but a small part of me sees it as a necessary punishment. Burning away at the heart of a deep well of sadness is an anger and resentment at my past self and at my reckless, manic obsessiveness.

The first few days are occupied with emptying the studio of water. The fire brigade return late at night, hours after they had finished putting out the blaze, to check that the heat levels had dropped. In the dark they hold a small heat camera up to the studio, scanning across the walls for any worrying pockets of hotness. The studio is submerged in a foot of water, still steaming, showing up as a brighter white on the screen, still over twenty degrees.

For the first two days I struggle to work out how to use a

hired industrial pump. It sludges out thick, black water, occasionally getting blocked by debris. I'm worried by the network of spider's-web electrical wires spreading across the studio. An electrician comes out to ensure the supply is completely cut. It appears I have been wading through water that could have lit up with a deadly electrical flare at any moment. I get the water down to a level as low as the pump will allow and begin the work of scooping the rest out with a bucket, filling hundreds with a dustpan. The water is solid black and becomes thicker and thicker as I get closer to the end. My hands and arms are covered in the gloppy, oily mixture. The space reeks of stale smoke, imbedded into the skeleton structure of the building. I am bone-tired but determined to carry on. I work from first light to last, want to get the whole thing over as quickly as possible. As I have not been sleeping it seems there is nothing better to do.

As I stand in the studio, daylight shines through the burnt-out doorway. It is an underworld in here, an exposed interior of things. A dehumidifier, the entire plastic container vanished, the leftover internal shell fossilised, is like a chunk of sunken ship pulled from a wreckage. The structure of the building is exposed, still standing, but the walls are stripped, the wood shrunk and brittle. I find a scrap of denim in the ash, the only remnant from boxes full of studio clothes. The insulation from the walls spills out of the building's frames and drops onto the floor, like the yellow fat of exposed flesh. Stacks of paintings have turned into frames, stripped completely of canvas, resembling the architecture of destroyed buildings. The canvas of one painting holds on, thinned into a brittle, black skin. With the slightest touch it breaks and falls into flakes of ash, floating to the floor. I can't tell what most of the paintings were as they are now all reduced to a similar state.

Sitting behind the work I had done with Ali had been

canvases made during the previous twelve years. Paintings from the *Orpheus and Eurydice* project, the *Demons Land* project, some uniquely personal canvases about myself and Kiran, paintings from the *Scavengers* series, the *Horsehead* series and *The Charnel House*. A career's worth of work. I discover handles of brushes, melted, with a few lonely, blackened bristles welded together. Pots and tins of paint, now flattened cylinders, paint oozing out of the side. Three bookshelves, barely recognisable, broken, burnt and laid across the floor. Hundreds of tubes of paint and medium fused into clumps. Plastics, metals, paints and mediums soldered into geological forms, like bits of coral or rock dug from the bottom of the sea. The beautiful, shocking deformation of a huge sheet of Perspex, folded like paper by the fire. A laptop, two projectors, mediums, boxes of personal belongings, a camera, a tripod, heaters, lightening panels, books, frames, memories, whole worlds.

I drag out burnt remains as I go. I make huge piles in the garden and fill a big skip. I slowly sort everything into groups. I decide that anything that was once part of a painting will be kept. It would be too crippling to get rid of it all. Once the studio is clear, I make a vain effort to mop out the last of the water; I even keep three buckets full of the smoke-filled stuff. I slowly start bringing the kept remains back in and organise them in sections as neatly as possible. I make two piles of the smaller debris (ash, scraps of wood, the thick paste from the floor). A few of the damaged bits of equipment I kept in the corner. The paints and brushes are beyond use, but I clean them up and put them into the boxes. I am turning the whole studio into an urn whose ashes I can't yet bear to scatter. I need to honour the work somehow, to lay it to rest. It's too early to know how to do this, or what I mean, but I know I cannot get rid of it yet. I am not ready to let go of what has already gone.

In shock, I spend the days on autopilot, working through the destruction. But mainly I am lifted by an overwhelming sense of relief, close to manic joy. For a moment during the fire I had seen a near-future fold out in front of me. I had seen the fire spreading and taking houses and lives. I had seen myself inhale more smoke and collapse and be lost with everything else. I am washed through with relief, a balm which flushes out the crushing waves of grief, shock and anxiety. I am alive. Kiran is safe. Luna is safe. The fire puts things dramatically and instantaneously into perspective.

My heart is swelling with the compassion and love everyone has shown. Neighbours make exquisite Indian meals, friends send flowers, my sisters, nieces and nephews beautiful, phoenix-themed gifts. Every time I feel crushed I am pulled up by kindness. Usually, I'm run through with cynicism about social media and the way it makes us live in an unhinged world disconnected from reality, but during this crisis many hands reach out to hold mine across the digital space. Depression can be isolating and alienating, but these small, lovely, profound, moving acts of kindness turn a period of devastation into one of warmth and connectivity.

Among the debris I make a surprising find. A folded piece of A3 paper, hidden or protected under something else, has survived. As I unfold it, its sections barely hold together. It is covered in a thick paste of smog, but an image is just about visible below the charcoal-covered surface. It is the printout of *The Raft*, the image that started everything. Its survival would feel impossible were this fiction: a neat, crude symmetry. Only two details of the image can be made out, if you look really hard into the dark. The father and son in the bottom left-hand corner, and the figure of hope, his waving arm and strip of fabric just visible. That small symbol of optimism, only just present, is too much.

I hold it with more care and attention than I have held anything before, terrified of damaging it. I carefully fold it back and store it inside a small box in the house.

When writing to Ali to postpone the unveiling, I didn't disclose the reasons why. I have not been able to tell him what has happened. But his rearranged visit looms and I am knotted with nerves, swallowed by guilt, unsure what to say or do. I clean up the studio as far as is possible.

We walk there in silence. I have spent the morning worrying whether I should tell him about the fire while we are in the house or in the studio itself, and decide on the latter. When we enter the shell of the building, I'm certain he must be able to smell the smoke and the damp. We stand silent for a minute, and then I stutter and stumble over my words, explaining that something has happened, that the unveiling has been delayed. Ali has heard about a fire from his daughter on social media. *Is everything OK?* Words clog in my mouth, retreat in my throat, snatch all my breath away. I break down into a chest-heaving panic of tears, and all I can say is, *I am so sorry Ali, I am so so sorry.* Ali reaches forwards, opens his arms and takes me into an embrace. I plant my face in his chest and weep and shake. This is not what I planned. *You are alive. You are not hurt?*

I don't remember the words I use to describe what has happened. I try my best to explain what has been lost. He is shocked, visibly shaken and upset, but mainly relieved I am OK. He says he has lost many friends and can't bear the thought of losing another. He is just happy that I am here. I had been so preoccupied about the loss of the paintings and my shame at what I had stolen from him through my stupidity that I hadn't thought his concern would be for me. After a cup of coffee Ali asks, *Can I see what's left?* Although we have been standing in the studio for a long while, Ali has no idea

of the extent of the devastation, of what little remains and in what form.

I describe to Ali what the studio looked like before the fire: the set-up of the final triptych, the cave-like space and surround of stacks of paintings from the work we had done over the last few years. I had held off showing Ali the final works, wanting them to be a surprise, and now I am left with the limits of language, and the crumbling nature of my memory to reconstruct the painting with words. But I want Ali to know what we had built together.

We move in a haphazard order around the room. We feel what's left of the walls, sift through the piles of paintings and the burnt remains of boards. There is only so long I can avoid showing him what remains of the triptych.

The imagery and paint are gone. The resin, the mouths, the thick layers of paint, the expanding foam, rose petals, hair, all burnt away. But some of the substructure has survived. The three large boxes have not been destroyed in the same way as everything else. Because of the method by which they were made, solid like sculpture, there is a lot more left. The exterior of the boxes is solid, and although the wood is now bent, frayed and brittle, it still holds firmly together. Shards and burnt panels of the small boxes remain, along with fragments of wood, the shaped chicken wire, copper screws, bits of fabric ripped from Kiran's old red dress, piles of charcoaled wood and fabric stuffed into the previously hidden spaces of the work. They are now monochrome images of blacks, whites and greys save for the odd burst of red. Each box, with its graded architecture of wooded and metal frames, resembles a blown-open building. Each box now looks like an aerial view down and across a bombed-out city. They are uncannily, unmistakably like drone shots across Aleppo or city views from the street level of Damascus, cities

of buildings seen from above or below, their interior damage revealed. In some cruel alchemy the fire has transformed rather than destroyed the paintings into the most literal and visceral recreation of the hellscape Ali fled a few years ago. It has turned the paintings into rubble and exploded damage, terrifyingly reminiscent of what the bus stop must have looked like when the bomb went off and he lost his sight.

The burnt boxes are a mirror of the studio. We are standing in a place reminiscent of them – we are in the same place as them. The safe space between the two worlds of painting and reality has been blown apart. I now don't know if we are inside a painting, a memory or the burnt-out studio. I feel dizzy, sick with vertigo, like a rupture has opened up in the world. Later Ali tells me he felt the same uncanny sense of the strange and familiar, of worlds colliding, of a cruel coming-true of everything we had set out to do. We are inside the painting and inside his past.

As I describe what they look like, and what it used to look like, Ali runs his hand across the surface. The textures repeat and everything feels the same. His hand reaches into a small box, where the brittle wood crumbles. Ali is unnerved by the fragility of it all. He fears destroying the work simply by touching it. I try to guide him away from the odd shard of glass and sharp bits of wire, but he wants to carefully feel at these points. A box opens up into a room, a street of a city, before collapsing back into what it is, no more or less. We feel above it, then below it, then inside it, and then just stand in front of it, knowing it to be a painting lost to a fire and nothing more. For a moment, though, the fire has done something transformational beyond our comprehension. *You must keep this*, Ali tells me. I tell him how I have decided to keep everything we have looked through in the studio, even though I am not sure why.

Ali asks if the paintings we looked at when he first came to

the studio are here. I take him to the stack of huge canvases against the wall and reach his hand to the exposed frame, saying this is where the canvas would have been. I get him to reach further through, then show him another, and another, and another. He feels the absent spaces that had been filled with canvas, paint, images, narratives. *I need to get out of here*, Ali says. He is suddenly shaking, uncertain on his feet as I lead him outside. For a moment I think he is going to faint, or collapse.

He rests his hands on his knees and gets out his e-cigarette while I fetch him a seat. Once he has caught himself, we go inside for a coffee and chat a little more, but he soon wants to go home, as he is hit by the weight of it all. He promises me he is OK, but I can tell he is emptied by the experience and doesn't want to show me. The guilt floods back in. It was a cruelty to bring him here. The project had been working towards catharsis. Now I am terrified I have created fresh wounds for him. Ali promises me he just needs time to process it and that he will be in touch.

In the days of waiting, I spend a lot of time in the studio. The extent of the loss has started to hit me. Paintings record histories and contain lives; everything leaves its mark and then exists – or half exists. Paintings never forget, they contain memories of the marks made and the damage done to them. The act of painting is an exploration of grief, an expression of sorrow, an articulation of death. It is as much about what's not there as what is. The hollowed-out frames in the studio painfully speak of this truth. Does the studio remember all the things that have been lost? Are their histories still alive in the remnants of these paintings?

Paintings chronicle personal and literal time. They are sites of palimpsest, recording ghosts and echoes of erasures. In the landscapes of Anselm Kiefer, we see paintings rendered with such brutal accretion of matter that they verge on the archaeological.

Their levels of strata reach into deepest times. The scarred surfaces of Antonio Tàpies's paintings are made of cement and sand, as if they have been sliced out of the streets of Barcelona. Like those of Alberto Burri, they are sites of damage, zones of trauma. In Oscar Murillo's paintings, marks are collected from global travel and remixed and rearranged, collaged maps which collapse time and space. In the abstract landscapes of Brian Graham, paintings are archaeological digs which require the viewer to piece together the fragments of imagery to connect with ancestors in Swanscombe and Boxgrove. The paintings open a doorway to pre-*Homo sapiens* history. Paintings are prayers to lost pasts.

Yet the longer I spend in the studio, the less I look at what has gone. Instead I start to see the remains as a new thing. The revelation of the burnt substructure of the triptych particularly strikes me, previously hidden, now exposed. What had been visible has been removed. Hidden worlds and deep forms have been revealed, a universal architecture of painting much like the language of mathematics that underpins the universe. A beautiful, haunting, dark vision has emerged from beneath my clumsy imagery and mark-making. Despite my attempts to create something, I had got in the way. Or perhaps I now just need to believe that the loss has come to something.

The mouths, faces and stories of the paintings are now gone and only boxes, frames and charred piles of burnt fragments remain. In the place of the mass of bodily references is a mass of fragmented, architectural ones. Even the colour of the bodies has gone; what remains is monochrome. I am reminded again of the rupture of the bomb which changed Ali's life, when time became a singular moment. The scattered material, the piles of burnt rubble, the organised chaos of destruction.

Counter to that, paintings can encompass an entire life, the

way in which we carry our trauma, our pasts and everything that has happened to us. The self is an accumulation of memories, some semi-erased, all of which leave echoes and traces in us. I had been trying to access Ali's past in some ludicrous act of imaginative time travel. But our pasts exist in our present. In this studio I sense the traces of the lines of all the work I have produced here, and of lives and worlds which have passed. A scrap of fabric holds a glimmer of cracked red paint, a tiny shard of what once was an entire painting. The burnt frame of a painting is now a window, its former image forgotten, holding the experience of what has happened. The studio has accidentally become the interior of a body, replicating Ali and myself. It contains translated hauntings of everything that has passed through it. It is not just a space of mourning, it is in mourning itself, and is desperately trying to remember what it once was.

12

Endings

*I wanted to live in a world in which the antidote
to shame is not honour, but honesty.*

MAGGIE NELSON

Géricault's relationship with the alienist (psychiatrist) Étienne-Jean Georget is shrouded in mystery. It appears he was Georget's patient, but the exact nature of the collaboration between the two men is unknown. A friend had encouraged Géricault to seek help for his depression and he had been introduced to Georget, and ultimately to his asylum. His visits to the asylum led to the final great works of Géricault's short life.

During their time together, Géricault produced a series of ten portraits of Georget's psychiatric patients. Each of the sitters had been diagnosed with a different type of monomania, a compulsive obsession. Could Géricault have been admitted as a patient for his compulsions? Or was Géricault producing work for a commission from Georget, perhaps to be used as examples in

teaching at public lectures? Could the portraits have been part of Georget's treatment of Géricault; a way to help cure his illness using art as therapy? Or perhaps they were produced as a collaborative exploration of a wider psychiatric treatise that combined art and science? The works don't answer these questions, but they do reveal a great deal.

Georget, who was four years younger than Géricault, was fast becoming one of the leading psychiatrists of the day. He was soon appointed director of an asylum. There was an intensity to him that Géricault recognised in himself. His expertise lay in forms of mania and the relationship between external and internal indicators of the condition. Georget was highly sceptical of his predecessors' trust in physiognomy, the widely held belief that a person's facial features or the shape of their head signifies their mental state. Georget believed that the stimulus for mania must be an internal product of the nervous system of the brain, which worked itself out into a patient's behaviour. The paintings might have been an attempt to debunk the myths of the day.

History is silent about the reason why Géricault entered the asylum and what took place there, save for the remarkable paintings he produced. The asylum was a fearful place where society hid people who did not conform to reason and order. Georget was at the forefront of enlightening approaches to mental health, setting up therapeutic groups at the Salpêtrière Hospital. He believed mental illness was not a fixed, permanent state but something which changed according to circumstances, something that could be treated. He saw the route to this as therapeutic, exploring the internal and past lives of the individual in order to heal their estrangements from self and society. He viewed the individual psyche as complex and unknowable, both to the self and to others, and thought that these forms of alienation were things that affected us all to different degrees.

Therefore the psychiatrist's role was to observe, not just to diagnose. If we were able to pay close attention to the state of each individual, rather than generalise and categorise them according to their illness, healing might be possible. Géricault's paintings step into this arena of psychological thought.

Of the ten paintings only five survive. Three are of men: the child snatcher, whose mania led him to believe that the child he stole was his own; the kleptomaniac, who could not resist his urge to steal; and an elderly man under the delusion of military greatness. The other two paintings are of women, both elderly. One is crippled by envy and the other addicted to gambling. The lives of these five people seem not to be their own. All five show the subjects situated in front of dark, ambiguous backgrounds, free of any context or indicators of where they are. Their faces are all brightly lit, and our attention is focused there. They all look beyond the frame. None of them return Géricault's gaze or, therefore, ours.

It is striking that none of the portraits resort to archetype, to a caricature portrayal of their illness. Each is treated with the simple dignity of observation. There is a humaneness to Géricault's objectivity. He is almost medical in his attention to the details in front of him. Here, the job of the portrait painter is similar to that of a doctor or scientist; he examines the evidence presented to him, free of judgement. Each portrait feels like a living, breathing individual. They have not been deformed or translated into myth, not mutated into monstrous or devilish clichés of mental illness. The paintings are not the grotesque, subhuman depictions of mental illness that other artists at the time were producing. Instead they are intimate, vulnerable portrayals. In their naturalism they are precursors, by a few decades, of the Realism of Gustave Courbet. They are radically ahead of their time and genuinely avant-garde creations. In inducing

empathy where there was usually none, they become political. Géricault takes these individuals from the hidden underbelly of society and confers on them the grand status of portraiture.

A large part of these paintings' radicalism is the accident of their context, which freed Géricault of the need to situate them within the staging of high art. He doesn't need to render the figures appropriate for the gaze of gallery viewers, and they are allowed to exist in a space of ambivalence. Their import is both more straightforward and more elusive than would otherwise have been the case.

The portraits were clearly painted at pace, in a furious burst of energy. They are built up with thin, translucent layers, applied swiftly but also with remarkable care and lightness of touch. The combination of speed and attention to detail lends a force to their creation. Before and after making these paintings Géricault was embroiled in a suffocating mixture of financial, emotional, physical and psychological pain. Perhaps the work was a temporary distraction.

An equal intensity is found in the sitters' facial expressions. The child snatcher's lips are turned down in sadness, his brow tightened with confusion and worry. The woman crippled by envy stares into the distance, every muscle in her face taut. The gambling woman is in a state of stupefaction, eyes wide open, looking outwards into nothingness, mouth and jaw slack, lips slightly ajar.

The atmosphere is heightened by the lighting in the paintings. The faces are spotlit, but with dark shadows and each contour of the face heavily etched. Géricault makes no generalisations, even in the palette he uses for the flesh of each figure. The gaunt, washed-out greys of the woman addicted to gambling contrast with the ruddier skin of the kleptomaniac and the red eyes of the envious woman. Much of the literature

about the paintings considers them examples of portraits of expressive physiognomy, where the face is the stage on which the soul expresses itself. Yet perhaps the opposite is true. There is no doubt we can see some kind of cause and effect between inner struggle and outward expression, but it is the emotional aftermath of the struggle that is expressed rather than the struggle itself.

We witness the almost semi-conscious zombification of the woman addicted to gambling, the pent-up anger in the woman overcome by envy, the wrought worry of the child snatcher and the blankness of the kleptomaniac – which is perhaps the most revealing, as it attests to what can't be seen or revealed as much as what can. Géricault avoids presumptions about how an illness might exhibit itself, instead capturing the individual suffering each figure experiences. He doesn't attempt to excavate explanations which are beyond reach. The faces are less a window into the soul and more a series of masks that confirm the unknowability of another person, the elusiveness of empathy.

Not one of the figures engages directly with Géricault. With the same pose given to all the figures, this is unlikely to be a coincidence; it is a directorial choice of Géricault's. We are looking at faces which don't look back, increasing our sense that the personal is impenetrable. We cannot reach them, possess them or fully know them. They remain, like all other humans, mysteries.

The paintings' suspension of judgement prompts both painter and viewer to enter the therapeutic spaces Georget encouraged. The portraits unfold with more depth each time we look at them, raising more questions about their internal complexities. As the psychotherapist Robert Snell observes, *studying them can alert us to the involuntary dynamic, the kaleidoscopic quality of our own mental lives.*

Géricault completed another set of drawings around this time, possibly also in collaboration with Georget. Georget published extensively about investigations he had undertaken on dissected cadavers. He believed there was a link between a person's nervous system and mental disorder, so he studied the interior workings of bodies of patients who had suffered from certain illnesses to uncover their mysteries. Géricault produced a series of studies of corpses stripped of their skin.

They are utterly unlike the dark images of the heads and limbs he had made a few years before, being observational still lives which reveal the musculature of the human body stripped bare. In their focus on the architecture of the body they were perhaps not just studies but part of a scientific investigation; at the very least, they indicate the belief Géricault shared with Georget that the unseen inner workings of the body reveal something about an individual's psychological condition. His approach was scientific in its rigour and in its desire to understand what cannot be known as much as what can.

Depression had stalked Géricault's family. His uncle and grandfather had died insane, as had one of Alexandrine's sons. Géricault himself had had severe episodes of depression and suicidal intentions. A couple of years earlier he had witnessed a suicide first-hand, when accompanying a friend to visit General Letellier, a veteran of the Napoleonic Wars. Letellier had recently lost his wife to a tragic carriage accident. Crippled by grief and a broken heart, he retreated to the privacy of his bedroom, lay down on his bed, took out his gun and shot himself. A man who had been through so much hardship defeated by love.

What happened next is incredibly revealing. Géricault's first instinct on learning of the suicide was to take out his pencil and paper and draw what he saw. Later he would turn the study into a beautiful and moving small painting, a homage to Letellier.

The immediacy of the drawing is like a eulogy or a final prayer. The background is sketched in with the lightest of marks, barely visible, but still meticulous in the depiction of the architecture of the room. The gun is present, half drawn. It is only the clothed corpse and the head which are fully portrayed, constructed with dense, cross-hatched areas of shading that shape the face.

The viewer's eye is drawn to and held in the centre, all attention focused on the face. The mouth hangs open, as if a last breath has only just been taken. The muscles around the eyes, which are slightly open, have slackened. There is nothing grotesque, ugly or macabre about the scene; it is quiet, gentle and touchingly beautiful. It gives the impression that love is the motivation of the portrait, rather than a morbid fascination. Géricault wished to capture things as they are, unflinchingly, to bear witness to the pains of life, however immediate, painful and personal. He made looking an act of lucidity.

Soon after completing the portraits of the insane, Géricault slid into another deep illness. Friends talked about his increasing paranoia and his fear of being persecuted. He started to see strangers lurking in shadows, craft adrift across the Seine which he was certain were following him with murderous intent. His psyche was flooded with the metaphors of water and boats, vessels into the underworlds of self and the dark depths of death.

A series of drawings of animals in combat from a few years before, many of them produced in London, illustrates how Géricault viewed his own struggles. In the drawings, lions and tigers fight. Lions attack and take down horses. Horses had always been for Géricault a metaphor for the inner states and turmoils of their riders, and these drawings lend themselves to metaphorical readings. We can interpret the savage attack on the horse, a symbol of power and grace, as a murderous assault on an individual's psychological wellbeing. The animalistic battle

is a wrestle to the death between two opposing wild forces. The most compelling drawing is the image of the triumphant lion, paws laid across the body of the horse, head turned with a nonchalant pride. The destructive force of the lion has won. The drawing is set in nature, but the background has been turned into a shallow stage. The horse is drawn with an elegance and tenderness that suggest deep mourning. The drawing is an omen of Géricault's struggles, and a powerful self-portrait of his psyche.

These late works are a form of Romanticism, expressed by the poet Rainer Maria Rilke in his articulation of the mission of the poet: *We are the bees of the invisible. We wildly collect the honey of the visible, to store it in the great golden hive of the invisible.* Perhaps Géricault was trying to portray that which can be seen and reaching for that which can't. It was what I was clumsily stumbling for with Ali, and perhaps what had accidentally been revealed by the fire.

Géricault accelerates his self-destruction. He takes himself on barebacked horse rides into the forest, going at breakneck speed, pushing the animal to the limit of its capabilities. Over the coming months he has at least three accidents. The first fall leads to an abscess on his spinal column, which grows into a tumour. Doctors warn of the severity of the injury and the care he needs to take of his health. He ignores them with a near-suicidal recklessness. The next time he rides the pain is too much and the abscess rubs with the movement. He climbs off his horse, takes a sharp blade and pierces it. The burning wound leads to an infection across his leg.

The final fall is his last accident. He sets out on a ride and the rest is a blank. He wakes up in a ditch, his horse moaning next to him, a mewling sound he has never heard before, more like that of a wolf. He closes his eyes, feels the cold water seep

through his clothes. He can't feel his legs. He wakes in his bed, surrounded by familiar and strange faces. He is bedridden. The doctor suggests the tumour is now terminal.

He is moved to a bedroom at his father's house and has regular visitors, a mixture of doctors, carers and friends. His body is slowly winding down. The descriptions of him wasting away and his youthfulness being stripped back with every passing day are alarmingly reminiscent of the last time I visited my dad. I am sadder when I imagine watching Géricault slip towards death, over 200 years after he died in a room I can't enter, than I was seeing my own father die.

Géricault can barely turn due to the pain it causes. He is forced to lie motionless on his back. Over the next months he is operated on a few times. When they operate on his back he requests a mirror to be held up so that he can watch as the knife opens him up. Even in terminal illness, with his body wracked by pain, he is keen to dig deeper and to understand the nature of flesh. He has confronted the realities of other bodies, and now here is his own, reflected back to him in a rectangle of glass. He watches in fascination, amazed to see the speed with which his body is breaking down, to see himself opened up. He doesn't recognise himself. Each time they remove the tumour it grows back and spreads. It works its way into his bones and weight falls off him till he is a husk, broken down and erased from the inside out.

He dreams of the works he will make when he recovers, huge canvases painted with giant brushes. He wants to complete *Abolition of the Slave Trade*. He talks about paintings of horses and beautiful women. The descent towards death is filled with desire for art, horses, love and lust. He makes a study of his hand in crayon and watercolours. One hand draws the other, in an act of being flesh and capturing flesh simultaneously. He

observes the bulge of the veins, the translucency of the skin, the thinning of the hand as the skin pulls across the bones. He has become skeletal. He is a painting in reverse, his interior structures revealing themselves to him as his body seems to eat itself. It is a remarkable study of the last moments of life which bears witness to the rotting of flesh and the transient nature of existence. Not long before he dies, a cast is taken of his right hand, posed as if in the act of grasping a brush or pen. In the still-wet clay he gently writes a note, *To all those I love, farewell*.

He fades. The last light now; the gloaming. *There is nothing as important as the love of a mother*. He repeats this as if it is an incantation. His eyes drop softly shut and he takes a few final breaths, each thinner. Then stillness. A life spilling out, all memories loosening and then slipping from the body. I imagine his soul spirals out of the body and looks down at the empty shell. It drifts out of the window and spreads and scatters into dust, the many selves taken back into the matter of the world. The body will follow. A version of the artist as myth lives on in the artwork, ghosting and present in the imagination of others. We don't truly die till all memory of us has slipped away. He is still here, a ghost in the painting, haunting my studio.

At the funeral Corréard delivered the eulogy. Perhaps he spoke of the raw, youthful energy and drive of Géricault, the mag-netism of his looks and charisma. Dead at thirty-two. A number of depictions were made, by friends and followers, of Géricault on his deathbed. In one he is seen still painting, in another he is surrounded by etchings of works from his past, engravings of old masters, and copies he had made when younger of the work of painters such as Titian. On his deathbed he was surrounded by multiple images and windows onto other worlds and pasts, living his last moments as if within a mosaic of paintings.

Even before he died the scavengers alighted. Works were sold at ludicrously low sums to cover some of his extensive debts. At his death the estate was handed over to functionaries with no understanding of the value of the work they were given access to. Over 250 paintings and thousands of drawings were crudely grouped, listed and valued for less than the cost of the materials. An auction was held and the works were sold to a mixture of friends, artists and private collectors for 52,000 francs, half what a single large work by a celebrated painter might be expected to get. But it is still more than the 3,000 francs the collection had been valued at. At auction the majority of the works were made viewable to the public for the first time, lifted from the privacy of the studio, providing a glance into the depth and breadth of his output and the sheer scale of his imagination and talent – before vanishing into the hands of collectors.

The Raft finally sold. Dedreux-Dorcy and Comte de Forbin, the director of the Louvre, finally convinced the state to purchase the work for a paltry 6,000 francs, the amount that might be expected for a modest small-scale work.

No single school of lineage emerged from Géricault's work. His legend imprinted itself across many artistic movements, each claiming ownership of him. He became as famous for his approach to his work as for the work itself, and shifted into cult mythology. He was the beautiful dandy, the artistic genius, the troubled creative, the macabre painter of decapitated heads, the artist who died tragically young. He was brought back to life as the figure people wanted him to be.

After he died a death mask was made from a cast of his head. The surviving bronze casts are ghoulish images: dark green and a mirror of the lifeless flesh of the decapitated heads he had made a few years before. His visage does not have the peaceful beauty of some death masks but is skull-like, withered and

gaunt, with deep sockets for eyes. Many versions were made and distributed among artists' studios as symbols. The possession of his mask came with an erotic charge: Delacroix wanted to kiss it, as if it to bring it to life. Géricault has become an icon. His head is separated from his body, his image from his person.

Before he died he wrote a simple one-line will, leaving everything to his father, who, now old and senile, wrote a note bequeathing their combined possessions to his grandson, Géricault's illegitimate son Georges-Hippolyte, who was now five years old and in foster care.

Fifteen years after his death a young sculptor, Antoine Étex, discovered that no monument or gravestone had been made for Géricault's burial place and set about righting the wrong. A community of artists and supporters gathered to raise the funds, but their attempts did not gain momentum and Étex decided to complete the job himself. A youthful stranger found him at work in his studio and said he wanted to offer his thanks for his generosity and that it wouldn't be forgotten. The next day the young man wrote a suicide note which laid out his last will and testament, requesting that 2,000 francs be left to Étex and a further 50,000 for the completion of the monument. He asked to be buried by the side of the father he never got to meet. He didn't go through with the suicide, but instead vanished into obscurity, living in a hotel room by the sea. After the first few years of his life he never met his mother or father again. Georges-Hippolyte died in 1882, nearly forty years after he wrote his will.

His mother, Alexandrine, lived her last years alone, sinking into a deep depression at her estate in Le Chesnay. One of her other sons died alone in an asylum, clinically insane. She was widowed in 1847 and it would be nearly thirty years till she died, aged ninety. She would never forget her nephew. Mothering him, encouraging him to paint, finding him a path into the

studio, their first kiss, their attempts to suppress lust and love, the pregnancy, the loss of a child, the loss of a loved one, the isolation of grief and shame. During her long life she surrounded herself with a private collection of works made by Géricault. She kept her collection secret, and no strangers were allowed to visit. Maybe we shouldn't attempt to access that room either. Perhaps by filling in the gaps we are trying to possess stories we should not.

In 1924, 100 years after he died, an exhibition of all Géricault's available work was displayed in France, organised by the Duc de Trevise and Pierre Dubaut. It was the first time since the auction that such a variety of his work had been presented to the public, and painstaking efforts were made to piece back together a broken mosaic of his output. For the first time, for many, it showed Géricault as more than *The Raft* and the myth that had been built around him. The exhibition was an act of repair, of reclamation. *The Raft* was merely one element in a sprawling archipelago of creativity of staggering variety.

Today will be the last time Ali visits. I wake at half three, head full, Luna lying across my legs. A while later she jumps off the bed and trots out into the corridor. A strange, warm glow fills the hallway and seeps into the bedroom. I get up and find her at the window in Kiran's office, staring out into the garden, no doubt excited by the flurry of birdsong. The view is of the sun rising behind the studio, announcing the arrival of the day. The last few weeks have been filled with new anxieties and worries. A month after my studio burned, the world has woken up to the spread of Covid-19, though there is yet to be any sense of urgency.

The spring sky is soaked with a beauty that should be a saccharine cliché yet feels like calm. My productivity levels have

declined steeply over the last weeks, but I sense a renewed hope that words and paint will spill out again. I can see the black rectangle onto the underworld darkness that is the burnt, open door to my studio. Under this sky it has dissolved into the wider surroundings and looks like a temporary entropy, like the seed of a great tree growing and determined to survive, rebirthing into the sky. This view is a microcosm of what seems like hope in these dark days. I send a photograph to my family and my mum notices the way the sky looks like the fire pouring around it, now outside and behind the studio, not inside it, a mirroring of what had happened. It is comforting to read it as a message about moving on.

Ali arrives and we go about our normal routine, touching the works, piecing them together. He wants to see the triptych again, but also to work more comprehensively through the stacks of burnt canvas frames and the piles of remnants. I have been thinking of what Ali had said about the dissolution of the boundary between art and reality, as if the studio itself has become, through the fire, a painting; has placed us in the space between the two worlds and burned down the divide. It makes the studio a strange space to be in, as if we are both inside a painting now.

The process over the next few hours is one of reverie as we attempt to piece together what has been lost. I want to retrace our journey and remember all the steps we have taken, all the works that have been made, and the stories that we have told to bring us to this point. Traces are here if we listen and look carefully. And in the debris I experience an extreme version of the feeling of completing a work of art, when the artist leaves the stage.

Ali and I visited the Ashmolean Museum some months before, to see the 9,500-year-old Jericho skull, lifted from the mud of the Levant. It arrives again in my mind: the care with which the mourners had wrapped a cloth round the head of the child and

pulled it tight, the soft bones of the skull slightly deformed by the pressure of the fabric. After the flesh had rotted away the skull was removed with exquisite care. A handful of wet, claggy plaster was loaded into a palm and smeared over the front of it. Clay bound this entire community together. Once baked, the skull became a site of memories. In the sockets where the eyes once lay, two shells were carefully embedded. What do they see, what do the sealed lips say? If we hold our ears up to them will we hear the sea, the River Lethe, the waters of forgetfulness? As the generations hand the skull down to their descendants it becomes an ancestor of mourning and holds many histories. It is no longer a house for one, but a house for many.

I wanted to hold it up to my ear, to place it in Ali's hands. But the Jericho skull is fragile and precious. It sits in a glass cage. It seems to commune with the dead and could take us to the past if we were just able to hold it. Or perhaps it has now been emptied out into a mere object, the lives it contained lost when it was dug from the ground by the archaeologist Kathleen Kenyon in 1953. The museum has become a cemetery.

I had been thinking of a painting as a structure, a room made by a painter, into which physical and conceptual material is brought. I had not realised that much of that material leaves the room when the artist steps out. When Géricault died, so too did much of what we want to believe is in the work. It is the viewer's room now, and their story to tell.

Everything I brought into the studio vanished when I finished making the paintings. It left with me. It is not in the work but in the process. The work awaits the arrival of new viewers. And the fire wrought another transformation. The noise of the mouths in the paintings had left little room for communication, had swallowed all external voices. Now these works are wide-open spaces to be filled. Ali has a gap through which to enter.

His hands reach inside box after box, surveying the damaged sides of each, making sense of the surface, the scale, the order and arrangement of everything. The scale in them shifts, as if the hand entering is feeling into an entire room, or inside some shrunken world. Each box is a little empty stage, the mouths and heads gone, the actors cleared out. Each is a metaphor of a painting as a container which can be emptied and refilled with endless arrays of meaning. Paint is a flexible and fluid language, able to contain light, time and emotion. But paintings also contain voices, and stories, and are screens onto which we can project our own narratives and find ourselves within. In emptying themselves out the paintings have provided Ali with a chance to step onto the stage and to add his own voice. The stories start flowing from him, and he circles back to one in particular.

Ali is reminded of an unnerving moment in Damascus, after a particularly severe bombing raid, when he visited a bombed-out theatre. The stage was empty, the audience gone. There he found access to his own memories. The burnt boxes remind him of the empty stage waiting for a voice, are incomplete without him. Through the absence of the mouths and voices and layers of imagery, an inversion has happened. The works have opened up. They listen rather than preach. I had put the artist ahead of the artwork.

In Martin Kippenberger's *Raft* works the drawings and prints are often ignored, as attention is focused on the paintings. Yet there is clearly not meant to be a hierarchy in the different media, and it is these small, quieter works that reveal the mourning exhalation of his final creative breaths.

The movement from Kippenberger's paintings to his drawings and prints is interesting. In many of the drawings the prankster energy of the paintings is absent, there is an altogether different

mood. In place of the looseness is a focus, care and attention to detail not often associated with Kippenberger's work. They are slower images, built up of fine lines and a delicacy of touch. A number of the prints and drawings were done directly on hotel stationery, not uncommon in Kippenberger's career, as he would democratically repurpose almost any material. Why hotel stationery? In part, of course, because it was to hand, and he wanted to take the ephemera of life and recycle it into new forms. Yet hotels are such rich spaces, with their odd blending of public and private spheres. Transient spaces, what would fashionably be called liminal, between states. They are places of transition, between one place and another. This hotel stationery sat alongside the other reappearing motif, of coins and currency, collected from around the world, affixed to the pages, creating a picture plane in which figures float in these joint symbols of travel, of transpiration, of being neither here nor there. Who are these coins for? What debt is there? Perhaps this is all a hint that these images are a preparation for the ultimate journey from life into death? Are they the fee for Charon as we cross the Styx and head to Hades, Kippenberger giving us a wink and a nod that even in death there is commerce?

Certainly, this movement into new states is present every-where in Kippenberger's drawings. In one the same pose is repeated, mirrored. One set of head and arms faces down and the other up, both spiralling out from the picture's centre, as if a mirror is held there, turning the figures into conjoined twins linked at the shoulders. Both figures are bent over, so only the arms, shoulder and back of the head can be seen. Both reach into the white space of the page, into nothingness, as if spinning around and from each other, from existence into non-existence. In one of the few drawings without a figure, Kippenberger fills most of the page with a small section from the bottom of *The*

Raft. A stage emptied of its occupants, seen as if we are floating above it. In the space below the raft are the stencilled words *The End*. Of all his works, this is the most explicit in its bare, stark confrontation of death and its emptiness. We the viewer, hovering in that space above, become the only living form. I think back to *The Raft* and how it sails on beyond Géricault's intention, beyond his death. It travels through history, gathering up new meanings while evolving and shedding old ones. Artworks are not static or singular.

When conservators varnished Braque's paper collages, he was indignant with rage. They did this to stop the fragile paper from rotting and degrading and preserve the works as pieces of historical, artistic and economic value. But Braque saw the varnishing as a torture; it was as if the conservators were killing a living thing and then pickling it. He thought the work should just be left to rot. We should stop seeing paintings as static things to preserve at all costs, kept behind glass in museums. An artwork is merely a vessel which contains meaning which is fluidly changing and shifting. In Japanese restoration, when a ceramic object is damaged the repair is not hidden, but rather filled in and celebrated in gold.

The wreckage of the *Medusa* lies at the bottom of the sea, unseen, in the dark. Presumably broken, rotted, filled with new life, covered in the sea's skin. Ali and I had been exploring the wreck of self at the bottom of the sea, diving into and swimming through lost and semi-destroyed spaces, looking to piece pasts back together.

On the wall of the Louvre, *The Raft of the Medusa* is devouring itself, swallowed by the chemically unstable black bitumen paint which slowly rises from the depths and paints itself from within. We are witnesses to the slow loss of a masterpiece. Viewers

try to imagine what it would have looked like. But perhaps we should see it not as dying, but mutating into something new. A raft moving through time, changing physically as it travels and speaking new truths to new ages, taking on new passengers along the way.

Paintings are not static, and neither is history. I had been trying to reach back to the past as if it were a thing awaiting discovery. The past is just a point we are seeing from now, and it is always moving as we do. The histories gathered in *The Raft* are not fixed but have been unfolding ever since it was completed. *The Raft* is a microcosm of the worst that humans are capable of doing to each other, but hope, in the form of a ghost ship on the horizon, still has a chance against despair. *The Raft* keeps searching for this hope, as does history. Its central black figure points to the politics of the slave trade in Senegal, and the raft becomes a metaphor for a wider metaphysical struggle of power and race. The French and British empires abused their colonial subjects in the horrors of the slave trade, stories which still play out and wreak damage. These are not dead histories laid out in textbooks but are still violating and oppressing people today.

In 2018, the Carters, Beyoncé and Jay-Z, released the song 'APES**T' as part of their collaborative album *Everything Is Love*, along with a video set at the Louvre. It opens with the sounds of rain, sirens and church bells over a black screen, before cutting to an ambivalent silhouetted figure, wearing ripped jeans and trainers, sitting on a roof outside the museum. Then the video cuts from outside to inside, and we are looking up from the floor to the ceiling of the museum's interior. It is ornate and symmetrical. A flashing light shifts the colour, and a new force is now in control of the space. Next are some cutaways to paintings, before the stars of the show appear. Beyoncé and Jay-Z stand in front of the *Mona Lisa*, backs to the world's most iconic

masterpiece, to which crowds flock magnetically. The singers are the main event now; they are the new icons. Then we see them at the top of the stairs with a supporting cast of dancers in front of *The Winged Victory of Samothrace*. The Hellenistic sculpture depicts the goddess of Victory standing on the prow of a ship, or the fragment of a ship. Here are The Carters, at the top of the stairs and the summit of the museum, looking out at us victorious, their curated outfits mimicking the fluid, folding white sculptural forms of the space they are occupying. This is not just a music video, it is a combination of dance, action, choreography, music, lyrics and cinematography to create a total artwork, every aspect of which is immaculately conceived and executed. They are in complete control of their vision, and we, the viewers, are dragged into their magnetic genius. Their access to the Louvre is a demonstration of their huge cultural and economic power. Here the world's most famous and popular museum and its artworks are merely the stage for a great play. In front of David's monumental canvas of *Napoleon Crowning Josephine*, a line of dancers with Beyoncé at the centre move in perfect synchronicity. Female bodies are given agency, the gaze controlled by the women, the dance led by Beyoncé. This is a crowning, and a new royal couple are in charge.

There is one painting they keep returning to. The film cuts to a white strip of fabric, held by a black hand, waving. It's a close-up of *The Raft*, shown in more detail than I have ever seen in real life. The quality of lighting and filming give a cinematic view into the painting, expanding it and clarifying it and focusing the eye, free of the distraction of the crowd and the glare of bad museum lighting and uneven varnish. The camera scans up the back of the black figure's back. It gives new angles, new ways into the work. Then, shot from below, panning out at pace, we see the painting in full for the first time. Jay-Z stands in front of

Géricault's *Raft*, head turned, looking back and up at the huge canvas.

The video cuts to another Géricault painting, *The Charging Chasseur*, which hangs opposite *The Raft*. That earlier painting of a soldier on horseback heading into war is all dynamic fear and movement. Then we jump to a film of a black man standing sculpturally still, in a video where movement runs throughout. He sits astride a horse, staring us down, the design of his trousers a nod to the American flag. The most iconic artists in the world take to the Louvre and draw straight lines between the histories recorded there and current affairs in the US. The oppressed black lives in the paintings hanging in the Louvre are the foundation of what's unfolding today. We are all complicit in an oppressive, violent present.

When the video cuts back to *The Raft* it is pushed further into the background, the scene being shot in a dim, flashing light. *The Raft* is only visible in snatches and all attention is on Jay-Z. Finally it drops further away as Jay-Z approaches the camera, hands clasped in prayer, looking out at us. APES**T is first and foremost a great song, entertaining and beguiling, with a beat and lyrics that drag you along. But it's also a powerful and defiant work of sophistication which uses *The Raft* as one piece of a complex jigsaw. The Carters are the stars, but the video also includes an array of dancers, who towards the end are given individual camera shots, their bodies contorting and bending into rhythmical shapes which are in equal part arresting, mesmeric and beautiful. The film is a vehicle – a new raft – which reaches across history and politics to demand we pay attention to issues around power, race, gender and human rights. *The Raft*, the museum and the past become an active site of confrontation, a place to ask questions and move forwards.

*

The studio is illuminated by the shafts of sun through the space where the door used to be. It is midday, so the sun is directly above it. The space is cave-like again, as if we have descended. I try to describe the subterranean atmosphere to Ali. As his hand pushes at the gaps where paint and image used to be, it seems he is feeling his way into pasts, lost layers, the damage and the wounds. We are the other side of the mirror, reaching out, trying to bring ourselves back. My hand is on Ali's, grasping it if I need to stop him reaching for a sharp surface, orchestrating his move-ments. We are leading each other in exploration.

When I was five my father and I made a drawing together. He laid his hand on a sheet of paper and I traced carefully around each of his fingers. We then covered my palm in blue paint and pressed it down in the outline of his. I had forgotten it existed when I found it in his filing cabinet. It reminds me of the last time I held his hand in mine, the skin paper-thin, the pulse almost vanished. I think of that picture now, an assertion of shared lives which most children will have made with their parents. It connects to the image Géricault made of his hand on his deathbed, trying to make concrete the self, even when his body was betraying him. Is painting an abasement of death, an assertion of consciousness and presence? Is it a remnant, like those hands in the caves, where our ancient ancestors filled their mouths with pigment, pressed their hands to the wall and sprayed it across them? Under Géricault's drawing of his hand is a shadow. The hand hovers just above the surface of the paper, much like mine and Ali's over the surfaces of the paintings. Perhaps painting is an expression of multiple hands reaching out, the artist and viewer on either side of the canvas.

I feel a vertiginous depth that opens wide before us. We have a sudden deep connection and the two of us feel completely synchronised. We reach across the gap into a feeling of love.

We see a darkness. We are in a deep, underwater space, a long, wide ocean with limitless dimensions. But there is a surface and a horizon. A light has entered through the wounds. We are swimming towards it, breathless and searching, filled with hope and love. I see my dad, Géricault, the small-boy version of me, Poor Tom, the fire, the bomb, the flowing paint, a sea full of mouths, an open door, or doors, and a window. On the surface of the water I see the underside of a wooden structure – the floor of a room, perhaps, or the underside of a painting, or a raft, bobbing on the sea, waiting for us to climb on board.

A few days later lockdown is announced, as the world wakes up to the scale and severity of the Covid-19 outbreak. I suspect it will be months till Ali can visit and months till the studio can be repaired and rebuilt. Months till I will be able to start painting again. I miss family and friends, the simple pleasures of human connection. The years of self-imposed isolation when I was drowned by grief and trauma feel a world away. All I wish for now is different types of touch, of hands reaching out across space from artist to viewer. Most days I sit in the studio and look through the remains, and gradually I think less of lost pasts and more of possible futures.

In the months of lockdown, it is that imaginative space I travel to reach other hands. I think to the cave paintings again, to the surround of hands. To the way that fire would have animated them and brought the ghosts to life. To art as ritual, at the centre of home, of family, of community. To the artist not as an individual but as a collective, reaching upwards and outwards beyond the limits of the self. Everything in contemporary life pushes us towards the individual, centres our selves in the world. This is a lie in which modern art participates when considering the importance of the author, the artist and the myth of individual genius. Or the importance of the viewer and their subjective take

on a work. *The Raft* points to the importance of the collective, where humanity is joined as part of a single living, breathing ecosystem. The raft is alive, travelling, gathering voices as it journeys into the future and back through the past. It's a model of history and of how to survive. As it moves, the cast grows and the chorus of voices on board speak to new stories and new lives. The painting signals as much to the new cast members it acquires as to those who survived the initial ordeal. We are all on board. And the raft keeps appearing, reshaping itself, coming in fresh forms and guises, images which show us the way.

In the earliest hours of 14 June 2017, on the fourth floor of a twenty-four-storey tower block, a fire erupted in a kitchen. Soon it spread to the window and latched itself onto the cladding, which had been installed a year earlier as part of a renovation scheme that put the exterior appearance of the building ahead of its structural and internal safety. Inside the aluminium cladding was a highly combustible polyethylene polymer filler. When exposed to fire it caught, melted, turned liquid and released huge amounts of energy. Internal doors did not meet fire stand-ards; the smoke-extraction system did not work; there appear to have been problems with gas pipes, and the water system was not fit for purpose. The fire raced up the cladding and engulfed the building.

The fire spread as a white scar, slicing diagonally up and across the building. The flaring border of orange and yellow was a radioactive wound glowing in the dark. The grid of rooms glimmered, signalling the hellscape inside. Soon smoke circled and rose like a gathering storm from within. Seventy-two people died inside.

In Jay Bernard's poem 'Hiss' there are echoes of the tragedy of the fire at Grenfell Tower, in West London. He describes a

building ravaged by fire as resembling some kind of sunken wreckage, soaked by the water which put it out. With its nod to multiple histories, including the transatlantic slave trade, it could be describing the wreckage of a ship at the bottom of a sea:

> *Going in when the firefighters left*
> *was like standing on the black beach*
> *with the sea suspended in the walls*

The interior of the building is described like the inside of a carcass; the building a living organism turned into a fragile skeleton. Bernard describes how black enters you and ghosts follow, searching for light, asking threefold:

> *What it was? What it was? What it was?*
> *in a vivid hiss heard only by your bones.*

The images of Grenfell after the fire resemble a skeleton or a burnt-out carcass. A wreckage towering up. Like Grenfell, *The Raft of the Medusa* was a symbol of a broken, corrupt system, of the Bourbon regime's toxic mix of incompetence and greed. Both Grenfell and *The Raft* are mirrors of what we have become, our failures of empathy and our broken system. Artists speak of the zeitgeist, as if it's a thing they can conjure, but the zeitgeist conjures itself, ruptures out and into the world in perfect form. We are Governor Schmaltz, cutting the rope, letting others drift of out to sea. We are complicit in Grenfell. But, as *The Raft* shows us, there is always hope amid the despair.

The photographer Khadija Saye's Twitter bio reads: *The same sun that melts the wax, hardens the clay.* Saye was only twenty-four when she died in the Grenfell fire. She was on the cusp of international acclaim, with major galleries and institutions making

approaches about future shows. She had just been selected as the youngest artist to be shown at the 2017 Diaspora pavilion at the Venice Biennale. She exhibited six photographs selected from a large body of self-portraits. Her mother was Christian and her father Muslim, and her work explored her British-Gambian identity. Her photos combined domestic objects with the iconography and religious practices of her mixed heritage. It was a migration of languages and symbols, collected together to make images, which were consciously elliptical.

In each image she poses in front of the camera. In one she holds what could be a bunch of flowers in her mouth, trumpeting them out towards us. In another her eyes are covered. In another still she holds a shell-like object to her ear, eyes closed, like a child listening for the sea. Saye made these images in the rooms of her home. The word 'camera' means room, a chamber where light is captured and held. In Saye's room and through her camera, she captured ghosts. Using a nineteenth-century technique, the collodion process, she was able to make the ghostly qualities more tangible. The paper was submerged in a silver-nitrate bath, the instability of the process causing the emergence of a ghostly image, as if appearing from nothingness. The image was non-reproducible and she felt she could transcend the limits of the photographic process. As she said, *With this process you surrender yourself to the unknown.* For Saye the photographic emergence, as if a cleansing, *ignites memories of baptisms.* In one of the images she faces outwards, her face covered, the palm of her hand spread and turned towards us. Four fingers are covered in horn-shaped, bone-like forms. The surface of the photograph is marked by the collodion process, with sweeps of tone captured, as if air and light have been traced and paused in motion. Ghostly swipes, like wind across the surface, assert the flatness of the picture plane, reminding us of the screen between viewer

and figure. This precarious and fragile image reaches intimately into spaces beyond.

Khadija Saye made these works on the twentieth floor of Grenfell Tower, and many more were lost with her, left unseen. Working from home, with a deep and focused attention on the specific roots of her background and the iconography and traditions of her life, she created images which are deeply personal, private and singular, *a reflection, physical manifestation of my relationship to the deep-rooted tradition of African Spirituality*. They are also universal. Like *The Raft of the Medusa*, they reach beyond the actuality of their subject matter and show how art can look beyond.

The first lockdown has reduced my contact with Ali to phone calls and emails. He writes to me about *The Raft*:

> Even if I went to the Louvre and stood there before *The Raft*, I know that I won't be able to touch it, to feel the texture, to explore and discover that painting with my fingers. I will never bridge that void between reality and imagination, between language and the visual. Perhaps all I can do is to stand on the verge of that void, the cliff edge, and commit the impossible, to step to that sphere where reality and imagination are inseparable. Sometimes I imagine strange sensations, like a craving in my fingers to touch this painting, to relieve myself from this obsession by creating a visual memory of *The Raft*.

The fire has shaken Ali, and in one phone call he says he is worried that perhaps he brought the destruction with him, a kind of irrational paranoia that art and reality had collapsed together and his past had found its way out in the studio. But we agree that we have accidentally made our own raft, that the burnt-out studio has become the vehicle, the space which

contains all the memories of our exploration and all the possibilities of new journeys.

Later Ali emails to expand upon his fears:

> Is it the fact that I will be always on that verge where reality and imagination meet and overlap? Exactly like when I found myself standing in the ruin of your burnt studio, struggling to overcome my shock and make sense, if any, of my story, your story, our journey on the raft we created in our project to voyage to the lost paradise of meaning. There, I stood touching the wreck of our project, your paintings, as if I was standing on the edge of that imaginary cliff with Poor Tom. But was it really an imaginary cliff? I saw the destruction of my beloved cities, of my home in your burnt paintings, a lost landscape far away from the dizzying height of that cliff.
>
> Is this life or is this fiction or something in the middle? I just don't know.

I can't leave things here, I have a responsibility to repair the literal and metaphorical damage caused. We are in too deep now, too far into the darkness.

A few months into lockdown, the burnt remains of the studio are still damp, but are gathered into some kind of order in stacks up against the wall and in piles on the floor. A rectangular beam of light illuminates the darkness, revealing the clouds of tiny burnt particles floating in the air, hovering, catching in the lungs and staining the skin. The clear-out has turned into a slow collecting and categorising of things. A couple of the burnt-out canvases that Ali and I first looked at have revealed themselves to be hauntingly beautiful. The canvas, folded over the skeleton frame, reveals the smoke-stained back with the imprint of the frame, and beneath the fold remains an image of two figures, one pulling the other from a void.

I spend days searching through the rubble, finding things, seeing suggestions of the past and for the future. I am ready now to transform this wreckage into something new. I cover charred remains in resin, the burnt forms glisten as if bejewelled, objects hauled from the bottom of the sea. I have slowly begun making paintings again. I am digging down into the past, and the studio is my archaeological site.

When divers located the seabed site of the wreck nearly 200 years after it crashed, they searched for evidence to confirm the find. A single calcified nail was the sole fragment which conclusively confirmed the wreckage was that of the *Medusa*. Their detective work began with a magnetometer, a device developed in France during the Second World War to locate German submarines. In the 1980s the geophysical surveying techniques were applied to various scientific fields, including underwater archaeology. Thirty kilometres off the coast of Mauritania, 100 metres from the wreckage of the *Medusa*, the discovery was made. The magnetometer searches for anomalies in the magnetic field and is able to locate any changes with remarkable precision. Even when searching the sites of wooden ships, it can be used to detect metallic objects within them. As the site was not to be excavated, opportunities to find definitive proof that the wreckage was the *Medusa* were limited. But the nail provided the answer. It was unusual for pegging nails in ships to be made from copper, and the inscription of F. R. on the square head gave the archaeologists further evidence. An order was found dating from 1806 for the construction of the ship, sent to Forges de Romilly, a manufacturer of copper nails. The use of such nails was a historical quirk and enabled the archaeologists to say with certainty that this single nail, taken from the sunken wreckage, was from the *Medusa*.

There's something mournful in the image of the nail, something I recognise in the remains of the studio. All the horror, pain and abjection in my work has been cleared away. Instead of the destruction I see beauty, and beneath the protective mask of performative, violent imagery I see a great, deep pit of melancholy. I hear Keats in this space. In 'Ode on Melancholy' he urges us, *No, no, go not to Lethe*, to not forget, to not block out the past but to dive deep, to confront the darkness, to reveal what has been hidden. I think of *The Raft*'s figure of hope again, of the gap that existed in the painting in its first iterations and then the arrival of that transcendent, beautiful form rising up out of the shadows. An act of defiance emerging from the darkness in search of light.

This is what I need to strive for. I will gather up all these materials and make new work, reach not for the darkness and horror of suffering but for something that can heal and offer hope. I call Ali and tell him our quest has further to go. This is not an end but a beginning. For the first time since the fire, I can see clearly, as if everything has been stripped away. We are both excited and longing for lockdown to be over, for touch to return and for the distance to be closed. We wish to travel together again.

I enter the studio, now a place of conjuring. Naked, I cover myself in the burnt, sodden piles of insulation, like a golden fur from a stripped animal, the flayed pelt of the building's interior. I wrap myself inside it and lie across a stage made from a charred, broken piece of wall which sags under my weight, the fragile edge breaking away. I lift a glass panel from the door. It is now laced with the markings of smoke, which I smear off with my hand. I lie under it, the insulation pushed between glass and flesh. I climb among the broken frames, the charred wood, the shattered shards of glass occasionally scratching my skin. It is a mournful performance with nothing in mind.

I want to let it all in and let it all out. I am happy in here alone, singing silently with all these ghosts. I am grateful to be pressed into a space which is between somewhere and nowhere. I am grateful to have made a raft from the wreck.

Author's Note

The Ali strand of this book was born from a wider project, *I Saw This*, which has continued following the fire, with a large body of artwork produced both from and with the burnt remains. From the beginning of our journey, Ali and I have been accompanied by a third and equal partner, the film-maker Mark Jones. Mark has been documenting the entire process and development of this project in order to create a feature film, entitled *Insight*.

For more information:
https://www.tomdefreston.co.uk/artist/works/i-saw-this

Notes

Prologue: Ghosts

p 1 The Rebecca Solnit quote is from her book *A Field Guide to Getting Lost* (Edinburgh: Canongate Books, 2006).

p 5 Saidiya Hartman's idea of 'critical fabulation' is discussed in her paper 'Venus in Two Acts', published in the journal *Small Axe*, Number 26 (Volume 12, Number 2).

p 6 The John Keats quote, *Thou foster-child of silence and slow*, is the second line in his 'Ode on a Grecian Urn'.

p 7 The opening two chapters of Lorenz E. A. Eitner's biography *Géricault: His Life and Work* (London: Cornell University Press, 1983) and the opening chapter, 'Spectacle of War', of Nina Athanassoglou-Kallmyer's *Théodore Géricault* (London: Phaidon, 2010) give the most comprehensive account of this period in Géricault's life and the wider historical context.

p 7 Eitner cites Michel Le Pesant, of the Archives Nationales in Paris, as the person who found the documents which revealed the secret affair with Alexandrine.

p 11 The quotes and references to Roland Barthes come from his book of fragments *A Lover's Discourse* (London: Vintage Classics, 2002).

p 11 *For in that sleep of death what dreams may come?* is a quote from Hamlet's soliloquy in *Hamlet*, Act 3, Scene 1.

Chapter 1. Possession

p 16 The opening two chapters of Lorenz E. A. Eitner's
biography *Géricault: His Life and Work* (Cornell University
Press, 1983) and the opening chapter, 'Spectacle of War',
of Nina Athanassoglou-Kallmyer's *Théodore Géricault*
(Phaidon, 2010) give the most comprehensive account
of this period in Géricault's life and the wider historical
context.

p 22 Jonathan Miles's *The Wreck of the Medusa: The Most Famous
Sea Disaster of the Nineteenth Century* (London: Black Cat,
2008) provided useful socio-historical context.

p 23 The ideas around the spectacle of suffering have been
influenced by a number of sources, but most explicitly
Guy Debord's *Society of the Spectacle* (St Petersburg,
Florida: Black and Red, 1984).

p 24 Simon Palfrey's *Poor Tom: Living 'King Lear'* (Chicago:
Chicago University Press, 2014), alongside my
collaboration with him on a project around *Poor Tom*, was
seminal in informing the ideas about *King Lear*.

p 25, 26 The Shakespeare quotes are from *King Lear*, Act 4,
Scenes 6–7.

p 27 The Warsan Shire quote comes from her poem 'What they
did yesterday afternoon'.

Chapter 2. Terribilità

p 31 The Eugène Delacroix quote is from the artist's journal,
1817. Sourced from the Folio Society edition (London:
1995) of his collected journal entries.

p 33 The quote *My heart is never easy for it is too full of memories*
comes from a letter from Géricault to Dedreux-Dorcy
(27 November 1817). This letter and its wider meditation
on his night-time walks and descent into depression is
referenced in various Géricault biographies.

Notes

p 33 Eitner's *Géricault: His Life and Work* cites Géricault's earliest biographer, Charles Clément, as the source for Géricault's letters on his time in Rome and his time spent in the Sistine Chapel.

p 33 Philippe Grunchec's exhibition catalogue *Master Drawings by Géricault* (Washington: International Exhibitions Foundation, 1985–6) has reproductions of drawings from Géricault's time in Italy that I have not seen elsewhere.

p 33–4 Wheelock Whitney's *Géricault in Italy* (New Haven and London: Yale University Press, 1997) is the most comprehensive account of Géricault's time in Italy and was a key source.

p 33–4 Both Eitner's *Géricault: His Life and Work* and Athanassoglou-Kallmyer's *Théodore Géricault* dedicate chapters to Géricault's time in Italy. Eitner provides extensive citations to earlier records, including letters to and from friends.

p 36 Notes on the history of the kaleidoscope were taken from David Brewster's *A Treatise on the Kaleidoscope* (Edinburgh: Archibald Constable and Co., 1819).

p 38–40 Various books have been hugely helpful in research on Jacques-Louis David and the wider climate in Paris in Géricault's life. Most extensively used have been Phillippe Bordes's *Jacques-Louise David: Empire to Exile* (New Haven and London: Yale University Press, 2005), Thomas Crow's *Emulation: David, Drouais and Girodet in the Art of Revolutionary* (New Haven and London: Yale University Press, 2006), Thomas Crow's *Restoration: The Fall of Napoleon in the Course of European Art* (Princeton: Princeton University Press, 2018) and Michael Fried's *Absorption and Theatricality: Painting and the Beholder in the Age of Diderot* (Chicago: University of Chicago Press, 1988).

p 42 Various sources helped in the research of Katie Bouman's work on black holes. These include Hannah Ellis-Petersen's article 'Katie Bouman: The 29-year-old whose

work led to first black hole photo', published in the *Guardian* on 11 April 2019; the BBC online *Science and Environment* article 'Katie Bouman: The woman behind the first black hole image' on 11 April 2019; and Katie Bouman's TedX talk, 'How to take a picture of a black hole'.

p 43 The quotes from John Milton are from his poem *Paradise Lost* (1674).

p 44 The quotes from Gilles Deleuze are from his *The Fold: Leibniz and the Baroque* (Minneapolis: University of Minnesota Press, 1992).

Chapter 3. Rupture

p 49 The opening quote is from Emily Dickinson's poem 'Shipwreck' (1896).

p 53–5 Various sources record how the story of *The Raft* spread through Paris, including newspaper reports, Savigny and Corréard's published account and the social milieu in which it was discussed and politicised. I have relied on three in particular: Eitner's *Géricault: His Life and Work*, Athanassoglou-Kallmyer's *Théodore Géricault* and Albert Alhadeff's *The Raft of the Medusa: Géricault, Art and Race* (Munich, Berlin, London, New York: Prestel, 2002).

p 54 Alexander Corréard and J. B. Henry Savigny's published account of their experiences was the primary resource for recounting events on the *Medusa* and the raft in this book. Patrick Maxwell's translation (Driffield: Leonaur, 2008) was the version used for reference.

p 54 Charles Clément is cited as the key source for details of Horace Vernet's studio as a meeting place in Eitner's *Géricault: His Life and Work*.

p 62 The Bertolt Brecht quote is from his collection *Svendborg Poems* (1939).

p 63 *'Tis the time's plague* is from *King Lear*, Act 4, Scene 1.

p 65 The quote from Toni Morrison's essay 'The Site of Memory' is taken from *Inventing the Truth: Art and Craft of*

Memoir, edited by William Zinsser (New York: Houghton Mifflin Company, 1995).

p 67 Reference is made to the ideas and language in T. S. Eliot's *Four Quartets*, first published in 1936 in his *Collected Poems 1909–1935* (London: Faber and Faber, 1940).

p 68 *the burden of the Mystery* is a quote from a letter Keats sent to J. H. Reynolds in May 1819.

p 68 The Denise Riley quotes are from her *Time Lived, Without Its Flow* (London: Picador, 2019).

Chapter 4. Lost at Sea

p 73 *You may forget* . . . fragment by Sappho (*c.*610–*c.*570 BCE).

p 74 Most biographers cite Charles Clément for the details around Géricault's new studio in the Faubourg-du-Roule.

p 81 Harold Rosenberg's quote comes from his article 'The American Action Painters', first published in *ARTnews*, December 1952.

p 82 Keats's idea of Negative Capability is outlined in a letter to his brothers, Thomas and George (22 December 1817) and is later expanded upon in a letter to J. H. Reynolds (May 1819).

p 87 Keats's poem 'Ode to a Nightingale' (1819*)* is referenced and quoted from extensively.

p 88 Andrew Motion's biography *Keats* (London: Faber and Faber, 2003) was a source for the biographical details around Keats.

p 89 The Mahmoud Darwish quotes are from his poetry collection *Memory of Forgetfulness*, translated by Ibrahim Muhawi (Berkeley: University of California Press, 2013).

p 90 The quote from Simon Palfrey, *Tom is life at the cliff-verge*, is from a pack of postcards published by the Bodleian Library for the *Shakespeare's Dead* exhibition in 2016. Also nods to ideas in his *Poor Tom: Living 'King Lear'*.

p 96 Alice Oswald, *Dart* (London: Faber and Faber, 2010).

p 96 *monstrous things* is a reference to Leonardo da Vinci's *A Treatise on Painting* (1632).

Chapter 5. Wrestling

p 101 The opening Rebecca Solnit quote is from her book *The Faraway Nearby* (London: Granta, 2014).

p 111 The quotes and references to Roland Barthes come from his *A Lover's Discourse*, which also informs the wider language around Géricault's longing.

p 111 Eitner's *Géricault: His Life and Work* and Athanassoglou-Kallmyer's *Théodore Géricault* helped give a framework to the biographical and historical details in this chapter.

p 115 Palfrey's *Poor Tom: Living 'King Lear'* explores in depth Gloucester's question *but have I fall'n, or no?*

p 118–19 Various sources helped with the material on Martin Kippenberger and Elfie Semotan's work: Chris Reitz's exhibition review in *Art Agenda*, 16 April 2014 and Anne Tome's review for *Brooklyn Rail* (March 2014), both for the exhibition at the Skarstedt Gallery (New York, 3 March–26 April 2014). Also Angelika Taschen and Burkhard Riemschneider (eds), *Kippenberger* (Cologne: Taschen, 2014).

p 121 Quotes and references to Poor Tom from Palfrey's *Poor Tom: Living 'King Lear'*.

p 122 Quotes from Keats's 'Ode on a Grecian Urn' (1819).

p 124 Quote taken from Gilles Deleuze's *Francis Bacon: The Logic of Sensation*, translated by Daniel W. Smith (London: Bloomsbury, 2017).

p 127 Quote taken from John Berger's book *Ways of Seeing* (London: Penguin Classics, 2008).

Chapter 6. Flesh

p 131 *I am a monster* ... is taken from a letter Géricault sent to his friend Dedreux-Dorcy, as referenced in Eitner's *Géricault: His Life and Work*.

p 134 Various books and articles helped with the research for Géricault's painting of heads and limbs. Most prominent were Athanassoglou-Kallmyer's *Théodore Géricault* and her article 'Géricault's severed heads and limbs: The politics and aesthetics of the scaffold', *The Art Bulletin*, Volume 74, Number 4, December 1992, and Alhadeff's *The Raft of the Medusa*. Both cite Charles Clément's biography as a key source and first-hand accounts from a number of visitors in regards to the state of the studio.

p 138 Quotes are taken from and reference made to Mary Shelley's novel *Frankenstein* (1819; London: Collins Classics, 2010).

p 139 The link between Géricault's studio and a *Phantasmagorie* was in part inspired by Athanassoglou-Kallmyer's *Théodore Géricault*. Marvyn Head's *Phantasmagoria: The Secret History of the Magic Lantern* (London: The Projection Box, 2006) provided further information on phantasmagorias. Some basic historical details were taken from the Wikipedia entries on Phantasmagoria and Paul Philidor.

p 142 The Théophile Gautier quote was sourced from Athanassoglou-Kallmyer's *Théodore Géricault*.

p 144 The links between Frankenstein and childbirth, and the Mary Shelley quotes, were explored in Ruth Franklin's online article 'Was Frankenstein really about childbirth?', *The New Republic*, 7 March 2012.

p 144 *Nothing seems solid* is taken from a letter Géricault sent to Dedreux-Dorcy, as referenced in Eitner's *Géricault: His Life and Work*.

p 144 *too too solid flesh* is a quote from *Hamlet*, Act 3, Scene 1.

p 150 Francis Bacon quote taken from John Gruen's *The Artist Observed: 28 Interviews with Contemporary Artists* (London: A Cappella Books, 1991); the other quote is from Deleuze's *Francis Bacon*.

p 150 *violence … does have a gender* is quoted from Rebecca Solnit's essay collection *Men: Explain Things to Me* (Chicago: Haymarket Books, 2014).

p 151 *Tom is mime shattered* is quoted from Palfrey, postcards
 published for the *Shakespeare's Dead* exhibition in 2016.
 Also nods to ideas in his *Poor Tom: Living 'King Lear'*.

Chapter 7. Flaying

p 157 *DEATH's cold SPELL* is a quote from Mary Darby
 Robinson's poem 'Absence' (1791).

p 158 The Virginia Woolf quote is from Susan Sontag's *Regarding
 the Pain of Others* (London: Penguin, 2004).

p 163–8 Various books and articles helped with the research for
 Géricault's work in Rome. Most prominent were Whitney's
 Géricault in Italy, Athanassoglou-Kallmyer's *Théodore
 Géricault* and her article 'Géricault's severed heads and
 limbs: The politics and aesthetics of the scaffold', and
 Eitner's *Géricault: His Life and Work*.

p 168 *The expression of the countenance* is from H. Matthews's *The
 Diary of an Invalid*, as cited in the endnotes of Whitney's
 Géricault in Italy.

p 172 The Linda Nochlin observation is from her essay
 'Géricault, or the absence of women', in *October*, Volume
 68, Spring 1994.

p 173 *The rise translates* is a quote from Palfrey, postcards
 published for the *Shakespeare's Dead* exhibition in 2016.
 Also nods to ideas in his *Poor Tom: Living 'King Lear'*.

p 175–8 Various sources helped with the material on Martin
 Kippenberger and Elfie Semotan's work:
 Chris Reitz's exhibition review in *Art Agenda*, 16 April
 2014 and Anne Tome's review for *Brooklyn Rail* (March
 2014), both for the exhibition at the Skarstedt Gallery
 (New York, 3 March–26 April 2014). Also Taschen and
 Riemschneider (eds), *Kippenberger* and Rachel Kushner's
 essay for the exhibition catalogue. Kushner's text provided
 the link to the jellyfish.

p 177 The Wikipedia entry on the *Turritopsis dohrnii* helped me
 in researching the immortal jellyfish.

p 181 Jean Baudrillard's *The Spirit of Terrorism: And Other Essays*
 (London: Verso, 2013) was a point of reference for the
 material on the Twin Towers.

p 182–3 The account of Richard Drew's photograph of the falling
 man relied on Tom Junod's piece 'The falling man: An
 unforgettable story', *Esquire*, September 2016.

p 183 Ideas on the spectacle of suffering are informed in part by
 Debord's *Society of the Spectacle*.

p 186 The Stephen King quotes are from his *Danse Macabre*
 (London: Hodder, 2012).

Chapter 8. Emergence

p 189 *I am terrified by this dark thing* is from Sylvia Plath's poem
 'Elm', from the collection *Collected Poems* (London:
 HarperCollins, 1962).

p 191 The Julian Barnes quote is from his *A History of the World
 in 10½ Chapters* (London: Vintage, 2009).

p 192 The Linda Nochlin quotes are from her essay 'Géricault,
 or the absence of women'.

p 193 Wheelock Whitney's *Géricault in Italy* and Athanassoglou-
 Kallmyer's *Théodore Géricault* were both particularly useful
 for research into Géricault's erotic work. Albert Alhadeff's
 *Théodore Géricault, Painting Black Bodies: Confrontations
 and Contradictions* (London: Routledge, 2020) was helpful
 on the racial politics of Géricault's erotica.

p 197 *I begin sketching a woman and she becomes a lion* is attributed
 to Géricault's biographer Charles Clément in Grunchec's
 exhibition catalogue *Master Drawings by Géricault*.

p 204 The Jean Genet quote and details of Dia al-Azzawi's
 painting *Sabra and Shatila Massacre* were sources from the
 Tate Modern webpage for the painting.

p 207 Olivia Laing's *The Lonely City: Adventures in the Art of
 Being Alone* (Edinburgh: Canongate Books, 2017) has some
 extensive writing on the art and life of Henry Darger that
 was useful in my research.

p 208 Olivia Laing's *Funny Weather: Art in an Emergency*
(London: Picador, 2020) talks about the Jean-Michel
Basquiat painting/quote *To Repel Ghosts*.

Chapter 9. Hope

p 213 *No light, but rather darkness visible* is from Milton's *Paradise
Lost* (1674).

p 214 Eitner's *Géricault: His Life and Work* documents the
gradual shrinking of the ship on the horizon in Géricault's
preliminary studies.

p 215 Corréard and Savigny's published account of their
experiences was the primary resource for the recounting
of events on the raft. Patrick Maxwell's translation was the
version used for reference.

p 217 Jonathan Miles's *The Wreck of the Medusa: The Most
Famous Sea Disaster of the Nineteenth Century* (London:
Black Cat, 2008) provided details on the birth and fate of
Georges-Hippolyte.

p 219 Eitner's *Géricault: His Life and Work* drew my attention to
seemingly different light sources in the painting. Charles
Clément is cited as the source for details of Géricault's trip
to Le Havre.

p 227 For the account of Mary Richardson, the following were
helpful: Mary Richardson, *Laugh a Defiance* (London:
Weidenfeld & Nicolson, 1953); the Wikipedia entry, which
provided some of the detail on her life; Diane Atkinson's
Rise Up Women! The Remarkable Lives of the Suffragettes
(London: Bloomsbury, 2018); and the online article '*Rokeby
Venus*: The painting that shocked a suffragette', BBC
Magazine Monitor, 10 March 2014.

Chapter 10. A Painting Is a Poem

p 235 *Touch has a memory* is from Keats's poem 'What can I do to
drive away' (1821).

p 236 Stephen Bann's *Paul Delaroche: History Painted* (London: Reaktion Books, 1997) has an excellent description of the codification of Christian compositional devices in Western painting.

p 238-40 Various books helped with details on the reception of *The Raft of the Medusa* at the Salon. These include Athanassoglou-Kallmyer's *Théodore Géricault*, Eitner's *Géricault: His Life and Work* and Alhadeff's *The Raft of the Medusa*.

Chapter 11. Wreckage

p 253 The Emily Dickinson quote is from her envelope poems, sourced in *The Gorgeous Nothing: Emily Dickinson's Envelope Poems* (New York: New Directions, 2013).

p 253 Various books helped in piecing together the development of the figure waving his flag to the horizon. These include Athanassoglou-Kallmyer's *Théodore Géricault*, Eitner's *Géricault: His Life and Work*, Alhadeff's *The Raft of the Medusa* and his *Théodore Géricault, Painting Black Bodies*.

p 259 The disputes over Governor Schmaltz and his role in perpetuating the slave trade in Senegal are discussed in Alhadeff's *The Raft of the Medusa* and his *Théodore Géricault, Painting Black Bodies*. The slave trade in Senegal during Governor Schmaltz's time there is explored in Martin A. Klein, 'Slaves, gum and peanuts: Adaptation to the end of the slave trade in Senegal, 1817–48', *The William and Mary Quarterly*, Third series, Volume 66, Number 4. Data referenced is taken from the research cited this paper.

p 260 Details on Géricault's personal life were drawn from the following books: Miles's *The Wreck of the Medusa*, Athanassoglou-Kallmyer's *Théodore Géricault*, Eitner's *Géricault: His Life and Work* and Alhadeff's *The Raft of the Medusa*.

p 261 Eitner's *Géricault: His Life and Work* and Alhadeff's *The Raft of the Medusa* are the main sources for details on

Géricault's time in London, but Athanassoglou-Kallmyer's *Théodore Géricault* filled in a number of the gaps.

p 261 Athanassoglou-Kallmyer's *Théodore Géricault* and Alhadeff's *Théodore Géricault, Painting Black Bodies* provided details on Géricault's boxing imagery.

p 261 The quote from Géricault's letter to Dedreux-Dorcy was found in Athanassoglou-Kallmyer's *Théodore Géricault*.

p 262 Athanassoglou-Kallmyer's *Théodore Géricault* and Eitner's *Géricault: His Life and Work* were the most helpful points of research for the Cato Street conspirators.

p 263 *Now more than ever seems it rich to die* is a quote from Keats's 'Ode to a Nightingale'.

p 264 Miles's *The Wreck of the Medusa* provided some of the details around Géricault's descent into suicidal depression.

p 264-5 Athanassoglou-Kallmyer's *Théodore Géricault* and Alhadeff's *Théodore Géricault, Painting Black Bodies* were the primary texts for research on Géricault's engagement with the abolitionist movement and the political and racial constructs in his boxer imagery, raft studies and the planned *Abolition of the Slave Trade* painting.

p 266 Details on the life of Edward Colston were taken from his Wikipedia entry and Kenneth Morgan's *Edward Colston and Bristol* (Bristol branch of the Historical Association, University of Bristol, 1999).

p 266 Saidiya Hartman's 'Venus in Two Acts' was published by the journal *Small Axe*, Number 26 (Volume 12, Number 2), June 2008.

p 267 The Nikesh Shukla quote is in reference to a post on Twitter and Instagram on 10 July 2020.

p 267 Vanessa Kisuule's poem *Hollow* is referenced and quoted (2020). First published on her Twitter accounts, @ vanessa_kisuule.

p 267 The Alexander Boris de Pfeffel Johnson quotes are from a Twitter thread posted under his Twitter handle @ BorisJohnson on 12 June 2020.

Notes

Chapter 12. Endings

p 281 The Maggie Nelson quote is from her book *The Argonauts* (London: Melville House, 2016).

p 281 Robert Snell's *Portraits of the Insane: Theodore Gericault and the Subject of Psychotherapy* (London: Routledge, 2018) and Athanassoglou-Kallmyer's *Théodore Gericault* provided information on the mystery around Gericault's relationship with the alienist Étienne Georget and analysis of the subsequent portraits he made.

p 286 Athanassoglou-Kallmyer's *Théodore Gericault* and Miles's *The Wreck of the Medusa* provided a comprehensive overview on Géricault's final years and the Letellier work, building on the details covered in Eitner's *Géricault: His Life and Work*.

p 288 *we are the bees of the invisible* is a quote from a letter of 1925 from Rainer Maria Rilke to his Polish translator, Witold Hulewicz, concerning his *Duino Elegies*.

p 289 The Géricault quotes and notes from the end of his life were sourced from Athanassoglou-Kallmyer's *Théodore Gericault*.

p 289 Géricault's study of his hand is written about and reproduced in Athanassoglou-Kallmyer's *Théodore Gericault*.

p 290 Details on the events following his death are drawn from a few sources, including Athanassoglou-Kallmyer's *Théodore Gericault*, Eitner's *Géricault: His Life and Work* and Miles's *The Wreck of the Medusa*.

p 294 Details on the Jericho skull and its history were gathered form various sources, including the websites of the British Museum and the Ashmolean Museum, the Wikipedia page on the subject, an article by Kristin Romey in *National Geographic*, 5 January 2017 and an article by Kathleen Kenyon in *National Geographic*, December 1953.

p 304 Jay Bernard's poem 'Hiss' is from the collection *Surge* (London: Chatto & Windus, 2019).

p 305 Khadija Saye's Twitter bio is referenced from her Twitter handle @Saye_Photo. Khadija Saye quotes and references to her process were sourced from the Victoria Miro Gallery website, from the exhibition *Khadija Saya: In This Space We Breathe*, 7 July–8 August 2020.

p 309 Information on the copper nail used to confirm the wreckage site of the *Medusa* was drawn from Jean-Yves Blot's *Underwater Archaeology: Exploring the World Beneath the Sea* (London: Thames and Hudson, 1996).

Bibliography

Alhadeff, Albert, *The Raft of the Medusa: Géricault, Art and Race* (Munich, Berlin, London, New York: Prestel, 2002)

Alhadeff, Albert, *Théodore Géricault, Painting Black Bodies: Confrontations and Contradictions* (London: Routledge, 2020)

Athanassoglou-Kallmyer, Nina, 'Géricault's severed heads and limbs: The politics and aesthetics of the scaffold', *The Art Bulletin*, Volume 74, Number 4, December 1992.

Athanassoglou-Kallmyer, Nina, *Théodore Géricault* (London: Phaidon, 2010)

Atkinson, Diane, *Rise Up Women: The Remarkable Lives of the Suffragettes* (London: Bloomsbury, 2018)

Bann, Stephen, *Paul Delaroche: History Painted* (London: Reaktion Books, 1997)

Barnes, Julian, *A History of the World in 10½ Chapters* (London: Vintage, 2009)

Barthes, Roland, *A Lover's Discourse* (London: Vintage Classics, 2002)

Baudrillard, Jean, *The Spirit of Terrorism: And Other Essays* (London: Verso, 2013)

Berger, John, *Ways of Seeing* (London: Penguin Classics, 2008)

Bernard, Jay, *Surge* (London: Chatto & Windus, 2019)

Blot, Jean-Yves, *Underwater Archaeology: Exploring the World Beneath the Sea* (London: Thames and Hudson, 1996)

Bordes, Philippe, *Jacques-Louis David: Empire to Exile* (New Haven and London: Yale University Press, 2005)

Brewster, David, *A Treatise on the Kaleidoscope* (Edinburgh: Archibald Constable and Co., 1819)

Corréard, Alexander and Savigny, J. B. Henry, translated by Patrick Maxwell, *Medusa: Narrative of a Voyage to Senegal in 1816* (Driffield: Leonaur, 2008)

Crow, Thomas, *Emulation: David, Drouais and Girodet in the Art of Revolutionary France* (New Haven and London: Yale University Press, 2006)

Crow, Thomas, *Restoration: The Fall of Napoleon in the Course of European Art* (Princeton: Princeton University Press, 2018)

Darwish, Mahmoud, translated by Ibrahim Muhawi, *Memory of Forgetfulness* (Berkeley: University of California Press, 2013)

Davidson, Susan et al., *Abstract Expressionism* (London: Royal Academy of Arts, 2019)

Debord, Guy, *Society of the Spectacle* (St Petersburg, Florida: Black and Red, 1984)

Deleuze, Gilles, *The Fold: Leibniz and the Baroque* (Minneapolis: University of Minnesota Press, 1992)

Deleuze, Gilles, translated by Daniel W. Smith, *Francis Bacon: The Logic of Sensation* (London: Bloomsbury, 2017)

Dickinson, Emily, *The Gorgeous Nothing: Emily Dickinson's Envelope Poems* (New York: New Directions, 2013)

Eitner, Lorenz, *Géricault: His Life and Work* (London: Orbis Publishing, 1983)

Ellis-Petersen, Hannah, 'Katie Bouman: The 29-year-old whose work led to first black hole photo', the *Guardian*, 11 April 2019

Bibliography

Falconer, Morgan, *Painting Beyond Pollock* (London:
 Phaidon, 2015)

Feaver, William and Moorhouse, Paul, *Michael Andrews*
 (London: Tate Publishing, 2001)

Fortenberry, Diane, et al., *Body of Art* (London: Phaidon, 2015)

Fried, Michael, *Absorption and Theatricality: Painting and the
 Beholder in the Age of Diderot* (Chicago: University of
 Chicago Press, 1988)

Gilliam, Sam, et al., *The Music of Colour: Sam Gilliam 1967–73*
 (Cologne and New York: Verlag der Buchhandlung
 Walther Konig, 2018)

Grebe, Anje and King, Ross, *The Louvre: All the Paintings*
 (London: Black Dog and Leventhal, 2011)

Grebe, Anje and King, Ross, *The Vatican: All the Paintings*
 (London: Black Dog and Leventhal, 2013)

Gruen, John, *The Artist Observed: 28 Interviews with
 Contemporary Artists.* (London: A Cappella Books, 1991)

Grunchec, Phillippe, *Master Drawings by Géricault* (Washington:
 International Exhibitions Foundation, 1985–6)

Halasa, Malu, Omareen, Zaher and Mahfoud, Nawara (eds)
 Syria Speaks: Art and Culture from the Frontline (London:
 Saqi Books, 2014)

Head, Mervyn, *Phantasmagoria: The Secret History of the Magic
 Lantern* (London: The Projection Box, 2006)

Hofer, Philip *The Disasters of War* (New York: Dover
 Publications, 1968)

Junod, Tom, 'The falling man: An unforgettable story',
 Esquire, September 2016

Klein, Martin *Slaves, Gum and Peanuts: Adaptation to the End
 of the Slave Trade in Senegal, 1817–48, The William and
 Mary Quarterly*, Third series, Volume 66, Number 4,
 October 2009.

King, Stephen, *Danse Macabre* (London: Hodder, 2012)

King, Stephen, *Salem's Lot* (London: Penguin Random House, 2013)

Kushner, Rachel, 'Martin Kippenberger: Raft of the Medusa', essay for exhibition catalogue (New York: Skarstedt Gallery, 2014)

Laing, Olivia, *The Lonely City: Adventures in the Art of Being Alone* (Edinburgh: Canongate Books, 2017)

Laing, Olivia, *Funny Weather: Art in an Emergency* (London: Picador, 2020)

Miles, Jonathan, *The Wreck of the Medusa: The Most Famous Sea Disaster of the Nineteenth Century* (London: Black Cat, 2008)

Motion, Andrew, *Keats* (London: Faber and Faber, 2003)

Nelson, Maggie, *The Argonauts* (London: Melville House, 2016)

Nochlin, Linda, 'Géricault, or the absence of women', *October*, Volume 68, Spring 1994

Oswald, Alice, *Dart* (London: Faber and Faber, 2010)

Palfrey, Simon, *Poor Tom: Living 'King Lear'* (Chicago: University of Chicago Press, 2014)

Pearlman, Wendy, *We Crossed a Bridge and it Trembled: Voices from Syria* (London: HarperCollins, 2017)

Richardson, Mary, *Laugh a Defiance* (London: Weidenfeld & Nicolson, 1953)

Riley, Denise, *Time Lived, Without Its Flow* (London: Picador, 2019)

Rothko, Christopher (ed.), *The Artist's Reality: Philosophies of Art* (New Haven and London: Yale University Press, 2006)

Shakespeare, William, *The RSC Shakespeare: The Complete Works* (London: Palgrave Macmillan, 2008)

Shire, Warsan, *Teaching My Mother How to Give Birth* (London: Flipped Eye Publishing, 2011)

Snell, Robert, *Portraits of the Insane: Théodore Géricault and the Subject of Psychotherapy* (London: Routledge, 2018)

Solnit, Rebecca, *A Field Guide to Getting Lost* (Edinburgh: Canongate Books, 2006)

Solnit, Rebecca, *Men: Explain Things to Me* (Chicago: Haymarket Books, 2014)

Solnit, Rebecca, *The Faraway Nearby* (London: Granta, 2014)

Sontag, Susan, *Regarding the Pain of Others* (London: Penguin, 2004)

Taschen, Angelika and Riemschneider, Burkhard (eds), *Kippenberger* (Cologne: Taschen, 2014)

Tellgren, Anna, *Francesca Woodman: On Being an Angel* (Cologne and New York: Walther König, 2015)

Whitney, Wheelock, *Géricault in Italy* (New Haven and London: Yale University Press, 1997)

Wood, Paul and Harrison, Charles, *Art in Theory 1648–1815: An Anthology of Changing Ideas* (London: Wiley-Blackwell, 2002)

Wood, Paul and Harrison, Charles, *Art in Theory 1815–1900: An Anthology of Changing Ideas* (London: Wiley-Blackwell, 2002)

Wood, Paul and Harrison, Charles, *Art in Theory 1900–2000: An Anthology of Changing Ideas* (London: Wiley-Blackwell, 2002)

Woodman, Betty, et al., *Francesca Woodman* (London: Phaidon, 2007)

Zinseer, William (ed.), *Inventing the Truth* (New York: Houghton Mifflin, 1995)

Acknowledgements

I could never have hoped to start, or finish, this book without the help of so many people. It still feels like a dream that it will be published, let alone by Granta. I could not have found a better home, and the guidance and support of the entire team has been incredible. Thanks to Sarah Wasley and Christine Lo for their care and attention in helping bring this book to fruition. To Linden Lawson for the remarkable improvements made by her copy-edits and to Jamie Keenan for his brilliant cover. And, of course, to the wider team who helped bring this book into the world and into the hands of readers.

A special debt is owed to my editor, Bella Lacey, whose fierce intellect, kindness and vision helped sculpt *Wreck* from the baggy mess I first presented to her. The same is true of my agent Harriet Moore, who in many ways gave me the permission to let the book be itself. There is a tenderness, rigour and creative and conceptual depth to her approach. Many thanks as well to the wider team at David Higham and the support they have given.

The book sits as part of a wider project, and my collaborators Ali Souleman and Mark Jones have been my guides and companions on this journey. Above their respective professional skills, it is the compassion and care as friends that I will always

treasure. *Wreck* is really a thank you to Ali, for trusting me with his story. But also to Mark, who in his role behind the camera is a ghost in the book, who might not be seen but is felt in the gaps between the lines. The documentary he has been making of my collaboration with Ali has existed in a beautiful feedback loop with this book. Thanks as well to Max Barton, for friendship, guidance and music.

Wreck also grew out of an earlier collaboration with Simon Palfrey, a writer and academic who is now a dear friend. Simon's presence and intellect can be felt in the book's foundations.

The book is obviously reliant on the work of many esteemed academics. I have been lucky enough to have had a few leading figures' help in directing and checking my research, with rigour and compassion. Andrea Bubenik, Albert Alhadeff and Simon Palfrey in particular have given me more support and guidance than I could have imagined.

My Creative Fellowship at Birmingham University was where many of the strands of this book started and found form. The support of the university, the RSC, the *Guardian* and Battersea Arts Centre was priceless. A special thanks to Ewan Fernie and Shelley Hastings. Earlier Leverhulme and Levy Plumb residencies at Christ's College and Cambridge University were also instrumental to much of the content. A special thanks to Anna Gannon, Carrie Vout, Martin Johnson and Matthias Wivel.

The Truthtellers project at King's College London had a critical impact on the later developments in the book. The ongoing collaboration with Christiana Spens, Pablo de Orellana and Mariah Whelan shaped some of its passages. In a similar way, the Demons Land project at Oxford University/Queensland University has run concurrently with much of the book's material and at various points bleeds into its thinking, so special

thanks to my collaborators there: Simon, Mark, Andrea and Henrietta Marie.

Many friends, old and new, have acted as a support system as the book has developed: Matthew Bradshaw, Jess Oliver, Jessie Widdowson, Samir Guglani, Lucy Ayrton, Paul Fitchett, Katie Webber, Kevin Tsang, Laura Theis, Lizzie Huxley Jones, Elizabeth Macneal, Zeba Talkhani, Lydia Ruffles, Katherine Rundell, Alan Buckley, Dan Fell, Will Avery, Robin Macpherson, Michael Yeatts, Theresa Loeber, Jonathan Gilliam, Tim Snaith, Alex Anderson, Andy Foulds. A special mention to Daisy Johnson and Sarvat Hasin, who have been the coordinates who made me dream of the book's possibilities, and inspire me daily.

Professionally I could not have got here without the support of Paul Smith, Matt Chanarin, Matt Price, David Trigg, Mandy Fowler, Adam Levine, Jo Barring, Camilla Guggenheim, Matt Carey Williams, Katharine Craik, Rebecca Daniels and Steven Kenyon Owen. But it was at Medicine Unboxed, thanks to Samir Guglani and Peter Thomas, where the very idea of me even writing a book first seeded. Their vision and the insight and guidance of Clare Conrad let me believe that it might be possible. At a later date, when I thought all was lost, it was Hellie Ogden and Max Porter who lifted me up and pointed the way forwards.

I owe my family everything. I hope when my nieces and nephews are old enough to read this that it makes them proud. The support and love of Andrea, Martyn and all my in-laws has been invaluable. My stepfather, Piers, has taught me what a good father can be. My sisters, Miranda, Madelaine and Milli, in so many ways this book is for you; thank you for always protecting me. My mum, whose unwavering love and towering strength meant that in spite of my dad we have all lived lives full of love and happiness.

Finally, my wife, Kiran. For reading and hearing a thousand drafts, for lifting me from the depths, time and again. For our cats, Luna and Marly, for the twins and the losses. This, and everything, is for you and thanks to you.

Permissions

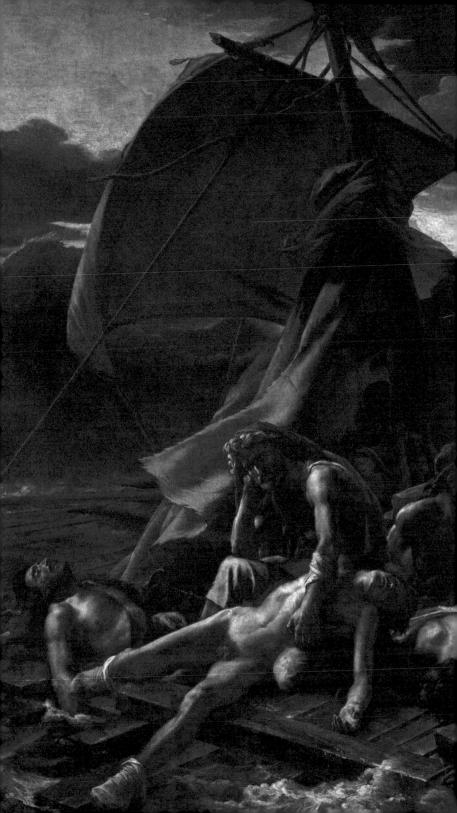